CONSTABLE
and his Drawings

CONSTABLE
and his Drawings

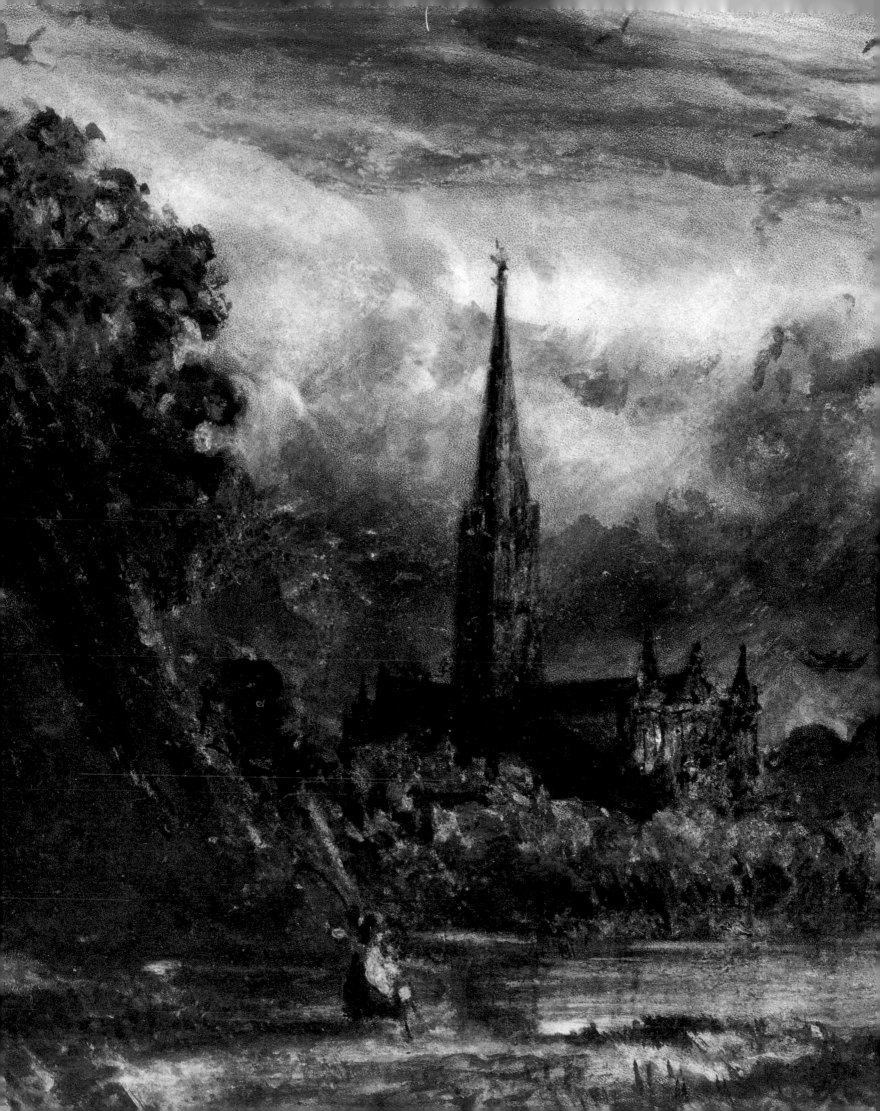

CONSTABLE
and his Drawings

IAN FLEMING-WILLIAMS

Philip Wilson Publishers Limited

© 1990 D. K. R. Thomson
First published 1990 by
Philip Wilson Publishers Limited
26 Litchfield Street, London WC2H 9NJ

British Library Cataloguing in Publication Data

Fleming-Williams, Ian
 Constable and his drawings.
 1. English drawings. Constable, John, 1776–1837
 I. Title
 741.942

 ISBN 0 85667 380 3 (hardback)
 ISBN 0 85667 388 9 (paperback)

Designed by Gillian Greenwood
Phototypeset in Monotype Lasercomp Apollo Series 645
by Southern Positives and Negatives (SPAN), Lingfield, Surrey
Printed and bound by Snoeck, Ducaju & Zoon, NV, Ghent, Belgium

Contents

Acknowledgements

This book could not have been written without the help of numerous individuals, specialists, most of them, in a variety of fields. Constable is an artist known to all and loved by many, and it was always heart-warming to find how readily people responded to requests for information, however remotely connected with him. For help of one sort or another, generously given, I would like to thank the following: Peter Bicknell, Anthony Browne, John Bull, Margie Christian, John Constable, Richard Constable, Malcolm Cormack, Michael Cowan, William Darby, Brian K. Davison, G. M. R. Davies, David Dymond, William Drummond, J. F. Elam, P. C. Ensom, Suzanne Eward, Craig Hartley, Norman Hickin, Evelyn Joll, Richard Kinsett, Vic and Lennie Knowland, Lionel Lambourne, Charles Leggatt, Robert Malster, Christopher Mendez, Jane Munro, Felicity Owen, H. G. Owen, David Patterson, David Posnett, Anthony Reed, Graham Reynolds, Michael Robinson, Dr Margaret Russell, Lawrence Salander, David Scrase, Kim Sloan, Mrs J. Swaffield, Mrs B. Walker, Dr Robert Woof, Andrew Wyld; also the team at 'Jill's' − A. F. E. Griffiths and R. J. Burgess − for their help with the seemingly endless task of photocopying.

I am particularly grateful to my editor, Jane Bennett, and to the designer of this book, Gillian Greenwood, for their sensitive handling of the author and the material he presented for publication. I would also like to thank Sally Prideaux for obtaining some of the less-easy-to-locate photographs and Douglas Matthews for a most comprehensive index. I owe a very special debt of gratitude to Felicity Butcher, Judy Ivy and Leslie Parris, who read the book, chapter by chapter as it was written, who corrected my spelling, suggested many improvements, checked a number of facts for me and who greatly reduced the loneliness of the long-distance writer.

Finally, I want to thank David Thomson, who shared his enthusiasm with me for Constable and the works in his collection. Without his firm support and encouragement I am sure I would have been unable to complete the work.

Ian Fleming-Williams
April 1990

'I never saw an ugly thing in my life:
for let the form of an object be what it may,
light and perspective will always make it beautiful'.

JOHN CONSTABLE

Foreword

Some of my early memories are the peaceful moments among paintings and sculptures in our home and particularly with the Constable oil-sketches that hung in our dining-room. My desire to understand these objects and their reasons for being was intense. I developed varying degrees of personal attachment towards specific works of art, but the Constable paintings still held a peculiar fascination for me. As a young schoolboy, I acquired a page from his 1835 sketchbook of Arundel which was to travel with me to various school lodgings and I have been collecting examples of his work ever since.

Today my collecting ranges from mediaeval art to paintings and works on paper by artists such as Munch, Klee, Mondrian, Twombly and Beuys, and I share with my wife a deep attachment to the works that we have about us. In this company, Constable's landscapes, with their restless skies and moving shadows, have no difficulty in holding their own and remain ever as they are, a perpetual source of growth and discovery, mysterious and spiritually compelling.

David Thomson

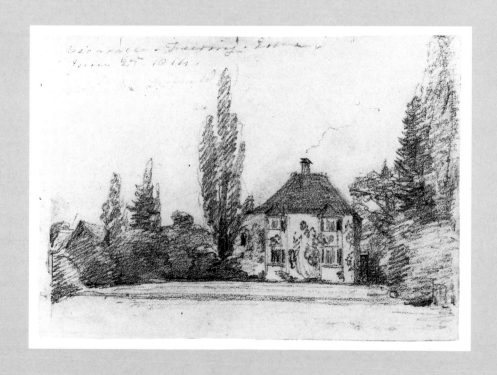

The Vicarage, Feering, Essex
Pencil on untrimmed wove paper
8 × 11 cm.
Inscribed 'Vicarage – Feering. Essex/
June 25.1814/ Rev.[d] W. Drifield', t.l.
A drawing that came to light recently
(1988). See page 124.

Preface

In the summer of 1985, I began to work on some of the Constable drawings that David Thomson had been acquiring for his collection. A few were already familiar, but, apart from a brief appearance in the sale-rooms, the rest were unrecorded or had little previous history. All strongly invited investigation. Because the Kennet and Avon canal is near to where I live, I started with a well-known study, then titled, 'A Lock near Newbury'. The view was soon identified, for canal enthusiasts had already seen reproductions of the drawing. I was shown the probable spot from which the drawing was made and found that there was much about the canal and its history that was relevant to an understanding of Constable's study. A previously unrecorded pen and wash drawing of vessels aground on Brighton beach next presented itself. I discovered that this sketch, with a small group of drawings in other collections, had quite a dramatic little story to tell. As work progressed, it became clear that there was much to be learnt about each individual sheet. The scope of the investigation broadened and with David Thomson's encouragement I began to develop the idea of a book based entirely on the Constable drawings in the collection. The original plan was to publish twenty-five of them, but as new ones were acquired, it was decided to increase the number and to attempt a more comprehensive survey of Constable as a landscape draughtsman. Though it was tempting to continue, as fresh drawings kept turning up (and continue so to do), when the present number of essays was reached, it was decided to call a halt and publish. The result is a total of twenty-two essays on forty-two items in the collection, arranged in chronological order, beginning with one of the earliest to show Constable's emerging individuality as an artist – the 'Hadley' of 1798 – and ending with 'Dowles Brook' (1835), one of the last studies he made from nature.

My approach has been to regard each drawing (or group of drawings) as a separate problem and to take up whatever threads seemed to lead towards a fruitful line of enquiry. Though linked together by the story of the life and of Constable's development as an artist, each essay is therefore relatively self-contained. Much use has been made of the documentary biographical material, whenever possible, at its source – whether the original manuscripts or the contemporary printed word. Full use has also been made of the opportunity to examine the drawings closely. In many cases I have been able to work with the subject of an essay on a small easel in front of me or at my elbow as I wrote. Neither in black-and-white photographs nor in colour transparencies on a light-box can one really see what has actually taken place on the sheet of paper.

Though widely accepted as one of the great painters of landscape, Constable's stature as a draughtsman has not yet been generally recognised. This short-fall is probably due to the fact that the majority of his drawings are monochromatic – only at the start of his career and towards the end did he use watercolours at all extensively – and that their impact is therefore insufficiently immediate for a ready appreciation. Colour has an instant appeal; it takes longer for a pencil, or pen and wash drawing to register, as it has to be 'read', rather like a page of print. The fact that Constable used the graphite pencil so frequently may also have contributed in some measure to the relative neglect of the drawings. Yet, as it is to be hoped the pages of this book will show, with that commonplace tool, the so-called lead pencil, he made some of his finest drawings – drawings that will stand comparison with those of any Continental master of landscape and remain as firmly fixed in the memory as any in colour.

Ian Fleming-Williams
June 1989

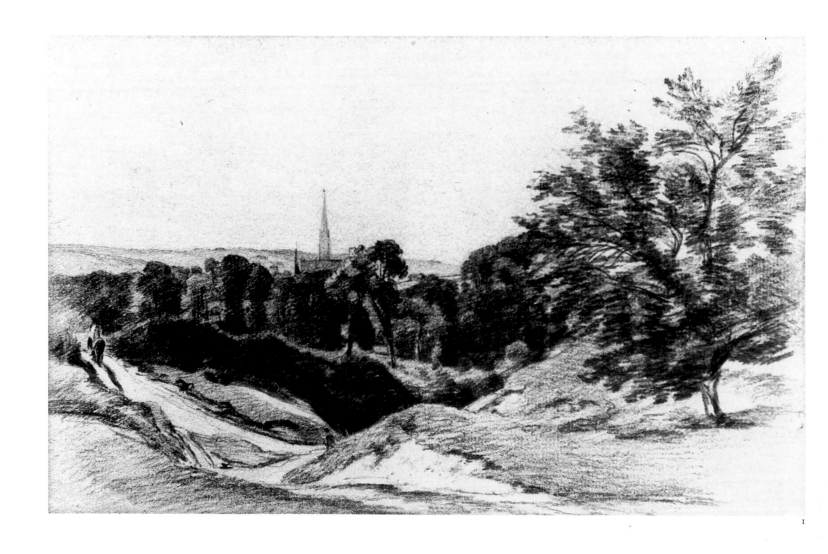

Introduction

In 1836, Constable delivered a series of four lectures on Landscape at the Royal Institution, in Albemarle Street. Towards the end of the final lecture he asked his audience to consider in what estimation pictures and the artists who painted them should be held.

> It appears to me [he said] that pictures have been over-valued; held up by a blind admiration as ideal things, and almost as standards by which nature is to be judged rather than the reverse; and this false estimate has been sanctioned by the extravagant epithets that have been applied to painters, as 'the divine', 'the inspired', and so forth. Yet in reality, what are the most sublime productions of the pencil but selections of some of the forms of nature, and copies of a few of her evanescent effects; and this is the result, not of inspiration, but of long and patient study, under the direction of much good sense.[1]

This was no final credo. Constable's feelings about 'the art', as he called it, were too complex to suffer summary packaging. He also had to take into account the particular audience he was addressing. There were friends present, but most of those attending would have been Members and their guests, more accustomed to hearing lectures on subjects of a scientific nature. A series by Michael Faraday on 'The Philosophy of Heat', was running concurrently with Constable's on Landscape, so some allowance should be made for the commonsensical attitude taken by Constable in the face of that gathering.[2] Nevertheless, he was speaking in all sincerity, and in the rhetorical question, what were the most sublime products of the pencil (meaning the brush), but a *selection of some of the forms of nature* (author's italics), he was presenting an issue in straight forward terms that for him came very near to the heart of the matter.

What did Constable mean? To what manner of selection was he referring? In the previous lecture, when talking about a Ruysdael seascape, he had broken off to quote the opening couplet from one of George Crabbe's *Tales*:

> It is the soul that sees; the outward eyes
> Present the object, but the mind descries;[3]

'We see nothing', he continued, 'till we truly understand it', and then went on to talk of what an ordinary spectator would have failed to notice in such a scene.[4] Reworded, his thoughts on this matter – crucial for an appreciation of Constable's degree of self-knowledge and his understanding of the creative process – were recorded in a letter to him from his friend and biographer, C. R. Leslie, when Leslie reminded him of a remark he had made, that, 'we do not see with our eyes'.[5] Earlier on, in a letter to his friend Archdeacon Fisher, Constable had written, '. . . a man sees nothing in nature but what he knows.'[6] In other words, to paraphrase Constable's quote from Crabbe, it is the mind that sees, that selects; the eye only presents the objects, the forms of nature.

How, we may well ask, does this – Constable's understanding of visual perception – declare itself in his work? Primarily, it seems, in his choice of subject-matter, by the plain fact that he drew and painted most of the time that which he knew and understood best. He is well-known, largely known, as a painter of certain localities: the Stour valley, Salisbury, Hampstead and the Heath, Brighton, etc. His knowledge of the Stour and its Vale – the mills, river-banks, locks, watermeadows and surrounding slopes – may be readily appreciated. That, after all, was the environment in which he grew up. But the extent to which it was that knowledge, that depth of understanding of the place and of those who were

FIG 1 *Salisbury Cathedral from Old Sarum*
Black-and-white chalk on grey paper, 19 × 29.8 cm. Oldham Art Galleries and Museums.

1 *Life*, 1951, p.323.
2 Preceding and current lectures also included: Edward Taylor on 'The Early English Opera'; Professor Lindley on 'Botany applied to Horticulture'; and Charles Wharton on 'Sound'. Earlier that year there had been lectures on 'Differential and Integral Calculus', 'The Manufacure of Paper hangings', 'The Structure of Fishes', 'Steam communication with India' and on a 'Mode of laying out and working a skew Bridge'.
3 The quotation is the opening couplet of the tenth *Tale – The Lovers' Journey*.
4 *Life*, 1951, p.318.
5 In a letter written from Petworth, 31 October 1836: 'I went with Chantrey one beautiful afternoon to Cowdrey but the ruin was not to him that which it was to you. It made me think of <y . . . > your remark that "we do not see with our eyes."' JC:FDC, p.246.
6 21 February 1823, JCC VI, p.113.

to be seen working there, that caused him so frequently to re-create those localities on paper and canvas, this has so far been insufficiently stressed. His own awareness of the necessity for 'knowing' before 'seeing' is just as plainly manifest in his choice of subject-matter when he was away from home ground. So often, when in strange country, it was to the familiar that he was drawn. On his first visit to Salisbury in 1811 the subjects he chose to draw were the great church itself, hard by the Palace where he was staying and then, twice, the spire from afar (like Dedham Church), seen high above the surrounding country (FIG 1). The first sketch he made on his arrival there in 1820 was of an old willow, bent over a river, so reminiscent of those he knew along the banks of the Stour (FIG 2). At Brighton, in 1824, his first oil sketch was of a fishing-boat, high and dry on the beach (FIG 3), a subject similar to a scene on the Orwell, in Suffolk, that he had painted some time before (FIG 4). Windmills and watermills, of course, he seems to have painted and drawn wherever he found himself – Warwickshire in 1809 (FIG 5),

FIG 2 *A River Bank near Salisbury*
Pencil on wove paper, 11.5 × 18 cm. Inscribed b.r., '13 July 1820.' Victoria and Albert Museum.

FIG 3 *Brighton Beach with a Fishing Boat and Crew*
Oil on paper, 24.4 × 29.8 cm. Inscribed on the back in pencil, 'Brighton June 10 1824'. Victoria and Albert Museum.

FIG 4 *Shipping on the Orwell, near Ipswich*
Oil on millboard, 20.2 × 23.5 cm. Victoria and Albert Museum.

FIG 5 *Open Landscape with Windmill*
Black chalk on trimmed, laid paper, 9.5 × 15.4 cm.; watermarked '16'. On the back, *Solihull Church and Holywell House*, faintly inscribed '13 August'. 1809. Drawn while staying at Malvern Hall, Warwickshire. The windmill is likely to have been one that stood at Orton End, north of Solihull.

2

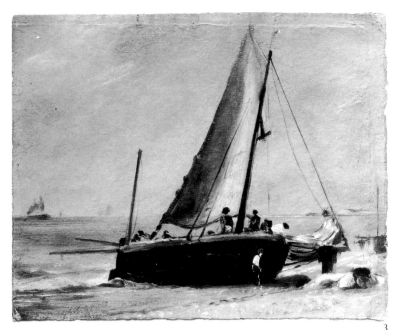

3

4

5

Brighton in 1824 (FIG 6) or Arundel in 1835 (FIG 7). Two of the last drawings he made from nature were of a plough and a barge, with the use of both of which he had such long-standing associations (see FIGS 284 and 285).

He had been trained, one should remember, by his father in the family business. This required more than a nodding acquaintance with milling, river and coastal transport, boat-building, farm management, the coal trade and a host of basic engineering skills. Besides the subject of an inner vision (a vision that enabled him, as he said, to think of pictures before he had ever touched a brush) for Constable landscape was therefore also *land* where people lived and worked, and for an understanding of which as such he possessed special knowledge and a trained eye. This meant that he understood more and consequently 'saw' more deeply into landscape than most other artists of his time. The practical advantage this gave him is to be seen in many of his drawings, in his sketches of locks, wooden footbridges, the litter on the beach of longshore fishing, etc. But the effects of his training, an almost innate feeling for structure, extended far beyond the works of man. The trees he drew and painted were fully anatomised, their weight and growth fully observed and noted. He appears to have had an instinctive feel for land-formation, for the look of a particular type of hill top, valley slope or alluvial floor, and unequalled among painters was his understanding of skies, the skies that were to be seen passing overhead every day.

FIG 6 *A Windmill near Brighton*
Oil on paper, 16.2 × 30.8 cm. Inscribed on the back in pencil, 'Brighton Augst. 3d Smock or Tower Mill west end of Brighton the neighbourhood of Brighton – consists of London cow fields – and Hideous masses of unfledged earth called the country'. 1824. Victoria and Albert Museum.

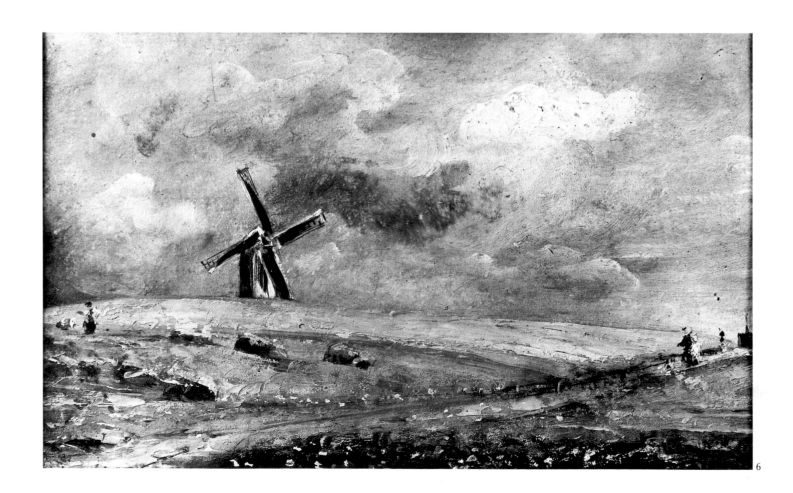

6

FIG 7 *Arundel Mill and Castle*
Pencil on trimmed wove paper,
21.9 × 28.1 cm. Inscribed in pencil,
t.l., 'Arundel Mill & Castle' b.r.
'Arundel Mill July 9 1835'. Victoria
and Albert Museum.

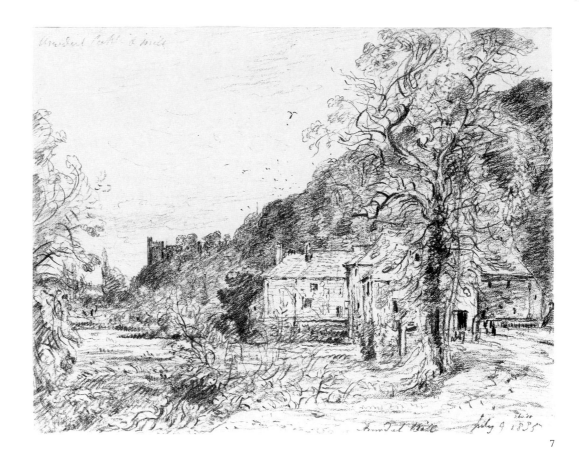

7

Constable's concern was in fact almost exclusively with the beauty to be found in the everyday scene. We are placed in a paradise here, he said, if we choose to make it such.[7]

In his *Life* of Constable, C. R. Leslie published a selection of sayings and quotations found among the artist's papers after his death. One of these, from an 1821 edition of Cennino Cennini's book on painting, ends, '. . . Day after day never fail to draw something, which, however little it may be, will yet in the end be much; and do thy best.'[8] There were periods in his working life when Constable appears to have done his best to follow the fourteenth-century painter's advice: in 1806, for example, during his tour of the Lake District; in the summers of 1813 and 1814, from which seasons there have survived intact two small sketchbooks crammed with drawings; during several weeks in Brighton in 1824, and again, ten years later, when staying in Arundel and Petworth. These were times when he was disinclined or unable to paint (perhaps for lack of materials), or had no need of colour to work as he wished. Drawing and painting require quite different attitudes of mind, and a feeling for one, with its concomitant selective processes, can engender a certain reluctance to switch to the other. In the years prior to Constable's full artistic maturity – i.e., 1800 to 1815 – there was a discernible tendency to swing from a period of drawing to another of painting and back again, as first in one medium and then in the other he gradually acquired articulacy.

7 JCD, p.73. From a note in the British
 Museum; Egerton Ms.3255. JC:FDC, pp.9
 and 22.
8 *Life*, 1951, p.275.

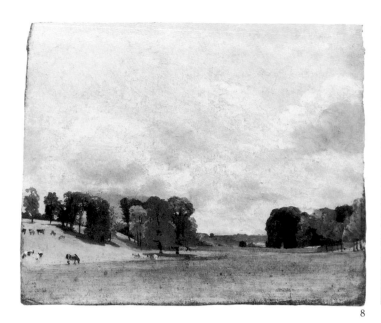

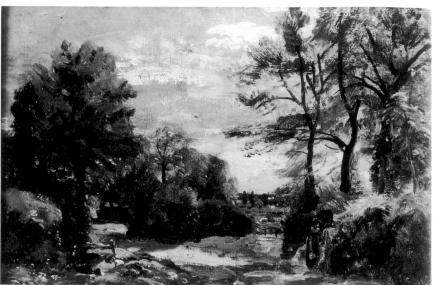

8

9

Most noticeably is this to be seen in the work of 1809 to 1815. It was between 1809 and 1812 that he achieved his historic breakthrough with the oil sketches painted direct from nature; establishing, with bold tonal and colour juxtapositions, landscape images of utter originality (FIGS 8 and 9). During those years his output of drawings was small, and in technique they show no comparable advance. Then, in 1813 and 1814, it was the turn of the sketchbook, and in the two already mentioned and in another of 1814 (equally small but from which only a few pages have survived), we see a development comparable to that which he had been making in oils – a technical advance, but also an enveloping movement towards a whole new range of subject-matter.

After this, it did not seem to matter in which medium he worked. The pencil-point he could use as if it were a brush, if needs be conveying a sense of colour through gradations of tone. With the brush, he could both draw and paint. In the end, all that mattered was chiaroscuro – meaning, literally, clear and obscure (i.e. light and dark) – but defined by Constable in another of his lectures as, 'that power which creates space', that was to be found everywhere and at all times in nature, in 'opposition, union, light, shade, reflection, and refraction'; the power by which 'the moment we come into a room, we see that the chairs are not standing on the tables, but a glance shows us the relative distances of all the objects from the eye, though the darkest or the lightest may be the furthest off.'[9]

In Chapter 4 reference will be made to what is known as scotopic vision, and elsewhere the reader's attention will be drawn to a feature in Constable's work – the *width* of his vision. It seems very likely that there is a connection between the two. Scotopic is the vision supplied by cells in the retina that respond only to tonal differences, to shades of grey; it is these cells that enable us to see when very little light is present, at night for example. In the periphery of the retina only tonal differences register. One of the keys to Constable's naturalism, as it is sometimes called, seems to be his acute tonal sense and his ability to achieve a certain tonal verisimilitude. This 'natural' look to much of his work owed a great deal to his concern with the total visual cone and even beyond it into the peripheral extremes of visual response. The visual cone, the amount we can comfortably

9 During the third lecture to the Royal Institution, 9 June 1836. Ibid., pp.316–7; JCD, p.62. Constable cited Claude and Ostande (presumably Isaac) as two masters of chiaroscuro. See also p.111 for Constable on chiaroscuro.

10 This is by no means always easy to realise. Hedges in his day were kept lower and there were many fewer trees. Most of his best-known views are now overgrown or overbuilt.

11 The purpose of the visit was to try and find out the hour when the drawing was made from the position of the shadow cast by the seated figure on the nearby stone that Constable so carefully shaded. Our guide sat on the appropriate stone for us at 3.00 p.m. We should have been there at around 7.00 in the evening when Constable apparently made his drawing.

FIG 8 *View at Epsom*
Oil, formerly on board,
29.9 × 35.9 cm. The inscription,
'Epsom June 1809', formerly on the
back, is now separately preserved.
Tate Gallery. The earliest known oil
of this important year.

FIG 9 *A Lane near Flatford (?)*
Oil on paper, 20.3 × 30.3 cm.,
c.1810 11. Tate Gallery.

FIG 10 *Stonehenge*
Pencil on untrimmed, wove paper,
11.5 × 18.7 cm. inscribed, b.l., '15
July 1820'. Victoria and Albert
Museum. When he drew the figure
casting his shadow on the leaning
stone, had Constable in mind the
motto on the sundial on East Bergholt
Church – 'Ut Umbra sic vita' (Time
passeth away like a shadow)?

identify and interpret without moving our eyes or head, is about 45 degrees, roughly what we see when looking through the viewfinder of an average, modest camera. When it has been possible to compare the photograph of a Constable drawing or painting with the actual view depicted from the spot where he worked,[10] the extent of the sweep he includes from left to right has often come as a surprise. This width of vision was brought home most effectively to the author on 15 July 1988, when an attempt was made to find the exact spot from which Constable made a drawing of Stonehenge (FIG 10) on 15 July 1820.[11] The accuracy of his noting proved remarkable, but to reach the place where he sat when sketching the monument one had to advance to within seven paces of the nearest stone, by which time the angle of vision embracing the whole circle had increased to rather more than 90 degrees. This, for the modern eye, felt uncomfortably close. It is doubtful if many artists at the present time, wishing to draw the entire circle of stones in a sketchbook of the same size – 4½ × 7½ in. – would think of planting themselves down as near as that. This is not to suppose that Constable made his drawing of Stonehenge around a single line of vision, that he did not turn his head to see the stones to left and right. But the selection of this and many other of his viewpoints, coupled with his management of the tonal peripheral image in so many of his works leads one to suspect that his arc of acceptance, as one might call it, was unusually great.

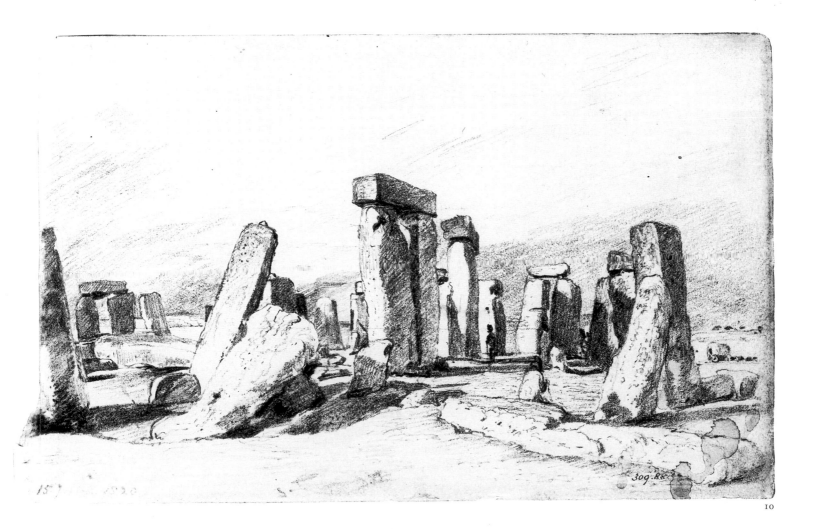

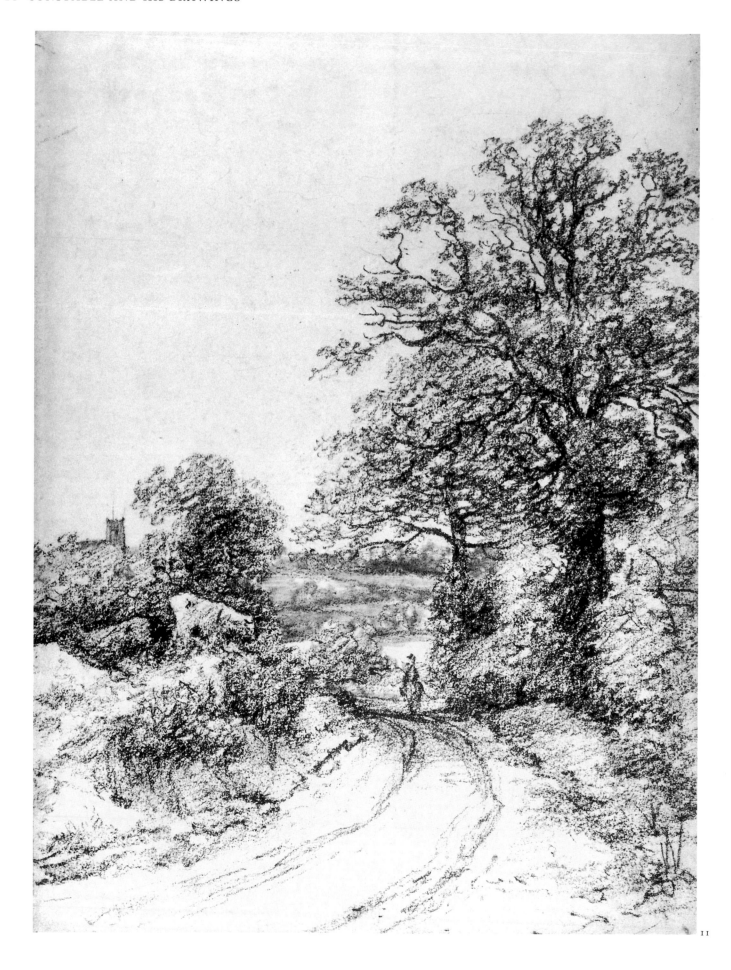

FIG 11 *Washbrook*
Black chalk and stump, with pin-
holes in all four corners, on wove
paper 33.3 × 24.3 cm.; watermarked
'17[?]4/J WHATMAN'. Inscribed on
the back, b.l., '5 Octr 1803/ noon.
Wash brook'. A drawing unrecorded
before 1988.

FIG 12 Ramsay Richard Reinagle,
A Rural Scene
Pencil on laid paper, 19 × 24.1 cm.
Private Collection.

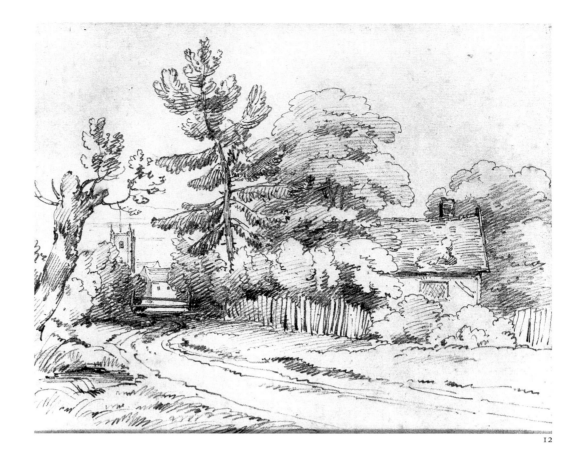

12

12 William Blake, on the other hand, seems to
 have enjoyed repetitious, flowing gestures.
13 See for example his drawing of the railings
 around his parents' tomb, PLATE 19.
14 See Tate 1976, nos 38 and 39, p.53.
15 See Fleming-Williams and Parris, 1984,
 pp.154–8.

He was unusual in another respect, in a way that bears closely upon our interest
in him as a creative source, both as a painter and as a draughtsman. There seems to
have been in his make-up a deep dislike for repetitive movement, an almost
physical resistance against repetitious gestures.[12] Capable of exercising a high
degree of physical control of brush or pencil when the subject demanded it, he
could make as many repeated strokes or touches as was necessary.[13] But
instinctively he seems to have wanted each touch or stroke to be different, if only
fractionally – for each movement to be spontaneous, to have a life of its own.
Evidence of this is to be found in his work from early maturity onwards. FIG 11 is
a chalk drawing inscribed 'noon. Washbrook' and dated on the reverse, 5 October
1803. In Constable's day Washbrook was a village on the main road a few miles
short of Ipswich, the route he would have taken when visiting a friend, George
Frost, an amateur painter who worked in an Ipswich coaching office. On that same
day he and Frost sat down side by side and made drawings of the warehouses and
shipping in Ipswich.[14] Frost, and his enthusiasm for Gainsborough were
influencing Constable strongly at this time, as we see in the drawing of
Washbrook. But even at this early stage the characteristics we are discussing are
discernible; more readily perhaps if we compare *Washbrook* (FIG 11) with a
drawing made by an earlier friend, Ramsay Richard Reinagle, probably in 1799,
when he was staying at East Bergholt with Constable and his family.[15] In his
drawing (FIG 12), Reinagle displays a certain panache, but only because he uses a
succession of well-tried calligraphic formulas. Compare the way the two artists
have depicted the tracks on the road. Reinagle has dashed his in, almost
disdainfully, with flourishing strokes; Constable has drawn them more tenta-

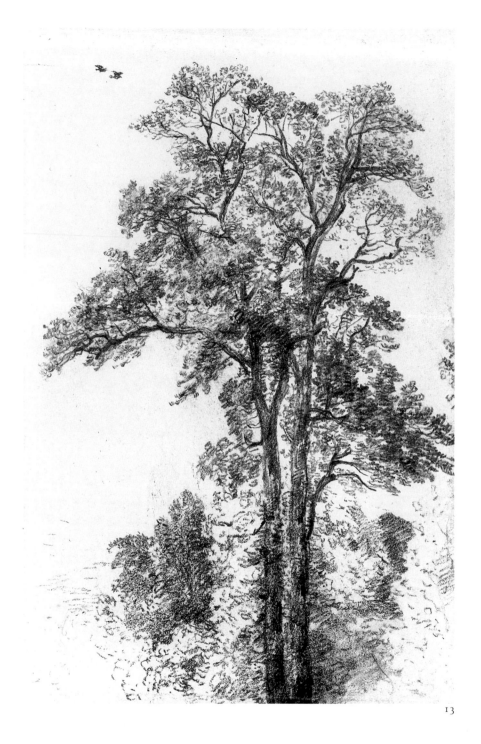

FIG 13 *Study of Trees*
Pencil on trimmed, wove paper,
17.9 × 11.4 cm. Inscribed on the back
in pencil 'Hampstead Oct.ʳ 1819 – '.

13

tively, but with each trailing line made a separately considered statement. Compare also the handling of the tops of the trees in the two drawings: the one, rubber-stamped, as it were, with stereotyped forms; the other, messy by comparison, but exhibiting hardly a repeated movement. The individuality of each mark may be noted in a later drawing, Constable's study of two trees dated October 1819, here reproduced actual size (FIG 13) and with an enlarged detail (FIG 14). A perhaps closer than usual scan of some of the plates in this book will provide the reader with plenty of further examples. In this context, one of the notes found after Constable's death by Leslie and published in his *Life* may be aptly quoted:

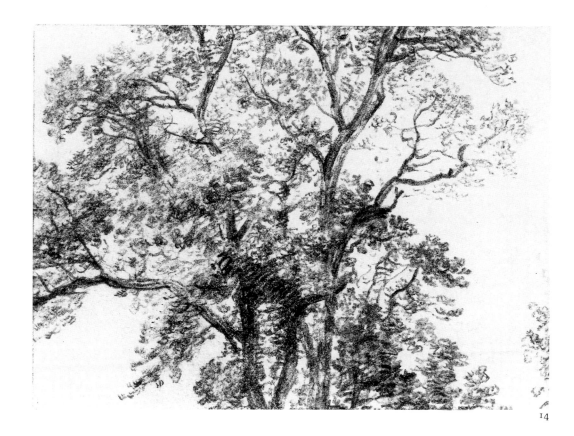

14

The world is wide; no two days are alike, nor even two hours; neither were there ever two leaves of a tree alike since the creation of the world; and the genuine productions of art, like those of nature, are all distinct from each another.[16]

For a time, drawing appears to have come more naturally to Constable than painting. For most of us the first marks we make are lines and dots with a pencil or crayon of some kind; the first images we achieve, shapes contained by lines. The earliest known signed and dated work by Constable is an outline of a windmill that he carved into wood at the age of sixteen.[17] His earliest sketchbook, possibly home-made, contained eleven drawings in pen and ink (FIG 27), rather scratchy views in and around his native village, East Bergholt, one of which is dated 1798.[18] Within two years he was working with a degree of fluency that he was unable to achieve in oils until 1802–3. Later, as we have said, there were periods when he painted almost exclusively; but there were also years when, in the more clement seasons, the sketch-book saw more of him than the easel. Overall, drawing played as important a part in his working life – if a more private one – as painting did. To know and understand Constable as well as to enjoy his art to the full, we need to give almost as much time to the drawings as to the paintings.

His range of work in oils was considerable: from 8×11 in. sketches such as FIG 9, dashed on to paper in an hour or so, to the monumental, complex exhibition pieces; from exquisite, highly finished little paintings, to the great, full-sized 'sketches' for paintings like *The Leaping Horse* (FIG 188) or *Hadleigh Castle* (FIG 213), executed very largely with powerful strokes and slashes of a palette-

16 *Life*, 1951, p.273.
17 See FIG 24.
18 V.& A. Reynolds 1973, nos 2–13, pls 2–6.
19 Oil on canvas. V. & A. Reynolds 1984,
 25.2, pl.573. Oil on canvas. Tate Gallery,
 ibid., 29.2, pl.705.

15

16

knife.[19] If on a smaller scale, his range of drawings is just as great. The sketchbook he used in 1819 was a mere $2\frac{1}{2} \times 3\frac{1}{2}$ in. (FIG 15); tiny framed compositions in the little 1813 sketchbook (FIG 16) are hardly bigger than a postage stamp. Yet he could work with equal effect at the opposite extreme. Two tree studies in the Victoria and Albert Museum are on 39×26 in. sheets of paper.[20] In one sense there is a greater range to be found in his corpus of drawings, as this nomenclature embraces a variety of media – watercolour, pencil, chalk, pen and iron-gall ink and diluted ink wash – used singly or in combination, conventionally or in ways of his own devising, with several different types of tool. In some late drawings we shall find him rubbing and dabbing at an ink drawing with his fingers.

Broadly speaking, most of Constable's landscape drawings may be divided into three main groups:

 I Drawings from nature made for the purpose of study (i.e. when learning), or when collecting material for future use and intended for his eyes only.

 II Drawings from nature or of recollected subjects made with varying degrees of tolerance towards subsequent viewing by others.

 III Drawings made specifically for public exhibition or as gifts.

Of the three, the last group is by far the smallest. Though the exact number of drawings he exhibited is uncertain,[21] it cannot have amounted to more than twenty, twelve of which are known to have been shown between 1832 and 1836. The number of presentation drawings was probably rather larger. Throughout his working life Constable gave drawings away to his friends and relations. His first comprehensive study of Dedham Vale was a set of four 20 in. panoramic views in pen and watercolour he presented in 1800 to a friend as a wedding-present.[22]

FIG 15 *House among Trees*
Pencil on wove paper, trimmed l. and
b., 6.7 × 8.8 cm. Inscribed, b.r., 'Oct^r
[?] 1819'. A page from an almost intact
sketchbook in the British Museum.

FIG 16 *Three Landscape studies*
Pencil on wove paper, 8.9 × 12 cm.
Page 48 in the 1813 sketchbook.
Victoria and Albert Museum. The
view here inverted is of Golding
Constable's fields with his windmill in
the distance.

FIG 17 *Study of Oak Trees*
Pencil on laid paper, 30.5 × 22.5 cm.;
Britannia watermark. Sotheby's
8 July 1982 (lot 73). An early attempt
to depict sunlight filtering through
foliage. University of Michigan Art
Museum.

When it became fashionable in the 1830s for young ladies to fill albums with
drawings by members of the family circle, he was often asked to contribute and,
defensively, developed a stereotype image for such occasions – an old willow by a
stream, with a little country church or cottage beyond.[23] These he signed in full
'John Constable R.A.', generally with a date. Only rarely is a signature on a
drawing attributed to him evidence of authenticity.

Between group III and the other two there is a clear line of demarcation; this is
not the case with I and II.

Group I. The working drawings. Inevitably a heterogeneous collection, under
this heading would come Constable's early learning studies (FIG 17), his notes for

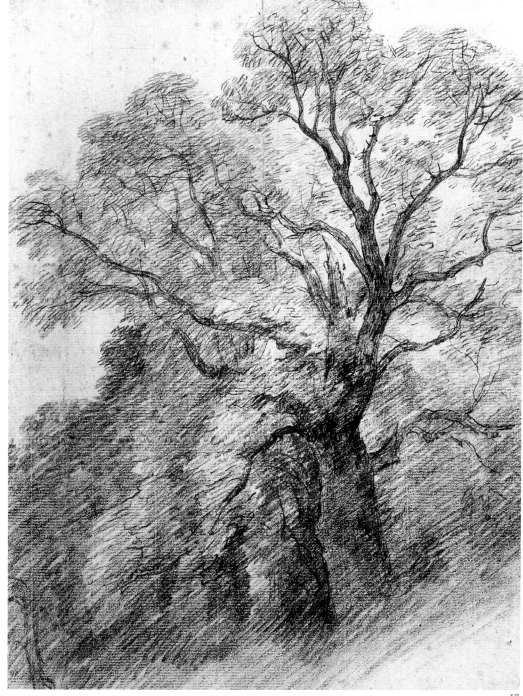

17

20 *An ash tree*. Pencil and watercolour.
 V. & A., Ibid., 35.4, pl.990. *An ash tree*.
 Pencil and watercolour. V. & A., ibid.,
 35.5, pl.991.
21 Because it is not always possible to tell
 from a contemporary exhibition catalogue
 whether an exhibit was a drawing or
 painting.
22 Three of which are in the V. & A.,
 Reynolds 1973, nos 16A–16C, pls.6a and
 6b. The fourth is in the Whitworth Art
 Gallery, Manchester; Tate 1976, no.22
 p.44.
23 E.g., *A church, with a willow beside a
 stream*, pen and ink with watercolour.
 Inscribed in pen, 'John Constable R.A. –
 1834 – ', and on the back in pencil 'Well
 Walk April 15 1834'. Yale Center for
 British Art, Newhaven. Reynolds 1984,
 34.8, pl.915. An unpublished letter
 (Private Collection) to the owner of one
 such album, Mary Atkinson, daughter of
 an architect friend of Constable's, almost
 certainly relates to this drawing of his. It is
 dated 27 April, as from Well Walk. 'I
 know not if the drawing which I have now
 added to Your Album – will be to Your
 liking – but as I did not succeed in filling
 up the outline of Your Salisbury [whatever
 that was] – I thought I would try
 something more normal. and have given
 You one of our little humble Suffolk
 churches – I wish it may be something that
 You approve.' etc.

18

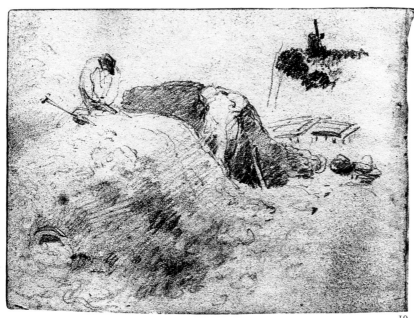

19

future paintings (FIG 18) or for a specific work in progress (FIG 19), the sketches of the odd objects that caught his eye (FIG 20), and scenes briefly noted that he wished to record (FIGS 21 and 22). If we are prepared to accept these as works of art – of varying quality – they were not intended as such.

Central to group II are the drawings C. R. Leslie described as 'complete landscapes in miniature'. Essentially pictorial in character, these are carefully composed, well articulated studies from nature, drawings that were plainly intended to be seen, and seen as works of art. Mostly they are to be found in the sketchbooks Constable used when in company: on his honeymoon in 1816; in

FIG 18 *St Mary-at-the-Walls*
Pencil on trimmed, laid paper,
9.6 × 15.2 cm.; watermark a crown
above a circle. Inscribed, t.l.,
'Colchester St Mary's / Oct.ʳ 29. 1808'.
Partly squared for transfer. Private
Collection.

FIG 19 *Men at work on Dung-hill*
Pencil on wove paper, 8 × 10.8 cm.
Page 60 in the intact 1814
sketchbook. Victoria and Albert
Museum. A study for a current
painting, *Stour Valley and Dedham
Village* (Boston Museum of Fine Arts).

FIG 20 *A Consecration Cross, Salisbury
Cathedral*
Pencil on wove paper, 11 × 17.5 cm.
Inscribed, b.l., 'Salisbury cathedral./
drawn 22ᵈ Augˢᵗ 1820. [b.r.] about
2 feet Square'. Private Collection. The
cross is to be found on the main south
transept.

FIG 21 *Workmen and Idlers beside a
Horse and Cart*
Pencil on untrimmed, wove paper,
left edge irregular, 10 × 13.3 cm.;
marked along top edge – for squaring
up? Inscribed, b.l., '1820'.

FIG 22 *Malvern Hall: a Garden Gate at
the West End*
Pencil on laid, trimmed paper,
9.5 × 15.3 cm. Private Collection. One
of several drawings of Malvern Hall
and its environs done in 1809.

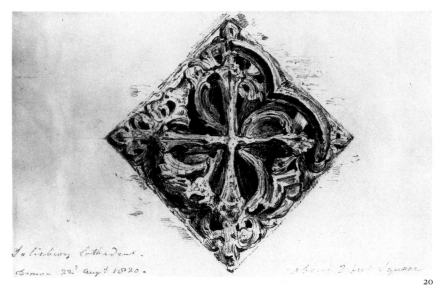

20

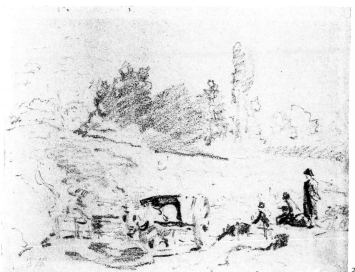

21

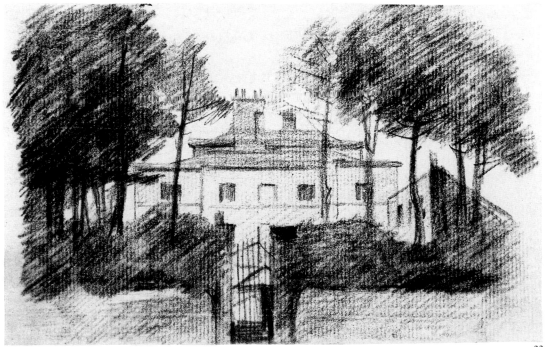

22

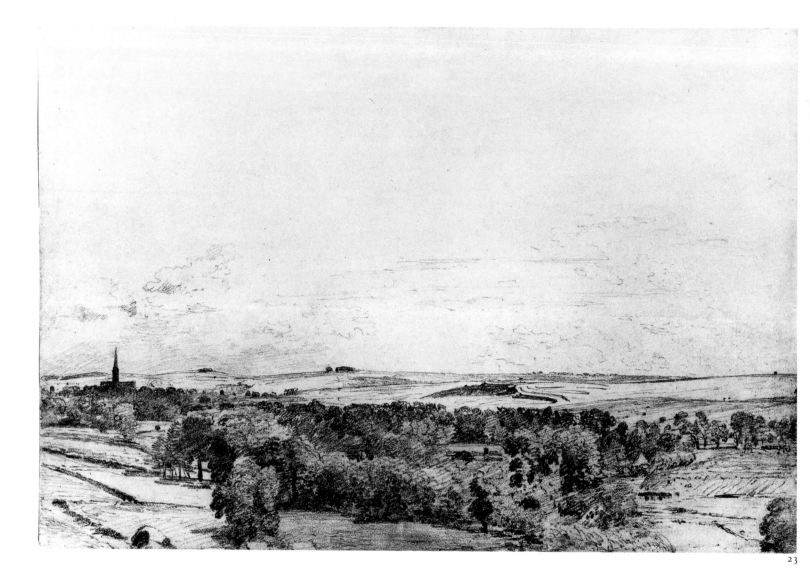

23

1820, when he and his family were staying with their friends the Fishers; when he accompanied Fisher on a Visitation of Berkshire in 1821. The example chosen, *Salisbury from Old Sarum* (FIG 23) was drawn the previous year.

Constable was always very conscious of the public and anxious about the reception of the paintings that he sent in annually to the Academy. In economic terms, the response was almost invariably disappointing: the work did not sell — except during one short period when he was being bought by the French. Having, as he imagined, failed to find a response among the gallery-minded, he attempted to reach a new public with mezzotints after twenty-two of his works, issued in five parts; a project to which he gave the title *Various Subjects of Landscape, Characteristic of English Scenery*. This also failed to sell; most of the sets he disposed of were presentation copies. In truth, his eminence as a painter of landscape was more widely recognised than he knew, but in his gloomier moments he could feel with some justification that the public at large was not greatly interested in him.

FIG 23 *Salisbury Cathedral from Old Sarum*
Pencil on wove, trimmed paper,
16.1 × 23.3 cm. 1820.

Most artists are motivated to a lesser or greater degree by a desire to communicate, and the majority, it seems, would like to do so to a wide public and gain recognition. Constable yearned for renown. He sought it in his pursuit of landscape: 'tis to her', he said, 'I look for fame – and all that the warmth of imagination renders dear to Man'.[24] But many artists learn to work for smaller numbers and for these the appreciation and support supplied by an understanding few is a sufficient stimulus. Some of course fail to find even a minimal response to their work. Constable was more fortunate. There were times during his courtship, after his wife's death and later still, after the death of his closest friend, Fisher, when he felt desperately alone and his work suffered. But for the better years of his working life, the greater part, there was always someone to whom he could turn for an appreciative response to his work and with whom he could share his love of nature.

Constable's love of landscape was not something he wished or even could keep to himself, and in the midst of it he often craved for someone of a like mind with whom to share it. 'In all my walks about this most beautiful spot I am continually thinking of you,' he told his friend Leslie in a letter from Sussex. 'How much your company would enhance the beautifull things which are continually crossing my path.'[25] In his biography of the artist Leslie described how, on their walks together, Constable would often draw his attention to some feature that he would otherwise have failed to notice. Fisher, quite a talented artist himself, was very conscious of how much he had learnt from his friend. 'You gave me another sense,' he told Constable, 'I lay in darkness & shadow until the Sun of good sense arose and shewed me what beautiful scenes I was surrounded with but could not see.'[26] In the letters he wrote Maria Bicknell during the long, anxious years of their courtship, he often wished for her to be with him to share his enjoyment. In the summer of 1812 he describes how he had been living a hermit-like life, 'though always with my pencils in my hand'.

> How much real delight have I had with the study of Landscape this summer [he continued] either I am myself much improved in "*the Art of Seeing Nature*" (which Sir Joshua Reynolds calls painting) or Nature has unveiled her beauties to me with a less fastidious hand – perhaps there may be something of both so we will divide these fine compliments between us – but I am writing this nonsense to You with a sad heart – when I think what would be my happiness could I have this enjoyment with You – then indeed would my mind be calm to contemplate the endless beauties of this happy country.[27]

It is in another letter to Maria (of 9 April 1814) that Constable first mentions a sketchbook of his as a sort of journal, as something he could show her.

> You once talked to me about a journal – I have a little one that I < kept > made last summer that might amuse you could you see it – you will then see how I amused my leisure walks – picking up little scraps of trees – plants – ferns – distances &c[28]

That was the little sketchbook of 1813, miraculously preserved intact, a book of seventy-two pages, filled with drawings, sometimes three to a page. It seems that it was only when writing to Maria that the idea occurred to him that the contents might give pleasure. Later that year, after he had seen her and possibly shown her the little 1813 'journal', it was plainly his intention to show her the one that he had currently been using. 'I have filled as usual,' he said, 'a little book of hasty memorandums of the places which I saw which You will see.'[29] Here we are on the

24 Constable to Maria Bicknell, 28 September 1812. JCC II, p.87.
25 16 July 1834. JCC III, p.111.
26 13 November 1812. JCC VI, pp.18–19.
27 22 July 1812. JCC II, p.81.
28 Ibid., p.120.
29 Ibid., p.127.

very border-line between groups I and II, between studies intended for his eye alone and drawings made with the full knowledge that they would be seen by a member or by members of his circle. There must have been many such border crossings before he began regularly to draw for others, when drawings made in solitary communion were subsequently seen and, (like Bottom) were translated, changed from private musings into objects recognised as works of art – as we of course now view them all, to whichever group they belong.

It will be some time before we shall be able to feel that we know the full extent of Constable's surviving corpus of drawings. Since the Bicentenary exhibition at the Tate Gallery in 1976, the first attempt to present him in the round, as it were, on a reasonably large scale, well over a hundred new or 'lost' drawings have come to light. In the last year alone (June 1988 to June 1989), forty-four hitherto unrecorded drawings have passed through the London sale rooms. Gaps are being filled. To the bare half-dozen previously known from the momentous year, 1809, two sales within a few months added fourteen unrecorded drawings. In July 1988 there appeared the first drawing inscribed with the year 1808 (FIG 18). New and important paintings have also been surfacing. These appearances have not passed unnoticed by scholars.

There has been a lot of new and often stimulating writing on Constable in recent years. Slowly we are obtaining a clearer picture of his intentions and of the nature of his art – both in his and in our own time. Culs-de-sac have been investigated. There have been conflicting views about him. Some still see him as a child of nature. By some critics he has been chastised, as it were over a barrel, somewhat harshly, perhaps rather too often without allowing him a chance to defend himself, either through his writings accurately read in context, or through the original drawings and paintings. It is always tempting to search for material with a theme in mind and to support a line of argument only with evidence that is in agreement with it. This book has no one theme. Here, an approach has been made from the opposite direction. The subject is Constable's drawings, when relevant his paintings and, because this is always relevant, the man himself, or as much as we know of him that seems applicable. Whenever possible, hypotheses and conjectures (and we have raised our fair share) have been allowed only when attempting to answer problems posed by the original material.

Notes to the text

Whenever possible, transcripts have been made from the original documents. Throughout, the writers' personal modes of abbreviation, punctuation and spelling have been preserved. Many of these will differ in detail from the published version, as the editor of the *Correspondence*, R. B. Beckett, adopted a policy of silent 'correcting'. Beckett's typed, unedited transcripts were used when only these were available – e.g., for Constable's letters to Fisher.

ABBREVIATIONS

Cormack 1986 — Malcolm Cormack, *Constable*, 1986

Farington — *The Diary of Joseph Farington*, ed. K. Garlick, A. Mackintyre and K. Cave, Vols I–XVI, 1978–84

Fleming-Williams 1976 — Ian Fleming-Williams, *Constable Landscape Watercolours and Drawings*, 1976

Fleming-Williams and Parris – 1984 — Ian Fleming-Williams and Leslie Parris, *The Discovery of Constable*, 1984

JCC I–VI — *John Constable's Correspondence*, ed. R. B. Beckett,
I *The Family at East Bergholt*, 1962
II *Early Friends and Maria Bicknell (Mrs Constable)*
III *The Correspondence with C. R. Leslie, R.A.* 1965
IV *Patrons, Dealers and Fellow Artists*, 1966
V *Various Friends, with Charles Boner and the Artist's Children*, 1967
VI *The Fishers*, 1968

JCD — *John Constable's Discourses*, ed. R. B. Beckett, 1968

JC:FDC — *John Constable: Further Documents and Correspondence*, ed. Leslie Parris, Conal Shields and Ian Fleming-Williams, 1976

Life, 1951 — *Memoirs of the Life of John Constable*, C. R. Leslie, ed. Jonathan Mayne, 1951

Oppé, 1952 — A. P. Oppé, *Alexander and John Robert Cozens*, 1952

Parris, 1981 — Leslie Parris, *The Tate Gallery Constable Collection*, 1981

Reynolds, 1973 — Graham Reynolds, *Catalogue of the Constable Collection in the Victoria and Albert Museum*, 1973

Reynolds, 1984 — Graham Reynolds, *The Later Paintings and Drawings of John Constable* Vol.I Text, Vol. II Plates, 1984

Rosenthal, 1983 — Michael Rosenthal, *Constable: the Painter and his Landscape*, 1983

Sloan, 1986 — Kim Sloan, *Alexander and John Robert Cozens: the Poetry of Landscape*, 1986

Tate, 1976 — Leslie Parris, Ian Fleming-Williams and Conal Shields, *Constable: Paintings, Watercolours and Drawings*, 1976

Wilton, 1980 — Andrew Wilton, *The Art of Alexander and John Robert Cozens*, 1980

CAPTIONS

Artist — The work by Constable unless otherwise stated.

Title — As in previous literature, unless it has been possible to substitute a more accurate one.

Medium — 'Pencil' indicates graphite pencil. For iron-gall ink, see Chapter 21, n.1.

Paper — Described whenever the type is known.

Watermark — Described when known.

Measurements — In centimetres, height before width. (In the text, approximate measurements may also be given in inches – e.g., '3 × 4 in. sketchbook'.)

Inscriptions — Only those in the artist's hand given unless otherwise stated.

Ownership — Collection Mr and Mrs David Thomson unless otherwise stated.

t., r., l., b. — Top, right, left, bottom.

The following editorial symbols have been adopted throughout

[] to denote an editorial insertion
< > to signify a deleted word
<...> to indicate an undeciphered deletion

Where possible, illustrations have been reproduced the same size as the originals.

1 'Hadley, 1798'

PLATE I 'Hadley 1798'
Pencil, pen and brown ink with green wash on a half sheet of deckle-edged, wove paper 29.5 × 44.9 cm.
Watermark fleur-de-lis in shield, crown above.
Inscribed in pencil '1798' top right; on the back in ink 'Hadley/ 1798'.

Constable's earliest surviving signed and dated work is believed to be an image he carved on one of the timbers of a windmill. The date is 1792; the image a likeness in outline of the windmill itself, the mill on East Bergholt Heath owned by his father (FIG 24)[1]. Cut with a knife into seasoned hard-wood, the image is simple enough, but as a description of the basic structure of a post-mill, from the brick pier upwards, it could hardly be bettered. Particularly noticeable is the presentation of the mill – at an angle, in perspective. Here, in embryo, we have Constable the artist, as yet quite untutored, but knowledgeable, observant.

Certain intimations of the greatness that was to follow are to be seen in the first of our drawings, a view dated 1798 of a farmhouse by a river (PLATE I), drawn some two years after his first lessons, possibly in the company of the teacher from whom he had been receiving instruction. Six years in the life of a young artist is a long time. It is in these years (in Constable's case, the sixteenth to the twenty-second) that the more precocious reach their early maturity. But Constable was a slow developer; for him, progress in the art was an uphill, laborious struggle, a struggle in which parental opposition played only a part. With his future achievements in mind, it is salutary and even touching to see how very gradual was his advance in those all-important years.

Constable did not belong to that class of genius that manifests itself in childhood. Later in life he consequently had little time for precosity. In his opinion there had never been a boy painter, nor could there be. 'The art requires a long apprenticeship, being *mechanical*, as well as intellectual.'[2] The young artist, in his view, must be a patient pupil of nature and, if a landscape painter, 'must walk in the fields with a humble mind'[3], for the art of seeing nature 'is a thing almost as much to be acquired as the art of reading the Egyptian hieroglyphics'[4]. These are opinions Constable expressed towards the end of his life. They are of value to us here as they tell us something of himself in the sparsely recorded early years. Central to an understanding of the course of his development is the emphasis he gives to the need for an humble, almost submissive state of mind. No arrogant man, he says, was ever permitted to see nature in all her beauty; the young should listen to the advice of their elders with deference, not hastily questioning what is not yet understood. Constantly he stresses the necessity for laborious study. 'If we refer to the lives of all who have distinguished themselves in art or science, we shall find that they have always been laborious.'[5] He also sees this as a moral issue: 'there is a moral feeling in art as well as every thing else – it is not right in a young man to assume great dash – great compleation – without study – or pains "Labour with Genius" is the price the Gods have set upon excellence'[6].

In a famous letter of 1821 to his friend John Fisher, a letter in which he writes of the things he most loves – the sound of water escaping from mill dams, old rotten banks, slimy posts, etc. – the places he associates with his careless boyhood and shall never cease to paint, Constable says that those scenes made him a painter, 'that is I had often thought of pictures of them before I had ever touched a pencil'[7] If some mystical meaning is not here intended, this must surely indicate that it was pictures of some sort that he had seen that enabled him as a boy to begin to visualise his native landscape pictorially. Although we do not know what paintings or engravings Constable would have had access to, advertisements in the local papers suggest that the viewing of prints, even in a country village like East Bergholt, would not have presented much difficulty. There were local

1 Golding Constable owned two windmills. The one on the Heath was visible from the upper windows at the back of the family home and it features on the sky-line in a number of Constable's drawings and paintings. Leslie (*Life* 1951, p.4), states that the carving was then (1840) still *in situ.*
2 From a note Leslie found among Constable's papers; Op. cit., p.276.
3 From notes taken by Leslie during Constable's last lecture at Hampstead in July 1836. JCD, p.71.
4 Ibid.
5 Ibid.
6 From a letter to William Carpenter of 15 February, 1836, when writing on the subject of some Bonington prints. JCC, IV, p.141.

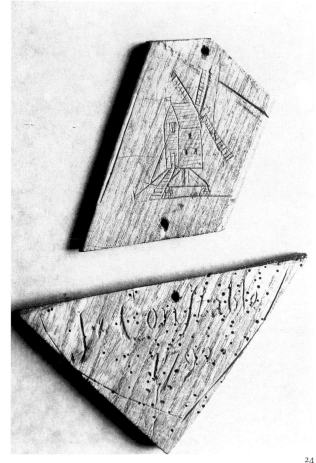

24

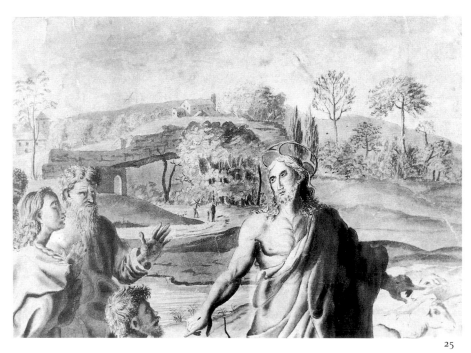

25

7 JCC VI, p.78.

8 *Ipswich Journal*, 4 September.

9 See, ed. Josiah Gilbert, *Autobiography and other Memorials of Mrs Gilbert, Formerly Ann Taylor*, 1874, Vol. I, pp.53–4. *A Jaques and the Wounded Stag* was among the paintings Ann Gilbert's father was engraving at this time. Op. cit., pp.63–4.

My father [she says] was now loaded with commissions, and the large parlour which, unoccupied, had been our play-room, became the centre of attraction to the neighbourhood. "The Pictures at Mr Taylor's" became the lions of Lavenham. One of them, a noble picture by Stothard – the first interview between Henry VIII and Ann Boleyn – contained sixteen figures, rather larger than life, so that it filled the side of the room. A beautiful one by Hamilton, about eight feet by six, represented the separation of Edwy and Elgiva, That of Jaques and the wounded deer was of the same size, with many others.

10 Two other copies dated 1795 after the Dorigny Raphaels, *The Blinding of Elymas* and *The Death of Ananias* were in the Isabel Constable sale, Christie's, 17 June 1892 (lot 134).

auctions – the announcement of a sale in Bergholt itself in 1784 lists, amongst others, prints after Rubens, Guido Reni, Claude and Titian, and names a number of the engravers[8] – and from time to time there were sales of paintings and of modern and Old Master prints in both Ipswich and Colchester, neither more than eight miles from Bergholt. It is even possible that when at school at Lavenham Constable would have seen the paintings that became such a centre of attraction in the neighbourhood, the paintings by living artists from which the engraver, Isaac Taylor, was working in his studio just across the road from the school playground.[9]

Drawing, however, was taught at none of the schools Constable attended, so before he met anyone from whom he could learn, he appears to have tried to teach himself by copying engravings by the Old Masters. Only one of these has at present been traced, his copy of Dorigny's *Christ's Charge to Peter* from one of the Raphael Cartoons[10]. In his copy, dated 1795, the detail of the landscape background (FIG 25) shows just how far he had to go and how much he was in need of tuition. Working from prints is all very well, but the tooling of the engraver into metal is very different from the draughtsman's comparatively free handling of pen and pencil, and copying, however faithfully, is no substitute for direct contact with another artist and the experience of seeing him at work.

There were local artists with whom Constable could have studied, such as the miniaturist, J. Smart, who exhibited Suffolk landscapes at the Academy and ran a drawing-school in Ipswich.[11] But caught up in the family business, Constable probably had little time after working hours for serious study. To some extent his isolated position and limited horizons were compensated for by the fact that next door there lived a teacher of sorts, who though of a relatively humble station in life, was able to satisfy his artistic needs for a time. This was the local plumber, glazier, house-painter and village policeman,[12] John Dunthorne (c.1770–1847), a man of many talents who had his workshop at the entrance to the stables of the Constable family home. As glazier and house-painter Dunthorne was familiar with the preparation of pigments and with many of the materials used by artists, but he was also an enthusiastic amateur landscape painter who 'spent all the leisure his business allowed'[13] sketching from nature. He and Constable became devoted friends and constant painting companions. It is unfortunate we know so little of Dunthorne's work. Although there are references in the Correspondence to his drawings, none has so far been identified. Constable would undoubtedly have learnt a lot from the older man about his crafts, but it is unlikely that he learnt much about drawing, the essential discipline. The story of Constable's development as a draughtsman really begins when he went on a business trip in the summer of 1796 to stay with relations in Edmonton, then a small country town outside London. There, amidst a cultured circle of new acquaintances, he formed two important if short-lived friendships: with an eccentric painter John Cranch (1751–1833), and with that remarkably enterprising character, John Thomas 'Antiquity' Smith (1766–1833), portraitist, engraver, topographer and part-time drawing master. For Constable, twenty years of age and comparatively unsophisticated, Smith must have seemed a creature from another world.

The son of a sculptor's assistant turned London print-seller, Smith, a born anecdotist with a lively memory for tittle-tattle, said of himself that he could boast of seven events in his life. As a boy be had been kissed by the beautiful actress 'Perdita' Robinson, patted on the head by Dr Johnson and had frequently held Sir Joshua Reynolds's spectacles. He had partaken of a pint of porter with an elephant, held Lady Hamilton fainting in his arms, three times conversed with King George III, and had been shut in a room with a lion belonging to the actor Kean.[14] At this time, in 1796, he was engaged in publishing in separate parts the first of his topographical works, *The Antiquities of London*. He also had in preparation a work of a didactic character that was to influence Constable profoundly, a work to be titled, in full, *Remarks on Rural Scenery; with twenty Etchings of Cottages from Nature and some Observations and Precepts relative to the Picturesque*. He had already published a similar work, without letterpress, TWENTY *Rural Landscapes from* NATURE *drawn and etched by himself*. In later life Keeper of Prints and Drawings at the British Museum, Smith is now best remembered for his minor classic, *Nollekens and His Times*, a maliciously 'candid' biography of the sculptor for whom his father, and he too as a boy, had worked. With his experience of the rougher side of London life, of famous artists' studios and the art world in general, it is no wonder that for a time Constable fell under the older man's spell.

To start with, Smith may have felt it politic to befriend this prosperous merchant's son, nephew of Thomas Allen, a local antiquarian big-wig. They corresponded. Smith was very helpful, sending Constable books, drawings and

prints to copy, and classical and anatomical plaster casts to work from. Constable was very anxious to please. On returning from Edmonton he set about collecting half-guinea subscriptions from his friends and relations for Smith's forthcoming *Remarks on Rural Scenery*, and made pen and ink drawings of picturesque cottages that he thought might be suitable for inclusion in it. Next year he visited Smith in London. In the autumn of 1798 Smith was invited to come and stay with the Constables in East Bergholt. He was taken about in the gig to meet Constable's circle of friends; on one occasion they paused so that Smith could make a sketch of an old well-head.[15] It is probable that together they drew some of the subjects that interested Smith. Two pen and wash studies of local churches[16] and a monument in one of them[17] by Constable are very much in the manner of his London friend. The following February (1799), Constable was admitted as a student to the Royal Academy Schools, having obtained his father's permission to study art full-time. There, he entered upon another of these influential but short-lived friendships, this time with a man of his own age, Ramsay Richard Reinagle, son of an Associate of the Academy: Smith – perhaps not altogether unwillingly – fades from view.

Constable was never in the fullest sense Smith's pupil; that is to say, there is no evidence of remuneration in cash terms for the information and advice the latter appears to have given so generously. His influence, however, and the importance at this particular juncture of that influence, is unquestionable. The Edmonton visit in 1796 was a turning-point in Constable's career. The previous year he had met for the first time a figure notable in the higher echelons of the art world, Sir George Beaumont, the most distinguished amateur painter of his day. Beaumont had given Constable his first glimpse of a painting by a great master, a picture Sir George liked to carry around with him, Claude's *Hagar and the Angel* (National Gallery), and had commended his copies of the Dorigny engravings. This was certainly a memorable experience, but at Edmonton, besides the antiquarian enthusiasts (another influence of importance), in Cranch and Smith, Constable met his first professional artists, and they gave him what he most needed – advice on both the theory and the practice of the art, as well as, in all probability, practical demonstrations in the use of materials.

Drawing (and painting too), like any other means of communication, has its vocabulary, a system of signs, symbols and marks, and, like the a b c of any written language, up to a point this can be learnt by rote, by copying. Learning a figurative a b c, however, is only a beginning. To become truly literate, graphically speaking, a young artist needs to be able to watch a more practised hand at work, to observe and to begin to sense the interacting movements of wrist, hand and eye. At this time, around the turn of the century, the value of watching an artist while he drew, of even sitting beside him and copying what he did stage by stage, was fully recognised. Many drawing masters taught by this method only. It is evident from both the character and the detailed handling of the pen and ink sketches of cottages he made after his return to Bergholt that Constable had been watching Smith at work. These were the drawings that he hoped would please his new friend. He talks of them in an off-hand manner in the first of his letters to Smith of 27 October 1796:

> I have in my walks pick'd up several cottages and peradventure I may have been fortunate enough to hit upon one, or two, that might please. If you think it is likely that I have, let me know and I'll send you my sketchbook and make a drawing of any you like if there should be enough to work from.[18]

11 One of Smart's early notices, in the *Ipswich Journal* 9 May 1789, announces that he intends to exhibit 'specimens' and a quantity of the latest prints; that he teaches drawing in schools and private families; and that he sells drawing-materials, paper, paints, etc. His drawing-school is advertised thereafter for a number of years. On 21 January, 1792, S. Trent announced that he was intending to open a school for drawing in Ipswich.

12 I.e., Constable; in which capacity he features in a number of entries in the East Bergholt Record of Parish Officers, 1795–1816; East Suffolk R.O.,FB 191/A1/1. Some of the expenses incurred during the carrying out of his duties as constable (e.g., 'Jour[ney] & Exp[enses] after Martin's Daughter...5[shillings]; 'Gave to two persons with a pass... 2 [shillings]; 'Writing notices to the Supply Militia...6 [shillings]') are to be found in EG3/I1/1.

13 Leslie, *Life*, 1951, p.3.

14 *Gentleman's Magazine*, Supplement to Vol.CIII, Part I, 1833, pp.641–44.

15 A pen and wash copy by Constable in the Courtauld Institute of Art after a drawing of a well-head by Smith is inscribed 'Well on the Road from E. B. to Ipsch done in a gig by J. T. S & this my copy from it'; Fleming-Williams, 1976, fig.5.

16 *Little Wenham Church*. Pen and watercolour. Private Coll.; Fleming-Williams, 1976, fig.6. *Stratford St Mary Church*. Pen and watercolour; Private Coll., Tate, 1976, no.17, p.41.

17 *John Brewse's Monument in Little Wenham Church*. Pen and wash, tinted. Private Coll.; Tate 1976, no. 16, repr. p.41.

18 JCC II, p.5.

In December he writes:

> A favourable opportunity occurring of sending you the cottages which I
> mentioned to you some time back, I would not let it pass; but I doubt they will
> not be worth the trouble of your looking over. If I should have been so
> fortunate to have found any that would suit you I should be glad.[19]

And on 16 January (1797), in gratified tones:

> You flatter me highly respecting my Cottages and I am glad you have found
> one or two amongst them worthy of your needle.
> I am obliged to you for the directions you sent me for etching but they were
> not directly what I want: what I doubt I am difficient in is the biting.[20]

From the last sentence one gathers that Smith had been giving him instructions in
the etching process, that Constable had experimented on a copper plate and
needed more information about the use of the acid to bite into the metal. His next

FIG 26 *The Deserted Cottage*
Etching, 15.9 × 19.1 cm. Inscribed t.l.,
'J.C. in. et.f.' Victoria and Albert
Museum. Here published for the first
time.

26

FIG 27 *Cottages at East Bergholt*
Pen and ink on laid paper. Two
drawings on one sheet: the upper
drawn surface, 14.3 × 17.9 cm,
inscribed t.r., 'E Bergholt Suffolk'; the
lower drawn surface, 15.4 × 19.9 cm.

FIG 28 J. T. Smith *In Green Street,
Enfield Highway*
Etching, image, 17.7 × 15.7 cm. From
Remarks on Rural Scenery, 1797.
Private Collection.

19 Ibid., p.7.
20 Ibid., p.8.

letter tells us that it was the proportions of nitric acid to water that he wanted to
know and that he had already spoilt one plate with aqua fortis of the wrong
strength. As far as we know only one of his etchings of this period has survived.
This is an hitherto unpublished print, *The Deserted Cottage*, undated, but
inscribed in the top, left-hand corner, 'I.C. in. et.f' (FIG 26). Closely matching
Smith's own technique, at a glance it could almost be mistaken for a missing plate
from his *Remarks on Rural Scenery*.

Drawings of cottages feature on seven of the surviving pages of Constable's
1796 sketchbook, presumably the one he sent to Smith. When he drew the quaint
pair in FIG 27, he obviously had Smith's cottages in mind, perhaps a tumbledown
affair such as the one that appeared in the *Remarks*, one of three titled 'In Green
Street, Enfield Highway' (FIG 28). But with his fine-pointed pen he was also
closely following Smith's technique with the etching needle, imitating the fidgety

27

28

FIG 29 J. T. Smith *Near Deptford*
Pen and wash, 10.8 × 14 cm. Private
Collection.

FIG 30 *A Thatched Cottage*
Pen and ink and grey wash on laid,
deckle-edged paper, 16.9 × 20.5 cm.
Private collection.

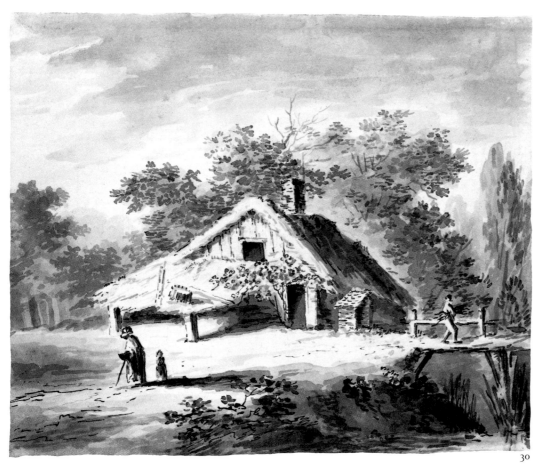

touches and irresolute, broken outlines. It is noticeable that there is no suggestion of light and shade in any of the drawings in the sketchbook. Constable was aware of their limitations when he wrote to Smith on 27 October, offering to make a (proper?) drawing of any he liked. Possibly his aim when making them was to reproduce Smith's etchings as he had seen them in an early state before the shadows were put in.

Apart from the contents of this dismembered sketchbook in the Victoria and Albert Museum, the only coherent group of early drawings by Constable is the couple of dozen that (with a few by Ramsay Reinagle) were left by the artist's sister, Mary, to her nephew Daniel Whalley, most of which are still with the

31

family.[21] As far as one can tell, all the Victoria and Albert Museum pen and ink drawings were done from nature or from sketches made on the spot. This is not the case with the Whalley group. Two or three are copies of some sort, probably from engravings. The rest are landscape compositions, inventions, covering a wide range, but mostly of rural scenes that would have pleased Smith, subjects with pond or stream near at hand, and with country folk negotiating marshy ground over rustic footbridges – the kind of subject-matter that Constable was to develop in big, six-foot oils such as *Stratford Mill, The Hay Wain* and *View on the Stour*. The Victoria and Albert Museum cottage studies are uniformly in pen and ink, with no vestiges of pencil. The Whalley drawings, on the other hand, exhibit a variety of media – pencil, chalk, pen and ink, brown and grey wash, and even a little occasional blue watercolour. Some of the brushwork is closely modelled on the kind of handling one can see in the only original drawing by Smith for his *Remarks* that has so far been located, the study for the etching titled 'Near Deptford' (FIG 29).

A comparison of this drawing with *A Thatched Cottage* (FIG 30) from the Whalley group, shows just how keenly, although as yet with a certain clumsiness, Constable was attempting to mimic Smith's mode of execution, adopting the older man's method of working progressively from lighter to darker washes, imitating the way he distinguished tree species by the directional lay of each brush-stroke. Smith completed *Near Deptford* (FIG 29) with the pen, touching in the tiles and thatch in the barn and sharpening some of the other features, the figure, the ground textures and a few twigs here and there. These tentative, delicate touches characterise all Smith's work with the pen or etching-needle. Constable used the pen very little if at all in his *Thatched Cottage*, but extensively in some of the other drawings in the group, in *Landscape with Willows* (FIG 31), for example, which,

21 See Fleming-Williams and Parris, 1984,
pp.155–6. A few of the drawings with
several by Reinagle, came on the market in
1971.

over faint pencilling and a few pale washes, is drawn entirely with a fine pen. Here again, he mimicks Smith's handling, adopting his hesitant, nervous manner and suggesting rather then defining each object he is seeking to represent.

For a beginner, the direction of his subsequent development will be established right at the start by the nature of the basic vocabulary to which he is first introduced, by the system of responses, the a b c or schemata that is made available to him. If Reinagle (whom he was to meet later) had been Constable's first tutor, the story might have been very different. He would have learnt a calligraphy the purpose of which was to provide a ready formula for every feature likely to be encountered in landscape (see FIG 47), a method of drawing incapable of rendering anything beyond its own limits. At this early stage Constable could hardly have been better served. With his powers of observation and his sensitivity, it was vital that he should be able to respond effectively to objective experience, pencil (or brush or whatever) in hand. Smith's mode, unlike Reinagle's ready-made approach, enabled him to make this kind of response. Furthermore, it was an open-ended technique that permitted an interplay between the landscape and the drawing itself as it progressed. Constable's pen and wash study of the farmhouse at Hadleigh (PLATE 1, for another Hadleigh see PLATE 29) shows just how much he had gained technically from Smith's example.

For a young man in Constable's somewhat isolated position, immersed in trade, but in his spare time trying to see his native countryside freshly, with the eyes of an artist, there was much valuable advice also to be found in Smith's *Remarks on Rural Scenery* which came out in the summer of 1797. Constable's friend Cranch had given him a reading-list of books to study on the theory and practice of painting[22], and at least one of these, Leonardo's *Treatise* (as we shall see[23]) proved very useful. But although by comparison Smith's work is slight – twenty-seven pages of letterpress bound in with twenty etchings of 'cottage scenery' – and though it rather tails off towards the end, there are passages contained in it that were more immediately relevant to Constable's needs at this stage of his career than any in Cranch's twelve listed works.

Smith's essential message was no more nor less than a plea for the beauty to be found 'equally pervading *every* department of nature', a beauty 'no less perfect in the most *humble* than in the most stately structures or scenery'[24]. Such sentiments, closely akin to those harboured by Constable throughout his working life and echoed by him in almost every one of his works, are not those most commonly to be met with in the current manuals for artists. Nor, in the contemporary literature on art, do we find guidance such as the following, which, if we are to appreciate its worth to the young Constable, we must have in full.

> In selecting from Nature the object to be depicted in rural landscape, the best advice I can offer is that you retire into the inmost recesses of forests, and most obscure and unfrequented villages: The former will supply the most various models for trees, underwoods, plants and foliage, whether perfect and living, or mutilated and in decay; and the latter, with the simplest and most artless *forms* of houses, bridges, gates, barns, fences, and other rural structures: In such situations too, you will be equally sure of finding the chastest *tints*; and in general the happiest choice and combinations of *natural colouring*: On the remote wild common – on the straggling undetermined borders of the forest – or in the silent sequestered dell, you shall find, unguarded, the richest treasures of pictoresque Nature – the antient, feeble, roof-oppressed hovel, fenced with various patches of brick and stone and mud mix'd wall with quick

hedge – stakes and rails, and wreathings composed of the stubborn thorn and the pliant willow, here and there again subdivided, or still more relieved by a bush of smiling May-thorn, or of the luxuriant-shooting alder – with those little creeping, rugged paths, stealing into obscurity beneath the umbrage of the blossomed orchard, or among bushes of alternate furze and briar, fringed with the dock, the thistle and the various-tinted fern; and trod by the wandering ass, or silent-browsing sheep: Situations like these, afford only the richest objects and contrasts crowded in luxurious varieties, but also (which is at least of equal importance) the advantage of that silent serenity in which you may most successfully study and comprehend your objects, indulge your feelings, and effect your purposes.[25]

We know too little about Constable in the later 1790s to be able to say how closely he followed these instructions and just how important such landscapes were to him, but it is nevertheless remarkable how often in the ensuing years he is to be found in forest depths, sequestered dells and the remote, wild common, places where he could study in silent serenity and indulge his feelings. It is equally remarkable how many of the landscape elements listed by Smith were to feature in Constable's paintings: decaying as well as living foliage; the ancient roof-oppressed hovel; gates, fences and walls patched with brick and mud; the pliant willow; the alder, rock, thistle and the various-tinted fern; even the wandering ass, to be seen, with or without her foal, in at least four of his major exhibited works.

In his *Remarks*, Smith makes no mention of what, for Constable, became a central theme in his landscape – the human element. But Smith, ever the anecdotist, had ideas on this subject too.

> Do not [he said] set about inventing figures for a landscape taken from nature; for you cannot remain an hour in any spot, however solitary, without the appearance of some living thing that will in all probability accord better with the scene and time of day than will any invention of your own.

This is recorded by Leslie in the *Life*, where he adds that often in their walks together Constable took occasion to point out from what he saw, the good sense of Smith's advice.[26]

The figures with which Constable populated his landscapes have so far not received the attention they deserve. Too often they have been misinterpreted, dismissed as being of little importance, or ignored altogether. This is not the place to enlarge on the subject, but it is as well to remember that seldom in a drawing or painting by Constable are the figures mere staffage, just accessories. Almost always they are playing some part, or were intended to convey the notion that they were playing a part in the context of the scene depicted. Many of the figures with which Smith enlivened his etchings of London's ancient buildings were portraits of well-known characters: an old woman on crutches, 'remarkable for her cleanliness', who claimed to be a sister of Sarah Siddons; a dealer of old iron, known as 'Old Rusty'; a barber who had frequently shaved Hogarth, etc. How many of the figures in Constable's paintings were recognisable likenesses of locally familiar characters one wonders?

There are figures to be seen in most of Smith's plates for his *Remarks*. Many appear to have been drawn from life. Two of his etchings are of special interest for us: a view of a cottage with a woman on her knees lowering a jug into a stream, titled (by Smith) *At Ponder's End near Enfield* (FIG 32), and another called *Near*

22 JC:FDC, pp.199–201.
23 See 'East Bergholt House', pp.119–20
24 *Remarks*, p.6.
25 Ibid., pp.12–13.
26 *Life*, 1951, p.6.

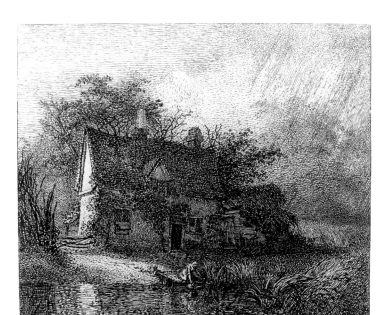

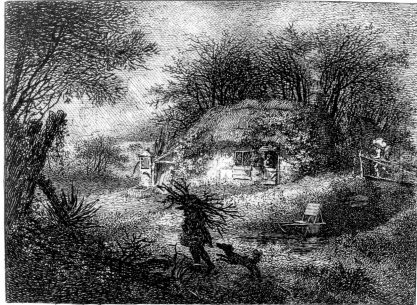

32

33

Battle Bridge, Midd. (FIG 33). In one of the Whalley drawings, *A Cottage near a Stream* (FIG 34), one of Constable's cruder and perhaps earlier efforts, we see him attempting to construct a scene similar to the one in FIG 32 – a dilapidated cottage near a stream, with neglected fencing, leafless tree-tops, and a wooden stage built at the water's edge, with a man leaning on a rail. The motif of the woman collecting water, however, was not forgotten. Downstream and just at the back of Willy Lott's house at Flatford there was a similar wooden staging built out over the water and in five of his later oil-paintings of the scene – two sketches[27], *The Mill Stream*,[28] the full-scale trial for *The Hay Wain*[29], and the final picture in the National Gallery[30] – Constable has a woman leaning out over the water, pitcher in hand, just like the one in Smith's etching (FIG 32). In another of the Whalley drawings, *The Load of Wood* (FIG 35), we see Constable adopting a motif from Smith even more closely, in this case a man bent under a load of firewood with a dog at his heels from Smith's plate of the scene at Battle Bridge (FIG 33). Besides the man with the dog in Smith's etching there are two other figures, a woman at the door of the little cottage and, walking across a footbridge towards her, a man carrying a heavy load. Constable placed a woman at a similar doorway in a pencil and wash drawing of 1798 in the Yale Center, a study he inscribed, Smith-fashion, 'A Rural Cot' (FIG 36); but closer still, this time to the man carrying the load in Smith's etching, is the small, hunched-up figure on the footbridge in the very centre of our first plate, the farmhouse near Hadleigh.

27 *Willy Lott's House*. Oil on paper. V.& A., Reynolds 1973, no.110, pl.65. *Willy Lott's House*, Oil on paper. Christchurch Mansion, Ipswich, Tate 1976, no.144, repr. p.98.
28 Oil on canvas. Christchurch Mansion, Ipswich, Tate 1976, no.129, repr. p.91.
29 Oil on canvas. V.& A., Tate 1976, no.190, repr. p.118.
30 See 'East Bergholt House', fig.112.

FIG 32 J. T. Smith *At Ponders End, near Enfield*
Etching, image, 12.1 × 14.2 cm. From *Remarks on Rural Scenery*, 1797. Private Collection.

FIG 33 J. T. Smith *Near Battle Bridge, Midd*^x
Etching, image, 10.8 × 14.5 cm. From *Remarks on Rural Scenery*, 1797. Private Collection.

FIG 34 *A Cottage near a Stream*
Pen and ink and grey wash on untrimmed, deckle-edged laid paper, 17 × 21.2 cm. Private Collection.

FIG 35 *The Load of Wood*
Pencil and brown wash on laid paper, image within ruled borders, 15 × 18 cm. Private Collection.

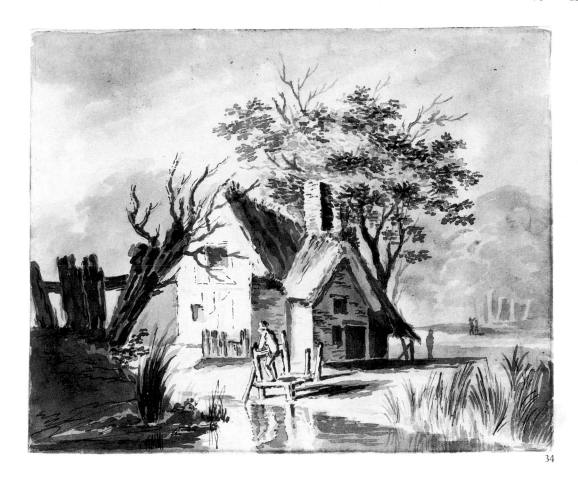

34

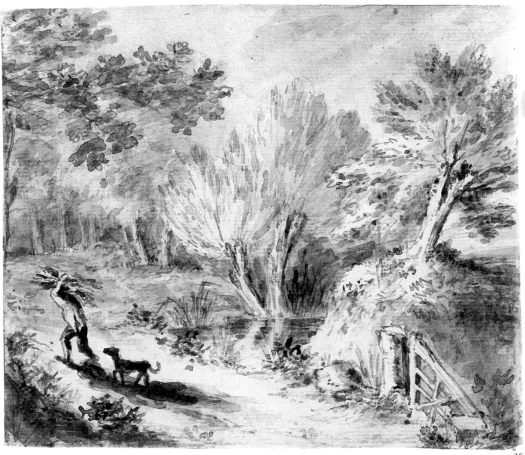

35

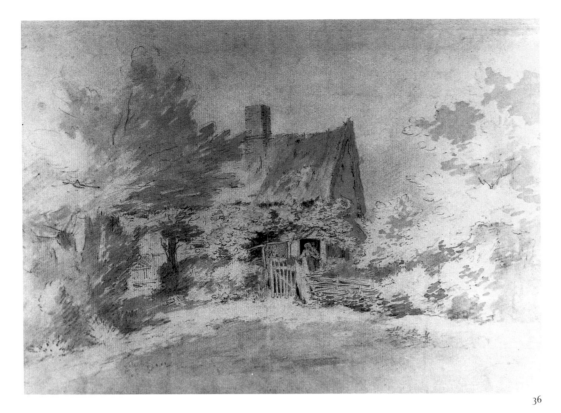

36

FIG 36 *A Rural Cot*
Pencil and grey wash on untrimmed, laid paper, 29.6 × 36.5 cm. Inscribed, t.r., '179[8?]'; b.r., 'A Rural Cot/ [J. . .?]'; on the back, t.r., 'Letitia Proby 23d Sep:t 1799'. Yale Center for British Art.

FIG 37 *Cottage among Trees*
Pencil and grey wash on untrimmed, laid paper, 17.5 × 28.5 cm. *c*.1798. Coll. Miss Sadie Drummond.

All the Whalley drawings are either compositions or copies, and none of the figures in them would have been taken from life. This is less likely to have been the case with the 'Hadley' (PLATE I). Hitherto, Constable had been attempting to master a vocabulary derived very largely from Smith. Evidence of the latter's influence is by no means lacking in the study of the farmhouse at Hadleigh, but in this drawing for the first time Constable seems to be expressing sensations that were entirely his own. Smith's cottages, selected for their quaintness, are seen with the condescending eye of the city-dweller. In his apology for rural scenery he says that he is content that it should be considered as 'no more than a sort of *low-comedy* landscape'. There is an element of low comedy, probably quite deliberately introduced, in some of Constable's Whalley drawings, where he is following Smith's lead most slavishly, in *A Cottage near a Stream* (FIG 34), for instance, a scene so obviously contrived. But peep-show concoctions such as these were far removed from the landscape he knew, the Suffolk farmland, where, as a born and bred countryman, he lived and worked. 'Hadley' (PLATE I), comprising many of the ingredients to be seen in the other drawings, is a work entirely serious in intent, expressive of a very different attitude towards landscape: it also represents a very different method of working.

A Cottage near a Stream (FIG 34) and *Landscape with Willows* (FIG 31), while technically dissimilar, are nevertheless both studio inventions and refer only indirectly to Constable's experience and knowledge of his own native scenery.

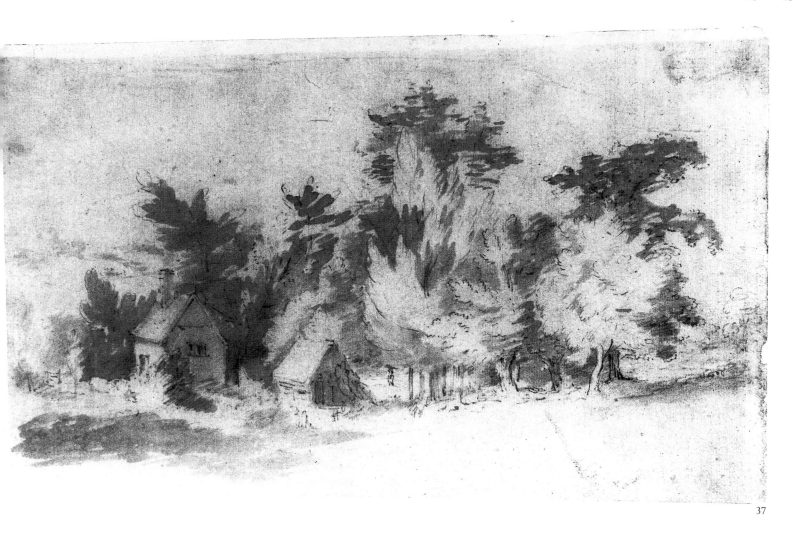

37

31 JC:FDC, p.294.
32 Lot 401 in the third day's sale at Foster's in May 1838 was 'Ruysdael (J.) The Little Bridge, (1); The Two Peasants and their dog, (2) [now known as *The Great Beech*]; The Cottage on the Hill, (3) 3'.

'Hadley', undoubtedly drawn on the spot, is very largely a record of experience at first-hand (very largely, only because the delicate pen outlining may have been done later). *A Rural Cot* (FIG 36) and a third drawing done at about the same time, *A Cottage among Trees* (FIG 37), show how he was beginning to realise his own sensations in the face of nature and to tackle the problems of working out of doors. For some of these new open-air studies he chose to work on large sheets of paper, sheets greater by several inches than any that have survived from the portfolio Mary Constable left to her nephew, Daniel Whalley.

For these few years, 1796–98, Smith was the major influence, but Constable was an ardent copyist at this time and there were others, Jacob Ruisdael for example, from a study of whose style or repertoire of images he was endeavouring to profit. In the letter of 16 January, 1797, he told Smith that he had a mind to copy an etching by Ruisdael and hinted that he would like to borrow one he had seen of two trees standing in water or another that Smith's father had copied. It is in his next letter that he talked of his difficulties with the acid and the biting. In the one that followed (postmarked 21 February) he wrote 'I think the Cottage something in the style of Solomon Rysdeal. am I right ... Pray let me hear something about Your cottages next time You write.[31] By 'Your cottages' Constable presumably meant Smith's etchings for the *Remarks*, in which case 'the Cottage' may well have been a reference to his own etching, the *Deserted Cottage* (FIG 26), and 'Solomon' named when Jacob (Salomon's nephew) was intended. As

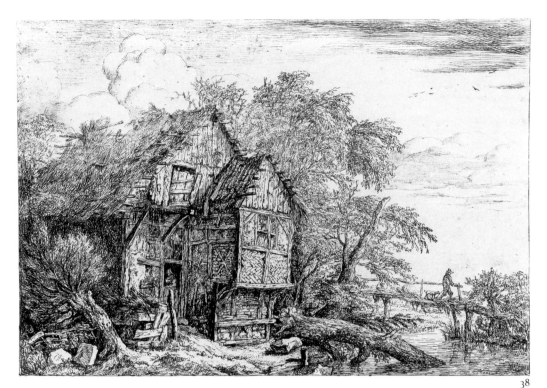

FIG 38 Jacob van Ruisdael *The Little Bridge*
Etching, 19.4 × 27.7 cm. *c.*1632.
Christie's 28–30 November, 1988 (lot 215).

38

a printmaker, Jacob Ruisdael's output was small, thirteen etchings only are listed (of which five are known only from single impressions). At his death, Constable owned three, one of which was *The Little Bridge* (FIG 38),[32] in a print of which there are echoes clearly to be found in his *Deserted Cottage* and no less obviously in his 'Hadley', both in his choice of subject – a waterside house, a footbridge, heavily pollarded willows, etc – and in his manner of execution.

Whenever it has been possibe by on-site comparisons to measure the width of Constable's angle of vision, it has frequently come as a surprise to find how great was that measurement, to find how much to left and to right of centre of a view he chose, or was able to include. In some cases the angle has been 90–100 degrees: that is, rather more than the normal eye can comfortably take in without strain or movements of the head. It is from this same wide-angled vision, so often present in later drawings and paintings and to be found in none of Constable's previous work, that the more spacious structuring of 'Hadley' and the *Cottage among Trees* appears to have derived. A portrait painted the year before (1797) by Henry Howard, shows Constable looking straight at us, with very little of the irises masked by the upper lids (FIG 39). The expression in this portrait, direct and wide-eyed, is almost child-like. The image of the little cottage and its grove of trees (FIG 37), with the gently touched-in pencil-work and palest of washes, is a true reflection of that steady gaze. Here, the washes were a response to the immediacy of the light that came streaming in from the left. Thus far only was Constable able to take the drawing *in situ*. 'Hadley' was probably brought to a similar stage on the spot – the whole sensitively pencilled in and the prevailing,

FIG 39 Henry Howard *John Constable* Oil on panel, 19 × 14.9 cm. Inscribed on the back, 'Howard, pinx! 1797' and perhaps in another hand 'John Constable aged 19'. Private Collection. Constable would have been 21 in the autumn of 1797, when the portrait may have been painted.

low-slanting sunlight noted with pale washes – this time, of green. But the character of the needle-sharp outlining – so like Smith's handling of detail – suggests that the pen-work and subsequent washes of a slightly different green, were done away from the motif; that, in effect, we here have two stages in Constable's development, the earlier, Smith-like, narrow view of landscape, superimposed upon the first signs of the later, more personal break-through, Constable's discovery of his own feelings for the broad face of nature.

39

2 The Stour Valley

PLATE 2 *Stour Valley*
Pencil and watercolour on untrimmed wove paper 17.3 × 27.4 cm., deckle-edged top,
bottom and left with pin-holes top left, right and bottom left corners.
Inscribed on the back in pencil 'Novr 4. 1805 – Noon very/ fine day the Stour'.

40

41

42

FIG 40 *Vale of Dedham*
Pencil and watercolour on trimmed,
wove paper, 13.4 × 16.9 cm.
Inscribed, b.l., 'Drawn Nov 1805 &
given/ to my friend J. T. Smith 1823/
J Constable'. A piece of paper framed
with the drawing is inscribed 'a very
fine morning'. Private Collection.

FIG 41 *Study of Trees in a Park*
Pencil and watercolour on trimmed,
wove paper, 17.3 × 13.7 cm. Inscribed
on the back, 3 Nov.r 1805 – Noon –
the Park' and '3 Nov.r 1805 – Noon.
the Park'. Victoria and Albert
Museum.

FIG 42 *Dedham Vale*
Pencil and watercolour on trimmed,
wove paper, 11.5 × 22.6 cm. *c*.1805.
Private Collection.

FIG 43 *Trees in a Meadow*
Pencil, black chalk and watercolour
on laid paper, 29 × 24.2 cm., sight
size. *c*.1805. Yale Center for British Art.

1805, an important year in the history of English watercolours, also marks the start of a sudden and dramatic development in Constable's understanding and management of the art of landscape. At present we know of only three dated works for this year, but significantly all three are watercolours. The first, dated November, is a view of the Vale of Dedham in a private collection (FIG 40); the second, a watercolour in the Victoria and Albert Museum, *Study of Trees in a Park* dated 3 November (FIG 41); the third, *Stour Valley* (PLATE 2), is inscribed 'Novr 4. 1805 – Noon very fine day The Stour'. Around these three a number of other watercolours can be grouped stylistically. For this discussion, with *Stour Valley*, two are of special interest: a watercolour titled 'Dedham Vale' (FIG 42), and another, *Trees in a Meadow* (FIG 43).

The precise viewpoint of *Stour Valley* has not so far been identified, but Constable wrote 'Noon' on the back of the drawing and as the line of vision is towards the sun it must have been on the north, the Suffolk side of the Stour. In the British Museum there are two watercolours of this period that appear to be views of the lower slopes of the Ryber valley, the little vale to the west of the road that runs down to Flatford from the north. The configuration of the land is similar in *Stour Valley*. *Trees in a Meadow* offers no recognisable feature, but it is doubtless another local view. At this time Constable does not seem to have been using a sketchbook; among his drawings there is no uniformity of size. *Trees in a Meadow* (29 × 24.2 cm.) is on an off-white laid paper; *Stour Valley* (17.3 × 27.4 cm.) on a medium weight laid paper, untrimmed with deckled edges and pin-holes in

43

three corners. The pencilling in *Trees in a Meadow*, in both graphite and chalk, is rather more evident than in most of these 1805 drawings. The colour in both is restrained. Both are also characterized by a curious stylistic dichotomy, a kind of double vision. In each we have some trees rendered in what might be called a naturalistic manner with brushwork suggestive of foliage, and other trees, usually the smaller ones, presented in a more abstract, circular or oval, generalised form. The two styles are starkly separate in *Trees in a Meadow*, where the main trees on the left over-reach a tight, almost defiant little group of encircled forms below. In *Stour Valley* the two types are less distinctive but still discernible. On the extreme right the tree is naturalistically treated and recognisably an oak, yet around the foot of the other main tree – an elm, maybe? – is a family of smaller ones, leaning this way and that, subjected to quite a different, more geometric discipline. Though slight, the pencil-work here suggests that these rounded shapes were in the artist's mind from the start. Not even the oak's leafy branches were outlined as foliage. Can this curious mixture of the two styles be accounted for and, for that matter, why watercolour? First, the apparent dichotomy.

FIG 44 *Study of a Male Nude*
Black and white chalk on irregularly edged brown paper, 55.5 × 43.7 cm. Victoria and Albert Museum.

In recent years, among the several problems that beset him as a landscape draughtsman, Constable seems to have been trying to resolve one in particular: how to reconcile two very different figurative systems, the traditional method of representing the human form which he had learned at the Royal Academy Schools and the more various but no less traditional mode (or modes) of representing landscape that he had learnt from his early instructors and from his study of Old Master prints and drawings.

As a student he had spent many working hours in the life-classes.[1] There he learnt to draw from the model (FIG 44). This called for a knowledge of anatomy – of the underlying structure – and a mastery of the currently available means of representing the human figure three-dimensionally. A number of his figure-studies have survived. FIG 44, the study of a male nude in black-and-white chalk is one of several on brown paper. In this we see him using the system that had evolved over the centuries in Europe for the representation of solid forms, the basic principles of which are set out diagramatically in FIG 45. This was a system of graduated shading of rounded forms from the lights to the darker sides, with secondary reflected lights in the shadows, and with shadows cast by one form on another. With this system of graduated modelling a convincing account could be given of solid forms; by the cast shadows information could be conveyed about the relationship of one solid to another, and to a limited extent about the space between forms. The shadow cast by the cylinder in FIG 45 shows that it is standing on a flat plane; the shadow of the right arm across the left thigh in FIG 44 specifies the space between thigh and arm; the cast shadow on the step beneath the foreshortened foot creates space in front of the step, just as, on a smaller scale, the shadow of the key in FIG 45 tells us of space around it.

This life-school method of rendering solids and spaces was applicable to certain features in landscape, the terrain, buildings, rocks, etc., and cast shadows could initiate a certain sense of space – the shadow running out from the foot of a tree-trunk could stand the tree up, as it were (see FIG 51). But to evoke sensations of deeper space other methods had to be used – linear and aerial perspectives. And a very different system was required to convey a notion of the larger, less tangible forms, the trees themselves, a main constituent of the countryside where

1 At the Royal Academy Schools, where he had been admitted as a probationer in March 1799.

45

47

46

48

FIG 45 William Crotch *Page in pocket-book 'Holywell 1803'*
Pencil on wove paper 11 × 17.4 cm.
Norwich Record Office.

FIG 46 *A Girl Seated Reading*
Pencil on laid paper, 17.2 × 12.7 in.
Private Collection, England.

FIG 47 Ramsay Richard Reinagle
A Pollarded Willow
Pencil on laid paper, 15 × 18.9 cm.,
sight size. *c.*1806. Private Collection.

FIG 48 *Study of an Oak*
Pencil heightened with white on
trimmed, blue, wove paper,
41.4 × 54.9 cm. Private Collection;
courtesy Salander-O'Reilly Galleries,
Inc.

Constable was working. A studied life-drawing such as FIG 44 was a like-image produced by a process constructive rather than gesturally mimetic. Only in more rapid linear drawings of the human form would the movements of the hand guiding the pencil-point come nearer to mimicking the shape or appearance of the model (FIG 46). Mimicry, on the other hand, the imitative gesture, was at the very heart of the other graphic tradition, the system (or systems) evolved for the depiction of all forms of natural growth in landscape plants, bushes, trees, etc.

Constable had been introduced to contrasting modes of conventional landscape calligraphy by his two early friends, J. T. Smith and Ramsay Reinagle. From the former he learnt to imitate textures of foliage and to outline with small, light touches of the pen or pencil; a finicky way of drawing, but one that permitted a sensitive, even an innocent viewing of the motif ('Hadley 1798' PLATE I). Reinagle's bolder, linear style of draughtsmanship (FIG 47) appears to have awoken in Constable quite a different response, a feeling for the vitality and strength of growth that could be better, or perhaps only expressed in rhythmic linear terms. In FIG 48, a large study of an oak tree, we see him combining the two modes. The gestural, virile outlining of trunk and branches, the short bursts of

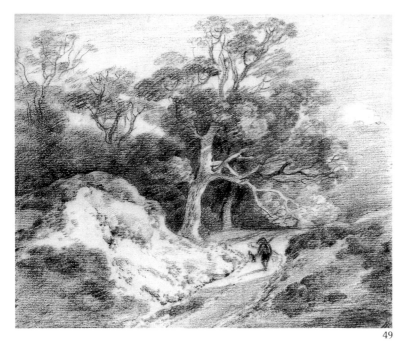

49

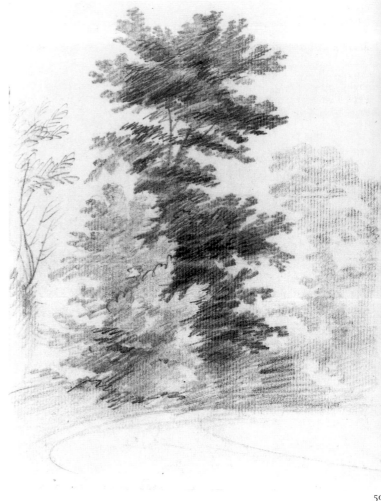

50

parallel strokes running up the trunk, the near foliage defined by little clumps of outline and the small areas of zig-zag shading for the further leaves in shadow, are all to be found in the drawings by Reinagle that Constable once owned.[2] Smith's influence is to be seen in some of the more hesitant, delicately drawn passages – in the crown of the tree and the foliage around its base. Entirely Constable, however, is the great variety of treatment (there was in him an inborn resistance to repetitive handling) and entirely his the air of authority that the drawing carries.

Tucked away in Constable's mind, but readily available for reference, there was another influence in this early experimental period – Thomas Gainsborough. Constable would not have needed to be told about the work of his fellow Suffolk artist – there is more of Gainsborough in his oils of 1802 than of any other painter – but it seems to have been through another friend, George Frost of Ipswich, an

2 A portfolio of Constable's early work (see 'Hadley, 1798', p.39, n.21) inherited by the Revd Daniel Whalley from his aunt Mary, the artist's younger sister, originally contained nineteen pencil drawings by Reinagle, perhaps done during his visit to East Bergholt in the summer of 1799. Two are so dated.

3 Reinagle and Frost are dealt with at some length in Fleming-Williams and Parris, 1984, pp.154–8 and 159–77.

FIG 49 Thomas Gainsborough *Figure with Dog on a Country Road*
Pencil on laid paper, 18.4 × 22.8 cm. Private Collection.

FIG 50 Thomas Gainsborough *Study of Trees*
Pencil on laid paper, 18.7 × 14.2 cm. Private Collection. At one time this drawing was attributed to Constable.

FIG 51 *A View near Langham*
Pencil on laid paper, 19.7 × 30.6 cm.; a discernible watermark within an oval. *c.*1805. Private Collection.

ardent admirer and collector of Gainsborough, that Constable came to know drawings such as the fine, *Figure with a Dog on a Country Road* (FIG 49), a work Frost is known to have owned and copied more than once.[3] From such drawings Constable learnt a great deal. In the later 1750s Gainsborough developed a stronger diagonal shading technique, and in drawings such as the *Study of Trees* (FIG 50), the forms of the foliage, lit or in shadow, were shaped entirely with zig-zag pencil-work. Frost adapted similar washes of shading for the larger masses of foliage in his own work, and Constable appears to have followed suit. This required a drastic change of technique. The new, more painterly handling of the pencil-point inevitably had a marked effect on the way Constable looked at landscape. Trees, and the leaf-masses they bore, could be envisaged more broadly, as volumes, and as such could be treated as forms in space subject to the action of light, like the model in the life-class. Light now became an important factor. His *View near Langham* (FIG 51) is representative of this next stage of experimentation. For much of it he is indebted to Gainsborough; the treatment of the leaves against the sky, the emphasis on certain tree-trunks, the bold execution and the drama of light and shadow, and also the melodic phrasing, the placing of the lighter and heavier stresses. Yet, in this Langham view, there is more, a fierceness of attack, a greater containment of the bulky masses of foliage, a greater penetration of depth.

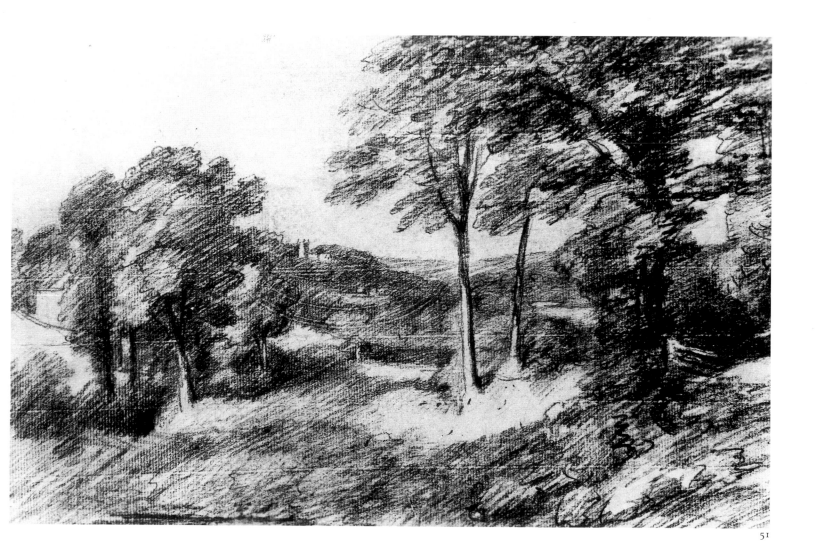

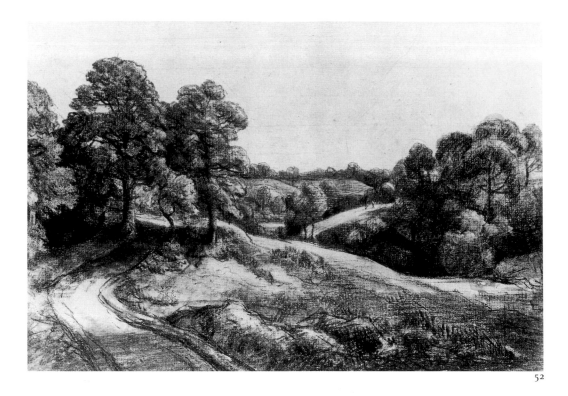

52

FIG 52 *A Wooded Landscape*
Black-and-white chalk on trimmed,
buff, laid paper, 34.5 × 51 cm. *c*.1805.
Yale Center for British Art.

FIG 53 *A Dell*
Black chalk and stump on buff, laid
paper, 33.5 × 49.2 cm. Unevenly
divided by three vertical pencil lines.
c.1805. Private Collection.

FIG 54 George Frost *A Track through
Trees*
Black chalk on laid paper,
38.8 × 29.2 cm. Private Collection
(1976).

Constable moves on a stage further in two large chalk drawings – 13 × 19 in. (30 × 80.3 cm.) – both at one time thought to be of Petworth (FIGS 52 and 53). The *View near Langham* is an exciting work, but it is short on information. Only in a few places, at the foot of an occasional tree-trunk for example, does he commit himself about the lie of the land; the rest is out of focus, insubstantial. A much more convincing account of the terrain is given in the two big drawings. This was achieved by making stronger distinctions between lights and darks, by explaining more clearly the behaviour of shadows over the ground and by the employment of quite a new technique – short, abrupt strokes of the chalk with multi-directional shading often softened or blurred with a 'stump'.[4] This veritable abandonment of the Gainsborough diagonal shading also enabled him to shape the trees more three-dimensionally, to model some, even as a sculptor might rough them out of lumps of clay, into spherical dumpling-like forms.

To represent trees, somewhat startlingly, as rounded volumes like this was not a problem, requiring merely an adaption of the figurative system learnt in the life-class, but to see them thus, globular or ovoid, was another matter. Hitherto he had learnt from others – Smith, Reinagle, Frost, Gainsborough – and then discovered the relevance of what he had learnt in the field. His new technique derived in part from Frost; in some of Frost's drawings we also find trees with similar crowns, rounded like cauliflowers (FIG 54). But in the work of none of these mentors do we see trees rendered thus, as sculptural, spherical forms. Was this an early intimation of originality or evidence of yet another influence? While there was undoubtedly something novel in the manner and degree of his application, it seems likely that the new mode originated in a system of drawing devised by a new London acquaintance, Dr William Crotch (1775–1847), Professor of Music at Oxford.[5] Organist, composer, polymath, lecturer and teacher of music, Crotch was also an enthusiastic part-time drawing-master – in 1805, one of five at Oxford[6] – who had developed his own individual method of teaching landscape drawing,

4 A stump, also known as *tortillon*, was a roll of chamois leather, blotting paper, or amadou (a prepared fungus), brought to a point at both ends, and used to blend together touches of charcoal, chalk or pastel. See J. Ayres, *The Artist's Craft*, 1984, p.60.

5 It is perhaps something of a presumption to assume that Constable and Crotch met in 1805. The facts are briefly as follows. Crotch did not move from Oxford to London until December 1805, but in January he had given six lectures on music at the Royal Institution, Albemarle Street (where Constable was later himself to deliver a series), and was in town that year to give recitals on a number of other occasions. Constable normally wintered there and is known to have been in London from March to June. A drawing by Constable of Crotch, inscribed by the sitter 'W. Crotch playing Mozart – drawn by John Constable RA MGS about 1806', is pasted into Crotch's *Memoirs* (Norwich Central Library MS 11244), with a sketch by Constable of Crotch's daughter, Isabella dated 1809. 'MGS' signifies Constable's co-option as a member of the 'Great School', a circle of artists, mainly amateurs, who subscribed to the tenets of the 'school' of landscape founded at Oxford by John Malchair (1729–1812). Crotch's uncertain, 'about 1806', is understandable for it was written many years later. Constable's friendship with Crotch was long-lasting. In 1836 he presented him with a set of the Lucas mezzotints, the *English Landscape* (see p.240) and when replying, in his letter Crotch refers to previous gifts, a little oil-painting and a water colour.
No system of drawing trees comparable to Crotch's is known to have been published.

6 According to Crotch, in his MS *Memoirs* in Norwich Central Library, MS 11244.

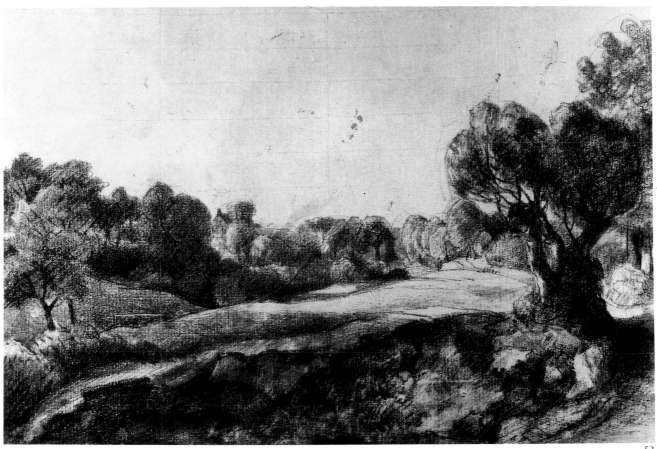

53

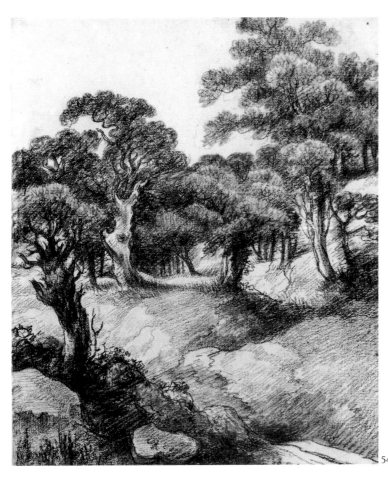

54

55

56

based on simple geometrical principles. These he had set out in what he called his 'great MS Memm book', *The Road to Learning*, a 400-page encyclopaedia of mainly acquired knowledge (with sections on Alchemy, Astronomy, Hydrostatics, etc.),[7] and also in a pocket-book of 1803 which he possibly carried with him to his drawing lessons.[8]

In our context there is a passage of some significance to be found on page 279 of the *Road to Learning* under the heading 'Painting (& particularly landscape)' (FIG 55).

> A Beginner ought to confine himself to drawing viz outline only without shading or colouring 'till he is able to draw any object whatever & this difficulty will be render'd much easier of execution by reducing all irregular forms into regular ones in the imagination. Thus fig.1 [see FIG 56] is reduced to the more regular fig.2. fig.3 to fig.4. by such angles the degree of inclination of any object from the perpendicular or horizontal will be easily & accurately ascertained. The drawing of buildings will therefore soon become easy because their forms are angular & rectilinear – trees however may be reduced to geometrical curvilinear figures as in fig 1, 5, 6, 7, & 8. Numbers will also assist him, he should ever observe whether any object is one 5th, one quarter, half, 3/quarters, twice, three times as high as any other object. & for the sake of practice should draw every possible kind of object.

Diagrams on a couple of pages in his 1803 pocketbook further illustrate Crotch's methods of instruction and bring us nearer still to the rounded forms making their appearance in Constable's landscapes. Both sets of diagrams are illuminating.

FIG 55 William Crotch *The Road to Learning, Painting (& particularly landscape)* page 279. Pen and ink. Norwich Central Library.

FIG 56 William Crotch *The Road to Learning* page 279, detail.

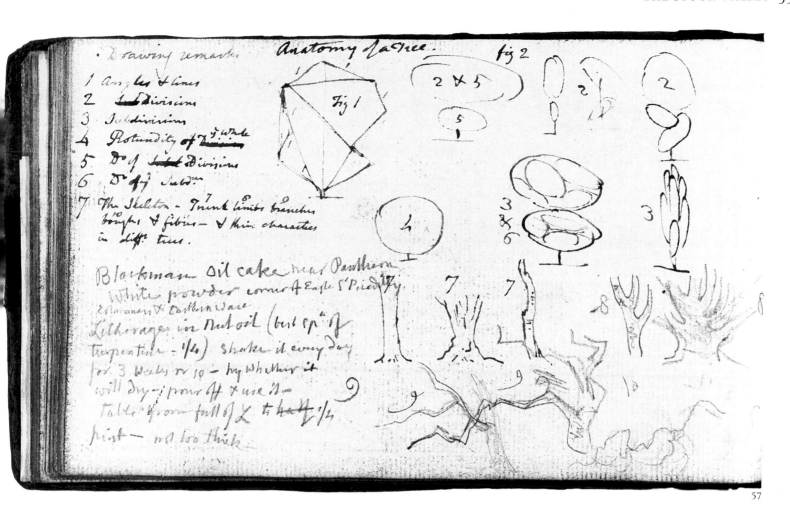

57

Crotch's figs 1 to 8 from *The Road to Learning* (FIG 56) and his figs 1 to 6 from the pocketbook (FIG 57) demonstrate two ways of bringing complex three-dimensional tree-forms down to a manageable level. In the former – his fig.1 – he begins by illustrating how the form of a tree may be reduced to a simple figure, a Leonardesque image of a few lines within a circle. Then in his fig.1 in the pocketbook (FIG 57) he goes on to show how, by dropping verticals from the highest points of trees, by judging the inclination of angles from the vertical or horizontal, and by estimating relative proportions – halves, thirds, etc. – this may be elaborated. The training of the eye to make these judgements is, of course, part of the education of any artist for whom, in Crotch's words, drawing and painting 'is the art of producing on a flat surface the representation of certain objects'. Could the eye-movements of such an artist be tracked as they flickered to and fro across the object or objects he was drawing, we would find a veritable web of such lines spun over the forms before him. This type of judgement – of angles and distances – is essentially two-dimensional, an exercise of the mind conducted on an imagined plane vertical to the line of sight and transferred to the surface on which he is working. To apprehend solids and space, the mind has to see or somehow to sense behind and beyond these planes.

In figs 5, 6, 7 and 8 in *The Road to Learning* (FIG 56), Crotch was showing how different species of trees could be reduced to simple geometrical shapes, the lines within indicating relationships of opposing profiles. In the other set of diagrams, Crotch's figs 2 to 6 (FIG 57), he is suggesting that the pupil should see trees as

rounded forms composed of subsidiary ones, in some cases overlapping each other. On the next page of the 1803 pocketbook, p.101 (FIG 58), on the right-hand side, he shows how an image more closely resembling a tree of a particular species, presumably an elm, can emerge from a grouping of rounded shapes in a sort of spatial whirl. (Typical of his bright, butterfly mind, are the transformations of branch into bird and beast with which he amused himself, and possibly a pupil, along the bottom of the page.) Crotch ventures no further than this – at least, not in his pedagogic notes: never, therefore, really coming to grips with the next stages, the closer application of his methodology in the face of nature. It was this task that Constable appears to have taken upon himself to undertake, but, strangely enough, in a new role, as a painter, a painter in watercolours, not, it seems, just as a draughtsman.

There could have been several reasons for his switch to watercolour. Landscape consists largely of intangibles – trees beyond reach, the spaces around and beyond, the constantly shifting light – and Constable may have felt that he could best approach his problem, the rendering of the insubstantial, with gossamer films of transparent colour. His use of the stump to soften and blur forms in the two big chalk drawings (FIGS 52 and 53), could have been a tentative move in this direction. But it is more likely that he chose watercolour because earlier that year, 1805, there had been presented to the London public, by a newly formed society of artists in a Brook Street gallery, two hundred and seventy-five paintings executed in that medium, the first recorded showing of such an assembly.

Watercolours, mostly just tinted drawings, had been seen at the Academy from the start, always, however, at a disadvantage, skied or wedged between heavily framed oils or tucked away in one of the smaller rooms. The Brook Street exhibition represented an attempt by the artists who worked in watercolours to have their products seen and judged as paintings in their own right. The exhibition was a resounding success. In six weeks from the day of opening twelve thousand visitors paid their shilling for admission. Every work was sold. Its impact on the art establishment was considerable.

Constable would undoubtedly have seen the exhibition. If there was any question of this, or of his having been influenced by the sight of watercolours in such profusion, we have only to remind ourselves of his choice of media for his sole exhibit at the Academy the following year: the most uncharacteristic, *H.M.S. Victory at the Battle of Trafalgar*, (FIG 70)[9] a 20 × 28 in (51 × 71.2 cm) watercolour painting of the battle at its height inspired possibly by several pictures of naval engagements by Nicholas Pocock in the Brook Street show. Watercolour, which can be handled with great rapidity, naturally lends itself readily to the capture of transient effects. Weather and times of day featured in many of the titles in the exhibition catalogue: 'An Evening Effect', for example, 'A partial shower', 'Sunshine and distant Rain', or, 'Still, warm Evening'. These may also have made an impression and may explain Constable's note on the back of *Stour Valley* (PLATE 2), 'Noon very fine day', one of the earliest of his subsequently innumerable observations on the weather.

We know nothing of Constable's movements or whereabouts in 1805 between Farington's record of a conversation on 1 June – 'Constable called. He told me he was engaged to paint an Altar Piece for a country church' – and 3 November when he dated the Victoria and Albert Museum *Study of Trees in a Park* (FIG 41), a scene unlikely to have been far from East Bergholt as *Stour Valley* was done the

FIG 58 William Crotch *Diagrammatic Study of Trees*
Page 101 in a pocket-book of 1803. Pencil. Norwich Central Library.

FIG 59 Paul Cezanne *La Côte du Jallais à Pontoise*
Pencil and watercolour, 31.5 × 49 cm. Private Collection.

58

59

following day. The only dated drawings being so late in the year could be explained by the commission for the altarpiece – almost certainly the six-foot *Christ blessing the Children*[10] in Brantham church – which would have kept him working indoors for much of the summer. But while engaged on this by no means successful work, it is improbable that he did not feel the need to escape occasionally out into the fields, and some of the undated drawings similar in character to the three November watercolours could well have been done during the summer in between spells in the studio. The *Wooded Landscape* and the *Dell* (FIG 52 and 53), for instance, look like early attempts to apply Crotch's geometric principles. The watercolour, *Dedham Vale* (FIG 42), also looks like an early experiment, but this time an attempt to produce a landscape image in watercolour combining the geometric principle with the life-class tradition of draughtsmanship. The view, looking across from the Suffolk side of the valley towards Langham, is one to which, from one viewpoint or another, he would return many times. The hour, late afternoon (after a day at his easel?), sent the low slanting light through the trees, rendering some translucent. Underneath the washes of muted colour there is quite a lot of graphite, but only in the darker parts of the tree on the right, where the pencilling is a strong diagonal zig-zagging, is this easy to see. Most of the pencil-work seems to have served only as a rough guide for the location and sizes of the main forms. In conception, the idea seems to have been to make a three-dimensional construction; in execution, gestural mimicry was kept to a minimum. The painting, with its uncertain, almost clumsy brushwork, is strangely reminiscent of the watercolours Cezanne was doing at a comparable stage towards the end of the 1870s, when he was beginning to evolve what has been called his 'constructive stroke' (FIG 59).[11] Cezanne was soon to abjure gestural mimicry almost totally in his landscapes.[12] For Constable, in the first decade of the century, the mimetic tradition still had much to offer; it was only at a much later stage – in the '20s and '30s – that we find him once again seeking for an alternative.

When reading from left to right across *Dedham Vale* (FIG 42), the nearer trees seem to grow, as it were, from translucent, seedling-globules, to full-blown, mature three-dimensional forms. In *Trees in a Meadow* (FIG 43), where the larger trees are described with bold, imaginative movements of the pencil and brush,

9 V. & A. Reynolds 1973, no.65, pl.36.

10 Oil on canvas. St Michael's Church, Brantham, Suffolk. Tate 1976, no.56, p.58.

11 See T. Reff, 'Cezanne's Constructive Stroke', *Art Quarterly*, Vol.XXV, no.3, pp.214–27.

12 Not in his Still Lifes, though. Sir Gerald Kelly used to regale his students at the Royal Academy Schools with accounts of his visits to Cezanne's studio, on one of which he discovered Cezanne using a compass in his endeavours to express to the full the roundness of the fruit he was painting.

FIG 60 *Cattle near the Edge of a Wood*
Pencil and watercolour on trimmed,
laid paper, 20.3 × 24.9 cm.; watermark
Britannia in a cartouche surmounted
by a crown. *c*.1805. Victoria and
Albert Museum.

60

there is no such gradation, and the Crotch-like, small rounded forms seem almost to belong to a different genus. The two systems or schema are more nearly reconciled in *Stour Valley* (PLATE 2). In this work, as in *Dedham Vale* and other watercolours of 1805, Constable has chosen to view the scene somewhat against the light. This enabled him to make the most of the pale yellow autumn foliage of some of the trees, with their stems and branches dark inside the incandescent forms. He was also better able to model the rest of the trees three-dimensionally with their more opaque forms largely in shadow.

It was customary for a painter in oils to have a number of brushes in use at a time, brushes of different sizes and, because they take time to clean, often a brush for each of the main colours he is working with. Watercolour brushes can be easily cleaned and seldom is it necessary to have more than one in use. Constable appears to have used at least two on *Stour Valley* a flat-tipped one, a type known as a 'fitch'; and a 'filbert', a brush shaped from a flattened metal ferrule to a slightly rounded tip, somewhat like a hazel-nut. The curving brush-strokes at the feet of the two main trees (PLATE 2) and the rippling, ribbon-like touches at the top of the oak-tree on the right were done with a fitch. For the blobs in the lower foliage of the elm he used a filbert. A great many of the blobs and placements of colour in the trees have finely serrated edges, to soften profiles and the margins of shadows, a watercolour equivalent of the softened edges obtainable with graphite pencil or chalk by cross-hatching or blending with the stump. These serrations could have been achieved by squeezing the hairs of the filbert apart, but it is more likely that Constable had a third brush for this, shaped with the hairs spread slightly open at the tip. This suggests a further link with the Watercolour Society exhibition in Brook Street. One of the most successful of the exhibitors, with

FIG 61 *Wooded Slopes*
Pencil on deckle-edged, wove paper.
28.2 × 43.6 cm.; watermark 'JOHN
HALL/180[3?]'. Christchurch Mansion,
Ipswich Borough Council.

twenty-three paintings on show, was John Glover (1767–1849), later known as the English Claude (and to become one of Constable's *bêtes noir*). For the rendering of foliage in his watercolours, Glover used special brushes, the hairs of which were held apart at the end by strands of thin wire. With one of these, which produced feathery, serrated edges to each stroke, he simulated the blurred profiles of his distant trees and woods and the soft masses of foliage. It was a technique peculiarly his own. Only in the work of 1805 and 1806 do we find Constable adopting this eye-deceiving technique.

Many of the watercolours of the following year, 1806, when he was handling the medium with greater confidence, were painted at speed. A few of 1805 also appear to have been executed quickly, the *Vale of Dedham* for instance (FIG 40). But in *Stour Valley* (PLATE 2), in *Dedham Vale* (FIG 42), and in another study looking towards the light in the Victoria and Albert Museum *Cattle near the edge of a wood* (FIG 60), there is no evidence of haste, rather the reverse. Though not dissimilar to Crotch's whirling tree (FIG 58) in that it is composed of subsidiary rounded forms, the elm in *Stour Valley* is in fact a work of a very different character, constructed of finely graded washes placed carefully to shape by inference rather than mimetically the separate leaf-masses. Painted just as carefully, though with fewer washes, are the smaller trees to the left, rounded like button mushrooms, and the fields of the valley floor bordering the river – this last so valuable a foil to the foreground visual swoop and the otherwise pervading sculptural forms. Only in the oak on the right is there inconsistency, where, with sharper and seemingly hastier flicks of his brushes Constable has tried to mimic the knobbly branches and smaller groups of leaves.

From the drawings of 1805 we have selected a few that show Constable's early attempts to reconcile two figurative systems and his response to Crotch's methodology. It is not possible to reconstruct with any degree of accuracy his several subsequent lines of development stage by stage, nor perhaps should we expect to be able to do so. But part of the story, Constable's adaption of Crotch's teaching, we can follow reasonably closely, right on into the following decade. Here we will conclude with a glance at an illustration of the process at work, a drawing of hilly slopes positively alive with rounded vegetable forms (FIG 61) probably done at the start of his tour of the Lake District the following year.[13]

13 Perhaps in the vicinity of Kendal, of which
town he dated the first drawing of the tour
– on 1 September.

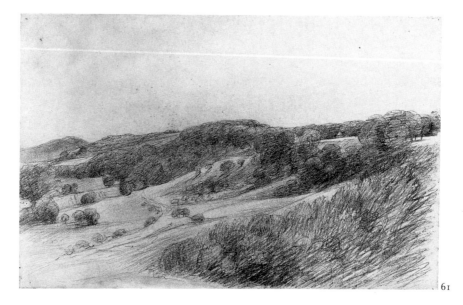

61

3 Miss Bicknell

62

FIG 62 *Girl Reading*
Pencil on wove paper, 22.3 × 18.2 cm.;
watermarked with a cartouche, Fleur-
de-lis and the letters 'SM'. Musée du
Louvre.

63

FIG 63 *Studies of a Girl's Head*
Pencil on laid paper, 22.8 × 17.9 cm.;
watermark crown over cartouche.
Inscribed, 'with John Constables —
regards/ to [Mr?] Evans' *c.*1806
Fondazione Horne, Florence.

From time to time there will be references in these pages to Maria Bicknell (1788–1828), who, in 1816, became Constable's wife. Her part in his career is of the greatest importance. The daughter of Charles Bicknell, a successful London solicitor, Maria was also the granddaughter of Dr Rhudde, Rector of East Bergholt, a dominating figure in Constable's native village. According to the artist's friend and biographer, C. R. Leslie, Constable and Maria first met in 1800 when she was still a child, presumably on one of her visits to her maternal grandparents at the Rectory. In a letter of February 1816, Constable refers to the seven years since he had 'avowed' his love for her.[1] From this it has been assumed that their courtship dated from 1809. The marriage was delayed by threats of disinheritance from Dr Rhudde, but before the Rector's attitude began to harden towards the betrothal the young couple had apparently been able to spend many hours together, wandering in the fields or down by the river. Articulate, intelligent, serious-minded, but with an Austenian penchant for the apt comment, in only one respect was Maria an unusual member of her class – that she inspired the love of a great painter and became part of his life as essential to him as his other love, landscape.

It was probably no coincidence that 1809, the year of Constable's avowal to Maria, was also the year that witnessed a major development in his art, the start of his historic series of oil-sketches from nature, his most personal contribution to the art of landscape. Equally, it does not seem to have been coincidental that the last of these sketches was painted in 1829, the year after Maria's death.[2] Those twenty years – years of his betrothal, his marriage, the births of his seven children, and his tragic loss – were the years of his fulfilment as an artist. After 1829, there were still great works to come, but the creative drive faltered. Before 1809, in the work of only one year, 1806, is there to be found a hint of the depth of feeling that was to find subsequent expression. It is possible that the work of this year too was linked with Maria Bicknell.

Nearly half of the two hundred or so surviving drawings of 1806 are of figure subjects: drawings in pencil, pen and ink, wash, or watercolours, of women and children (with only an occasional male presence) in a domestic setting. Mostly they are of nubile, attractive young women at leisure – reading, conversing, strolling, dancing, or just posing in graceful attitudes, singly or in small groups.[3] To find Constable thus, at his ease in the midst of polite, middle-class society, is unusual. Still more unusual is it to see him so frank an admirer of pretty women, and to have him gazing so intently at these girls in their fashionably revealing garments. Between artist and sitter sometimes the relationship seems positively flirtatious. Several are of the sitter seen from behind, with bare shoulders rising to a swan-like neck and an upward sweep of hair (FIG 62, 63 and 64).

There is no entirely consistent style for these drawings. Some are slight, hesitant and even niggly; others are drawn with a comparatively heavy hand. But, as if on a rising tide of energy, there seems to have developed in these figure studies a new, bolder style of draughtmanship, a rhythmic, springy sweep of line that was soon to carry all before it, reaching a climax in the work of the autumn, in the magnificent drawings he made of mountain scenery in the Cumberland Lakes.

This surge of dynamic drawing was more than just a stylistic or technical development; more, too, than just the enjoyment of a new-found freedom of execution. Its origins surely lay deeper, in a reservoir of emotion hitherto untapped. Constable himself said that painting (and presumably drawing too) was but another word for feeling.[4] By this, of course, he meant the feeling for

64

1 To Maria, 27 February 1816, JCC II, p.179.
2 When staying with the Fishers at Salisbury with his two eldest children.
3 The main collections of these figure studies are to be seen in three intact sketchbooks in the Louvre, R.F.08700, R.F.08701 and R.F.08698; in the recently mounted contents of the Fisher Album in the Royal Albert Memorial Museum, Exeter; and in the British Museum. There were a number also in the Ridley-Colborne Album, Sotheby's 18 November 1971 (lot 50), many of which are reproduced in *Exhibition of Drawings by John Constable*, William Darby, 1972.
4 Constable to Fisher, 23 October 1821, JCC VI, p.78.

FIG 64 *Study of a Girl's Head*
Drawn on the back of the previous
study, (FIG 63).

FIG 65 *Self-portrait*
Pencil on wove paper, 23.7 × 14.5 cm.
Inscribed b., 'March 1806'; also
'April', partly covered by shading.
Tate Gallery.

FIG 66 *Figure of a Girl Mourning*
Pen and ink on trimmed paper,
19.7 × 15.2 cm. Inscribed, b.l., 'April
19. 1806/ Miss B − '; on the back, an
address: 'Mrs Benge 4 Park Place/ S^t
James's Street/London'. British
Museum.

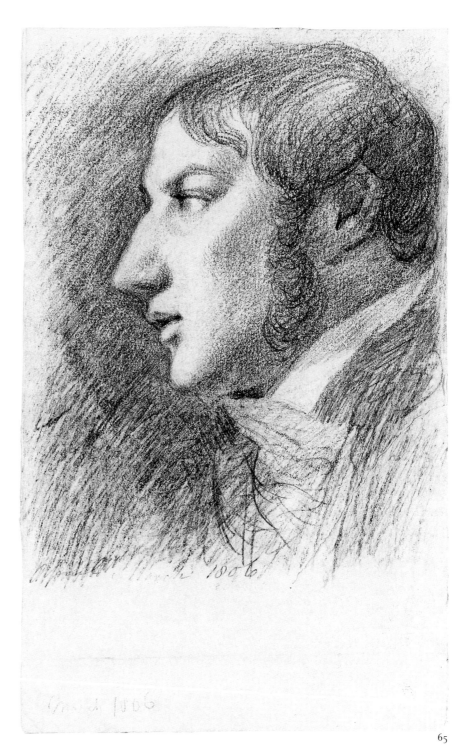

65

66

landscape, for nature. But as we see so often in his life later on, Constable's feelings
for landscape were coloured by his love for Maria, by the frustrations of his
passion for her as well as by its eventual manifold fulfilments. Might not this
dramatic breakout in 1806, this release of energy also have been inspired by her?
By a romantic, possibly undeclared love? The few facts at our disposal do not rule
out the possibility.

A new degree of self-awareness, of his appearance and character, is signalled by
the earliest dated drawing of this year, the splendid profile self-portrait dated
March 1806 (FIG 65). The next dated work is a pen and ink study of a woman (or
young girl) seated beside an urn in an attitude of mourning (FIG 66). Drawn on the

FIG 67 *Maria Bicknell*
Pencil on cream wove paper,
48.8 × 34.8 cm. Inscribed in a later
hand, b.r., 'Mrs. J.C.' 1806? Tate
Gallery, Undated, but stylistically
very close to the self-portrait,
(FIG 65).

back of part of a letter addressed to a 'Mrs Benge' (a lady otherwise unknown), the figure study is inscribed 'April 19 1806 / Miss B'. If the study was drawn from life, the model may have been a Miss Benge; on the other hand the 'B' might have stood for Bicknell. In April Constable would almost certainly have been in London to send his exhibit of that year to the Academy. It is likely that he would have stayed on into May for the opening of the Exhibition, but from dated drawings he is known to have been in East Bergholt by June. Maria appears to have visited her grandparents there that year and to have been accompanied on her 'pedestrian rambles' by a Mrs Everard,[5] a regular visitor at the Rectory who subsequently became a valuable ally for Maria and Constable in the later stages of their courtship. Then there is the question of Constable's portrait drawing of Maria, now in the Tate Gallery (FIG 67). An undated pencil study, stylistically very close to the artist's self-portrait, so far it has remained unplaced in the chronology of his oeuvre. If it was drawn in the year 1809, when Constable is reckoned to have declared his love, Maria would have been twenty-one years of age. Estimating the age of a sitter from a portrait is always a difficult task, but the quiet, reserved expression we see here in this sensitive drawing seems to be that of a girl younger than twenty-one. It could easily, one feels, have been drawn in 1806, when she was eighteen.[6]

Finally, if the charming young girl at the Rectory *had* aroused Constable's feelings, it might partly explain why he seems to have spent so much time making watercolour studies of East Bergholt church that summer (FIG 68). Sketching in the churchyard would have placed him where he could be readily seen by anyone walking from the Rectory to the centre of the village. From the shadows under the 'ruined' tower near the road, where he made three watercolour drawings (FIG 69), he would have been able to observe passers-by almost without being seen; or if he so wished, from there he could have stepped out in the sunlight to make his presence known.

5 Elizabeth Everard to Maria Bicknell, 5 November 1806, JC:FDC pp.112–14.
6 Maria's age, twenty-one years, when Constable declared his love for her in 1809, could indicate that he had waited until she was of age before revealing his feelings for her.

68

69

4 1806

PLATE 3 *Epsom*
Pencil and watercolour on wove paper, left edge trimmed 10.7 × 17.7 cm.
Inscribed in pencil on the back 'Epsom Book 1806 Aug/ Constable'.

70

71

1805 had seen the start of important developments in Constable's art. The following year was distinguished by the quantity and variety of his output, but more significantly by attempts to identify and articulate his own unique sensations in the face of nature and, in some of his drawings, by the glimmerings of a new vision of landscape. If we see them in the context of his other work of 1806, we can obtain an inkling of this vision from our four drawings of this year (PLATES 3 to 6).

The first of his 1806 watercolours is now little more than a curiosity (FIG 70). In November (1805) there had appeared in the Press the announcement of a competition, with a winning prize of £500, for the best picture of the great sea-battle that had so recently, on 21 October, been fought off Cape Trafalgar.[1] Constable knew the *Victory*, having drawn her in 1803 when she was at anchor off the Medway,[2] and, according to Leslie, had heard an account of the battle from a Suffolk man who had been on Nelson's flagship.[3] But it may have been the notice of the competition that provoked him into choosing such an unlikely subject for his submission to the Academy of 1806. Now faded to a ruin, the 20 × 28 in (51 × 71 cm) painting – bearing the somewhat cumbersome title, 'His Majesty's Ship Victory, Capt. E. Harvey [sic], in the memorable battle of Trafalgar, between two French ships of the line' – does not appear to have made much of an impression. Although it was accepted by the jury, it was only one of a dozen tributes in the exhibition to Nelson or his fleet, and (787th out of a total of 938 exhibits) was hung in the last of the galleries at Somerset House, in the room mainly reserved for architectural drawings.[4]

The next watercolours were done in Suffolk. Some are dated June. This is unusually early for Constable to be out of London; normally he did not join his family in Bergholt until towards the end of July. Several of the watercolours were

FIG 70 *H.M.S. Victory in the Battle of Trafalgar*
Watercolour on paper laid down on a second sheet, watermarked 'J.WHATMAN/1804', 51.6 × 73.5 cm. 1806. Victoria and Albert Museum.

FIG 71 *East Bergholt Church, South Archway of Tower*
Pencil and watercolour on trimmed, wove paper, 15.7 × 11.2 cm. c.1806. Victoria and Albert Museum.

1 Organized by Boydell, the publishers, one of the notices appeared in the *Morning Chronicle* for 22 November. See E. Shanes, 'The Victory returning from Trafalgar', *Turner Studies*, Vol.6, no.2, p.63 and p.64, n.3.
2 A drawing, at present untraced, dated 18 April 1803, from the collection of the artist's son Charles Golding, of the Victory at anchor is reproduced in W. L. Clowes, *The Royal Navy: a History*, 1897–1903, Vol.v, p.25.
3 *Life*, 1951, p.18.
4 The present, severely faded condition of Constable's only battle scene, may indicate that it was a work that in later years had pride of place on the walls of the family home.

FIG 72 *Epsom Common*
Watercolour on trimmed wove paper,
10.6 × 17.4 cm. Inscribed on the
backing, possibly in the hand of
Isabel, the artist's daughter, 'Epsom
Common, 4th Augst – 1806'. Yale
Center for British Art.

FIG 73 *Epsom*
Watercolour on wove paper with
irregular edges, 15.6 × 24.1 cm.
Inscribed, b.l.' 'Epsom. Augst 6th
1806'. Private Collection.

FIG 74 *Epsom*
Watercolour on wove paper,
16.8 × 23.2 cm., sight size. Inscribed,
b.l., 'Epsom Aug 10 1806'; below,
probably in another hand,
'J. Constable.' Christie's June 1979
(127). These drawings of Epsom were
made when Constable was staying
with his aunt, Mary Gubbins and her
family at Hylands, their house in
Surrey.

of the church (FIG 71 and FIGS 68 and 69) and in the previous chapter we have
hinted why this may have been so. By the middle of July he was staying with a
family, the Hobsons, at Markfield, their country house near Tottenham,
Middlesex. While there he seems to have had little time for landscape. In August
he spent a week or so with his maternal aunt's family, the Gubbinses, at Epsom.
This was a visit more productive of outdoor sketches. There are watercolours
dated 4th, 6th and 10th, and another inscribed, August (PLATE 3). There are also
some pencil drawings from this stay. These four watercolours are divisible into
pairs, each pair being curiously unlike the other (PLATE 3, FIGS 72, 73 and 74).

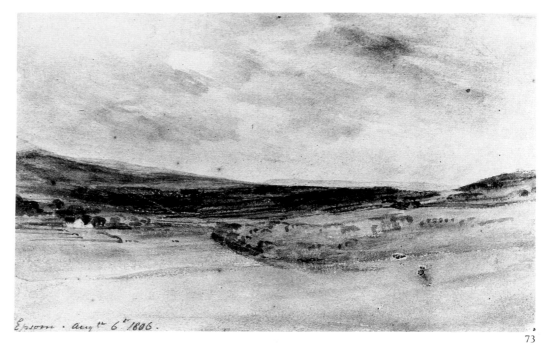

73

72

74

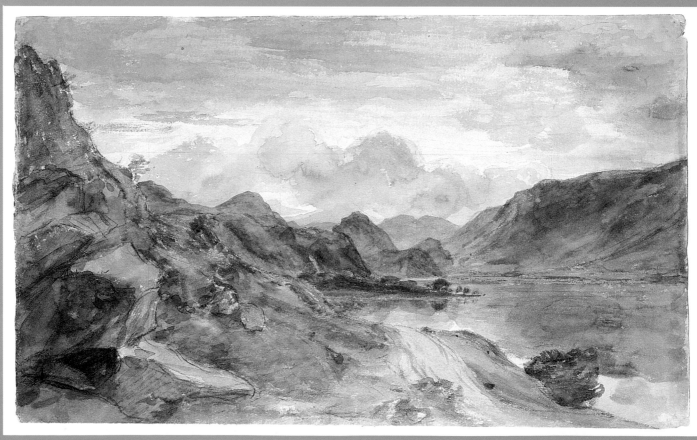

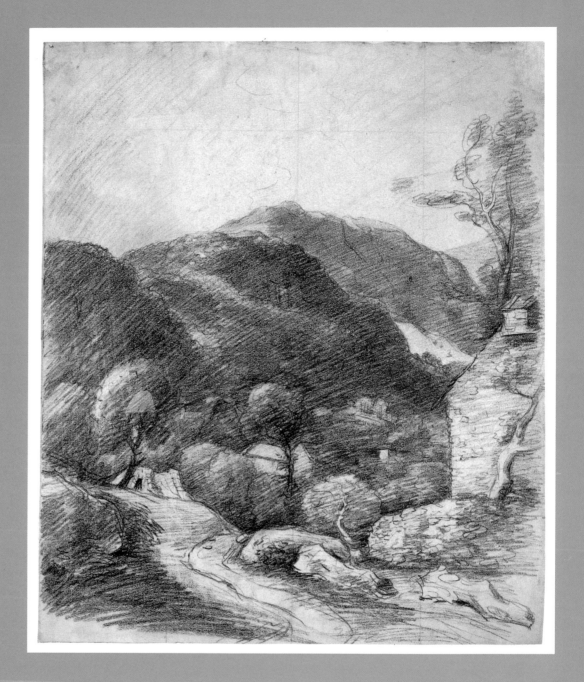

75

FIG 75 *Manchester*
Pencil on laid, trimmed paper,
10.4 × 8 cm. Inscribed on the back,
'Manchester 27 Aug. 1806'.
Whitworth Art Gallery, Manchester.

Constable's next dated work, a pencil study of a bridge at Manchester (FIG 75), was drawn on 27 August, when he was on his way to Cumbria.

The seven weeks he spent in the Lake District and the ninety drawings and watercolours he produced during his tour deserve a full-length study. Here it is the intention to deal with the subject only in part, with those aspects most obviously relevant to three of our drawings (PLATES 4, 5 and 6). The earliest known drawings of the tour are of Kendal, a view of the Castle is dated 1 September.[5] The last, of Langdale, is inscribed 19 October.[6] For the first few days Constable stayed with a Mr Worgan at Storrs, on the eastern side of Lake Windermere. He then joined some new friends, the Hardens, who lived in an attractively sited house, Brathay, named after the river that flowed past the grounds into the head of the lake. He was probably staying with them when he made the pencil study to be seen in PLATE 4, a view from a bend in the road a mile or so up the valley behind the house. By 19 September Constable had left Brathay and was among the hills to the north with a companion, George Gardner. On the 23rd, when he made the watercolour of Derwentwater (PLATE 5), he was approaching the defile that led into Borrowdale. Here, in that then comparatively unfrequented valley, he spent the next three weeks, mostly alone, his companion having left him. On 15 October, his hostess recorded his reappearance at Brathay: 'Mr Constable returned & being [a] wet morning he occupied himself in beginning a portrait of John [Harden, her husband] which I hope will prove like.'[7]

During this tour, greatly stimulated by the Lake scenery, Constable appears to have experienced within himself powerful and still deeper feelings about landscape; and gradually, through a process of stylistic blending and distillation, to have discovered ways of expressing these sensations. Especially relevant were his recollections of the watercolours of Thomas Girtin (1775–1802), thirty of which he had been shown by one of his earliest mentors, Sir George Beaumont.

Leslie, in his biography, tells us of the Girtins owned by Beaumont and of their influence on Constable. He is writing of the young artist's first meeting with the Baronet – when the latter was staying with his mother at Dedham in 1795 – and of Constable's first sight of the Claude, *Hagar and the Angel*,[8] that Sir George took with him when travelling:

> Constable looked back on the first sight of this exquisite work as an important epoch in his life. But the taste of a young artist is always the most affected by contemporary art. Sir George Beaumont possessed about thirty drawings in water colours by Girtin, which he advised Constable to study as examples of great breadth and truth; and their influence on him may be traced more or less through the whole course of his practice. The first impressions of an artist, whether for good or evil, are never wholly effaced; and as Constable had till now no opportunity of seeing any pictures that he could rely on as guides to the study of nature, it was fortunate for him that he began with Claude and Girtin.[9]

While substantially true, this account is slightly misleading, for though Beaumont may have met the twenty-year-old Girtin for the first time in the same year (1795), the watercolours he is known to have possessed were of a later date and these, with the rest of the group, would probably not have been seen by Constable until after he began his studies in London in 1799. But if, for him, Claude preceded Girtin, this does not mean that the latter was in any degree of less importance to Constable. Sir George's Claudes were the subject of close study in 1800 and 1801, when Constable spent many hours copying them at the Beaumonts' house in Grosvenor Square,[10] and the French master's influence is to be seen in his first *Dedham Vale* of 1802.[11] Girtin becomes a clearly recognisable influence for the first time in the watercolours of 1806 – in some of the Suffolk studies, in two of the Epsom watercolours, and, as we shall see, in many of the Lakeland drawings and paintings.

It is only from Leslie that we know that Beaumont owned thirty or so Girtin watercolours. About a third of these have been identified, all of which appear to be copies of drawings by Sir George; interpretive, relatively free copies, mostly of Lake District subjects. Nothing is known of the remaining numbers, but it is likely that many were original works, not copies, and just possible that a few may be directly reflected in some of Constable's watercolours.

One artist, as well we know, can deeply influence another, sometimes changing the very nature of his vision. In his time, Girtin's influence was considerable. It was said that he was the first 'to give a full idea of the *power* of watercolour painting; the first wholly to change the practice of the art'.[12] Leslie states that it was possible to trace Girtin's influence throughout the whole of Constable's practice. This, doubtless, was evident enough to him (Leslie), for he had the artist himself to point it out. We are not so fortunately placed and must seek for tangible evidence of Constable's debt to Girtin. In the work of these early years, certainly

5 Watercolour. Henry E. Huntington Library and Art Gallery, San Marino.
6 *View in Langdale*. Pencil and grey wash. V.& A., Reynolds 1973, no.86, pl.48.
7 See Daphne Foskett, *John Harden of Brathay Hall*, 1974, pp.29–31. So far as we know, the portrait was not finished.
8 *Landscape with Hagar and the Angel*. Oil on canvas, National Gallery, London.
9 *Life*, 1951, p.5–6.
10 For example, Constable was copying a 'small upright' Claude, when Farington called on the Beaumonts on 29 May 1800.
11 *Dedham Vale*. Oil on canvas. V.& A., Reynolds 1973, no.37, pl.21.
12 R. and S. Redgrave, *A Century of Painters*, 1866, Vol.I, p.387.

76

77

in the 1806 watercolours, this is most plainly to be seen in two of the Epsom watercolours (FIGS 73 and 74) and in his view of Lyth valley (FIG 76).[13] It is of course not possible to say precisely which Girtins Constable had in mind when choosing to paint these shallow, rather featureless valleys, but the watercolours they most resemble are those Girtin did during a tour of the West Country, possibly in 1800, when the viewpoints he chose were often similarly removed from rural life and he seems to have taken particular delight in rendering deeply receding perspectives as a succession of closely-packed, near horizontals (FIG 77). The Girtin influence may be illustrated by a further comparison, Girtin's *The Tithe Barn, Abbotsbury* (FIG 78), with a couple of Constable studies: a view of the Bergholt church tower south archway (FIG 71) and a large, brown and grey wash drawing of an unidentified church (FIG 79). Quite new in Constable's work to date is the manifest appreciation here of the thrust and weight of the two buildings.

Conditional upon a watercolour artist's selection of his subject matter is of course his ability to make responses on the paper with his brush – blobs, touches, and many kinds of washes – that cohere into a recognisable image. This, the very vocabulary of his art, a painter will initially acquire largely from others. In this respect Constable was no exception, and though it was not only from Girtin that he seems to have been learning at this time, as we can see from the examples we have before us, his handling, sometimes touch for touch, is similiar to Girtin's fluent brushwork, particularly in his adoption of the other man's Canaletto-like dot-and-dash method of indicating hedgerows, lines of trees and the interstices of masonry.

These watercolours of June and August, and the one of the Lyth Valley, show Constable choosing subjects that would enable him to experiment with Girtin's own very personal style of calligraphy. Later, among the more dramatic Cumbrian hills, not unexpectedly, it was Girtin's watercolours of Lakeland scenes that appear to have guided Constable in his choice of subject-matter and that eventually emboldened him almost to break free of conventional stylistic restraints altogether. It may be remembered that the Lake District Girtins were based on original drawings by Sir George Beaumont. Having shown Constable his

13 This was kindly identified as a view of Lyth Valley from Brigsteer by Claud Bicknell of Kendal.

FIG 76 *The Lyth Valley*
Watercolour on wove paper,
22.9 × 32.5 cm., sight size. Christie's
22 February 1952 (lot 19).

FIG 77 Thomas Girtin, *Estuary of the
River Taw, Devon*
Pencil and watercolour on laid paper,
26.2 × 45.1 cm., c.1801. Yale Center
for British Art.

FIG 78 Thomas Girtin *The Tithe Barn,
Abbotsbury*
Pencil and watercolour on wove
paper, 36.2 × 31.3 cm. Inscribed, b.r.,
'T. Girtin'. Leeds City Art Galleries.

FIG 79 *Porch and Transept of a Church*
Grey and brown wash on untrimmed,
wove paper, 33.5 × 43.7 cm. Victoria
and Albert Museum.

78

80

Girtins, it is unlikely that Beaumont did not show him the originals, his own drawings in the sketchbooks he had filled during his stay in Keswick in 1798. It is even possible that it was the sight of the scenes Beaumont had sketched around Derwentwater, the valleys, crags, falling waters and mysterious skies, that had led Constable to set out northwards from Brathay to discover them for himself.

Most of the drawings in the two albums of Beaumont's 1798 tour – ninety-five in one, eighty in the other – are inscribed with the date and a not always precisely named viewpoint.[14] In all, he appears to have spent nearly two and a half months at Keswick. Throughout the stay he had sketched apace, on some days making as many as eight drawings. Mostly they are slight, but the majority enable one to recognise the views. Constable, on the route he took, seems to have tried to find as many as he could of the subjects drawn by Sir George – The Vale of St John's, Skiddaw and Saddleback, Derwentwater, Lodore and, naturally, Borrowdale. He even found his way up into the hills above Lodore to the remote hanging valley and hamlet, Watendlath, a lonely spot Beaumont had visited twice. Constable mentions Sir George in the inscriptions of two of his drawings. On the back of a view looking down into Borrowdale from the path to Watendlath, on 25 September he wrote: 'Borrowdale – fine clouday day very mellow like the mildest of Gaspar Poussin and Sir G B & on the whole deeper toned than this drawing'.[15] And again, on the verso of our watercolour of Derwentwater (PLATE 5), in another of his weather-notes: 'Sepʳ. 23 noon 1806 about 2 o clock the clouds had moved off [?to] the left and left a very beautiful clear effect on all the Distances – very much like that in Sir G B picture of the Lake of Albano – the heavy clouds remained edged with light'. If the crystal-clear sky-line reminded Constable of Beaumont's *Lake of Albano* in that year's Academy,[16] the almost exact matching of hill-outlines in his *Derwentwater* (PLATE 5) with those in a sketch of

14 His view of Derwentwater, for example (FIG 80), which is inscribed 'Keswick'. Most, if not all of Beaumont's work of 1798 is to be seen in the library of the Wordsworth Trust, Grasmere.

15 *View in Borrowdale*. Pencil and watercolour. V.& A., Reynolds 1973, no.74, pl.42.

16 At present untraced, the painting (13½ × 19½ in.) was sold for 39 guineas at Christie's, 15 May 1830 in the Lawrence sale. On the back was the inscription: 'Sir George Beaumont to Sir Thos Lawrence July 24 1821 with his best regards'.

FIG 80 Sir George Beaumont
Derwentwater
Pencil and grey wash on wove paper,
13.7 × 19.7 cm. Inscribed on the back,
'Keswick Monday July 3 1798'. Page
14 in the 'Leather Album' of
Beaumont sketches. Wordsworth
Trust, Dove Cottage, Grasmere.

FIG 81 Sir George Beaumont, *Bridge
and Barn, Watendlath*
Pencil and grey wash on wove paper,
13.7 × 19.5 cm. Inscribed,
'Wathenlath July 3'. Wordsworth
Trust, Dove Cottage, Grasmere.
Beaumont visited and sketched this
remote hamlet on at least two
occasions.

FIG 82 Sir George Beaumont *The
Bridge, Watendlath*
Pencil and wash on wove paper,
13.7 × 19.4 cm. Inscribed t.r.,
'Wathendlath June....'; '30 June' on
the back. Page 9 in the 'Leather
Album'. Wordsworth Trust, Dove
Cottage, Grasmere. This is the
drawing from which Girtin made his
watercolour, (FIG 85).

the scene by Sir George (FIG 80) – the two viewpoints are only a few yards apart –
must surely indicate that he also had in mind some of the Baronet's sketches of
1798 and that they were alerting him to suitable subjects. Constable's views of
Watendlath are also remarkably similar to Beaumont's. Sir George could never
resist the picturesque Cumberland bridges, with their arches an apparently
haphazard construction of stones (FIGS 81 and 82), and Constable seems to have

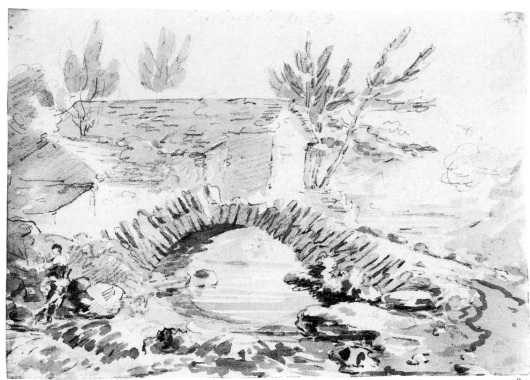

81

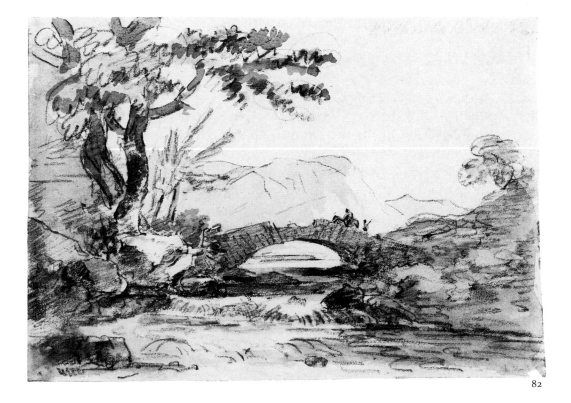

82

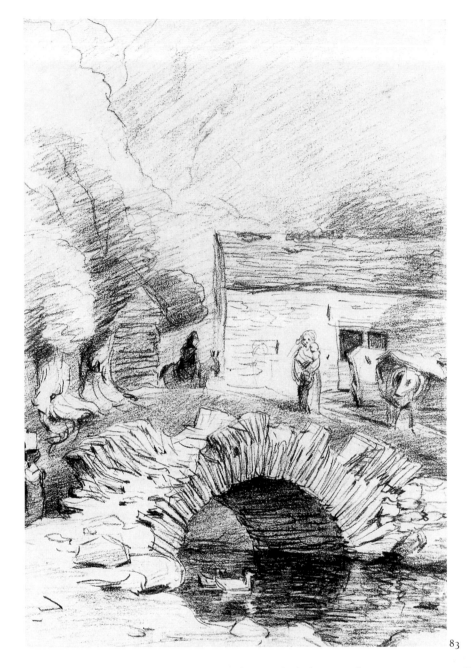

FIG 83 *Watendlath, with Figures and Cattle*
Pencil on wove paper, 26 × 17.8 cm., sight size. 1806. Private Collection.

83

been equally charmed by them (FIGS 83 and 84). But here, at Watendlath, Constable would have been able to recall a work of greater moment than any of Beaumont's somewhat light-weight drawings: Girtin's copy, or more, properly, his 'realisation' of Beaumont's view, one of the thirty we can safely assume were shown to Constable as examplars of 'great breadth and truth' (FIG 85). As the Girtin watercolours, by Constable's own account, were so profound an influence, we should perhaps consider for a moment the nature of this breadth and truth and the meaning it was intended that the words should carry.

'Breadth', in artistic circles, was then a rather new, 'in' word. Sir Joshua Reynolds, in his *Discourses* in the 1770s, used it, but sparingly and imprecisely.[17] By the turn of the century, however, its meaning among painters had become clearer.[18] The word was defined at some length in a lecture delivered at the Royal Academy in 1802 by the then Professor of Painting, Henry Fuseli, a lecture that, as a third-year student, Constable would undoubtedly have attended. It is worth

17 *Fourth Discourse*, 10 December 1771, published 1772: on colouring, '...a quietness and simplicity must reign over the whole work to which a breadth of uniform and simple colour, will very much contribute'. *Fifth Discourse*. 10 December 1772, published 1773: of Raphael, '...He never acquired that nicety of taste in colours that breadth of light and shadow', etc. The O.E.D. gives Reynolds, 1788, as its earliest illustrative quotation.

18 Among press notices in the next decade or two we find: of *The White Horse*, 'painted with great breadth and truth', *New Monthly Magazine*, 1 June 1819; of *Salisbury Cathedral from the Bishop's Grounds*, '...the architectural parts are well delineated, though perhaps for breadth of effect less attention to the detail would have been better', *Morning Chronicle*, 12 May 1823; and of *A Boat Passing a Lock*, '...the distance is very clever, but it wants breadth', *London Magazine*, June 1824. Ruskin's definition, from his *Elements of Drawing* (1851), runs, not very helpfully: '...a large gathering of each kind of thing into one place; light being gathered to light, darkness to darkness, and colour to colour'.

19 Fuseli's influence on Constable could reward study. It seems more than likely that the flowing, springy line Constable adopted in many of his figure and pencil drawings of 1806, even his interest in the sloping shoulders and swan-like necks of young women (see FIG 62), derived from Fuseli.

20 Lecture V, on 'Composition and Expression' given at the R.A. on 19 March 1802, was finally published with five other of Fuseli's lectures in 1820. Our quote has been taken from R. Wornum, ed. *Lectures on Painting by the Royal Academicians. Barry, Opie and Fuseli*, 1848, p.466.

FIG 84 *Watendlath*
Pencil and grey wash on wove paper,
trimmed r. and b., 10.7 × 24.1 cm.
1806. Private Collection.

FIG 85 Thomas Girtin *The Bridge,
Watendlath after Beaumont*
Watercolour on wove paper,
26.1 × 32 cm. Eton College. A
watercolour once owned by
Beaumont.

having the relevant passage in full, for Fuseli's colourful prose reflects the man whose personality played such an important part in the lives of the students in the Painting School at the Academy.[19]

Breadth, or that quality of execution which makes a whole so predominate over the parts as to excite the idea of uninterrupted unity amid the greatest variety, modern art, as it appears to me, owes to Michelangelo. The breadth of Michelangelo resembles the tide and ebb of a mighty sea; waves approach, arrive retreat, but in their rise and fall, emerging or absorbing, impress us only with the image of the power that raises, that directs them; whilst the discrepance of obtruding parts of the infant Florentine, Venetian and German schools, distracts our eye like the numberless breakers of a shallow river or as the brambles and creepers that entangle the paths of a wood, and instead of showing us our road, perplex us only with themselves. By breadth, the artist puts us into immediate possession of the whole, and from that gently leads us to the examination of the parts according to their relative importance, breadth is the judicious display of fulness, not a substitute of vacuity.[20]

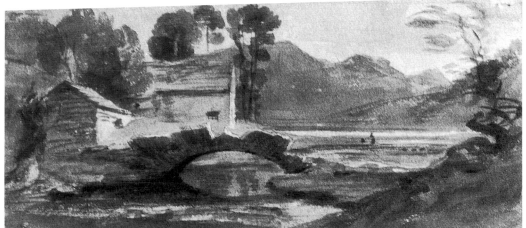

84

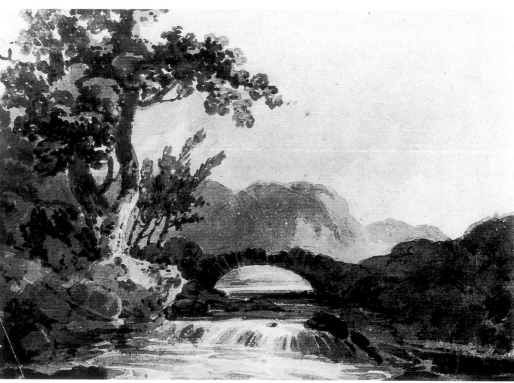

85

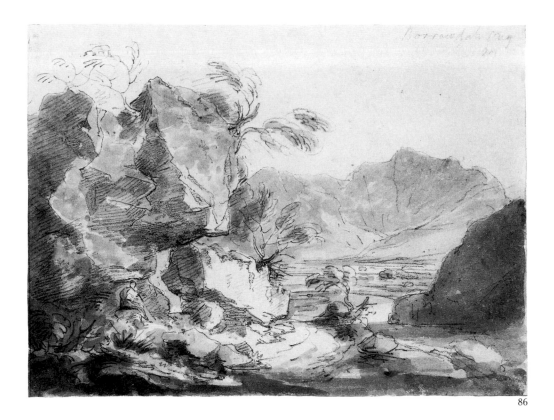

86

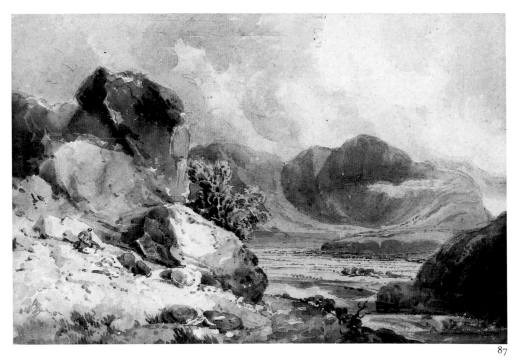

87

FIG 86 Sir George Beaumont
Borrowdale
Pencil and grey wash on wove paper,
14.4 × 19.3 cm. Inscribed, t.r.,
'Borrowdale Aug/ 24', and on mount,
'Borrowdale August 24/ 1798'.
Wordsworth Trust, Dove Cottage,
Grasmere.

FIG 87 Thomas Girtin *Borrowdale*
after Beaumont
Watercolour on wove paper,
32.5 × 49.5 cm. Wordsworth Trust,
Dove Cottage, Grasmere. Another of
Girtin's 'realisations' after Beaumont.

A comparison of two further pairs of drawings by Beaumont and Girtin after
Beaumont (FIGS 86, and 87, 88 and 89) will enable us to see what Beaumont really
meant by 'breadth'.[21] His own style of drawing was courtly, lively and well-
mannered. Always at his ease, he had a formula for every feature – tree, rock,
water, figure – and seldom appears to have been at a loss, possibly because he was
highly selective, only including that for which he had a ready reply with his
pencil. Though consistent in style, it is only in some of his attempts to capture
fleeting effects that he achieves any sense of unity. Girtin's *Borrowdale* (FIG 87),

21 The Beaumont originals with Girtin copies
were first discussed and reproduced by
David Thomason and Robert Woof in the
catalogue of their exhibition,
Derwentwater: The Vale of Elysium, at the
Grasmere and Wordsworth Museum, 1986,
Nos 121–5.

FIG 88 Sir George Beaumont, '*Grange Bridge*'
Pencil and grey wash on wove paper, 15 × 21.1 cm. 1798. Wordsworth Trust, Dove Cottage, Grasmere.

FIG 89 Thomas Girtin '*Grange Bridge*' after Beaumont
Watercolour on wove paper, 21 × 28 cm. Private Collection. With Girtin's *Borrowdale*, another drawing Beaumont owned.

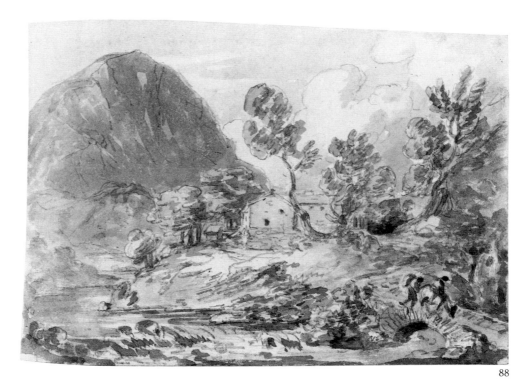

88

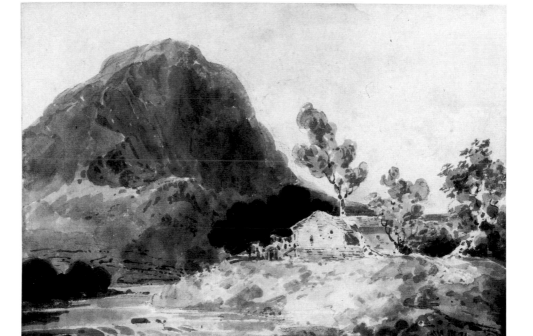

89

on the other hand, makes an impact straightaway, putting us immediately into 'possession of the whole' and then leading us, as Fuseli says one should be led, 'to the examination of the parts according to their relative importance'. It is his masterly control of the image and its component parts that is striking in Girtin's large watercolour as well as in the so-called 'Grange Bridge' (FIG 89). And it was this breadth of vision and control that Constable seems to have been aiming to achieve when, with mounting excitement, he began to articulate his own feelings about the scenes he was discovering.

The breadth in Girtin's watercolours is plain to see. Their truthfulness, the 'truth' that Beaumont urged Constable to study, lies perhaps in their capacity, shared with many great works of art, to suspend disbelief. In essence they were copies and consequently could not offer a more accurate account of the terrain than the Beaumont originals, but as representations of landscape they were more convincing, and therefore seemingly more truthful. From a further comparison of the Borrowdale pair (FIGS 86 and 87) we see that Girtin obtained this higher degree of credibility by creating a stronger sense of mass, space and scale. In Beaumont's drawing, and in another larger version in black-and-white chalk on grey paper,[22] as if convention forbad him from pointing out the obvious, he made only vague and rather cursory statements about the massive foreground rocks and the slope on which they rested, about the river and valley floor and the distant hills. In his second version he even negated the hills' enclosure of the valley by introducing an intervening, smaller range from behind which there rose, at an improbable angle, wisps of cloud. Using a stronger chiaroscuro, Girtin gives greater emphasis to the weight of the rock-masses; he draws more keenly the curving plane of the river and the lines of hedgerows down in the valley; and by making full use of the rounded hollow enclosed by the distant hills he creates an idea of space that seems to echo back towards us. He too introduces a wisp of cloud, but in his drawing this appears to be floating in front of the peaks behind and the lower slopes, bouyant in space. Contrasting solid with void, Girtin convinces because he excites the viewer's recollections of touching and moving, the experience of every day to which Beaumont only minimally refers. This view was another that Constable found, sketched and worked up into a watercolour. In his drawing, *Borrowdale: View towards Glaramara* (Reynolds 1973, no.88 Victoria and Albert Museum), presumably with the Girtin copy in mind, Constable also made more of the river down on the valley floor and of the clouds among the distant encircling hills.

For a lowlander like Constable, accustomed to the landscape of Suffolk and Essex, with its wide alluvial valleys, gently undulating plateaux and skies passing overhead unhindered, it must have been an awesome experience, however well he was prepared for it, to enter the Lake District; a relatively violent landscape with a history of geological upheaval, a landscape of hills and valleys alternately revealed and concealed by cloud and mist.[23] Eventually, when his seven weeks' total output is known and every scene identified, we may be able to follow his progress almost day by day during the tour and understand how, as an artist, he coped with the problems he encountered, both emotionally and technically. Our two pencil drawings (PLATES 4 and 6) and three from other collections (FIGS 90, 91 and 92), when placed in series will enable us to follow in part the process of adjustment.

Four are on 9 × 15 in. sheets of paper, a comparatively large area to work over and manage in pencil, the fifth is even larger. *Langdale Pikes from above Skelwith Fold* (FIG 90), drawn on his third day among the fells, was taken from a vantage-point above the valley of the River Brathay, looking westwards, quite near the Hardens, with whom he would shortly be staying. Below, we see Elterwater, its surrounding hills, and beyond, the knobbly, artichoke-like summits of the Pikes, sun-lit against a lowering sky. Considering how much there was spread out before him in this wide-sweeping panorama, Constable did remarkably well – every rhythm, we should remember, of hill-crest, shoulder, wooded slope or vale, was

22 Repr., No.123 in the catalogue mentioned above.
23 Constable had visited hilly country before when he toured Derbyshire in 1801, but though full of character the hills and dales there are not on the same scale as the Cumbrian fells and valleys. Summer 1801 was fine too, and he would not then have seen sky and land so intermingled.
24 As John Dunthorne, Constable's East Bergholt painting crony, seems to have done on a number of occasions.

for him entirely strange. Already he was developing a remarkable variety of responses and touches; wriggled, shorthand-like profiling; a scatter of telling accents strongly marked; hill-forms modelled with a sort of dusting of graphite. For some of the modelling he has used light 'washes' of the diagonal shading adopted the previous year. Many of the nearer trees are drawn as little globules, like the ones in the Ipswich *Wooded Slopes* (FIG 61).

The next drawing (PLATE 4) is a view of the Brathay taken from down in the valley beside a bend in the road that leads to the village of Skelwith Bridge (a view now totally obscured by trees, although the wall and the track on the left are still to be seen). It is not known what Constable had drawn the previous two days but there are now changes in the way he is viewing the landscape. This is handled more broadly; his pencil dwells less on details. The distant hills, their outlines delicately touched in, are strongly modelled, again with a smooth dusting of graphite. But the foreground is treated more openly, with freer, flowing strokes of the pencil. A prominent feature is the inclusion of the two figures. The man sitting with his back to us may be a companion (possibly George Gardner, posing on request),[24] but the woman with a basket is more likely to have been a passer-by. Many of the scenes he subsequently sketched were viewed from places far off the beaten track, places the locals had little reason to visit and higher than most visitors were inclined to venture. But if he was nearer habitation and the

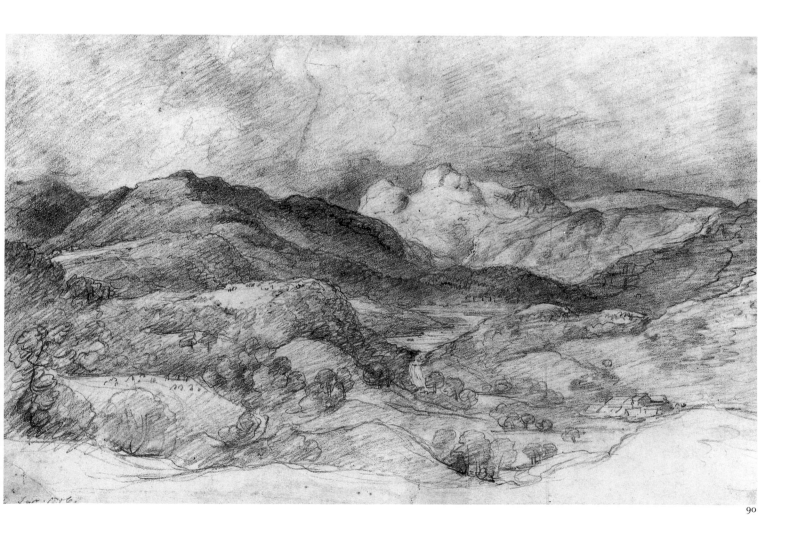

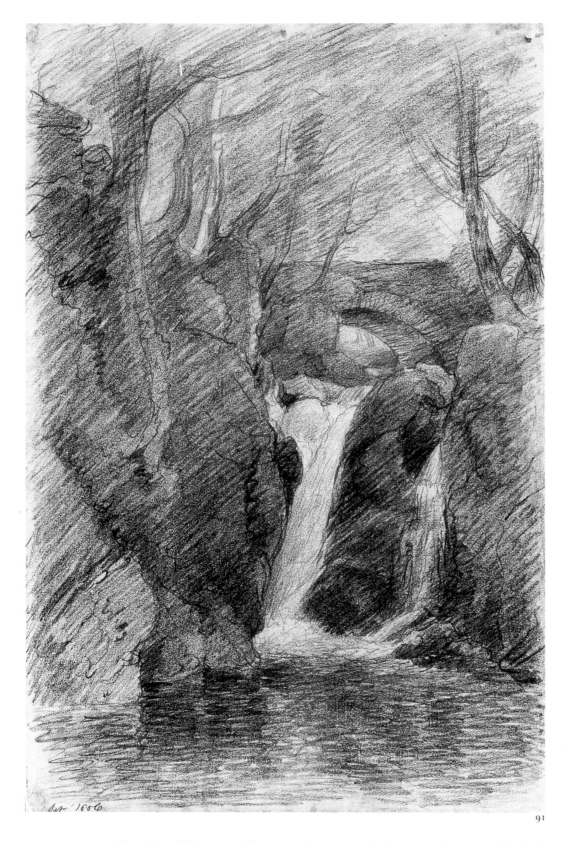

FIG 91 *Rydal Falls*
Pencil on wove paper, 38.7 × 25.4 cm.
Inscribed, 'Sept 1806'; on the back,
'12 Sept 1806'. Abbot Hall Art
Gallery, Kendal.

91

25 In some of the larger drawings, it is
 evident that Constable used both forearm
 and wrist, with the elbow as a pivot, when
 shading, for the slant of the zig-zag
 pencilling curves more steeply downwards
 as it approaches the left-hand side of the
 paper.
26 See John Murdoch, *The Discovery of the
 Lake District*. 1984, p.70.
27 The British Institution had held the first of
 its annual exhibitions earlier that year,
 1806. Constable subsequently adopted the
 policy of exhibiting at the B.I. work
 unsold at the previous year's Academy.

opportunity offered itself, he would quite often record whatever he saw of the life in those parts. At Watendlath (FIG 83) he found plenty – one woman drawing water, another holding a child, a pony and rider, cattle and ducks (where it seems there have been ducks ever since); always he followed J. T. Smith's advice, never to invent figures for his landscapes.

FIG 92 *Lodore and the Approach to Borrowdale*
Pencil on wove paper, 23.4 × 38.5 cm.
1806. Henry E. Huntington Library and Art Gallery, San Marino.

Rydal Falls (FIG 91), the third in this group of drawings, marks the next stage in the steadily increasing enlargement of Constable's vision. The subject naturally lends itself to a bolder treatment, but both in execution and in his choice of viewpoint there is evidence of a greatly intensified dynamism. The subject had already become popular with artists, but most chose a more static, frontal view, as Wright of Derby had done in his well-known painting. Constable composed more originally, from the left, so that we only catch a glimpse of the stream above the falls and the eye is led under the half-concealed bridge by a twisting, sort of corkscrew perspective. In this sketch Constable's pencil has travelled over the paper at speed in swift, compressed zig-zags.[25] In the last two pencil drawings of the series, *Lodore and the Approach to Borrowdale* (FIG 92), and *Glaramara* (PLATE 6) from Borrowdale, the diagonal pencil-work has built up into a storm of almost explosive force: in the *Lodore*, describing the slant of evening light; in *Glaramara*, the massive hills and the (for us) familiar rounded forms of the trees. Both are broadly seen (broad enough, one wonders, for Sir George?) and pictorially composed.

It has been said that Constable's main experimental interest in the Lakeland drawings tended to be compositional.[26] This is probably true of some of his studies. It is certainly true that some, like the present pair – *Lodore* and *Glaramara* – would have been suitable for transfer to canvas. In the next three years Constable was to exhibit six paintings of Cumbrian scenery at the Academy, and four of these at the British Institution,[27] and he must have been on the lookout for

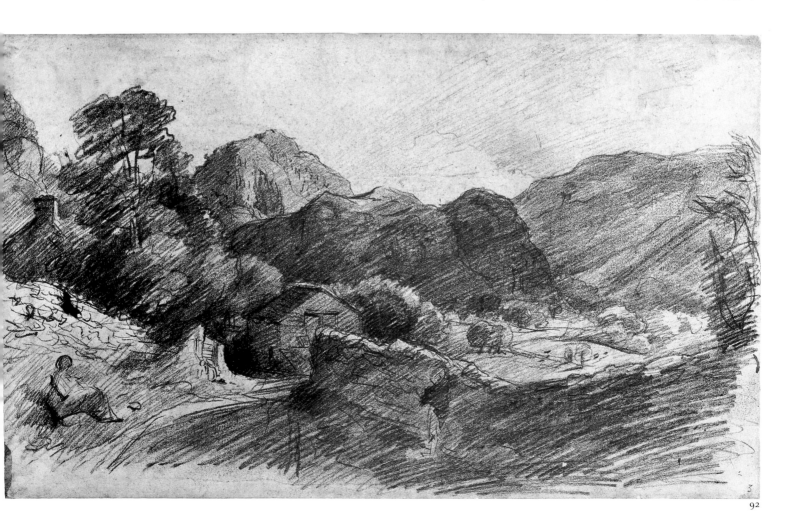

92

suitable subjects and mentally composing pictures much of the time during his tour. Several of the drawings have been squared up. This is normally done over (i.e., on top of) a study when there is a need for repetition, perhaps an enlarged repeat on to a canvas or some other support. Three of the drawings we are discussing, *The River Brathay* (PLATE 4), *Derwentwater* (PLATE 5) and *Glaramara* (PLATE 6), have been squared up, but, most unusually, in all three this was done before drawing commenced, or at any rate before the completion of the work, and a lot of the ruled lines as a result are totally obscured by the overworking. Equally puzzling is the seemingly arbitrary nature of the squaring up. In the *Glaramara* the horizontal intervals run: 9.0, 8.7, 8.5 and 8.2 cm; and the two upper vertical intervals measure 6.0 and 8.5 cm. *The River Brathay* is even more strangely divided: vertically, into five approximately equal columns, but horizontally, by lines at intervals of 5.2, 3.9, 3.8, 4.0 and 7.7 cm.[28] Parts of this last drawing could well have been worked up away from the scene over pencil outlines done on the spot.[29] In the *Lodore*, we also have a pair of figures contributing towards the balance of the composition, in this case with the woman seated and the man standing and almost hidden by the shadow of the wall, but there is no squaring up. This is a work done entirely on the spot, probably at one sitting. Beyond, just over the top of the wall, in the middle distance, Constable has noted with a few deft touches a small group of cattle with the lengthening shadows they were casting.

In both of the Girtins, *Borrowdale* (FIG 87) and 'Grange Bridge'[30] (FIG 89), there is a keen awareness of space and of scale. Working as he was at one remove from actuality, this Girtin achieved by a feat of the imagination. Confronted by the physical presence of fell and valley, by the raw material itself, it is hardly surprising that Constable should feel even more keenly the elemental balance of mass and space and, in contrast to his own native scenes, the scale of the Cumbrian landscape. His noting of the cattle, diminished by perspective and dwarfed to mere specks by the surrounding hills, is a key to some of the sensations he was experiencing and attempting to express. His awareness of scale, of the sheer size and bulk of those land-masses, was further and even more consciously articulated in the drawing of Glaramara (PLATE 6).

This is the largest of the five drawings (16 × 13 in), and loses a great deal of its rough, almost tempestuous power when seen (as it is here) in a reduced form. Here, pencil-pressure is of particular importance, gradations of light to heavy pressure controlling both the effect of aerial perspective (i.e. space and depth) and the fashioning of forms (the modelling of half to deep shadow). Most of the heavier strokes of the pencil are reserved for near and foreground accents – the arch under the bridge, the banks and tree-trunks beside the road – but the heaviest are the marks representing the ends of the lower slates on the roof of the house on the right. This, of course, was to stress, as it were to measure, the distance from the gable of the house to the lighter-toned shadows of the hills beyond, employing tonal difference, i.e., atmospheric perspective, to make the point. This spatial juxtaposition is further enhanced by a play with scale, by drawing our attention to two little groups of trees picked out in the distance, one in a patch of sunlight to the left of the heavily drawn slates, the other, further reduced in size by perspective, in half-light against another sunlit slope just above the corner of the house. These small, carefully selected, eye-catchers are not immediately notice-able. The scene first makes its impact – as Fuseli said it should – as a whole; then,

(if rather less gently than recommended by the Professor of Painting), we are led – or bounced – from one rounded form to another into the depths of the shadows, there to discover in turn the two little tree-groups, which by juxtaposition with the house bring us back to familiar ground close by.[31]

Lodore and *Glaramara* are drawings of considerable originality and power, and represent a remarkable advance in technique. There is a comparable advance to be seen in his watercolours, in which medium he was experimenting constantly.[32] But the story of this development is as yet incomplete, partly because our knowledge of the way watercolour-painting in general had been developing in this critical decade is somewhat limited. We know quite a lot about the kind of work the watercolour painters were presenting to the public at this time: mostly painstakingly executed studio works, ambitious in scale to rival the oil-painters, and in mood frequently pastoral. But there is still much we need to know about the growing edge of the movement, the more experimental private work and about the exchanging and cross-fertilization of innovative ideas.[33] Constable clearly learnt a great deal from his study of Girtin, but there were other, at present unidentified influences at work in the watercolours of 1806, the equation is not a simple $G + C$, more a, $G + C + (X + Y)$, where X and Y represent stimuli towards a new way of applying washes of colour and a new interest in light.

Bold brushwork and sharply contrasting lights and darks are both present in the dated watercolour (9 June) of the East Bergholt church archway (FIG 71), in which Constable has also used the Girtin calligraphy of dot-and-dash touches with the point of the brush. But entirely in the new manner are the other studies of East Bergholt church we have seen (FIG 69), the Yale *Epsom Common* dated 4 August (FIG 72), and our PLATE 3 a drawing inscribed on the back, 'Epsom Book [i.e., sketchbook] 1806 Aug'. Stylistically a matching pair, these last two are of particular interest as they have both been preserved from the damaging effects of sunlight and their condition is well-nigh pristine. Works as strikingly different as this and the other pair of Epsom watercolours (FIGS 73 & 74), executed within a few days of each other, indicate a duality of purpose that we should perhaps attempt to understand.

Essentially, the two pairs of watercolours represent two types of response to visual experience. In the first (PLATE 3 and FIG 72), the aim is to paint light, to render primarily a retinal image, only that which is seen; in the second it is more the intention to depict the tangible – mass, texture, weight, measurable space, etc. – that is, to present an image with which other kinds of sensory experience may more readily be associated. With his particular technique, his blobbing and touching-in, Girtin was able to impart a deep-seated feeling for the structure of landscape and whatever objects he was painting. Cast shadows played a part in many of his watercolours, but for him it was whatever surface the light happened to be striking that mattered, rather than the light itself.[34] In neither of Constable's Girtinesque Epsom views nor in *The Lyth Valley* (FIG 76) is there much feeling for light. Instead, full stress is given to texture, measurable space and the structure of the land.[35] Our *Epsom Common* (PLATE 3), presenting a strongly retinal image, seems more than anything to be an attempt to capture the effect of a particularly radiant flood of light. The means are simple enough, a limited palette (cold and warm and a narrow tone-range) and softly sweeping brushwork; it is something of a mystery though, exactly how he has achieved this effect of refulgent light.

A similar comparison can be made with two of the studies of churches. The

28 See p.273 for a discussion of Constable's ruled horizons and his squaring up.

29 Are the forms on the curve of the roadside behind the woman rocks or bushes? If drawn on the spot one feels that he would have made this clearer.

30 The subject has yet to be correctly identified. At present we can only be certain that the view is not of Grange Bridge at the entrance to Borrowdale.

31 In another of the broadly executed pencil drawings, *Borrowdale, Morning* (Leeds City Art Galleries; Tate 1976, no.76, repr. p.66), a view of the bend in the Derwent at Peathow, Constable has similarly indicated scale with a pair of aphid-sized cattle, this time hard by a tall tree in the middle foreground.

32 For example, in a single watercolour, *A View in Borrowdale* in the V.& A. (Reynolds no.80, pl.43) we find him making several experiments, both technical and stylistic: rendering the craggy cliff-face with short strokes of a dry, square-ended brush, scraping away for the lights with a blunt as well as a very fine-pointed tool; painting in the leaves and branches of a foreground tree almost mockingly, as might any pupil of any hack drawing-master.

33 Cornelius Varley's more experimental work came as a real surprise when it was shown for the first time; see *Exhibition of Drawings and Watercolour by Cornelius Varley*, P.& D. Colnaghi, 1973, pl.52, with an excellent introduction by Michael Pidgley. Of less importance, perhaps, but no less innovative, is the work of the amateur, J. S. Hayward, a linoleum manufacturer, whose work was first seen in 1974 at the Manning Gallery. (A catalogue, *John Samuel Hayward, 1778–1822*, with introduction, itemizes 69 drawings). Other artists come to mind. Joshua Cristall, who was in Borrowdale in 1805, working in a fresh, very personal style; and in the same year, another visitor to the Lake District, James Holworthy, a founder member of the Society of Painters in Watercolours, who made a number of large pencil and wash studies of atmospheric effects in the Lakes, on one of which he noted: 'X [relating to an 'X' made in the sky] Brightest gradual diminution towards other End by a covering of watery cloud', 'growing lighter' and 'very tender grey melting into Blue'.

34 *The White House*, Tate Gallery, a view of Chelsea Reach at twilight, possibly Girtin's most famous watercolour, is of course an exception.

35 Like the eponymous building in Girtin's *White House*, a lone farmhouse plays an important role in both Epsom watercolours, establishing scale and a focal point.

stones to be seen in the first (FIG 79), are eyed almost as an antiquarian might examine and finger them, with the closest attention paid to corbel, moulding and off-set, and none of the detailing is lost in the shadow across the transept (or is it a chantry?). In the second (FIG 69), looking westwards through an arch of the church tower, it is the downpour of light and the broad shapes of the shadows that he records, paying scant attention to the fabric of the partly ruined structure.[36] This is an image with an immediate impact; the other needs to be scanned.

The summer of 1806 was unusually hot. According to the records for July, the temperature in Essex reached 95 degrees. It may have been partly the unaccustomed succession of cloudless skies that awakened in Constable this new interest in light. If so, the almost total absence of clear skies and sunlit hours he met with in the Cumberland fastnesses would have proved hard to bear.[37] Later, he attributed an oppression of spirits he experienced among mountains to the effects of solitude.[38] This is understandable in the circumstances. He had led an intensely social life that summer, at times amidst a veritable bevy of attractive young women. At Brathay too there had been no lack of company, and after Gardner left him he must have felt very much alone in Borrowdale. But equally it could have been the wilder weather and the lack of sunlight that he found oppressive. A watercolour of Windermere, painted before he moved off into the hills, depicts a scene bathed in a warm, low-slanting light under a hazy blue sky.[39] This, as a record of fine weather, is unique among his Lake District watercolours. Cumbria is notorious for its rainfall, but Constable does not seem to have experienced the really rough side of the weather until he found himself in the more mountainous area to the north. Significantly, it was then that he began making notes about the weather on the backs of his drawings. On 21 September , '...stormy with rain' and 'stormy day – noon'. The next day, '...very stormy afternoon'; and the day after that, on the verso of *Derwentwater* (PLATE 5), the note already given in full, 'about 2 o clock the clouds had moved off [?to] the left and left a very beautiful clear effect on all the Distances...the heavy clouds remained edged with light'. On the first of his dated Borrowdale watercolours he recorded, 'fine clouday day [i.e., no rain] tone very mellow – like the mildest of Gaspar Poussin'. Two days later (on the 27th) he obtained a view of the entrance to Borrowdale, but only at 'twilight – after much Rain' (FIG 93). There are further notes: 'Evening after a fine day' and 'Evening after a shower' (both, 1 October); 'Noon clouds breaking away after rain' and 'Dark Autumnal day at noon...the effect exceedingly [sic] terrific' (4 October), and, 'Stormy Evening' (6 October).

Although the weather could have been worse (for Seathwaite at the head of Borrowdale is reckoned to be the wettest inhabited spot in England)[40], Constable, as we can see, had much to contend with. Between showers there was no lack of drama – clouds eddying downwards, constant changes of visibility – but seldom the light he could have wished for. During the nineteen days spent in Borrowdale only once was he able to paint a clear sky – late one evening, when the moon was rising over Stonethwaite.[41] In Borrowdale a grey overcast seems to be the norm in October, and the rather poor light (and possibly the time spent indoors on wet days) could have been a contributory cause of Constable's oppressed spirits.[42] Yet, as it happens, he may well have unexpectedly benefited from having to work in these conditions.

In half-light, the pupil of the eye opens wider and the brain begins to receive signals from the receptor cells of the retina equipped to 'fire' their discharges in

36 The tower of East Bergholt church, most often described in titling as the 'ruined tower', is in fact an uncompleted structure, a shell, in a decayed state. Originally intended to be a west tower to rival Dedham (completed c.1520), with a similar plan – a way through on a north/south axis that would provide shelter over the west door – after a start in the middle 1520s, for reasons no better known than that 'times were out of joint,' work on the building ceased before the first stage had been completed. Triple internal shafts, to be seen here in Constable's watercolour, suggest that a rib-vault was intended but never built.

37 Cumberland and Westmoreland, the conjoining border of which divides Grasmere and Windermere in the south from Thirlmere, Derwentwater and Borrowdale to the north, are now combined into Cumbria. Constable distinguishes between the two counties in the titles of his exhibits – e.g., 'A mountainous scene in Westmoreland' (B.I., 1808), or, 'A scene in Cumberland' (R.A., 1808).

38 According to Leslie: 'I have heard him say the solitude of mountains oppressed his spirits'. *Life*, 1951, p.18.

39 *Windermere*, pencil and watercolour, Fitzwilliam Museum, Cambridge; repr. in colour, Reg Gadney, *John Constable R.A. 1776–1837, A Catalogue of Drawings and Watercolours...in the Fitzwilliam Museum*, 1976, pl.4, p.25.

40 Sty Head Tarn, the source of the Derwent, of which Constable made a sketch (V.& A., Reynolds 1973, no.83, p.146) on 12 October, has the highest recorded annual rainfall in the British Isles – 172.9 cm.

41 *Borrowdale by Moonlight*, pencil and watercolour; verso, *Watendlath* (FIG 83). Sotheby's 13 November 1980 (lot 99), bt Spinks. Private Collection.

42 In October 1982 and 1983, during two six-day visits to Borrowdale, it rained every day (though not all day), and the author saw the sun once, for about an hour.

43 See R. L. Gregory, *Eye and Brain*, 1966, p.48.

44 *Life*, 1951, p.270.

FIG 93 *Borrowdale, Twilight*
Watercolour on wove paper,
11.7 × 24 cm., left edge untrimmed.
7 mm unfaded border all round.
Inscribed on the back, 'Borrowdale 27
– Sep^r. 1806 – twilight often much
Rain'. Courtesy of Salander-O'Neill
Galleries, Inc.

conditions of low illumination.[43] These cells only register tonal differences, shades of grey, providing what is known as scotopic vision. In this state there is a reduction in the registration of detail as well as colour. An artist will sometimes be seen looking at his motif or painting with eyes half-closed. This he does to reduce the input of light, which 'stopping down' will enable him to see the relationships of the larger tonal masses better, undistracted by irrelevant detail. A recollection of walks with Constable by his friend, George Field, the artists' colourman, suggests that in later life at least Constable was fully aware of the value of observing nature in semi-darkness.

> 'At all times of day, at night and in all seasons of the year, Constable had inexpressible delight in viewing the works of nature. I have been out with him after all colour of the landscape had disappeared, and objects were seen only as skeletons and masses, yet his eye was still active for his art.'[44]

Most of Constable's watercolours of the Lake District have faded badly, the blues he used being fugitive, and we are left with little but the pinkish reds, browns and murky darks with an occasional flash of yellow-green. Their pinkish tones are depressing, and it is often difficult to envisage them as they originally looked. Some, however, have retained much of their magical quality in the handling of the tones and, like the view of Borrowdale done at 'twilight – after much Rain' (FIG 93), look as well if not better in black and white. These are amongst the earliest recognisable examples of Constable's successful mastery of the medium, the first in which he integrates the hitherto disparate elements that were manifest in the Epsom watercolours.

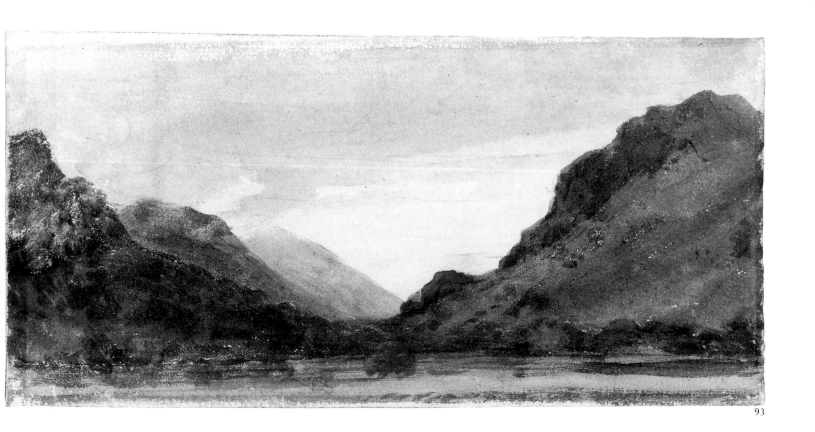

This success may be due in part to the prevailing weather conditions and to Constable's enforced use of his scotopic vision. One of the best-known of the Lake District watercolours, a drawing inscribed '...twilight after a fine day' (FIG 94) exemplifies this new mastery. Possibly an even better example of scotopic vision is our FIG 93, *Borrowdale, Twilight*. Here, breadth, the subordination of the parts to the whole, is fully realised. Like the study of East Bergholt church (FIG 69), the work makes an immediate impression – dark hills against a sky, lightest in the distance – but in this Borrowdale view, while detail is muted by shadow, we are given a full account of the structure, particularly of the hill on the right, where the sensitively drawn and re-drawn outline of the dark rock masses and the skilful, Girtin-like touches on the buttressing slope so effectively describe its character. Fully under control, too, are the intervals in the tone-scale, the grading, for instance, of the hills on the left, all three so perfectly 'in keeping'.[45] It is in watercolour drawings such as this that we first see signs of the future Constable, the truly great landscape painter. It was to be a further three years, however, before he began to express himself as effectively in oils. Here, it is perhaps worth noting that Constable chose to paint two of his earliest successful oils – *Malvern Hall* (Tate Gallery) and *The Park, Malvern Hall* (Private Collection) at moments of low illumination, the former at dusk, the latter on a grey day with a low ceiling of dark clouds.

The sort of clouds that were to darken Constable's days in Borrowdale may be seen lurking under the overcast just above the distant hills in his *Derwentwater* (PLATE 5), the watercolour he made on 23 September when approaching Lodore (and what is sometimes called the Jaws of Borrowdale) along the eastern shore of the lake. Like most of the drawings made on the tour this was not a page from a sketchbook; only at the start does he appear to have had one with him.[46] For the remaining drawings, the majority, he used paper of a variety of sizes which he pinned down on to a board of some sort, perhaps a strongly-bound travelling portfolio. It was the practice of many artists on tour to make their sketches on the spot in pencil and to work on them later with wash or colour, perhaps at the end of the day. It is likely that Constable continued his drawings in the evenings or on wet days. Small clusters of pin-holes in the corners of some of them confirm that these at any rate were done in stages.[47] But if there is no other circumstantial evidence, we can only make guesses about the way in which the rest were executed. It is of some importance to know whether a landscape was done from nature or not. Two quite different mental attitudes are involved; direct experience requiring one sort of selective process; recollection, another. But it is sometimes difficult to tell whether a drawing or painting was done wholly out of doors, partly so, or entirely away from the motif. *Derwentwater*, a watercolour of remarkable freshness and beauty (one of the bare half-dozen that has survived unfaded), is a tantalizing work, as it dangles evidence before us that, if confirmed, would establish it without a shadow of doubt as a drawing done entirely on the spot. Stylistically, it resembles some of the other Borrowdale watercolours that seem to have been done entirely outdoors.[48] The skeletal pencil-work was obviously just to provide guide-lines – a couple of sweeps of the pencil to indicate the curving slope of the hill across the lake on the right, etc. Only in the foreground darks is there a suggestion of shading. The brushwork seems too spontaneous to have been done away from the motif, the shaping of the crags too authoritive. Girtin's *Borrowdale* (FIG 87) convinces by its imaginative power; this

45 Keeping 'in Painting denotes the representation of objects in the same manner that they appear to the eye at different distances from it', *Barclay's Complete and Universal Dictionary*, 1808; i.e., a consistent decrease in size and change in tone and colour as objects recede into the distance. Originally a painters' term, it is now more widely used, it seems, to denote moral, social or sartorial conditions of suitability.

46 Several drawings made around Kendal are of the same size – approx. 4 × 7 in (10.2 × 17.8 cm) – as are a group of pencil drawings of Epsom and the environs.

47 Numerous pin-holes are to be found in two of the more elaborately worked-over watercolours in the V.& A. (Reynolds 1973, no.72, pl.40, no.89, pl.49) both titled *View in Borrowdale*.

48 At least three of Constable's panorama-style Lake District views in the V.& A. have the appearance of outdoor sketches: *Saddleback and part of Skiddaw* (Reynolds, 1973 no.72, pl.40) *View of Borrowdale*, 2 October (ibid. no.76, pl.41) and *View in Borrowdale*, 13 October (ibid., no.85, pl.48).

49 Pencil and watercolour, inscr. '21 Sepr 1806 St. John's Dale'. On the back, a watercolour of Sty Head dated 8 October, Museum of Fine Arts, Boston.

watercolour by its acuity of observation and its rendering of daylight. Proof that *Derwentwater* was painted beside the road, rests on one slight piece of evidence. On a watercolour Constable made two days before in the Vale of St John,[49] there are a number of light spots among the washes of colour, spots that could only have been made by drops of clear water, and their spread over the drawing strongly suggests that the artist had been caught by a shower while at work. There are several light spots to be seen in *Derwentwater*, but unfortunately only one, in the shadow of the nearest rock about an inch from the left-hand edge, has the character of a rain-drop – the minute system of radiating, capillary rivers. We can be certain that a spot of clear water fell here, but at present it is not possible to decide whether it came from Constable's water-pot, from another nearby source, or from the skies overhead.

5 The White Horse Inn

PLATE 7 *The White Horse Inn*
Pencil on laid paper, left edge trimmed with scissors, 10.9 × 18.6 cm.
Watermark part of a crown.
On the back a rapidly-drawn pencil sketch of trees and undergrowth with a distant cottage.

The annual fair at East Bergholt was an event regarded by the Constable family with mixed feelings, as it took place in Church Street and the adjacent space known as The Green, both of which were immediately in front of their house, with only their drive, front lawn and the low garden wall and its railings between them and the inevitably noisy throng (see street plan, FIG 95)[1]. Ann Constable, the artist's mother, clearly disapproved, a 'most wretched fair', she called it in a letter to her son of 1810;[2] later referring to it as 'our Miserable fair.'[3] One can understand. It must have been very disruptive. In a letter written on 28 July 1816, Constable told Maria that the fair was to be in the coming week and he wanted to get out of its way,[4] which is what he did, by painting down at Flatford on the 29th[5] and at some distant spot well away from the crowds on the opening day of the fair, the 30th.[6] When he next wrote (1 August), however, the fair was in full swing and he seems to have been rather enjoying it: 'I am writing all this', he told her, 'amid a tumult of drums and trumpets & buffoonery of all sorts it is a lovely afternoon & the fair is really very pretty'.[7] We last hear of the event from him in a letter he wrote many years later from Flatford to his eldest son in 1832, '...the fair here is just over – I heard some of the drums and trumpets among the trees as I walked over the meadows [in the valley below] in the evening last night'.[8]

Like most towns and a great many villages throughout the country, East Bergholt had been holding its fair annually for many centuries. An early record is an order by the Lord of the Manor in the reign of Henry VI that the bailiff should collect rents and profits from the stalls 'next the graveyard of EstBergholt church and to answer for them'.[9] In the seventeenth century, there appear to have been attempts to have it banned, and warrants were issued for anyone who set up a stall or booth 'for the pretended fair of East-Bergholt this p[r]sent year [1685]'.[10] But for may years after that it was listed as one of the regular 'Toy fairs' in the Suffolk calendar, and it was not until 1872 that, by Order in Court, it was abolished.[11] Most of the larger fairs were for the sale of live-stock, food-stuffs, hardware or general merchandise, but many were for the buying and selling from stalls and booths of consumer goods, and these, known as toy fairs, generally provided a variety of additional attractions – travelling players, puppets, living curiosities (the pig-faced lady, the giant, the Albiness, etc.), painted panoramas, swings, wild animals. Of the ninety-two annual Suffolk fairs listed, forty-two were for 'toys' only.[12]

These were occasions for a general unbuttoning, and very naturally, things sometimes got rather out of hand. In 1811, Justices of the Peace for a parish not far distant (Preston St Mary) warned hawkers, pedlars, etc., that they would not allow a fair to take place, as it tended '...only to create idleness and disorder in the parish'.[13] In the same year there appeared in a London paper a letter listing nineteen villages around the metropolis where 'opportunities are already afforded to the lower orders for injuring their morals and dissipating their property.'

> It may be truly said [the letter continues], that while these Fairs last,
> intemperance, riot and profligacy, know no bounds. Nocturnal dances succeed
> the dissipation of the day, and prove a copious source of seduction and
> debauchery. Such Fairs are indeed nuisances of the very worst description;
> they draw together in swarms those dissolute and disorderly people...who on
> those occasions sally forth to defraud the unwary, to corrupt the
> inexperienced, and raise supplies by plunder and depredation.[14]

FIG 95 *East Bergholt Enclosure Map, 1817*
Detail showing the centre of the village and the Constable family home, East Bergholt House. East Suffolk Record Office.

1 The house from the front, looking up the drive from near one of the gates, is to be seen in PLATE 11.
2 26 July; JCC I, p.47.
3 7 August, 1810; ibid, p.49. Mary Constable, the artist's sister, echoed her mother's sentiments, referring to 'our wretched Fair', in one of her gossipy letters to her nephew, John Charles, written from Flatford in 1839; ibid, p.309.
4 JCC II, p.189.
5 *Willy Lott's House*; oil on paper. Christchurch Mansion, Ipswich. Tate 1976, no.144, p.98.
6 *Stoke by Nayland*; oil on canvas. Private collection. Repr. frontispiece, Fleming-Williams & Parris, 1984.
7 JCC II, p.191.
8 29 July; JCC V, p.139.
9 T. F. Patterson, *East Bergholt in Suffolk*, 1923, p.37.
10 Ibid., p.129.
11 Ibid., p.151.
12 R. W. Malcolmson, *Popular Recreation in English Society, 1700–1850*, 1973, p.23.
13 *Suffolk Chronicle*, 13 July, p.1.
14 *The Examiner*, 8 September, 1811, p.585.

95

There was concern among residents of East Bergholt about their annual fair, too. This was supposed to be held on two days only at the end of July, but having erected their stalls and laid out their wares, it seems that the itinerant retailers were becoming increasingly reluctant to depart at the end of the second day. In 1811, on 24 July the day before the fair, some of the principal residents, led by the Rector, Dr Rhudde, and his churchwardens, therefore employed a Dedham solicitor, Peter Firmin, to draft a notice for the local paper, the *Ipswich Journal*, in the name of the Lady of the Manor.

EAST BERGHOLT FAIR

WHEREAS many Persons have, for several Years past, caused their Stalls and Booths to continue and stand, and made a practice of selling and vending their several Goods, Wares and Merchandizes, beyond the stated days allowed for the same, viz. the last Wednesday and Thursday in July: Notice is hereby given, that if any person or persons shall, after the date hereof, cause, permit, or suffer their Stalls or Booths to continue and stand, or shall sell or vend, or cause, permit, or suffer to be sold or vended, any Goods, Wares, or Merchandizes, after the expiration of the stated days allowed for the same, such person or persons will be prosecuted for the same, pursuant to the statute in that case made and provided.

This appeared in the *Ipswich Journal* for Saturday 27 July, so it looks as though the stallholders were extending their stay well beyond the recognized time. Worded almost exactly the same, the notice appeared again the following year, 1812, this time on 18 and 25 July, the two Saturdays preceding the last Wednes-

96

day and Thursday of the month when the fair was held. They did not have to publish the notice the next year, 1813, so presumably the stallholders had bowed to the inevitable and taken themselves off elsewhere. Under Dr Rhudde, the rule of the village was strict.

In all, there are nine separate sketches by Constable of the annual fair at East Bergholt: two oils, two pencil studies in a small sketchbook, and a group of five larger drawings in soft pencil of which one is our lively, *White Horse Inn* (PLATE 15).[15] One of the oils, a view of the fair from a first-floor window of the Constable's house (FIG 96), has a label on the back inscribed 'Painted in 1811', presumably a dating transferred from the back of the original canvas. Two small drawings are in the intact, Victoria and Albert Museum, sketchbook of 1813.[16] None of the five larger drawings is dated, but they all appear to have been done at about the same time. None is of the fair as it was laid out in 1811, and they are all of a novel and consistent style – not a style, however, that would reduce down to the scale of 3×4 in and match the handling in the 1813 sketchbook. In 1810, when his mother wrote telling him about the fair, Constable was in London. Stylistically, it is also most unlikely that the drawings were done in 1814. So this leaves us with 1812 as the most probable year for the group, the year when the stall-holders had to retire in good time before the authorities began to carry out their threatened prosecutions.

Two quite separate locations are recorded by the drawings in this group. Three (FIGS 97, 98 and 99), are of the main part of the fair in the centre of the village; the other two (PLATE 7 and FIG 100) are of scenes Constable witnessed outside *The White Horse*, a pub at Baker's End, half a mile away on Bergholt Heath.[17] FIGS 97, 98 and 99 show the fair from view-points just outside the gates of Golding Constable's house. The first (FIG 97), with the group and the donkey beside the camp-fire, the wagon (for wild beasts?), the two-wheeled trailers and the bare tent-poles, appears to have been drawn either before the crowds had begun to arrive, or after the fair, on the Friday, when the stall-holders were beginning to pack up and leave. As a background to the second (FIG 98), taken from a more central point, we see the roof-lines of the cottages opposite East Bergholt house

15 Two additional works, a 9×12 in. oil in Budapesth; and a drawing, p.13 in the V.& A. sketchbook of 1814 (Reynolds 1973, no.132), record a feast of 'Plumb Pudding and Roast Beef' provided at East Bergholt for 'the Poor of its Men, Women & Children to the number of near Eight Hundred', on 9 July 1814, to celebrate 'the blessings of a general Peace, for which they had Thanked God'. Patterson, ibid., p.151.
16 Reynolds 1973, no.121, p.85, pl.92 and p.87, pl.93.
17 No longer an inn, the house still stands, in appearance hardly altered. For this identification I am very grateful to Mrs Bruce Walker of East Bergholt.

FIG 96 *A Village Fair at East Bergholt*
Oil on canvas, 17.2 × 35.5 cm.
Inscribed on a label on the stretcher,
'Painted in 1811'. Victoria and Albert
Museum.

FIG 97 *East Bergholt Fair*
Pencil on trimmed wove paper
11 × 16.4 cm. Inscribed t. in pencil
'Book/ c' 1812. Private Collection.

FIG 98 *East Bergholt Fair*
Pencil on laid paper, 11.5 × 17 cm.
1812. Henry E. Huntington Library
and Art Gallery, San Marino.

FIG 99 *East Bergholt Fair*
Pencil on laid paper, 10.7 × 17.8 cm.
1812. Private Collection.

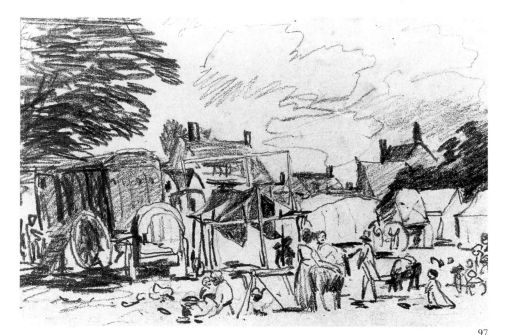

97

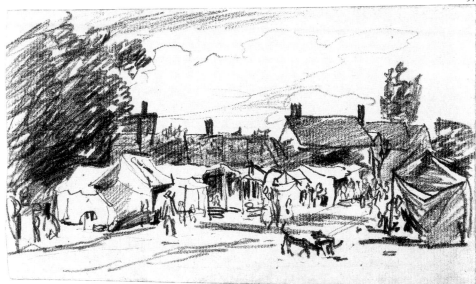

98

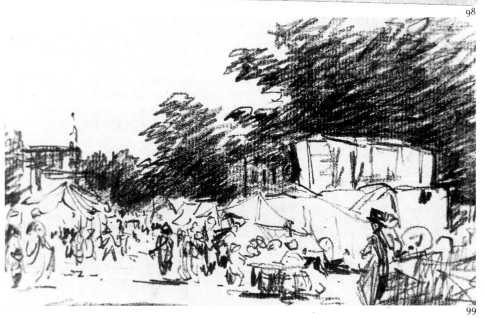

99

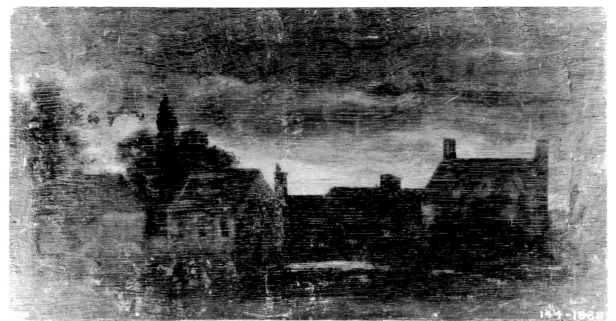

100

(see FIG 95),[18] familiar from the oil-sketch (FIG 96) and another oil in the Victoria and Albert Museum that Constable made late one evening from his home (FIG 100). The fair is obviously at its height in the third drawing (FIG 99): a dignified pair of ladies enter left; children gather round a stall in the centre; to the right we have the back of a travelling theatre; in the distance the east end of the church. Night-time, when the lights come on, is of course more the hour for noisy jollifications,[19] but none of these three drawings provide evidence of the villagers behaving other than in an exemplary fashion. Outside *The White Horse* the mood was very different.

There were other inns at East Bergholt. *The Lion*, just around the corner from the Constables' home (see street plan FIG 95) would undoubtedly have had a busy trade during fair week. But if it became one of the centres of the festivities this has left no record – not even among court proceedings. Perhaps Dr Rhudde and the principal inhabitants saw to it that there were no untoward incidents here, in the very heart of the village community. Out on the Heath, where stood *The White Horse*, there would have been fewer restrictions.

Alehouse gatherings had long been a main attraction for the working- as well as for the sporting-man, and publicans were ever ready to provide entertainment for their customers: bull-baiting, cock-fights, horse and donkey races, wrestling, cudgelling and cricket matches. Space was required for racing and cricket, and at Bergholt this, until the enclosures of 1817, was provided by the stretches of common-land in the eastern half of the parish, known as The Heath. In August, 1769, John Johnson, publican at the sign of *The Bell*, advertised, 'Eleven Hats, at Half a Guinea value each', to be played for on the Heath by companies of gentlemen cricketers, eleven men each company, 'The Stumps to be pitched at one o'clock...N.B. Dinner at twelve'.[20] Some years before, the landlord of the tavern we are interested in, *The White Horse*, had organised a similar event. His notice ran:

18 The cottage numbered '3' in the street plan is the one bought by Golding Constable for his son, the artist, for his use as a studio.
19 The second oil-sketch of the fair is a 6½ × 9½ in. view of the scene by night, with the stalls brightly lit and above, a cloudy moon. Private collection.
20 *Ipswich Journal*, 12 August.
21 Ibid., 10 July 1756.
22 Eadweard Muybridge's photographs of horses in motion were published in 1878 in *La Nature*. See, Aaron Scharf, *Art and Photography*, 1966.

FIG 100 *Village Street (Cottages at East Bergholt)*
Oil on panel, 19 × 36.2 cm. Victoria and Albert Museum. A view across the street from East Bergholt House.

FIG 101 *A Race outside the White Horse, East Bergholt*
Pencil on laid paper, 10.5 × 18.3 cm. 1812. Henry E. Huntington Library and Art Gallery, San Marino.

To all GENTLEMEN LOVERS OF CRICKET

NOTICE is hereby given that on Wednesday the 21st of this instant July at the sign of the White Horse on East Bergholt Heath in Suffolk will be Eleven Hats of Six Shillings value each hat given gratis to be played for at cricket by any two and twenty men, by their humble servant

John Bird

Stumps that day were to be pitched rather later, at two o'clock.[21]

The White Horse was well suited to be a venue for sporting events. It stood on a convenient spot at a T-junction on the Brantham road, on the edge of the Heath, at this time an extensive, irregularly-shaped area of uncultivated land still available to commoners for grazing and to all for recreation. From here, there ran a second road, northwards, across the Heath, passing on its way one of Golding Constable's windmills. This, with its sails square on to us, is to be seen in the distance in PLATE 7, above the heads of the somewhat disorderly-looking crowd in the road.

There are several puzzling features in the two drawings of the crowds outside *The White Horse*. We do not know, for instance, how this first scene relates to the event in Constable's other drawing (FIG 101). In time, they seem to be some distance apart. The second clearly represents the concluding stages of a donkey-race (or at any rate a race with a donkey in it), for the rider of the foremost animal is sitting as he would on an ass, well back on the creature's hindquarters. Here Constable resorts to the current, pre-Muybridge formula for racing horses[22] – the outstretched fore and back legs. Elsewhere, he attempts to respond more spontaneously to the animated scene. But, working perforce at speed, only here

101

and there – in the foreground, the dogs and the children with the donkey, beyond, the onlooking donkey – does he manage to render legible much more than the general impression of a mass of figures. Still less, in the other drawing (PLATE 7) has he managed to articulate individuals in the shifting crowd. This scene really is a puzzle; what *is* going on? Plainly, Constable is reporting some kind of rough-house, an incident in which, with his frantic scribbling, he almost seems to be taking part (had he, too, been seeking refreshment?). Two clues, only, suggest themselves. Firstly, among the figures there is to be seen a marked inward inclination, as though the spectators had gathered around some sort of contest. Secondly, a clue that rather supports this notion. There are two lines, one in each direction, slanting obliquely upwards (in perspective, apparently), from a point on the ground directly below the windmill. These suggest an enclosure, a ring, though not necessarily a boxing-ring. In those days there were contests just as popular as boxing and only a little less brutal: backsword, single-stick and also cudgelling, in which the object was to break the head of the opponent, 'whether by taking a little skin from his pericranium, or drawing a stream [of blood, that had to run for at least an inch] from his nose, or knocking out a few of the...teeth'.[23] Equally popular as a contest was the ringing of hand-bells, that in some parts of the country became as common and as keenly fought as wrestling bouts. But would such a contest have aroused as much feeling as there seems to have been abroad that day outside *The White Horse* at Baker's End?

An additional teaser is provided by the two objects hanging high above the crowd at the end of the slender pole sticking out from the inn-sign, both of which objects appear to have been fairly heavy, judging by the bending of the pole and the fact that only the pennant is flying out in the wind. In a number of towns and villages it was the custom to parade round the streets with an enormous wooden or stuffed glove and a pennant at the end of a tall pole to indicate that the fair was open, and that traders from outside could legally enter with their merchandise.[24]

FIG 102 *The Artist's Birthplace*
Pencil on laid paper, 9.1 × 15.5 cm. Inscribed, b.l., 'Augst 2. 1812'. Private Collection. Viewed from one of Golding Constable's fields at the back of the house.

102

There may have been such a traditional ceremony at East Bergholt, but if so, why should the display end up at Baker's End, half a mile from the fair itself? At the end of the pole in the drawing of the donkey-race (FIG 101) there are also two objects, but these do not seem to be the same as the pair in PLATE 7. Could each relate in some way to the quite different events taking place below; could they not have been prizes or wagers of some sort for which the contestants were competing?

Although these two drawings – and the other three of the fair for that matter leave a number of questions unanswered, as a group they nevertheless make a significant contribution to the overall picture we have of Constable as a draughtsman. Stylistically, with their heavy outlining and forceful handling, all five are quite at odds with the known drawings of this period, in most of which, like the sketch of his home drawn on the Sunday after the fair (FIG 102), the use of line is kept to a minimum. Here, in Constable's view from the fields at the back of the house, and likewise in some of his greatest drawings, he demonstrates a high degree of control and restraint. But we should never allow ourselves to forget the great reservoir of creative power that was being constrained. Sometimes, as in his strangely passionate drawing of the scene outside *The White Horse* (PLATE 7), there was an eruption of feeling, restraint was flung to the winds, and we are made fully aware of this latent strength that was normally held in check.

23 Quoted from William Hone, *The Year Book*, 1832, in Malcolmson, ibid., p.94.
24 Christina Hole, *English Custom and Usage*, 1941, pp.92–3.

6 Two leaves from an 1814 sketchbook

PLATE 8 *Farmhouse at East Bergholt*
Pencil on wove (?trimmed) paper 8.1 × 10.9 cm.
Indistinctly inscribed in pencil top left '. House – E.Bergholt'.
On the back two compositional studies (see PLATE 10).

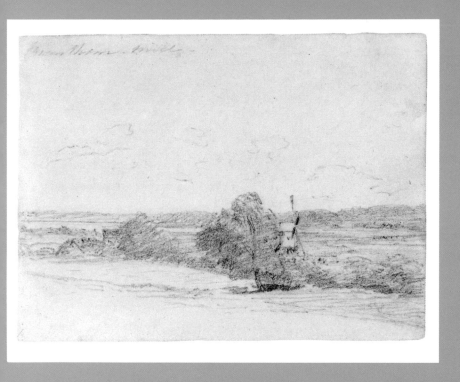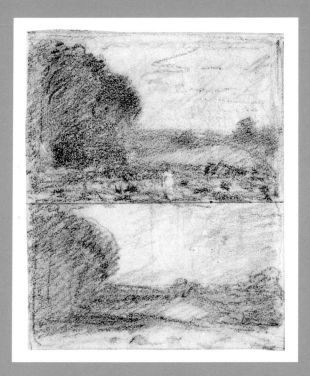

PLATE 9 *Brantham Mills*
Pencil on wove paper slightly trimmed left edge 8.1 × 10.8 cm.
Inscribed in pencil 'Brantham.Mills' top left.

PLATE 10 *Two Compositional Studies*
(drawn on the back of *Farmhouse at East Bergholt* [see PLATE 8]).
Size of image 8.3 × 6.8 cm.

In March 1814, while at work on the larger of his two Academy pictures, Constable felt in need of encouragement and turned to Maria for support. 'Let me have one line from you', he wrote, '. . .I have a large picture almost ready for the Exhibition & to make me happy (which your affectionate notes always do) would greatly benefit it.'[1] Meetings at this time were not always easy to arrange and their letters meant a great deal to both of them. Earlier that year Maria had suggested that Constable might write a little every day 'and at the end of three weeks or a month it would be a delightful Journal.'[2] In his letter Constable ends up telling her of jottings of a different kind that she might enjoy:

> You once talked to me about a journal – I have a little one that I < kept >
> made last summer that might amuse you could you see it – you will then see
> how I amused my leisure walks – picking up little scraps of trees – plants –
> ferns – distances &c.

He was of course referring to a sketchbook, the pages of which provide an account of how he spent much of his time that summer.

Sketchbooks played an important part in Constable's working life, but never more so than in the summers of 1813 and 1814. There were originally three, all much the same size (roughly, $3\frac{1}{2} \times 4\frac{1}{2}$ in.),[3] and handy to slip into a pocket. Two have survived unbroken, the one he carried around with him in the summer of 1813 (FIG 103) and one of two he used in 1814. These are in the Victoria and Albert Museum.[4] The third has been broken up. The intact books contain, respectively, ninety and eighty-four pages. It is unlikely that the dismembered one had many fewer than the other two, but at present only a dozen or so pages of drawings from this sketchbook have been identified.

Constable had three spells in the country in the summer of 1814; about a week at the end of April; six weeks in June and July; and then nearly fourteen weeks, from 30 July to 4 November. This year, he and Maria were able to correspond with greater freedom, and from the start his spirits were high. In the letters there are more references than usual to his enjoyment of the countryside and the satisfaction he was deriving from his work. On the short April visit he took several walks in search of 'food', as he called it,[5] for his pencil. He found the countryside beginning to look very beautiful 'as it is little else than blossom'.[6] When he returned in June, the village, he said, was in great beauty and never had he seen the foliage of the trees more promising. The fine weather held on into September and he was occupied 'entirely in the feilds'.[7] By October he was beginning to view the summer retrospectively.

> We have had a most charming season and I hope I have endeavoured to avail
> myself of it: it is many years since I have pursued my studies so
> uninterruptedly and so calmly – or worked with so much steadiness &
> confidence I hope you will see me an artist one time or other – but my Ideas of
> excellence are of that nature that I feel myself yet a frightful distance from
> perfection.[8]

In his last letter from Suffolk (25 October) he tells Maria of a visit two days before to see an aunt he was particularly fond of in Nayland, '. . .My way was chiefly through woods and nothing could exceed the beauty of the foliage'.[9] His last dated page of drawings in the Victoria and Albert Museum sketchbook, two views with Stoke-by-Nayland church on the skyline, were done on the way over to Nayland. From his months in Suffolk he returned with two pictures for the Academy which he had painted in the open air – *Boat-building* and *View of Dedham*[10] – but with

FIG 103 *East Bergholt Church, a Thatched Cottage and an Artist at work* Pencil on wove paper, 8.9 × 12 cm.; page 25 in the sketchbook of 1813. Victoria and Albert Museum.

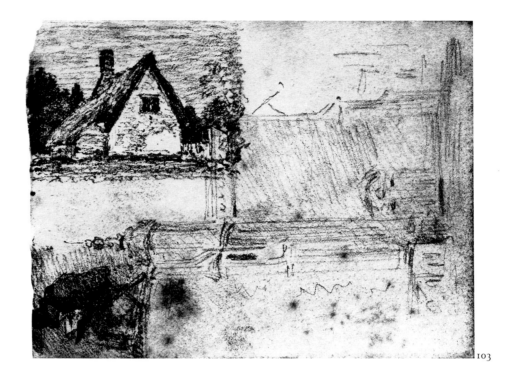

103

1 JCC II, p.120.

2 Ibid., p.115.

3 The precise sizes are: 8.9 × 12 cm. (1813; V.& A., Reynolds 1973, no.121, pls.76–93); 8 × 10.8 cm. (1814; V.& A., ibid., no.132; pls.102–16); 8.1 × 10.8 cm. (1814). The slight taper in the vertical measurements of the last, the earlier 1814 sketchbook pages, is important for the identification of drawings from this book. There is no such fractional taper in the other book of 1814.

4 Reynolds 1973, nos 121 & 132.

5 JCC II, p.121, 4 May, 'I took several beautiful walks in search of food for my pencil this summer when I hope to do a great deal in Landscape for I find myself every day less fitted for portraits. I assure you I feel great hope and confidence in myself on that subject.'

6 Ibid.

7 Ibid., p.131, '...this charming season as you will guess occupies me entirely in the feilds and I believe I have made some landscapes that are better than is usual with me – at least that is the opinion of all here'.

8 Ibid., p.133.

9 Ibid., p.134.

10 *Boat-building*, V.& A., Reynolds 1973, no.137; *View of Dedham*, Museum of Fine Arts, Boston, Tate 1976, no.133; repr. p.93.

11 *Feering Church and Parsonage, near Kelvedon, Essex*, Whitworth Art Gallery, Manchester. Tate 1976, no.125, repr. p.89.

12 JCC II, p.127.

material contained in his two sketchbooks that he was subsequently to use in the making of some of his greatest pictures.

Farmhouse at East Bergholt (PLATE 8) and *Brantham Mills* (PLATE 9), the drawings with which we are here mainly concerned, come from the earlier of these two books, the now dismembered sketchbook Constable used during his six weeks in Suffolk in June and July. Nearly two of these weeks – 18 June to 1 July were spent on a visit to an old family friend, the Revd W. W. Driffield, who at one time had lived in Bergholt. Driffield had extracted from Constable a promise of a drawing of his vicarage at Feering, near Colchester, and of the church nearby. This the artist fulfilled handsomely, with one of his rare and finest watercolours[11] and a drawing of the house with his host rolling the lawn. During his stay Constable accompanied Driffield on a short tour of Essex, necessitated by the latter's need to visit his living at Southchurch, near Southend-on-Sea. This enabled Constable to take a walk along the shore and to make a number of sketches, including two of the ruined Hadleigh Castle, a subject to which he was to return years later, in much less happy circumstances (see p.222). Constable told Maria about this trip in a letter dated 3 July. 'I have filled as usual a little book of hasty memorandums of the places which I saw which you will see.' Then, as if to excuse the cursory nature of the drawings made in Essex: 'My companion though more than seventy is a most active and restless creature and I could never get him to stop long at a place'.[12]

Although most of the drawings in the two intact sketchbooks of 1813 and 1814 conform to a viewing of the books through from first to last page, both contain drawings that were done the other way up, as though the ends were reversed. Others were drawn with the page held vertically, either way (FIG 16). Constable also drew at random, in no particular order. On turning over the pages of these remarkable books, filled with little landscape masterpieces, one wonders how he overcame the mechanical difficulties of working to such a scale. Sometimes he

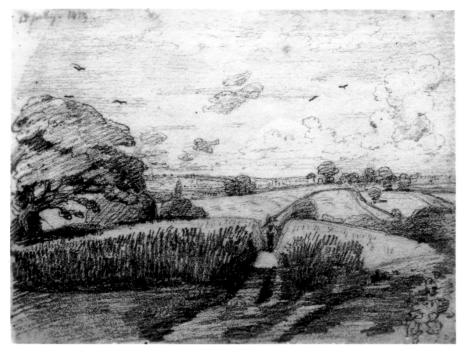

104

105

may have been able to sit down and rest the book on his knee; in FIG 103, a page from the 1813 sketchbook, in a postage-stamp-sized drawing squeezed into the corner, we see a fellow artist, probably his crony Dunthorne, at work sitting on a three-legged stool. But Constable often drew standing up, in which case he must have held the book in his left hand while he sketched. An occasional small grubby patch on an inside corner at the bottom of the page suggests that he was then holding the book with his thumb pressing the page open.

Constable frequently drew on both sides of the paper and when we have a loose leaf from one of these sketchbooks such as ours of 1814 (PLATES 8 and 10), talk of recto and verso can be misleading. When this came up for sale in 1981 it was stuck down on the supporting mount, the *Farmhouse* (PLATE 8) uppermost, with the window of the upper mount overlapping the edges of the drawing. The two compositional studies (PLATE 10), drawn on the other side, were only discovered when the drawing was lifted. This also revealed the inner edge of the leaf – where the folio had been torn and pulled away from the stitching – and the fact that in the original pagination, the farmhouse had been drawn on the *back* of the two compositions.

1813 and 1814 were the key years in Constable's development as a landscape draughtsman. Just as 1809–1812 was the period of his historic break-through with his oil-sketches, it was during these two years that he appears to have discovered the full potential, within its narrow limits, of the graphite medium, and to have further extended his vision. The main advance seems to have taken place during July and August 1813. A comparison of a drawing made on 13 July

FIG 104 *Cornfield at East Bergholt*
Pencil on wove paper, 8.9 × 12 cm.;
page 21 in the sketchbook of 1813.
Victoria and Albert Museum.

FIG 105 *A Group of Cottages and a View towards Dedham*
Pencil on wove paper, 8.9 × 12 cm.;
page 63 in the sketchbook of 1813.
Victoria and Albert Museum.

13 A. Shirley, *The Published Mezzotints of John Constable*, R.A., 1930, App. A, p.225.

14 Constable had painted a similar view in 1804 from slightly higher up, in which only the tops of the two windmill sails appear. *The Stour Estuary*, Beecroft Art Gallery, Southend-on-Sea; Tate 1976, no.41, repr. p.53.

15 Golding Constable owned such a pair, though not so conveniently sited, Flatford Mill and the windmill on Bergholt Heath. The former he had inherited from an uncle, Abram Constable (1700–64) in 1765; the latter had been advertised for sale in the *Ipswich Journal* for 29 July, and Golding started paying poor rate on it soon after (East Suffolk Record Office, EG 3/G/1/4). He is listed as having paid rates on *two* windmills from 1772 to 1783. In a letter to her son of December (?) 1810, Constable's mother tells of much rain and great flooding, '& on Saturday 3 weeks a most tremendous Gale of Wind – but thank God – Vessells Barges & windmills [note the plural] all safe'. JCC I, p.52.

(FIG 104), not long after his arrival in Suffolk, with a couple on one page done some weeks later on 1 and 5 September (FIG 105), will perhaps best indicate the changes in his handling of the pencil-point and the enlargement of vision. In the earlier drawing of the path through the cornfield, although Constable has made effective use of the shadowed foreground to offset the sunlit fields beyond, outlining has played an important part – in the shaping of the tree on the left, for instance – and the landscape is seen essentially in terms of light and shadow. In the later pair, the subjects are seen and represented tonally, subtler effects of light are conveyed, and there is even a sense of what the black-and-white magazine illustrators of the earlier 1900s used to call 'colour'.

Though so few drawings appear to have survived from the earlier, dismembered book of 1814 (the one Constable told Maria on 3 July he had filled with hasty memoranda), two at least, the *Farmhouse at East Bergholt* (PLATE 8) and *Brantham Mills* (PLATE 9), show that at the start of this new season of sketching there was no hint of a return to the earlier manner of the previous July. On the contrary, in both these drawings there is a renewal of experimentation. The use of outline is now minimalized. The whole is seen as a tonal field in which objects and their component parts are represented in terms of lights and darks of varying strengths with a closely related, quite spontaneous system of textures. In the drawing of the *Farmhouse* the edges of some forms are seen clearly – dark roof against light sky, or light foreground profiled against the shaded ground under trees and bushes. Other forms merge into one another. As in direct visual experience, parts are seen at first glance, others do not initially register. The toned roof and the dark accents of chimney and windows against the sky and white gables attract the eye straight-away. But we do not immediately notice the projecting, single-storey outbuilding capped by its chimney or the partly concealed anatomy of the trees. This revealing and partial concealing was soon to become part of a deeply-rooted principle in Constable's art. Later he was to write much about chiaroscuro (meaning, literally, clear and obscure), an inexact term in contemporary parlance but which for him had a particular meaning and value. In the Introduction to his *English Landscape* (see p.240) Constable states that his aim was to direct attention to the source of one of the Art's most 'efficient' principles, the '["] CHIAR'OSCURO OF NATURE", to mark the influence of light and shadow upon Landscape, not only on its general effect on the "whole", and as a means of rendering a proper emphasis on the "parts", in Painting, but also to show its use and powers as a medium of expression, so as to note "the day, the hour, the sunshine, and the shade"'.[13]

The day, the hour, the sunlight and the shade, and a proper emphasis on the parts were seldom better expressed by Constable in pencil than in the apparently simple, but exquisite *Brantham Mills* (PLATE 9). Brantham Lock, the last (or first) in the canalized Stour, with its two mills, lay about a mile and a half downstream from Flatford. In our drawing, a view looking eastwards towards Mistley and the open estuary, we see the windmill with the roof of the nearby tidal watermill partly hidden behind trees.[14] Such a juxtaposition, adjacent mills driven by wind and water, was not uncommon in Suffolk. It was a convenient arrangement, for one system could be used when the other was unable to work.[15] This must often have been the case at Brantham where the watermill was driven by a head of tidal water and could only operate for a few hours in the twenty-four. The ownership of the watermill at this time has not been established, but the windmill, for a time

anyway, appears to have been the property of Golding Constable. If the tidal mill was not his also there must have been some amicable arrangement between the two owners for a complementary working of the mills.

For Constable, this was territory almost as familiar as Flatford itself. His father, one should remember, was a merchant with a diversity of business interests in the area. Besides farming-land, the mills at Brantham, Dedham, Bergholt and Flatford, he had a coal-yard at Brantham[16] and another extensive yard at Mistley on the Essex side of the Stour estuary. Here Golding's barges left their cargoes of grain and flour for shipment by one of his vessels to London, and from here the barges returned upstream with their corresponding loads of coal, iron, chalk and (probably) London night-soil, that the *Telegraph* or the *Balloon* (as the Constable vessels were successively named) had brought round from London. It was just below Brantham, at Cattawade, that there had assembled a large gathering in August 1797 to witness and celebrate the launching of a fine corn brig that had been built for Golding.[17] From Flatford or Bergholt the shortest way to Mistley and Harwich lay through Brantham, and Constable must have passed that way by water or on foot, or ridden or driven there, times without number. He was also fully cognizant of the state of the river and its banks, *vis-a-vis* the commercial river traffic. In 1808 he appears on his father's behalf at Sudbury before the Stour Commissioners, to complain

> ...that the haling paths [tow-paths] on the Sea Wall above Brantham mill, on the Lands in the several Occupation of John Dearsley and William Colman, are very ruinous and dangerous for navigating thereon...Mr John Constable also complains, that the Shoal below Flatford Mill Lock is too high, and that the Bank in the said Lock is washed away and reduced so as to occasion a great loss of water – That the lining of the posts of the Lower Lock of Dedham Lock, has contracted the passage way for < passages > Barges so as greatly to impede their Navigation, that the Gates of Dedham Lock want reparation, that the Lock Bank is so thin and weak (little having been done since the last order for the Reparation thereof) as to be dangerous, for Navigators, and that the Float out of Mr Gosnall's meadows over the Country River, into Meadows called the Rays, is much out of repair.[18]

None of this is irrelevant for a proper understanding of Constable. For it was the full knowledge of what he was looking at when he was drawing or painting his native countryside, his knowledge of the fields and their owners, the houses, hedges, watercourses, the ditches and many of the individual trees, with the countless and probably quite unconscious successions of motor-memories they evoked, that enabled the landscape as a whole to speak to him as it did. Few painters have known as much about the scenes they painted; none have known more.

Of this depth of understanding, some of which can be traced back to Constable's boyhood (see FIG 24, for example), of this, John Ruskin was of course quite unaware. Yet when he wrote, as he imagined disparagingly, that Constable perceived in a landscape 'that grass was wet, the meadows flat, and the boughs shady; that is to say, about as much as, I suppose, might be apprehended between them by an intelligent faun and a skylark', the great Victorian came very near to expressing something of one's own puzzled response to a drawing such as the *Brantham Mills* (PLATE 9), which seems to have been executed as effortlessly as the skylark sings – and with the same joyous spirit. One can only sense the sharp

16 Golding Constable took over the Brantham coalyard from his uncle, Daniel Constable in 1769, who had been paying rates on it since 1752. E.S.R.O., FB/190/A1/2 & 3.
17 *Ipswich Journal* 19 August 1797. See p.212.
18 *Stour Commissioners' Minute Book*, E.S.R.O., EI1:394/1.

FIG 106 *A Windmill by a River (Brantham)*
Pencil on wove paper, 8 × 10.8 cm. Inscribed t.r., 'Sepr. 3d 1814 Saturday noon [or 'morng']'. Page 47 in the intact 1814 sketchbook. Victoria and Albert Museum. Dedham Church Tower may be discerned in the far distance to the right.

106

eye and keen intelligence that has shaped the work. Does such seeming artlessness defy, or does it invite penetration? Perhaps a little of both. We can appreciate the skill with which, by means of a few judiciously placed dark accents – the shadow beneath the tree, the windmill's foreshortened sail and its cast shadow – Constable has captured the radiance of that sunlit, summer day; and one can see how effectively these darks are set off against the lighter tonal 'palette' to suggest atmospheric perspective and a sense of depth and enveloping space. We can also appreciate how much else is so simply suggested: the levelling off of the field near the hedge by a few gentle strokes of the pencil and the lie of the shadow under the tree, the whole sky itself by a little hardly perceptible pencilling. But for us, the rest, the greater part really, whatever it is that has brought it to life, this will ever evade analysis and remain a mystery.

Brantham Mills is undated, but it was probably drawn in June before Constable's departure for Feering on the 11th. On 3 September, in the second sketchbook he used that year, Constable made another drawing of the windmill at Brantham, this time looking westwards, upstream, with Dedham church tower just visible on the far horizon, and a figure in a boat (possibly Dunthorne again?) in the foreground (FIG 106). Stylistically, the two drawings are far apart. This may perhaps be explained by the fact that by then Constable was fully occupied in the fields with his oil-paints, and was consequently viewing landscape very differently – with a painter's eye – and had become adjusted to a bolder, rhythmic system. An undated drawing a little later in the same sketchbook, of a group of men with a barge at Flatford (just across the river from Willy Lott's house) will

107

FIG 107 *View of the Stour*
Pencil on wove paper, 8 × 10.8 cm.;
page 70 in the intact 1814
sketchbook. Victoria and Albert
Museum.

FIG 108 David Lucas after Constable
Autumnal Sun Set
Mezzotint image, 19.9 × 24 cm. First
published proof. Tate Gallery.

10

further illustrate the stylistic change that had taken place (FIG 107). This last could have been drawn as a possible subject for a painting, but as far as we know it was never developed. A number of drawings in the same book were, though. Indeed, none of the sketchbooks proved a richer store of ideas and material. Two drawings of Hadleigh Castle from the earlier, dismembered book of 1814 also provided subjects for paintings (see p.222), but it is doubtful whether they were drawn with this in mind. We need have no such doubts about the two compositions in PLATE 10 from the same sketchbook, both of which are clearly first thoughts for a painting, drawn away from the motif.

In a number of ways this is an unusual page. All but a couple of the two hundred or so drawings in the 1813 and 1814 sketchbooks were drawn on the spot or, one may guess, soon after the scene was observed.[19] The exceptions (both from the 1813 book) consist of a pair of outline studies which appear to have been done for the large painting of Willy Lott's house that Constable exhibited in 1814, and even these could have been drawn on the spot.[20] The pair in PLATE 10, on the other hand, bear none of the hall-marks of work done before the motif — the particularised notation, the instant reflex responses to direct experience. Also unusual are the double-framing and the technique employed, the blurring of the graphite pencil-work with the tip of the finger (or, possibly, with a chamois-leather 'stump').

The subject on which these compositions are based is one we have seen already in the drawing from the 1813 sketchbook (FIG 104), a view looking westwards down what was then known as Bergholt Hill. In the drawing and in a painting of the subject from which David Lucas made one of his mezzotints — *Autumnal Sun Set* (FIG 108) — the footpath, a main thoroughfare between Bergholt and Stratford St Mary, is a prominent feature. This does not appear in either of the two compositions. However, instead, there is a suggestion of haycocks or corn-stooks in the foreground. In the painting, *Autumnal Sun Set*,[21] there are no signs of cultivation in this field; nor were there in the initial progress proofs of Lucas's mezzotint. The stooks only appear in the later stages. Perhaps Constable had remembered having noted them in 1814 in these two diminutive compositions.

19 For example, a few such as the upper drawing in FIG 118 are of moonlight scenes and could not have been drawn on the spot.
20 Reynolds 1973, no.121, pp.31 & 70; repr. together, Parris 1981, p.158, FIGS 3 and 4.
21 V.& A., Reynolds 1973, no.120, pl.71.

7 East Bergholt House

FIG 116 *Flatford Lock from downstream*
Pencil on wove paper, trimmed irregularly, 22.8 × 30.5 cm.; watermark 'J. WHATMAN 1808'. On the reverse an off-print in printing ink. An oil sketch of this view with a barge and tow-horse is in the Mellon Collection. Constable made two drawings of the subject in the intact 1814 sketchbook.

this work as having been done into English from the French translation of *Tratto della Pittura di Leonardo da Vinci*, Paris, 1651; a publication based on an abbreviated copy of the *Codex Vaticanus* (Urbinas 1270).

6 Only the house itself remains unchanged, of course, but the outline of the wall, roof and openings tally most convincingly with those on the perspex. Although it is possible to pick out the correct line of vision, an existing hedge, new since Constable's day, prevents one from standing back on the exact spot from which the artist made his tracing.

7 I am very grateful to Dr C. S. Rhyne for bringing this drawing to my notice and to Leslie Parris for allowing me to make use of his notes on the work.

8 Parsey's central theme in *The Science of Vision* is three-point perspective, the system in which rising verticals are shown converging upon a third vanishing-point. 'When looking at the tower of a church', he writes, 'the top appears narrower than the same breadth at the bottom...yet there is not one picture in the world that has that effect, and consequently no picture (prior to my own) has been drawn as mankind sees objects'. The painting he mentions was no.1032 in the R.A. of 1837, 'A perspective view of a proposed cemetery chapel, showing the natural convergence of perpendiculars.' An engraving of the picture forms the frontispiece of *The Science of Vision*.

9 *Willy Lott's House*. Oil on paper. Christchurch Mansion, Ipswich. Tate 1976, no.144, repr. p.98. Constable may well have had the tracing by him when painting his study. Three measurements taken from the house in the oil-sketch and the tracing agree very closely. There is a significant similarity also in the outline of the trees behind the house; a silhouette notably different in *The Hay Wain*.

sheet of perspex, and by holding up the result on the spot to the actual view at Flatford, it was possible to confirm that the drawing was indeed a tracing of an outline taken from that viewpoint.[6] An off-print on the back of the drawing, a brush-drawn outline that matches the pencilling on the recto exactly, only in reverse (FIG 113), indicates that the brushwork on the glass was still wet when Constable was tracing through from it on to his paper, and that this second stage had therefore followed closely on the first. It would have been quite possible for Constable to have made a tracing in this way with the thin paper held up against the glass to a candle or to the sun. An even clearer off-print is to be seen on the back of the tracing of the Flatford Mill view (FIG 114).

A further confirmation that these outline drawings were traced through the glass is provided by an inscription on a drawing in Munich of East Bergholt church porch (FIG 115).[7] This, written in the top left-hand corner of the drawing, reads:

> To try the problem (by the Glass) wether the side of any building standing square on the base of the picture does receed to the point of distance or not

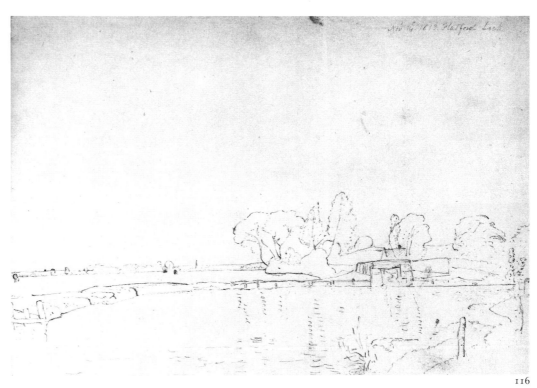

116

Constable's purpose in making this tracing on the spot was to ascertain whether vertical lines, in this case those of the porch, perceptibly converged upwards towards a vanishing-point ('a point of distance'), as of course the upward-tilted camera shows us that they do.[8] Here, accuracy of representation was his aim.

Was this always the case? Constable told Parsey that he first used his apparatus when studying painting 'in his native place, unaided by others', that is in his early years. This is understandable. But he appears to have continued to use the apparatus throughout his Suffolk years. There are dated tracings of 1813 (FIG 116) and 1814 (PLATE 11). The tracing of Willy Lott's house was taken on the same spot and is almost exactly the same size as an oil sketch of 1816.[9] The Flatford Mill tracing (FIG 109), with the barges in position (and a detail of one of the bows), must surely be a preliminary work for the painting that was exhibited in 1817

117

FIG 117 *East Bergholt Church Porch,
'A Gothic Porch'*
Pencil on wove paper, 31.9 × 23.5 cm.
Henry E. Huntington Library and Art
Gallery, San Marino.

FIG 118 *East Bergholt House, two
Views*
Pencil on wove paper, 10.8 × 8.1 cm.
The moonlight view inscribed below,
'Oct 2ᵈ 1814'; the daylight view, b.l.
'3ᵈ Oct'. Victoria and Albert Museum.

118

(FIG 110). The Munich view of the church porch (FIG 115) is identical to a drawing in the intact 1814 sketchbook[10] and only a few inches smaller than a magnificent pencil study from the same viewpoint in the Huntington (FIG 117), almost certainly the Royal Academy exhibit 'A Gothic porch' of 1818. What are we to make of this apparently continued use of the tracing device? Clearly, it fulfilled a need. But why, in these later years, when his almost unrivalled skill as a landscape draughtsman was nearing its peak, was it necessary to resort to outlining a scene on glass with his head kept in place by lengths of string held taut between his teeth?

With the present proliferation of the photographic image and the many graphic equivalents, it requires an effort of the imagination to realise in Constable's day how far apart were the current two-dimensional concepts of landscape – the current images to be seen on paper or canvas – from everyday optical cognition, from the appearance of the countryside as seen by those who lived and worked in it. It was Constable's initial achievement, the magnitude of which may be all too easily underrated, to narrow the gap between pictorial representation and the

'real' world, as people thought it looked. In 1802, as he told his friend Dunthorne, there was, he reckoned, 'room enough for a natural painture', a more natural style of painting. But as we have learnt from recent studies on Degas, what appears to be the most natural or spontaneous is often calculated effect, the work of prolonged study and plain craftsmanship, in Constable's own words, 'of long and patient study under the direction of much good sense'. And for him, in his truly heroic endeavour to create a more natural painture, it was plain good sense to use every available aid, (including his own primitive apparatus for tracing outlines) to help him narrow that gap.

We have no idea how regularly Constable made use of his apparatus. Barely a dozen of the tracings have so far come to light. But this, after all, is hardly surprising. They were of value only as preparatory works. When they had served their purpose, he had no further use for them. Two that have survived, *Willy Lott's House* (FIG 111) and a view of Stoke-by-Nayland church,[11] were in a collection, much of which was little more than studio detritus.[12] In all but one, the motif is drawn in outline only, the exception being *East Bergholt House* (PLATE 11). Long suspected of being a tracing because of the characteristic meandering profiles of the bushes and the foreshortened curve of the drive, conclusive proof that the outlines in this view of the family home had been traced was provided by the discovery of the tell-tale offsets of brushwork on the back when the drawing was lifted. Although happily placed in time, as this was the last of three views of the house made on successive days (see FIG 118), the drawing of the house is something of a puzzle because there is no other known view of the front for which it might be considered a preparatory study. It is possible, however, that there may have existed such a work, or at any rate, that there had been a request for just such a one.

It may be remembered that in June of this year (1814), Constable had fulfilled a promise to make a drawing for the Revd W. W. Driffield of his rectory and church at Feering, on the London side of Colchester. While he was there, Constable made a large detailed pencil drawing of the front of the house and a watercolour of the rectory and church at a distance from across the fields.[13] There is a story about Constable and the drawing of the house recorded in one of the notes David Lucas made in the margin of his copy of Leslie's *Life*.

> Here he was drawing late in the evening (Mʳ Driffield) retired early to rest looking out of the casement wishing him goodnight Constable proceeded with his drawing as long as a ray of light permitted him at the dawn of day (being an early riser) he was again occupied at the same spot when his host rose in the morning early he was astonished to find his visitor. where he had left him the previous night and acosted him thinking he had been on the same place the whole of the night[14]

From this careful on-the-spot study Constable made the drawing he sent to Driffield, an even more elaborate work (FIG 119) in which, as staffage, he included his host in knickerbockers rolling his lawn, with his horse, Ball, grazing contentedly nearby. This he completed and dispatched to Feering the following October (1815). Driffield was delighted with the drawing, had it framed and hung in his drawing-room, and only faulted it on two counts: '...you have not done *Ball* justice...and *I* never roll my garden in *black* breeches.'[15]

It is worth while dwelling on Driffield's commission (or was it a request?) at this length because such portrayals were not unusual. Some years before, when

10 Reynolds 1973, no.132, p.82, pl.116.
11 Pencil, (15.2 × 29.7 cm.) Private Collection; repr. William Darby, *Exhibition of Drawings by John Constable*, R.A. n.d. [1972], no.5.
12 The Ridley-Colborne Album, Sotheby's, 18 November 1971 (lot 50).
13 *Feering Church and Rectory*. Whitworth Art Gallery, University of Manchester; Tate 1976, no.125, repr. p.89.
14 JC:FDC, p.55
15 JCC I, p.129.

119

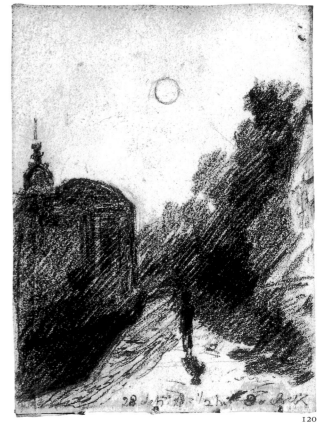

120

FIG 119 *Feering Parsonage*
Pencil and watercolour,
30.5 × 38.1 cm. Inscribed, b.l., 'John
Constable fecit. 1814'. Private
Collection.

FIG 120 *East Bergholt Church by
Moonlight*
Pencil on wove paper, 8 × 10.8 cm.
Inscribed below, '28 Sep! [. . .]
8 o'clock'. Page 72 in the intact 1814
sketchbook. An inscription on the
previous page (71) reads: '28 Sep!
8 o'clock James [Gubbins?]'. Victoria
and Albert Museum.

Constable's interest in Maria Bicknell was making itself all too plain, his mother, eager to place him in a favourable light with the young lady's grandfather, Dr Rhudde, sent to her young artist son in London a watercolour he had given her of the church and asked him as a favour to make another version of the work and have it framed and glazed as a present for the rector. This was done and, with a label lettered by Dunthorne, the picture of the church was given to Rhudde. The drawing, a handsome 15 × 23 in watercolour[16] has survived intact, with the label and, within an oval, the inscription shown above.

Was there, in October 1814, a reason why Constable should have been contemplating a similar task, this time a formal portrayal of East Bergholt House? A glance at the family's recent history shows that, having only a few weeks before made a portrait drawing of a house belonging to an old family friend, he could very well have been asked for another, this time of his own home.

While he was away at Feering his mother had been attending a sad occasion, the funeral at Epsom of her sister Mary's husband, James Gubbins. The Constables,

and this branch of the family, the Gubbinses, were very close. For a time, when in London, Constable seems to have regarded their house, *Hylands*, almost as a second home. His drawings and watercolours of Epsom and Leatherhead, and a particularly fine oil-sketch of 1809 (FIG 8) at the Tate[17], were all done when he was staying with them. An oil-painting by him of *Hylands* from the fields at the back of the house is still with the family.[18] In a letter to Maria from East Bergholt of 28 August, Constable tells her that they were expecting 'all' the Gubbinses (presumably the women, his aunt and her two daughters, Mary and Jane), that their visitors would be staying a month, and that he hoped James, the elder son (a captain in the Dragoons), of whom he was very fond, would shortly be joining them.[19] In the event, the Gubbinses did not see much of him. The weather was exceptionally fine and he took full advantage of it. '. . . this charming season', he told Maria, 'as you will guess occupies me entirely in the fields and I believe I have made some landscapes that are better than is usual with me – at least that is the opinion of all here',[20] which seems to imply that his work was being seen by the whole household. Later, in the same letter – written at his bedroom window in the evening 'with a calm, Autumnal setting sun', glowing on the gardens and fields below –he confessed that he had hardly seen his aunt and cousins. The nights, of course, were fine too, and besides the sketch of the house on 2 October (FIG 118), he made two other moonlight drawings, the second of which, dated 28 September (FIG 120), shows his cousin, James standing near the church, an eerie silhouette under the full moon with his foreshortened shadow cast on the roadway before him.[21] This is unlikely to have been the only time when the two cousins took a stroll together after dark, but Constable's days were fully occupied and, he said in a later letter to Maria, 'my cousins could never get me to walk with them once as I was never at home 'till night. I was willing [wishing?] to make the most of the fine weather by working out of doors.[22] All three of his moonlight drawings in the little sketchbook were done at around 8.00 p.m. Both of the daytime drawings of the front of East Bergholt House (PLATE 11 and FIG 118) were done quite early, at about 8.30 a.m. His paintings were keeping him in the fields all day, but he was evidently quite content to go on drawing after dark and also before starting on the main day's work.

The Gubbinses, at least the womenfolk, appear to have found him something of a disappointment, for there had been hopes that he would have found time to take a likeness of his cousin Jane. In a letter she wrote her son soon after his return to London, Mrs Constable reviewed the work of this summer, commented on his solitary habits, and had something to say about a sketch of her niece.

> . . . I believe it is thought – you avoid Notice too much which damps the ardour even of the best Friendship tis true you have been delightfully busy this Summer – and so far so good; and on taking a retrospect since you left the Paternal roof this time; it is a pleasure to your Aged Parents that there is so little to regret – so much to be pleased with. Your father has nothing to regret all was pleasant and he thinks you was very industrious & made Hay as it were while the Sun shone . – for myself – I have no fault to find – and only one thing to regret – that in the course of 5 weeks – a sketch could not be taken of Cousin Jane Gubbins as she anxiously hoped would have been the case . . . in this I cannot plead for her sketch as I could not for Love or Money obtain one for Myself – of my Much Loved Grandchildren[23]

This last, of course, being a dig at his failure to sketch some likenesses for her of his sister Martha's two children.

16 Inscr. 'John Constable Feb.ʸ 1811'. Lady Lever Art Gallery, Tate 1976, no.101, repr. p.77.
17 See fig.8.
18 Tate 1976, no.44, repr. p.54.
19 JCC II, p.131.
20 18 September, ibid.
21 James Gubbins died the following year on the field of the Battle of Waterloo. His horse appears to have bolted into the French lines where, after surrendering, he was brutally killed by a French officer. Ibid., p.156.
22 25 October, ibid., p.134.
23 6 November, JCC I, pp.107–8.

12

Here, in preceding paragraphs and also in some of his drawings, we have evidence to support the notion that Constable had perhaps executed or at least had planned to execute a portrait pencil study of East Bergholt House. Earlier that summer he had made a careful study of the Rectory at Feering, preparatory to a larger presentation drawing. When he did the three pencil sketches of his home (PLATE 11 and FIG 118) there were interested visitors, the Gubbinses, staying as guests, who would also have surely seen his drawing of Driffield's rectory. There had been talk of his making a portrait sketch of one of the daughters. He might have responded more favourably to a request for a drawing of the family home as a memento of their visit – perhaps he did. The large 1811 watercolour of the church shows that he was prepared to oblige when pressed. Furthermore, there is the drawing of the house itself, our tracing, with its washes of shading and its inscription, a drawing strongly suggesting that there had been an intention to proceed further.

The idea that Constable did execute a pencil study of East Bergholt House receives additional support from two drawings in the Victoria and Albert Museum: the *View over Golding Constable's Gardens* (FIG 121) and *East Bergholt Church, South Archway of the Tower Remains* (FIG 122) – highly finished performances – and from a glance at the list of his exhibits at the Academy the following year, 1815. In that exhibition he had an unusually large number of

FIG 121 *View over Golding Constable's Gardens*
Pencil on trimmed, wove paper, 30.1 × 44.8 cm. watermark 'J. WHATMAN/ 1811'. Laid on an old mount within ruled pencil lines on two sheets of paper, each watermarked, 'J. RUSE 1804'. Victoria and Albert Museum.

FIG 122 *East Bergholt Church: South Archway of the Tower*
Pencil on wove paper, 26.9 × 20.7 cm. Laid on an old mount within ruled pencil lines. With the previous drawing (FIG 121), probably exhibited at the Academy of 1815. Victoria and Albert Museum.

24 *View of Dedham*, Museum of Fine Arts, Boston; Tate 1976, no.133, repr. p.93.

works on show, five oils and three untitled drawings, most if not all of which would have been done the previous summer. The first of the Victoria and Albert Museum drawings, a view from an upstairs window at the back of the house, a drawing still in its original mount, was undoubtedly one of the three drawings shown at the 1815 Royal Academy. The second, of the church tower, is stylistically very close and is mounted for framing and glazing in a similar fashion. There seems to be no reason for supposing that this too was not another of the drawings shown at the Academy of 1815. Apart from these there appear to be no other candidates for the untitled drawings in that year's exhibition. Where, one wonders, is the third?

Both of the Victoria and Albert Museum drawings were still in the artist's possession at his death. Only a few of the works he exhibited at the Academy found purchasers; mostly (like the Victoria and Albert Museum pair), they were returned unsold. Why is this elusive third drawing not with the other two? One of the paintings he showed at the Academy that year did not in fact remain with him. This was a view of the Stour valley that had been commissioned as a wedding present for Philadelphia Godfrey, daughter of the squire of East Bergholt.[24] If the third drawing had been similarly earmarked for a new owner, possibly by the Epsom relations, this would explain why it is now not with the other two. And if this was the case, might it not well have been a portrayal of East Bergholt House, where the bereaved Mary Gubbins and her family had spent five weeks with her sister after her husband's death?

122

8 The 1816 sketchbook

PLATE 12 *Dedham Lock and Mill*
Pencil on trimmed wove paper 8.6 × 11.4 cm.
Inscribed indistinctly with a harder pencil, bottom centre, 'July 22 1816'.

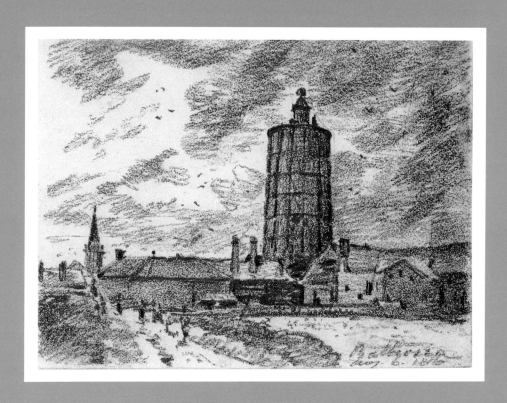

PLATE 13 *The Horizontal Mill, Battersea*
Pencil on wove paper, left and bottom edges trimmed 8.6 × 11.6 cm.
Inscribed bottom right 'Battersea/ Aug.6.1816'.

In April 1815, Constable sent in eight works for the annual Royal Academy exhibition, his largest entry to date. All were accepted and hung. Two of the five oils are known: *View of Dedham* (Museum of Fine Arts, Boston)[1] and *Boat-building* (Victoria and Albert Museum)[2]. The others were titled *Landscape, a sketch*, *Village in Suffolk*, and *Landscape*. The remaining three exhibits were all catalogued somewhat unhelpfully as just 'A drawing'. Two of these, however, as we have seen, may be identified with a pair of fully finished pencil studies in the Victoria and Albert Museum, a view over the gardens of Golding Constable's house (FIG 121) and the drawing of the south archway of the unfinished tower of East Bergholt Church (FIG 122, see p.127 for a possible third). After Constable's somewhat unpromising exhibit in 1806, the 'Trafalgar (FIG 70), this appears to have been the first public showing of any of his drawings. Hitherto he had been reticent about his draughtsmanship. There had of course been the occasional formal presentation drawing, but apart from these until now there is no evidence that anything was known of his achievements as a landscape draughtsman outside a very small circle of intimates. The presence of the three drawings in the 1815 Academy indicates a new confidence in his powers. This is reflected in the pages of the small sketchbook he carried around with him the following year, 1816.

The period covered by the sketchbook – July to December – was one of the most momentous in his life. He had reached a critical stage in his development as a landscape painter. In 1803 he had exhibited two of his oil-studies from nature, but after that for the next decade the landscapes he showed were painted in the studio from drawings and oil-sketches done on the spot. Then, in 1814, he painted at least two *pictures* out of doors, one, *Boat-building* specifically for the Academy, the other, the *View of Dedham* for a commissioned wedding-present, but probably also with the Academy in mind. Now, in 1816, he was engaged on the largest canvas he had so far attempted in the open air, the *Flatford Mill* (FIG 110), that was to be shown the following year as 'Scene on a Navigable River'. This summer he was also committed to two landscapes for a patron, General Slater-Rebow, views of the General's country seat, Wivenhoe Park, near Colchester (FIG 231) and of his charming fishing-lodge a few miles away at Alresford.[3] At a most inopportune moment Constable also received two further commissions, portraits this time, on one of which – an old clergyman, terminally ill – he apparently felt he had at least to make a start.

There were shortly to be important changes for the family at East Bergholt. Following the death of his mother (a powerful influence) the previous year and of his much loved father in May of this year (1816), it was decided that the family home in the village with much of its contents and the thirty acres of land that went with it, would have to be sold. It was arranged that one unmarried brother and sister, Ann and Golding, should set up separately on their own and that Abram and Mary, the other unmarried pair, should return to the Mill House at Flatford where their parents had started their married life together. A notice was drafted for the London papers advertising the sale of the house. The price was discussed: £5,000, or should it be £6,000?[4] Soon, for Constable, East Bergholt would no longer be home.

In addition, and most important of all, Constable's seven-year-long engagement to Maria Bicknell, a period of great torment and emotional stress, was quite suddenly brought to a conclusion. They had been corresponding for five years and in their letters marriage had often been discussed, but Maria was unable to

overcome her family's objections to her choice of a husband and Constable had not been in a position to maintain her as she felt she had a right to expect.[5] (He was never to be a fully-fledged professional; all his life he was largely dependent on un-earned income.) Then things began to change. By February it was understood that he would inherit a sixth part of his father's not inconsiderable property, and there were further prospects from an aunt at Nayland Constable was very fond of. Two events finally brought things to a head, the death of his father and the marriage of his closest friend, John Fisher.

With the Fisher's uncle, the Bishop of Salisbury, officiating, this marriage took place on 2 July. Constable called that day on his friend Farington with news of the wedding and freshly resolute about his own affairs. 'Constable told me today', the diarist recorded, 'that under all circumstances He had made up His mind to marry Miss Bicknell witht. further delay & to take the chance of what might arise. He said they should have abt. £400 pr. annum.'[6] On 27 August Fisher wrote to Constable from his new home at Osmington, near Weymouth, urging him to tell Maria that he, Constable, was ready to marry her and offering a date when he would be available to marry them himself. 'If she replies, like a sensible woman — as I suspect she is, well, John, here is my hand I am ready, all well & good.'[7] All was well and good, or at least, nearly all. Maria, of course, said she could not let Fisher suppose her not to be a sensible woman, and within a few weeks, after warm words between her and her father the night before, she did indeed give her hand to Constable. On 2 October 1816 the ceremony was performed by Fisher in St Martins-in-the-Fields, before two witnesses, neither of whom were relations.

So far, thirty-eight drawings from the 1816 sketchbook have been identified. Others may come to light. The intact sketchbooks of 1813 and 1814, as we have seen, contained drawings of several kinds, ideas for paintings, composed landscapes, brief memoranda, studies of landscape 'still-life'. Many in the earlier books were of an experimental, exploratory nature. The small sketchbook of 1815 appears to have been used rather differently, less as a file of working or reference material, much more as a book of landscape views done for their own sake, for pleasure, and also perhaps for the enjoyment of others.[8] This is even more apparent in the 1816 sketchbook, in which almost every drawing, as far as it goes, is a complete statement.[9]

Constable seems to have carried the little book in his pocket for much of the time in the busy weeks before the wedding. There are drawings done while he was at home in Bergholt, when he went to Wivenhoe and to stay with his old friend Driffield at Feering. He also did some sketches during a trip to London. Here we are concerned with seven of the pages from the book, two of which, *Dedham Lock and Mill* (PLATE 12) and *The Horizontal Mill, Battersea* (PLATE 13) belong to this earlier summer period.

Dedham Lock and Mill and an undated pencil sketch of Flatford Mill (FIG 123) are the only drawings that relate directly to previous or later paintings. From the same spot beside the lock gates at Flatford, Constable had made several oil-sketches, and of the same view painted an important picture, the *Flatford Lock and Mill* exhibited as 'A water-mill' in the Academy of 1812.[10] After the forceful oils, the pencil sketch, the last of the series, seems almost like a small act of valediction. On the other hand, *Dedham Lock and Mill*, one of a new series, looked more to the future.

After his father's funeral in May, Constable had returned to London. By now he

1 Tate 1976, no.133, p.93, repr.
2 Reynolds 1973, no.137, pl.95.
3 National Gallery of Victoria, Melbourne. Tate 1976, no.146, repr. p.98.
4 JCC I, pp.136-7.
5 Lack of money had long been one of the barriers to their marriage. '...I wish we could find that most necessary evil money', Maria had written in 1814 (JCC II, p.124), and in her next, '...but indeed my dear John people cannot live now upon four hundred a year' (ibid., p.126).
6 Constable appears to have overcome Maria's scruples and to have persuaded her that they could after all scrape along on £400 p.a.
7 JCC VI, p.29.
8 Our knowledge of the contents of the 1815 sketchbook is far from complete. Barely a dozen drawings from it have so far been identified. Of course the sketchbook itself may have been left unfilled, though this seems improbable.
9 For a full discussion of the contents of the book, see Fleming-Williams, 'John Constable: the Honeymoon Sketchbook', *The Old Water-colour Society's Club; Sixty-first Annual Volume*, 1986, pp.4-25.
10 Christie's 21 November 1986 (lot 105), repr.

and Maria were permitted to see each other as often as they wished and this enabled him to paint a portrait of her. On 16 July he returned to Bergholt, where, he told Maria, 'we make a charming family party', nine, all told, with his married sister's two children and 'your portrait'.[11] It had poured all the way during the journey down, and from her reply we gather that the weather had not improved. 'You must lament this rain very much', she wrote on the 20th, and then continued, 'there can be no going on with Dedham'.[12] This last pulls one up short. In his letter (of the 17th) there is no mention of Dedham, so she must have been alluding to something they had talked about before he left for the country. Had a Dedham view been discussed with her as a possible subject for painting? It looks very much as though it had, particularly so in view of the fact that on the 22nd he

123

124

FIG 123 *Flatford Mill*
Pencil on wove paper, 8.6 × 11.4 cm.
Private Collection.

FIG 124 *Dedham Mill*
Pencil on laid paper, 9.6 × 15.3 cm.,
trimmed left edge; watermark
Britannia in an oval. *c.*1809.

FIG 125 *Dedham Church and Mill*
Pencil on wove paper, 11.6 × 18.6 cm.
1817. Henry E. Huntington Library
and Art Gallery, San Marino.

FIG 126 *Dedham Mill*
Oil on paper, 18.1 × 24.8 cm. *c.*1812–
15. Victoria and Albert Museum.

FIG 127 *Dedham Lock and Mill*
Oil on canvas, 54.6 × 76.5 cm. 1817.
Tate Gallery.

FIG 128 *Dedham Lock and Mill*
Oil on canvas, 71 × 90.2 cm. Now
identified as Constable's exhibit in the
R.A. of 1818, 'Landscape: Breaking up
of a shower'.

125

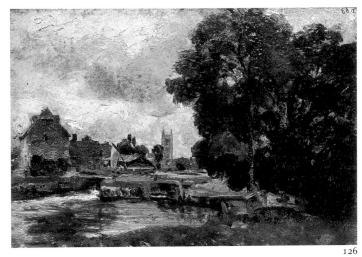

126

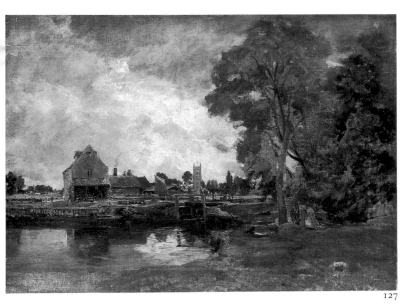

127

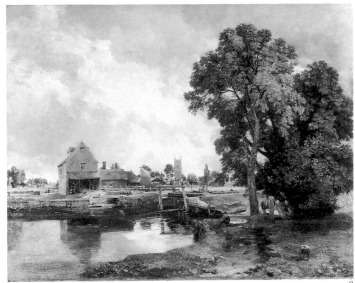

128

made a drawing there, *Dedham Lock and Mill* (PLATE 12). Besides this pencil sketch, there are four other studies of the subject: a drawing of *c*.1809 (FIG 124), a larger drawing of 1817 (FIG 125), and two oils, one in the Victoria and Albert Museum (FIG 126), the other in the Tate (FIG 127). Of the subject there are three finished versions, one of which is dated – 1820.[13] The earliest and largest of the three (FIG 128) is closest to the Tate Gallery study, and there is strong evidence to support the proposition that it was this version, with the title 'Breaking up of a Shower', that was shown at the Academy in 1818. All but the earlier pencil sketch are of the scene from the same view-point, on the north bank of the canalized Stour, with Dedham Church tower beyond and immediately above the lower lockgate, and with the sluice and mill to the left. In the paintings, a sail in the middle distance betrays the presence of the pool and wharf hidden behind the massive timber-work around the sluice. The early drawing (FIG 124) was taken from farther back and includes more to left and right. Here, the church tower is partly concealed by foliage and diminished in stature by a poplar of equal height close by. This tree is also to be seen in the drawing of 1817 (FIG 125). In the little 1816 drawing (PLATE 12) and in all the oils the tower stands clear as a strong accent, unhindered; here we find the rhythm and phrasing of the final

11 JCC II, p.187.
12 Ibid., p.188.
13 Reynolds 1984, no.20.10, pl.137.

composition first expressed; here, like the opening bars of a chaconne or passacaglia, the slow beat of the essential theme is laid down for the first time. The means are deceptively simple. With a relatively blunt-pointed pencil and an unerring eye, Constable reduces a scene of some complexity down to a miniature alive with information. From this Lilliputian composition there sprang one of his most memorable images, an image that was to remain with him long after the completion of the three paintings (FIG 129).

The purpose of Constable's next visit to London that summer was to take up a young spaniel puppy, a present for Maria and her sister, Louisa.[14] Dogs of one sort or another and a variety of domestic pets were a part of Constable's family life. For the artist, pleasure in the company of dogs at East Bergholt and the enjoyment of the landscape were part and parcel of life in the country. 'Nothing can exceed the beautiful appearance of the Country at this time', he wrote Maria in June 1812, 'its freshness – its amenity – the very breeze that passes the window is <everything> delightfull it has the voice of Nature. I took a walk this morning attended with three little mates as to Yorick [his favourite pug] His behaviour is quite ridiculous – he seems to promise himself so much pleasure'.[15] Later that year: 'I am usually [up] early in the morning – and this morning was so very fine that I yielded to the pressing invitations of *Yorick* and his <friends> companions to take a walk and did not return till eight o'clock.'[16] In January 1816 he travelled to London with two little companions 'the most ridiculous little pug puppies – a younger brother and sister of poor Yorick's'[17] which he had promised to deliver to an aunt in Chelsea. Dash was the name of the young dog intended for Maria. 'You cannot imagine what a real beauty the spaniel puppy is', he told Maria, 'we call him "*dash*" because he is like a charming fellow we once had of that name – but let me know if you have any name you like to have him called better "John" you said you did not like for a *dog*.'[18] Maria approved of the name and only feared she would love the puppy too much and that he might tear up the garden and displease her father. The visit to London to present Dash to his new owner is recorded by two drawings, both made on 6 August. One is of an octagonal house on Putney Heath (FIG 130), the other of an unusual Thames-side feature, the Horizonal Mill at Battersea (PLATE 13).

Constable would have passed close by the Horizontal Mill if he had crossed to the south of the river by the old wooden Battersea Bridge (FIG 131) on his way to see Maria in Putney. A mill of this kind was a rarity (only three others are known, none of which he could have seen) and as something of a windmill 'buff' it was very natural that he should have wanted to record it. Built in 1788 by Thomas Fowler from designs by Captain Stephen Hooper, it was originally intended as a mill for grinding linseed, but was later put to work for the distilleries nearby.[19] 140 ft high and tapering in width from 54 to 45 ft, the structure consisted of a concentric casing of slats which could be turned on their axes like Venetian blinds to admit or restrict the wind, the whole enclosing a vertical shaft carrying 96 eighty-foot vanes or 'sails' i.e., double planks placed vertically which acted like a turbine and drove half a dozen pairs of stones. Surmounting the whole was a lantern to house Capt. Hooper's patent speed regulating gear. The rather bizarre appearance of the mill at one time gave rise to a story that it had been intended as a gigantic packing-case for Battersea church to which the Emperor of Russia is supposed to have taken a fancy during his visit of 1814 and was desirous of having transported back to the Motherland.[20]

FIG 129 *Dedham Church and Lock* Pen and brown wash, 13.3 × 11.2 cm. Present whereabouts unknown.

FIG 130 *The Octagonal House, Putney* Pencil on wove paper, left edge irregular, 8.8 × 12.1 cm. Inscribed, b.l., 'Putney Heath. Aug. 6. 1816'. Private Collection. Probably *Bowling Green House*, residence of William Pitt.

FIG 131 J. T. Serres *A View of the Thames at Battersea* Oil on canvas, 27 × 38 cm. Sotheby's 19 July 1978 (lot 122).

14 This was to replace the loss of a young terrier, *Frisk*, 'a *great torment*, and a *great pet*' (JCC II, p.151), who had died (or been put down) the previous December. One of the earliest references in the Correspondence to a rainbow as a symbol of hope – later to become such an important theme for Constable – is to be found in a letter of Maria's when she was telling Constable of the puppy's mischievous habits, '...hope befriends us, it is the rainbow of the shower', JCC II, p.151.
15 JCC II, p.78.
16 Ibid., p.89.
17 Ibid., p.169.
18 Ibid., p.187.
19 Captain Stephen Hooper, from whose designs the Battersea mill was built, erected his first horizontal mill at Margate (Rex Wailes, *The English Windmill*, 1954, repr. pl.VI). This, however, had been preceded by two mills of a similar type designed and built by the father of the artist, John Mortimer, at Eastbourne (Walpole Society, Vol.XXXII, p.23). The lower part of one of these mills was converted into apartments for summer visitors, and by a curious chance, in this form was later (in 1780) the subject of two drawings by Dr Fisher, later Constable's patron, then preceptor of Prince Edward, with whom and with other Royal children he was on holiday (see A. P. Oppé, *English Drawings at Windsor Castle*, 1950, p.51).

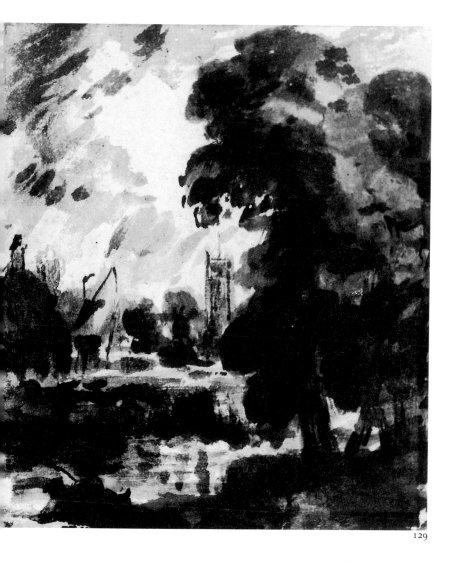

129

131

130

PLATE 14 *Salisbury Cathedral and the Bishop's Palace*
Pencil on wove paper, left and bottom edges trimmed, 8.6 × 11.3 cm.
Inscribed bottom left 'Salisbury 8 Oct.ʳ 1816'.

PLATE 15 *Osmington Church and Village*
Pencil on wove paper, bottom, top and left edges trimmed, 8.8 × 11 cm.
Inscribed bottom left 'Nov.ʳ 16. 1816'.

PLATE 16 *Redcliff Point*
Pencil on wove paper trimmed left and bottom edges, 8.7 × 11.4 cm.
Inscribed bottom right '8 Nov.ʳ 1816'.

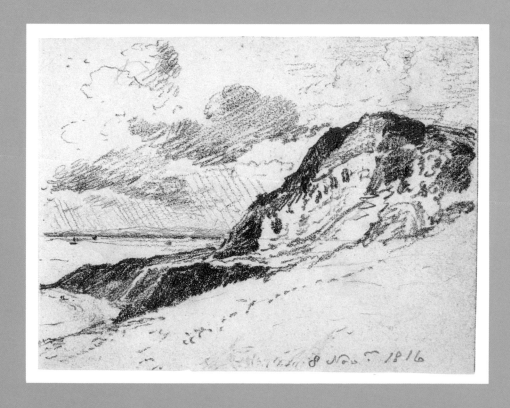

In the drawing (PLATE 13), we are looking westwards towards the church, St Mary's. At the foot of the mill we see the sinister-looking (and, one imagines, the melancholy-sounding) bullock houses, antecedents of modern intensive farming, where 600 bullocks could be housed, fed on the grain and meal from the distilleries. After an unusually hot spell in June, there was almost incessant rain that summer, right through until the end of August. With the roofs shining in the evening light, it looks as though 6 August had been one of those wet days; windy too, judging by the torn sky and wildly scattering birds. Drawn with the same certainty of touch as *Dedham Lock and Mill* (PLATE 12), but with an even blunter pencil, this sketch of Battersea is one of the most dramatic in the whole sketchbook. Perhaps the boldness of execution is a reflection of his emotional state, which, if he had paused to make the drawing on his way back from Putney, would doubtless at this time have been of an unusually high order.

Dash proved a favourite with Maria ('a most elegant puppy') and her sister, Louisa. Precise instructions as to his diet were contained in some of Constable's letters ('...this is the way our dogs and puppies have always been fed and nobodys have looked as well as ours'),[21] parts of which Maria found it difficult to read. Later, Constable began to fear that Louisa was becoming too fond of Dash, 'especially as he has of late shown so great an inclination to *wandering* – which is a grand defect in any *him* who wish to retain a ladys favors.'[22] We last hear of him in 1819, when Maria took their eighteen-month-old first-born son to stay with Louisa, '...pray take care that dash does not hurt our darling'.[23]

About half of the drawings in the small sketchbook of 1816 were of Suffolk and Essex; the remainder were done in Wiltshire and Dorset, when Constable was on his honeymoon. None of the letters he wrote to his family during this period have survived and the only documentation of those ten weeks is to be found in Farington's entry in his diary for 10 December.

> ...Constable called, having returned to London yesterday with His wife after passing six weeks with the Revd. John Fisher, in Dorsetshire, some days at Salisbury, with the Bishop and his family, and a few days with the Revd. Dr Cookson at Binfield, Berks. He told me that Dr. Cookson, my old acquaintance, has 3 sons and 2 daughters...The eldest daughter is married to the Revd. John Fisher.

Drawings tell us rather more: that the honeymoon couple spent the first week of their tour in Salisbury; the next few days with relations in Southampton; that they were at Osmington, near Weymouth, by 17 October, where they remained until 3 December or thereabouts; and that their final visit, to Fisher's in-laws, the Cooksons, at Binfield in Berkshire, was made on the return journey.

At this time several coaches ran from London to Salisbury every twenty-four hours. For some, Salisbury was their destination; others continued on south or westwards, to Poole, Weymouth or Exeter. According to the 1830 time-tables, nine and a half hours was the fastest time for the journey. At night, it took anything up to seventeen hours. Only one stage-coach made the trip in daylight – the *Light Salisbury*, which left at 7.00 a.m. and arrived at 5.00 p.m., with stops at Basingstoke and Andover.[24] It was by this coach that Constable travelled with two of his children when they went to stay with John Fisher (then Archdeacon) in 1829, and it would surely have been this coach that he would have chosen for himself and his delicate young wife in 1816.[25] By the morning of 4 October he was out sketching the cathedral, so it seems likely that they had travelled down the

FIG 132 *Salisbury Cathedral: South Transepts*
Pencil on trimmed, wove paper, 11.4 × 8.7 cm. Inscribed, '4 Oct^r 1816'. Ex. Hornby Album. Private Collection.

FIG 133 *Salisbury Cathedral and the Bishop's Palace, from the Southeast*
Pencil on trimmed, wove paper, 8.6 × 11.1 cm. Ex. Hornby Album. Private Collection.

20 Henry S. Simonds, *All about Battersea*, 2nd ed. 1882, pp.43–4.
21 JCC II, p.196.
22 Ibid., p.227.
23 Ibid., p.245.
24 John Chandler, *Stagecoach Operations through Wiltshire*, South Wiltshire Industrial Archaeological Society, Historical Monographs, no.8, 1980.
25 With an inherited pulmonary weakness, Maria had to avoid cold and damp night airs. 'I *study* my health', she told Constable, in her gentle, half self-mocking tones, 'so it ought to be good, wih the exception of yesterday, which I am suffering for a little to day. "The dews of the Evening carefully shew those tears of the sky, for the loss of the sun." but it is not such a sad thing to be so delicate. I must not be out after sun set, it is easy enough tho' to guard against it, so that trouble is soon got over, the moon shall tempt me no more'. 9 September 1815. JCC II, p.151.
26 The hour is happily revealed by the pinnacles on the south-east corners of the two transepts, which act as sundials, casting shadows that bisect almost exactly the lower corner right-angles of the lead roof.
27 Since Constable made his drawing of the Palace, the only major change in the south elevation has been the demolishment of the west wing, c.1931.

132 133

day before, that is, the day after their wedding. They had been married, it may be
remembered, by John Fisher, the Bishop of Salisbury's nephew. The Bishop, a
beneficiary of patronage himself (in his case, that of the Sovereign, George III),
believed in helping others, and Constable's career was one of many in which he
had taken an active interest. His wife seems to have had a particularly soft spot for
the artist and in such romantic circumstances would doubtless have been happy
to offer hospitality.

The Constables appear to have spent just over a week at the Palace. *Salisbury
Cathedral and the Bishop's Palace from the South-east* (PLATE 14), inscribed
'Salisbury 8. Oct. 1816', is the second dated drawing of the stay. The first
(FIG 132), a view looking along the two south transepts from just outside the
palace gates, was drawn about mid-morning on the 4th.[26] This, and a further,
undated drawing (FIG 133), all three of which only came to light in 1979, provide
the evidence that the Constables began their tour at Salisbury. The two views of
the cathedral from the south (PLATE 14 and FIG 133) are the only ones we have
that include the Bishop's Palace from this angle. Architecturally, the Palace was a
thirteenth to nineteenth-century conglomerate, the work of a succession of
bishops, but in character it was essentially two-faced: castellated and formal on
the north side; plainer and much less imposing on the opposite, garden side.
Constable stresses the domestic character of the southern aspect in his two
drawings.[27]

FIG 134 *Preston Church: Interior*
Pencil on untrimmed, wove paper,
top edge irregular, 11.7 × 8.8 cm.
Inscribed, vertically, t.l., '17 Oct
1816'. Private Collection.

134

The Battersea sketch (PLATE 13) and the Salisbury drawing of 8 October
(PLATE 14) are separated in time by nine weeks. They are also far apart both
technically and in mood. Constable's switch from a soft, blunt-pointed pencil to a
sharper, slightly harder one may have been fortuitous, but the slower pace, the
sensitive, lighter touch and the suggestion of warm sunlight and colour in the
later drawing seems to reflect a more significant change. An artist of Constable's
temperament, capable of responding with such intensity to direct experience,
could be profoundly affected by a change of circumstance. For many months, for
years even, he had been under great pressure. Now, he and Maria were together
and a future was assured. For so long he had yearned to have her with him to share
his delight in landscape. 'When I think what would be my happiness [he had
written in 1812] could I have this enjoyment with You – then indeed would my
mind be calm to contemplate the endless beauties of this happy country. In Your
society I am freed from the natural reserve of my mind – tis to You alone that I can
impart every sensation of my heart'.[28] Some of these heartfelt sensations, one feels,
are to be found in a number of these later pages of the small 1816 sketchbook, in
drawings such as the present sketch (PLATE 14) – *Salisbury Cathedral and the
Bishop's Palace from the South-east* – and in others, such as the next pair:
Osmington Church and Vicarage (PLATE 15) and *Redcliff Point* (PLATE 16).

After Salisbury, Constable took his wife to spend a few days at Southampton
with an aunt, Mary Gubbins (née Watts, sister of Constable's mother) and her
family. While there the artist made several drawings, two of which – views of the
east windows of Netley Abbey (Victoria and Albert Museum)[29] dated 11 October,
and of the fourteenth-century *God's House Gate* on the waterfront (known only

28 JCC II, p.81.
29 Reynolds 1973, no.147, pl.117.
30 One of John Fisher's many copies of
 Constable's drawings in the three
 surviving sketchbooks; in this case from
 the 'Osmington' sketchbook, Private
 Collection. See Fleming-Williams and
 Parris, pp.184–90.
31 Southampton City Museum and Art
 Gallery.

FIG 135 *Weymouth Bay from the Downs near Osmington* Oil on canvas, 55.9 × 76.9 cm. 1816. Boston Museum of Fine Arts. Painted mainly if not entirely on the spot. Portland Bill is on the left; the entrance to Weymouth Harbour just above Redcliffe Point. Here, Constable's arc of vision is approximately 100 degrees.

from a copy)[30] – were in the small sketchbook. One of the larger drawings, *Weston Shore, Southampton*, is dated 12 October.[31]

The Constables had settled in with John and Mary Fisher in their vicarage at Osmington when the artist next dated a drawing; this time an interior, a view looking down through the chancel arch into the body of the little church at Preston, a parish next to his own that Fisher was temporarily taking care of. Drawn in the small sketchbook and dated 17 October, this is another of Constable's tranquil, unhurried sketches (FIG 134).

Fisher had been given the living of Osmington, a parish to the east of Weymouth, by his uncle the Bishop some years before, but he had only come to live there after his marriage in July of that year, and some of the walks and excursions on which he and his wife went with the Constables must have been as new to them as they were to their guests. The village itself lay snugly among its trees between the coastal ridge and the still higher line of downs inland. Weymouth and its Bay, with the ever-present silhouette of Portland to the south, were to be seen from these heights as well as from the southern slopes and cliff-tops of the coastal ridge. Constable made a number of pencil studies of the views from these vantage-points and painted one superb picture looking across the Bay (FIG 135). But a main attraction for the Fishers and their guests appears to have been the shore-line itself, with its beaches and bird-life, its ledges of rock running out into the sea, and the small boats and crab- or lobster-pots used by the local fishermen. Some of these ledges, hazards for the fishermen, have colourful names, Frenchman's Ledge, Hannah's Ledge and, at the foot of the high headland, the more ominously named Black Head Ledges.

Constable's drawing, *Osmington Church and Vicarage* (PLATE 15), though undoubtedly accurate, does not quite convey the general impression the village makes on a visitor. Typical of many villages on the more exposed stretches of the

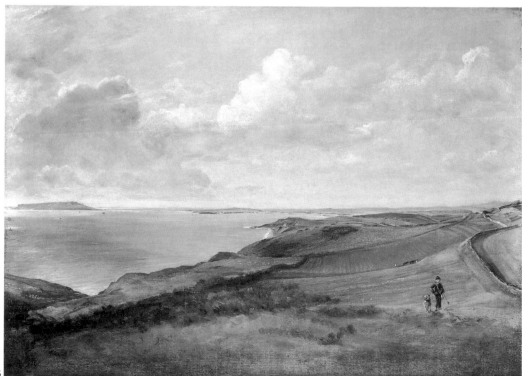

135

136

137

coast, it lies in a valley hidden away from the prevailing winds just below the Weymouth road that runs along the seaward ridge. From the village itself, something of a warren, the visitor catches only glimpses of the surrounding hills. Constable obtained his view of the church and its vicarage by walking up a steep track to the east. Known in the village as the Roman Road, this is to be seen in a reciprocal, evening view from the vicarage by John Fisher, inscribed 'From drawing room. Osmington J. F.' (FIG 136). Fisher had asked Constable to bring Maria to Osmington after their marriage in his letter of 27 August.

> The country here is wonderfully wild & sublime & well worth a painters visit. My house commands a singularly beautiful view: & you may study from my very windows. You shall [have] a plate of meat set by the side of your easel without your sitting down to dinner: we never see company: & I have brushes and paints & canvas in abundance.[32]

Nothing is known of Fisher as an oil-painter (apart from the fact that he always seems to have had painting equipment ready for Constable's use), but his sketchbooks contain examples of his own work as well as copies of Constable's drawings. Some of his watercolours though delicately executed, have considerable charm. Here, however, in his view from the vicarage drawing-room (FIG 136), his efforts to emulate Constable's pencil-work only serve to show up the brilliance of his friend's handling. Whereas every touch from Constable's pencil is decisive and meaningful, Fisher, attempting to work at equal strength, merely flounders. By some magical process Constable infuses his view of the village with light. Fisher also notes the shadows cast by hedge and tree, but he is

FIG 136 John Fisher *View from the Vicarage, Osmington*
Pencil and watercolour on wove paper, 26.4 × 17.2 cm. Inscribed, b.r., 'From drawing room, Osmington J F'. Private Collection. The first page in a sketchbook containing a number of copies of Constable drawings (see FIG 138).

FIG 137 William Pye *Osmington Mills*
Oil on canvas, 21.3 × 33.6 Signed and dated '89' on the back. Present whereabouts unknown.

FIG 138 John Fisher after Constable *Osmington Mills*
Pencil on wove paper, 17.2 × 26.4 cm., image between ruled border, 11.6 × 18.4 cm. Inscribed b.r., 'Osmington Mills'. Private Collection.

FIG 139 *Redcliff Point*
Photographed in 1988.

32 JCC VI, p.29.

Osmington Mills

138

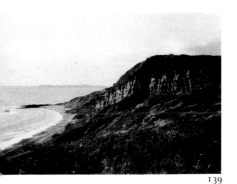

139

inconsistent and fails to create a sense of illumination. The comparison is possibly unfair, but the simplicity, the straightforwardness of Constable's technique is deceptive and to appreciate its strength and depth it is sometimes helpful to see his work with that of other, less-gifted artists.

From Osmington village, sheltering in its valley, the more easterly route to the sea ran southwards over the crest of the coastal ridge and then half a mile or so down a deepening gulley by a winding track to the cove called Osmington Mills. The stream that had cut its way down, and shaped the gulley, finally fell as a cascade on to the beach (FIG 137); presumably it was this stream that served the mill or mills after which the little bay was named. FIG 138 is a copy by Fisher of a drawing Constable made beside the track that led down to the shore. From here, to the west, the land mounts up to the summit of Black Head (about 250 ft) and then gradually descends in a series of undulations towards Redcliff Point and the little bay just beyond, Bowleaze Cove, where Constable painted his well-known *Weymouth Bay* (National Gallery, London). Redcliff Point, the subject of the next drawing (PLATE 16), can be seen quite plainly in the middle distance jutting out towards Portland Bill in the Boston coastal scene, *Weymouth Bay from the Downs above Osmington* (FIG 135). Although a hundred feet or so lower than Black Head and somewhat changed since Constable's day by erosion (FIG 139), Redcliff is still capable of making quite an impression on a visitor. Constable was certainly struck by the headland's rugged character: the geologically dramatic slab of Corallian rock resting on the Oxford Clay; the contrast of pigmentation, the orange-coloured rock bright against the dark grey, slag-like masses below. It is not

known when he first began to take a serious interest in geology. Ten years before in the Lake District he had drawn and painted in watercolours greater up-rearing land masses than this coastal ridge and had then shown an intuitive feel for the structure of the earth's crust. But in his sketch of the rock-face of Redcliff Point there appears to be a greater intellectual awareness of land formation, and a franker curiosity about structure. The pencil-sketch (PLATE 16), with its schematic rendering of the strata, is almost like a note made by a scientific observer in the field.

Some years later Constable made the acquaintance of one of the better-known early writers on geology, Robert Bakewell (1768–1843), author of the popular *Introduction to Geology* (1813), a copy of which, in a later edition, Bakewell inscribed and presented to Constable's son John Charles (p.266). It is possible that Constable enthused about the Osmington coastline to Bakewell, for he had news of the geologist for his fifteen-year-old eldest boy when writing to him in 1833 about their collection of fossils:

> ...Mr Bakewell is just returned from Weymouth Bay – the spot where poor
> Mr Fisher lived he brough[t] a fossil Pine apple, a tropical plant from Portland
> Island – as large as alfred['s] Head.[33] also a fossil crocidiles head from < Gil >[34]
> Osmington – a little one.[35]

In this letter Constable also tells his son that he has spoken to Bakewell about a geological map and promises him, one, though they are expensive. Bakewell and his fossil pineapple from Portland and his crocodile's head from Osmington are mentioned again in Constable's next letter to his son.[36]

On 3 December Constable made the last of his Osmington drawings. Though he never succeeded in joining Fisher again for a holiday on the Dorset coast, it did not need much to remind him of these weeks spent there. A glimpse of the distant Dorsetshire hills from the top of Fonthill tower some years later made him long for Osmington, the remembrance of which, he told Maria, 'must always be dear to you and me.'[37] Their times together had meant much to Fisher too. In 1825, when anticipating another visit (which did not materialize) he talked of how they would 'wander home from the shore about dusk to the remains of dinner as heretofore; & spend the evening in filling up sketches.'[38]

By 6 December, the date of the next drawing (PLATE 17), the Constables, on their way back to London, were staying with Mary Fisher's parents, the Cooksons, at Binfield in Berkshire. While he was there Constable sketched a number of subjects: the rectory and the church from across a field; the church itself (twice); a nearby lake, or river (twice); and while on a day trip to Shottesbrooke some five miles away, he made drawings of the east window of the church and of the park (PLATE 18). All but a view of Binfield church were drawn in the small sketchbook. A drawing he made on 6 December at Binfield, a 'snapshot' of a figure on a footbridge watching a dog in the watersplash below (PLATE 17), is one of the most intriguing. It is matched by a pen and watercolour drawing of a similar size of John Fisher and his dogs that Constable did while staying with his friend in 1829. In that drawing (FIG 140), a top-hatted Fisher in black is standing on a footbridge, sketchbook (?) in hand with a flurry of dogs behind him, one with its tail in the air. Dogs and their owners appear in several other drawings and paintings Constable made at one time or another when staying with Fisher, and it is tempting to see the top-hatted figure in the Binfield sketch,

33 Alfred, Constable's third son, then aged nine.
34 'Gil', an interesting slip of the memory. Constable had obviously started to write 'Gillingham', where Fisher later had a living and where Constable had joined him for a two weeks' stay in August 1823.
35 JC:FDC, 90.
36 Ibid., p.92.
37 JCC II, p.284.
38 JCC VI, p.199.

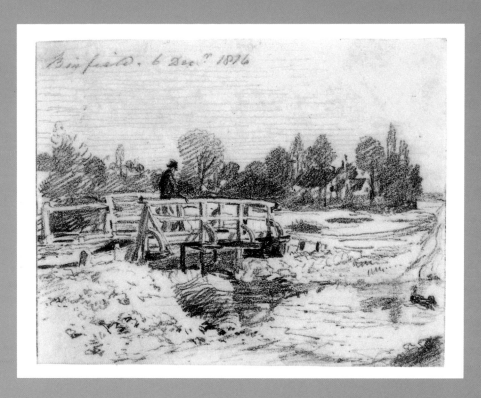

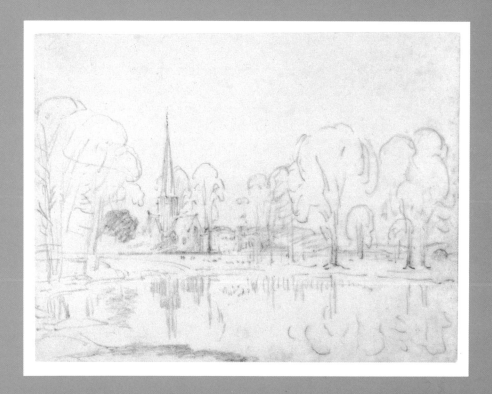

PLATE 17 *Binfield: a Watersplash*
Pencil on wove paper, right edge untrimmed, 8.6 × 11.1 cm.
Inscribed top left 'Binfield. 6 Decr 1816'.

PLATE 18 *Shottesbrooke*
Pencil on trimmed wove paper 8.6 × 11.3 cm.
(the right-hand half of a double-spread; see FIG 142).

with the dog splashing about in the stream (a reminder of Variation 11 in Elgar's *Enigma*)[39] as that of Fisher – even to regard it as a probability. There is no record of the Fishers having accompanied Constable and his wife to Binfield on their return journey, but it would have been very natural for them to have done so, that is, for Mary Fisher to want to see her parents again.

It is worth noting that in these drawings of 1816 (and, indeed, in most of his other landscape drawings done from nature), Constable hardly ever fails to comment on the sky. The character of the day, or of a particular time of that day, is for him an integral part of the scene, and sometimes it is quite remarkable how, with the simplest of media, he is able to capture the quality of light prevailing at the time. Even a cloudless or featureless sky is noted, as in this Binfield sketch, with careful, horizontal strokes of the pencil.

Constable's rendering of the little footbridge also deserves notice, how, with his light and heavy dark strokes of the pencil he, as it were, builds the structure, timber by timber. His eye for practicalities, for the way things have been made, appears to have been instinctive. FIG 141 shows him sketching for the umpteenth time *Flatford Old Bridge*, a construction not unlike the smaller footbridge at Binfield. Here too his mind has fastened on 'how', *how* it was fashioned, *how* it worked. On Flatford Bridge there were only one or two braces from the projecting horizontal members to the vertical rail-supports. The four arch-braces at Binfield casting their shadows, so deftly and so well explained, were obviously a feature that interested him and that he much enjoyed drawing.

The expedition to Shottesbrooke took place the following day, the 7th. We have no idea of the reasons for the visit. Shottesbrooke was then in the possession of the present owner's family, but they had other properties and there were periods when the house was rented out and occupied by others. There is no record, unfortunately, of its occupation in 1816. The two drawings Constable made there were done on successive pages in his sketchbook – the view of the park (PLATE 18) being continued across to the left-hand page, i.e., to the back of the previous drawing (FIG 142), the study of the east window of the church (FIG 143). The scene has changed remarkably little in the intervening years (FIG 144). The lake is still there to catch the reflection of the church and the spaced-out trees (of which there are several growing where Constable saw similar trees standing a hundred and seventy years before). Though unlike our other six drawings of this year, it was not unusual for Constable to sketch a scene in so linear a fashion; especially if his purpose was to make a topographic rather than a pictorial record. It is interesting to see that the trees by this time must have lost all their leaves, but he nevertheless still registers them essentially as rounded, spatial volumes, not, as others might have drawn them, just bare boughs and branches.

FIG 140 *John Fisher and his Dogs*
Pen, iron-gall ink and watercolour on wove, untrimmed paper with left edge irregular, 9.3 × 12.8 cm. Inscribed on the back '22ᵈ July/ 1829/ Salisbury/ fisher & his dogs'. Victoria and Albert Museum.

FIG 141 *Flatford Old Bridge*
Pencil on wove, untrimmed paper with left edge irregular, 22.4 × 33.1 cm. Victoria and Albert Museum.

FIG 142 *Shottesbrooke*
Pencil on two sheets of trimmed, wove paper, 7.5 × 11.2 and 8.7 × 11.3 cm. Only recently have these two sheets been brought together.

FIG 143 *Shottesbrooke Church, the East Window*
Pencil on trimmed, wove paper, 11.2 × 7.4 cm. Inscribed, vertically l., 'East Window. Shottesbrook church. Berks/ Decʳ 7. 1816'.

FIG 144 *Shottesbrooke*, photographed in 1986.

39 In Edward Elgar's *Enigma Variations*, Op.36, the first bars of Variation 11, a musical portrayal of his friend, G. R. Sinclair, were suggested by Sinclair's bulldog, Dan, falling down a steep bank into the River Wye, his paddling upstream, and his joyful barking on regaining the bank.

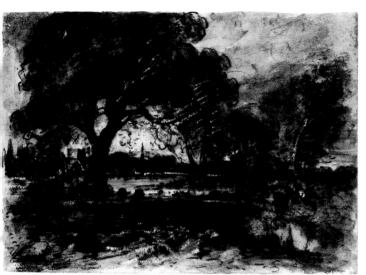

140

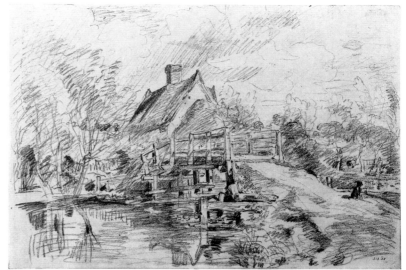

141

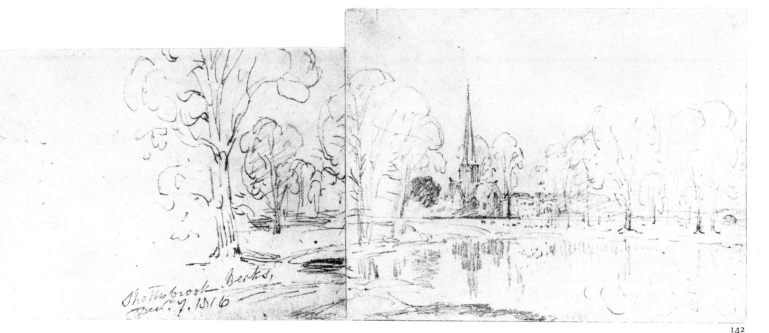

142

143

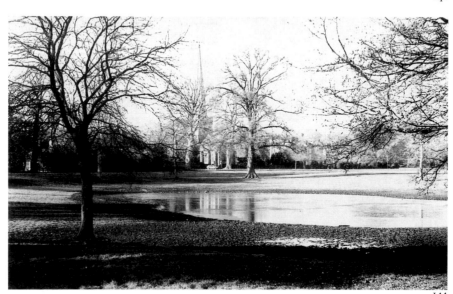

144

9 The Parents' Tomb

PLATE 19 *The Parents' Tomb, East Bergholt*
Pencil on trimmed wove paper 19.6 × 32 cm.
Faint ruled construction lines on plinth and church.

Parents tend to suffer at the hands of biographers, but so far Golding and Ann Constable have not been dealt with too unkindly by history and historians. It is hoped that when their part in the upbringing and the career of their artist son is examined in full – as it should and surely will be – they will receive the understanding they deserve; and that the importance of *their* understanding of a sometimes exceedingly difficult fourth child will be duly recognised.

Family, and the stability it could afford, meant a great deal to Constable: initially, the family under his father's roof to which by birth he belonged; then, his chosen family, Maria and the children, the family of his own making. His was a nature that for free creative play required a background of strong human attachments. During their lifetime – that is, for nearly two-thirds of his – this was provided very largely by his father and mother.

Since the publication in 1962 of some sixty letters in the first volume of the Correspondence, Ann Constable has become the more familiar of the two. Stories of her dry humour have been retold. Her inbred habit of 'thinking from action to its moral conclusion' and its influence on her son has been perceptively noted.[1] Almost every biography mentions the fact that it was she who in 1795 obtained for her son an introduction to Sir George Beaumont, and her attempt to intercede with those who opposed her son's attachment to Maria Bicknell have been acknowledged. But maternal care is often undervalued. Like most mothers she worried constantly about the health of her family; especially about that of her husband and son John, who, of her six children, seems to have been her particular favourite. For him she performed all the countless little acts expected of a loving mother: supplying him with parcels of food and clothing (the kinds of shirts he fancied) and, when he was running short, endeavouring to coax small sums of money out of her husband for him. But from the letters he stored safely away, many of them several pages in length, there also emerges the picture of a mother, who, while sensitive, caring, and possessed of imagination, was nevertheless a woman to be reckoned with.

She could view his working-life as a student sympathetically, yet apply the curb, as here, when she thought he was tempted to move into lodgings that would prove too expensive:

> Pray be very Careful of yourself – I form an idea that the warmth of the
> Academy Room [i.e., the Life-class] – smoke from Lamps or many Candles – &
> then Coming into the air & Streets of London are most inimical to tender Chests
> & Lungs – therefore do not be too adventurous – not sit up *too late* – The
> Account of the enormous Rent – askd for apartments – for a Single Gent –
> surprises us – especially in times like these; – what professional Man that is
> climbing as it were up the ladder of Preferment – & advancement in Life; can
> afford to give 160£ – 150£ a year, – for 2 rooms – and then have Board,
> Washing & Fireing &ccc to provide himself – the most kind an Generous
> Father is startled at this[2]

She could share with him his love of landscape. After an absence of some three weeks one summer she was 'struck with the beauties of the Langham – Dedham & Bergholt Vales – now so rich & delightful'[3]. But there were times when she found it hard to understand him. Waywardness in genius is a characteristic perhaps more readily to be understood and tolerated at a distance than at close-quarters. In Constable's case it is remarkable how successfully he contained the powerful forces within himself, only in private do we find him straining at the restrictions

of family and social framework. Nevertheless, he could be tiresome, and difficult to comprehend were the periods when he produced very little and abandoned so many of his paintings; when, as his father put it, he despaired and filled his rooms with lumber – i.e., unfinished works (see p.157). Ann, too, found his perhaps necessary bouts of comparative idleness very hard to bear. Again and again in her letters we hear her urging him to be more industrious. '...whenever you begin work with zeal – you have always succeeded. Energy and good temper gives the grand Finale to your Pictures – when you fag it [i.e., at] your work – it never pleases';[4] '...do Paint with Energy and Spirit – do not be Supine – work'.[5] And in a letter for his birthday (1813), after wishing him many further birthdays

> with happiness and Comfort –
>
> Much very much of this depends upon your own mind & exertions for you cannot have lived thirty seven years without knowing that; & I do hope the sight you have so lately seen in the Exhibition of Sir Josh Reynolds Performances will stimulate your exertions to promote your own Emolument, & your Parents & Friends hopes and wishes; – see what has been done by one bright genious & one Pair of hands, – who can then be satisfied with one Landscape – a few sketches & some unfinished Portraits – for an annual Employment do my Son exert yourself[6]

Such appeals had their effect. The day after receiving another letter from his mother in which she had been urging him to exert himself, Constable wrote to Maria:

> ...I am endeavouring to settle myself as much as possible to my profession – as I am convinced that nothing so much as employment will keep the mind from praying [sic] upon itself – especially an employment <that> which takes up the attention so much as painting does as it is our duty to make every manly exertion[7]

In one of his mother's letters she quotes an extract from one of his. In this – the only surviving fragment from the many he wrote her – he tells her of a determination

> ...''not to lose my time and Harrass my Mind as I have done – and am decided in my Mind – what to do for the next exhibition [the 1815 Royal Academy] which I will not drive of to the last; and I will be resolute in not allowing my Nerves to be shaken & my Mind irritated as it had been'' [to which she adds] *May these good resolutions* my dear Son be strengthened by a Superior Power, – and May you be Ultimately Successful is my earnest Wish and Prayer.[8]

Ann Constable's last complete letter, written on 7 March 1815, is characteristic. After an unhappy interregnum, her son in London was once again welcome at the Bicknell's house in Spring Gardens (of Maria she strongly approved, calling her a 'Pearl of Great Price'), and this change in the fortunes of the young couple she considered 'a great point gained'. She concluded her news of his father's health with the observation that 'his mind is I really think as strong and as energetic as ever; so as never in any instance to lose the *resolution* of a *Constable*'. On the 9th, Dr Rhudde (Maria's curmudgeonly grandfather) was to celebrate in London his 81st birthday and she suggested to her son that if he thought it aright he might call and pay due respects to his 'Grandfather – *in expectation*'. She spoke strongly against her son's old friend, their neighbour, John Dunthorne senior, of whom she thoroughly disapproved. 'Mis B[icknell]', she said, 'would not Countenance for a *Moment* such a Charracter.' She ended thus:

1 Rosenthal, 1983, p.10.
2 10 November 1811, JCC I, p.69.
3 26 July 1810, ibid., p.47.
4 17 July 1810, ibid., p.45.
5 16 February 1812, ibid., p.77.
6 10 June 1813, ibid., p.96.
7 12 December 1811, JCC II, p.55.
8 20 November 1814, JCC I, p.109.

We all unite most Cordially in Love to you – Nancy; Mary; Golding [the eldest son]. & Abram all gone to dine at Holton Hall – Miss Cookes Birthday – Darby & Joan eat the roast Pork & *apple Sauce* together.[9]

Two days after writing this letter, while tending her garden, Ann Constable suffered a slight paralytic stroke. This was unexpected. It was Golding's health that had been causing anxiety. Four weeks later she died. Constable could not bring himself to attend her funeral.

It is just possible that, in a painting by Constable familiar to many of his admirers, we have an hitherto unacknowledged memorial to his mother. In the Academy of 1815, the year she died, one of his exhibits was the drawing he had made the previous year of the view from a window at the back of East Bergholt House (FIG 121). This subject he developed after his mother's death in the two remarkable paintings known as *Golding Constable's Kitchen Garden* and *Golding Constable's Flower Garden* (FIGS 145 and 146). Though seemingly a pair (and often written about as such) the two paintings are not in fact strictly contiguous scenes. For the view of the kitchen garden was painted from a second-floor window and the other, of the flower-garden, from a window on the first-floor. Nor were they painted at the same time. The first, of the scene under a high, mid-day sun, was probably painted in July, the second, of the view in an evening light, was done rather later, possibly in August. Constable had painted the first view, of the kitchen-garden, on several occasions. The scene meant much to him, for between the distant rectory (where Maria used to stay with her grandparents) and the

FIG 145 *Golding Constable's Kitchen Garden*
Oil on canvas, 33 × 50.8 cm. 1815. Christchurch Mansion, Ipswich Borough Council.

145

FIG 146 *Golding Constable's Flower Garden*
Oil on canvas, 33 × 50.8 cm., 1815. Christchurch Mansion, Ipswich Borough Council.

paddock fence on the edge of the cornfield, were fields – some hidden in a hollow – where he and Maria were able to walk together undisturbed (and out of sight if they so wished) in the early days of their courtship. May he not have painted the second scene, the view with the flower-garden, because this subject too had acquired a certain poignancy – for him, and for the whole family? There had recently been a radical change in the planning of this part of the garden. When Constable made his drawing the previous summer of the view at the back of the house, the circular bed in the middle of the lawn with paths on either side was filled to overflowing with a mass of tall shrubs. Now, in 1815, when he painted the view of the garden, there was to be seen a round well-weeded bed, housing a modest display of flowering plants. With her command of the household Ann Constable would surely have had a say in this reorganization, even if she did not initiate it, and it is not impossible that it was while tending the newly laid-out beds that she was overcome by giddiness, the onset of her fatal illness.[10] If this was the case, or, anyway, if the planning or original planting had been hers, this part of the garden would have had a special value for her family. Here, we may have the reason for the painting. To her son, a picture of the garden in an evening light, with the newly-planted bed in deep shadow, might well have seemed a fitting tribute to her memory.

Painting these two pictures from upstair-windows of the house that summer of 1815 would have had the additional advantage that while working, Constable could be near his father who, slowly but visibly was losing his strength and

9 7 March 1815, ibid., pp.115–6.
10 Consisting only of grass and the gravel drive, the front garden would hardly have required her attention.

becoming house-bound. For these, his father's last months, Constable broke his normal pattern of work, and instead of returning to London as was his habit at the end of the season, he remained at home from July (1815) right through to March of the following year, with only three relatively short spells in London to see Maria. Not long after his mother's death, while his father had the strength to sit, Constable began a portrait of him (FIG 147).

Her letters and her portrait (as she was some years before) bring us near to Ann Constable (FIG 148). From her temperament and habits of mind, her second son John inherited several characteristics: a warmth of feeling for his fellows and a curiosity about their behaviour (that on more than one occasion led him into trouble, with accusations of malicious gossip); an acuteness of observation; a certain touchiness about social nuances; and a depth of religious faith that throughout his working life would invest most of his conscious actions with a moral purpose. Golding is more elusive – only four of his letters have survived – but he is of equal importance for an understanding of the son he called 'Honest John'. For, besides Golding's stature, his strength and his grasp of physical practicalities, it appears to have been largely from his father that Constable inherited his creative drive.

The son of a farmer of Bures St Mary (some twelve miles upstream from Flatford), from the start of his career Golding displayed a talent for imaginative enterprise and organization. An early, handsome inheritance in 1764 – that included Flatford Mill – from an uncle, a corn-factor, enabled him rapidly to expand and diversify his interests. By 1768, he had built up a business in the iron-trade, supplying local smiths with bar and plate iron and a variety of steel imported from Sweden and Russia.[11] Coal, as well as corn, became his business. He built a sailing vessel, a brig, the *Telegraph*, and a fleet of barges. He bought the windmill on Bergholt Heath[12] (beside the site of which there is still a coalyard), several tracts of farmland and property elsewhere in Suffolk, and built himself a commodious house in the centre of Bergholt village. In 1785 he was described by a fellow miller as man of fortune, a miller who 'has a very elegant house in the street and lives the style of a country squire.'[13] By the end of the century he was a leading figure among the Commissioners of the Stour Navigation, the body that managed the canalized river and its considerable traffic; he was a Director of the Tattingstone poorhouse (the local workhouse that housed over a hundred souls); and since 1766 had had a continuous record of service in Bergholt Parish as Overseer, Surveyor or Churchwarden. In 1789, he played a prominent part in organizing the coal-merchants of Suffolk and Essex during a long drawn-out dispute with the collier-owners of Newcastle and the North. As an authority on charitable enterprises his reputation appears to have been wide-spread; certainly as far afield as Lavenham, where, in the particularly hard winter of 1799/1800, his advice was sought on the management of soup-shops and the gainful employment of their 'numerous poor... he being a competent adviser, from his long and extensive experience upon the subject.'[14] Clearly, in those parts, he had become a figure of some consequence.

However, from a scan of the local newspapers, it is also evident that it was Golding's policy to avoid ostentation and self-advertisement – a policy that for most of his working life, his son John also pursued. In *The Ipswich Journal* Golding is to be met with as a local resident, advertising for a lost pointer and offering for sale a chestnut gelding, 'near 15 hand high, master of fourteen stone'[15]

FIG 147 *Golding Constable*
Oil on canvas, 75.9 × 63.2 cm. 1815. Tate Gallery.

FIG 148 *Ann Constable*
Oil on canvas, 76.5 × 63.9 cm. ?1815. Tate Gallery.

11 'To be Sold By Mr. GOLDING CONSTABLE at his Warehouse at MISTLEY-THORN, upon the best & most reasonable terms. ALL sorts of square & flat Sweden & Russia BAR-IRON, Swedish Plate Iron and Bolts, with a useful variety of the best Steel' etc. Advertisement in *Ipswich Journal*, 2 April, 1768.
12 Golding presumably bought this mill soon after it was advertised as for sale in the *Ipswich Journal* for 29 July 1769. 'An exceeding good WINDMILL... built in the year 1767; situate on an extensive Common in EAST-BERGHOLT, in Suffolk, within three miles of Manningtree, a large Port for shipping Corn etc... Enquire at the said Mill.'
13 From an entry in the Diary of John Crozier, of Malden, Essex, for May 1785. Ed. A. F. J. Brown, *Essex People, 1750–1800*, 1972, p.32.
14 *Ipswich Journal*, 8 February 1800.
15 Ibid., 17 March 1787.
16 Rosenthal, 1983, p.211.
17 Constable to John Fisher, 13 April 1822, JCC VI, p.88.

148

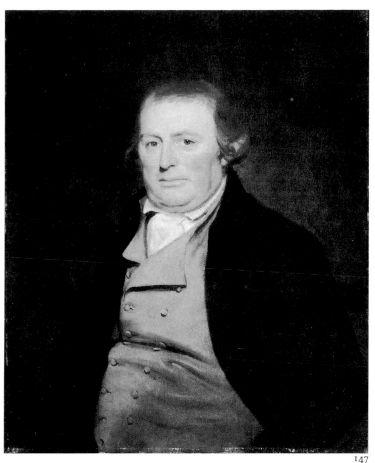

147

(which gives us some idea of Golding's own weight). He appears as ship-owner and coal-merchant on a number of occasions, but seldom is he to be found in the role of corn-merchant or miller, and never does he allow his name to appear in the published lists of the 'principal inhabitants' of East Bergholt who were subscribing to patriotic or charitable funds. This preference for keeping discreetly in the background was probably a necessary precaution, a sort of camouflage. Millers in general were not liked. Milling as a business was suspect and after a bad harvest or in the summer when supplies were running out, when there was a shortage of wheat and a consequent rise in the price of flour, millers' houses, their mills and granaries, and the London-bound waggons laden with corn were the targets most frequently attacked by angry and frustrated crowds. In Suffolk, these shortages seem to have recurred every five or six years.

It has been suggested that in 1821 and 1822 Constable was deeply disturbed by the current agrarian unrest and protests in Suffolk, that in the outbreaks of arson and rioting he would have seen the 'disruption of a society and constitution that had once been perfect',[16] and that this had a profound effect on his art. It is likely that Constable, like his brother Abram who had reported 'never a night without seeing fires near or at a distance', was 'uncomfortable about the state of things in Suffolk'.[17] But although the outbreaks of 1821–22 were of unusual violence, rural protests and rioting were a regular if regrettable feature of life in the country in those hard times, a life very far from perfect, and during the 1790s when he was working in the family business Constable would have been fully aware of dangers

and difficulties Golding had to forestall and contend with. For example there was a great deal of unrest in 1795. Trouble had been anticipated by corn-traders in three towns – Ipswich, Manningtree and Hadleigh – and they had acted wisely. In July they placed two advertisements in the local paper announcing that until prices fell they would be selling flour ground less finely so that more could be bought 'at the same price which now is'.[18] They advised other traders to follow suit. As a signatory, that is as a miller pleased to declare public welfare his concern, Golding here heads the list of the Ipswich dealers, and he also appears among the twelve for Manningtree. Elsewhere, in neighbouring towns and villages, the trade fared less well. In August, a granary was broken into up-river at Bures St Mary and the wheat sold in the open street at a reduced price.[19] Riotous crowds in September assembled outside the house of a miller in Sudbury (further upstream) and threatened to demolish his mill. Sacks of flour from another mill were taken and sold in the market. The Sudbury millers were forced to yield and sell below the current price.[20] A few days later, a waggon bound for Colchester was stopped by a crowd of three hundred, mostly women, and twenty sacks of flour were taken off and sold.[21] In November, three windmills were blown down in a hurricane; in one, the miller was killed, and the 'lower class of people' were reprimanded in an editorial for exulting at the news.[22] It is doubtful whether Flatford Mill, tucked away on its own down by the river, would ever have aroused such hostility. But if Golding had not conducted his affairs with care and discretion, his house in the centre of the village and the windmill standing far out on the Heath for all to see might easily have been the subject of threats when times were hard. His youngest son Abram was able to appreciate the difficulties Golding had encountered when he in turn had charge of the mills. '...my father', he told his brother in 1821, 'had sad times to contend with in early life he got through so may I'.[23]

For Golding, not the least of those sad times must have been his realization that neither of his elder sons would be entering the business that he had worked so hard to create: the eldest, Golding, because he was handicapped and could never hold a position of responsibility; the second son, John, because, of all the most improbable professions, he had chosen to become an artist. This decision was the cause of much heartache and tension. Having eventually permitted his son to leave the business and having agreed to support him during his training in London, it was a further disappointment to have him apparently failing to succeed, very largely because of his obstinate adherence to landscape, the least remunerative branch of the art. For some years Golding thought his son was 'pursuing a shadow'.[24] Worse was then made worse when the seriousness of John's attachment to Maria Bicknell became known.

We have little direct knowledge of Golding's feelings for his artist son, but it is evident that when roused, in his direct, business-like manner, he could express himself quite forcibly. The following was written on 31 December 1811, at a time correctly judged by Golding to be critical, when Maria had been sent away into the country and Constable was just back from a desperate dash to Worcestershire to see her.

Dear John – – –

Your present prospect & situation I consider as far more critical than at any former period of your life; as a Single man I fear your Rent and Outgoing, on the most frugal plan will be found quite equal to the produce of your profits.

Suppose you were to take a helpmate with a small income & your House became furnished like poor Spurgeons; what would your Situation then be? All this might happen to you. – – –

If my opinion was requested it would not be to give up your female Acquaintance in toto; but by all means to defer all thoughts of a Connection until some removals have taken place, & your expectations more certainly known. – – –

My further advice recommend a Close application to your profession & such parts as pay best. At present you must not chuse your Subject or waste time by invitations not likely to produce future Advantage – When once you have fixt on a subject finish it in the best manner you are able; & not through dispair put it aside & so fill your Room with lumber. – I fear your great anxiety to excell may have carried you too far above yourself; & that you make too serious a matter of the business & thereby render yourself less capable; it has inpaired your health and Spirits – Think less & finish as you go (perhaps that may do). Be of Good Cheer John; as in me you will find a parent & a sincere friend. –[25]

Golding's gradual decline during the autumn of 1815; a crisis in his condition in January of the new year; and thereafter his steady weakening, are all movingly chronicled in Constable's letters to Maria from East Bergholt. Never, it seems, had he been closer to his father, nor more appreciative of the family and their 'comfortable and happy fireside'. It was a hard, cruel winter and Golding found the cold exceedingly trying. On 17 December Constable reported that his father had not left his bedroom, and a fortnight later that for some days he had been in the greatest danger. For them all, it had been a truly 'awful and affecting scene'. There was an improvement, and on 19 January Constable took a large picture he was working on into the bedroom. His father was able to walk up to it on the other side of the room; 'How much pleasure', he told Maria, 'it gives us all to see him.'[26] Written just before taking his paintings to London for the Academy, a letter of 24 March carries Constable's last report on his father: sometimes cheerful, always patient and tranquil.

...he has been deciding upon some affairs of moment to all of us and what is more gratifying than any thing else so much to his own satisfaction – indeed it could not well have been otherwise here we are so much one.[27]

After the opening of the exhibition at Somerset House, Constable saw his father once more, but was in London when he finally died. The last moments he described to Maria when at Bergholt for the funeral.

...My dear Father's end was so happy – he died while sitting in his chair as usual – without a sigh or pang – and without the smallest alteration in his position or feature – except a gentle inclination of his head forwards – and my sister Ann who was near had to put her face close to his to assure herself that he breathed no more – thus has it pleased God to take (I doubt not) this good man to himself[28]

For Constable, the next three years – 1817, 1818, and 1819 – witnessed a gradual but all-important reorientation. When he and Maria married in 1816, East Bergholt was still in effect his home, and the surrounding countryside still the prime source of material for his landscapes. In the summer of 1817 he brought his

18 *Ipswich Journal*, 18 July 1795.
19 Ibid., 8 August 1798.
20 Ibid., 12 September 1795.
21 Ibid., 19 September 1795.
22 Ibid., 14 November 1795.
23 28 January, JCC I, p.191.
24 Farington, 28 June, 1801.
25 JCC I, pp.73–4.
26 JCC II, p.169.
27 Ibid., p.183.
28 19 May 1816, ibid., p.184.

wife down to Bergholt for a holiday; they stayed ten weeks. This was the last Maria saw of Suffolk; it was also his last long look at his native scenery. In November, when he and Maria returned to London, they moved into a home of their own, No.1 Keppel Street, Bloomsbury. Dedham Vale and the canalized Stour continued to supply him with the material he needed for his larger exhibition pieces, but now, distanced by some seventy miles and ever increasingly with the passage of time, the familiar ground became a landscape of the past. For fresh material he began to look elsewhere, to Hampstead and its skies, to Salisbury and, later still, to Brighton and the sea. After the holiday of 1817 Constable did not discontinue his visits to Suffolk. There were to be short holidays with two of his children in 1827 and 1833, and he was down there from time to time almost every other year, but once he had a home and a family of his own in London he was to be found at Flatford or Dedham only because he was needed, to discuss family business, attend a sick-bed or a funeral, or to vote at an election.

In both 1818 and 1819 he visited Bergholt twice. Now they were on their own, his brothers and sisters had no need of the large house built by Golding, with its bakery, stables, counting-house and outbuildings. This was discussed on Constable's first visit in July 1818, and it was then decided that, with much of the land, the old home would have to be sold. By October a buyer had come forward and Constable's presence was again required during the negotiations for the sale of the property. He had to attend the signing of the final documents in May of the following year (1819) and he was down there that autumn, in October, for the sharing out of the family silver, linen, etc.

These visits to his old haunts were part pain, part pleasure. The loss of his parents had affected him deeply. 'I cannot enter this dear village', he told Maria, 'without regrets

> the affecting sentiment of this roof containing now no more those who
> nourished my childhood & indulged my early years in almost every wish – the
> thoughts of these dear memories fill my eyes with tears while I am now writing.[29]

And earlier on:

> . . .so used have I been on entering these doors to be received by the
> affectionate shake of the hand by my father and the endearing salute of my
> Mother that imperceptibly I have often found myself overcome by a sadness
> that I could hardly restrain.[30]

There were, however, deeply felt associations with the landscape. In a letter of May 1819 he wrote of a walk on the Langham hills (on the Essex side of the Stour)

> . . .and through a number of beautiful feilds & by the side of the River – and in
> my life I never *saw* Nature more lovely . . .Every tree seems full of blossom of
> some kind & the surface of the ground seem quite living – every step I take &
> whatever object I turn my Eye that sublime expression in the Scripture <seems
> verified before> "I am the resurrection & the life" &c seems verified – about me[31]

It was on one of the October visits, in 1818 or 1819, that he made the drawing of the tomb of his parents from the north-east corner of East Bergholt churchyard (PLATE 19).

A number of Constable's larger and more elaborate drawings, his set pieces, are inscribed – sometimes, on the back, quite fully. There is no inscription of any sort, either on the front or on the back of our study of the church and the tomb. But the following in a later hand is reported as having been at one time on the mount on which the drawing was laid down:

FIG 149 *East Bergholt Church and the Parents' Tomb*
Pencil on wove paper, 6.7 × 9.3 cm.
Inscribed, t.l., 'E B 28 Oct[r]/ 1819';
page 23 in an intact sketchbook.
British Museum.

FIG 150 *East Bergholt Church, the Stair-turret*
Pencil on wove paper, 9.3 × 6.7 cm.,
page 25 of an intact sketchbook.
British Museum.

FIG 151 *The Parents' Tomb*
Pencil on wove paper, 6.7 × 9.3 cm.,
page 19 of an intact sketchbook.
British Museum.

149

150

151

East Bergholt church. With the tomb of Golding and Ann Constable, parents of J. Constable, by whom this was drawn 28 Oct, 1818. Golding died 1816 aged 76. Ann died 1815 aged 67. By the side of their tomb are the tombs of Jas. Revans, his wife, and son and daughter. Revans was Golding Constable's faithful servant.[32]

29 21 October 1818, JCC II, p.238.
30 17 July 1816, ibid., p.187.
31 9 May 1819, ibid., p.246.
32 Reynolds, 1984, 18.30, p.22.
33 This, the smallest of Constable's sketchbooks, measuring 6.7 × 9.3 cm., is in the British Museum. The drawings it contains are mostly Hampstead subjects.
34 As we can see from this drawing, the tomb is capped by a stone with two, longitudinal, shallow, sloping surfaces. Deeply cut and still plainly legible is the commemorative inscription to Golding: 'Sacred to the Memory of/ GOLDING CONSTABLE/ who died the 14th day of May 1816/ Aged 78 years'. On the other, north face, his wife is commemorated thus: 'Sacred to the Memory of/ Ann the Wife of GOLDING CONSTABLE/ who died the 9th day of March/ 1815 Aged 67 years'. The railings are no longer there. Presumably, they were removed during World War II.

Were it not for some pages in a small sketchbook that Constable used at Bergholt in 1819,[33] there would be no reason to doubt the date, 1818, on the mount. But three of the drawings in this sketchbook were done in East Bergholt churchyard and one (FIG 149), a sketch of the parents' tomb and the church taken from a position only a few feet away from where he sat when making the study in (PLATE 19), is also dated 28 October – the full inscription reading, 'E B 28 Oct^r/ 1819'. Was it just coincidence that he drew similar views on the 28th of two successive Octobers (a date of no known commemorative significance in the Constable family history), or was '1818' on the mount a mis-reading, and was 1819 the true date of the large study? The other two churchyard drawings in the small sketchbook are (FIG 150) a view of the turret at the north-east corner of the church (built to contain stairs to the rood-loft), also a feature in the large study, and a close-up of the parents' tomb seen end-on (FIG 151).[34] It was Constable's normal practice to use his smallest sketchbooks for 'snapshots' and to stand while

he drew in them. The large study and all three of these churchyard sketches appear to have been drawn at a relatively low level – i.e., from a seated position.

Apart from these four drawings, and a 4×5 in. pencil sketch in a private collection of the house from the fields at the back, dated 27 October 1818, all we know of Constable's two October visits is contained in the letters he wrote to Maria from Bergholt – the two in 1818 (dated 21st and 25th) and the three in 1819 (dated 24th, 26th and 28th). In a postscript to the second letter of 1818 he told Maria that he was as yet unable to fix a day for his return to London, 'perhaps Wednesday [28th], but you shall know'.[35] In his letter of Thursday 28th in 1819, he talks of seeing her at tea-time on Saturday (the 30th). So, if he had delayed his departure in 1818, our large drawing could have been done during either visit. In favour of 1819 as the more probable date for our study, is the character of the three small sketches, which would seem more logically to have ante- rather than post-dated the 'final', large drawing. Slightly against this is a description of the inclement weather Constable gave in his letter of 24 October (1819). Winter, it seems, had set in early that year.

> . . . there is a sad ravage made with the trees owing to the wind and the weight of snow hanging on the foliage – one would think there had been the battle of Waterloo in Mr Godfreys park – and the Roads are impassable from the broken – boughs & fallen trees – the doors were stopped up & snow is not yet gone[36]

In his first letter home from Bergholt in 1818 he had talked of the cold easterly wind and of his hands benumbed after his journey by coach, but also of how little the trees were changed 'so late in the year'.[37] However, one imagines the lack of broken boughs, fallen trees or traces of snow need not weigh too heavily against 1819 as the more likely date for the drawing.

Saint Mary's Church, East Bergholt, its priests, its services and its congregation (representing much of the village community) played a central part in the life of the Constable family. Golding, the father, was churchwarden for thirteen years. Their pew, granted by a faculty of 1787,[38] was on the middle aisle, next to their doctor's and Mrs Roberts's, the elderly lady who lived opposite and who took such an interest in the artist in his youth. In this same aisle, in their path, lay a reminder of an earlier generation, a gravestone inscribed in memory of Abram Constable, cornfactor (1701–64), the uncle from whom Golding inherited Flatford Mill.[39] Gatherings outside after the services were an occasion, an opportunity for the exchanging of news. In his letter of 25 October 1818 to Maria, Constable told her that he had been to church twice that day (Sunday), and was delighted with the enquiries 'on every side' about her and their child.[40] Of the church itself, so short a distance from the family home, Constable made more studies and sketches than of almost any other subject – well over forty pencil, watercolour and oil-sketches, besides several exhibition works. An exercise in perspective of the building from the south-west is among his earliest known drawings.[41] Our study (PLATE 19) and the two drawings in the 1819 sketchbook (FIGS 149 and 150) appear to be the very last he made of St Mary's.

The elegiac was a mood familiar to Constable. His earliest published work (1806) had been an engraving by Chapman of an *et in Arcadia ego* subject, a scene in Bergholt churchyard with three figures around a tombstone – an elderly man and two girls – one of whom kneels to read an inscription lamenting the death of a youth, in the words of Thomas Gray, 'to Fortune and to Fame unknown' (FIG 152). A similarly pensive trio featured in a painting he had exhibited in 1810, again of

152

35 JCC II, p.240.
36 Ibid., p.254.
37 Ibid., p.238.
38 Norwich Faculty Book 6 FCB/4 f.57. 'East Bergholt, faculty for seat in church to Golden Constable, gent.'
39 The inscription reads: 'Abm Constable/ formerly of Bures in this County/ but later of London Cornfactor/ who died the 11th of July 1764 (aet 63) also/ of Isabella his wife/ who died the 13 June 1768/ aged 64.'
40 JCC II, p.240.
41 *East Bergholt Church: the exterior from the S.W.* V.& A., Reynolds 1973, no.15, pl.7. Possibly a study for an oil shown at Messrs Leggatt's (then of Cornhill) in 1899, no.55. Present whereabouts unknown.

FIG 152 *Frontispiece for 'A Select collection of Epitaphs and monumental inscriptions'*
Published by J. Raw, Ipswich, 1806.

FIG 153 *The Church Porch, East Bergholt*
Oil on canvas, 44.5 × 35.9 cm.
Exhibited 1811. Tate Gallery.

FIG 154 *The Churchyard of St Mary's, Hendon*
Pencil on untrimmed, wove paper with left edge irregular,
22.4 × 33.1 cm. Inscribed, b.l., 'Hendon/ 28 June 1818'. Victoria and Albert Museum.

the churchyard at Bergholt, but this time with the scene in deep shadow and only the sundial high up on the porch lit by a late afternoon sun (FIG 153). In June 1818, in the churchyard of St Mary's, Hendon, he made an evocative study of two tombs in a fading light with a background of dark yews (FIG 154). If our drawing of the parents's tombs in East Bergholt churchyard was intended as a valedictory study, it is singularly lacking in any of the more obvious signals of pensive melancholy. Ruled construction lines, still showing in places, indicate that the drawing was not lightly undertaken. Every object has been subjected to an intensive scrutiny. (Particularly effective is his handling of the railings around the tomb – as varied in their strengths and random spacing as the bar codes modern retailers employ for their computer pricing.) There are shadows, but these are cast by a rising sun, and in their depths every detail is to be seen, illuminated by a reflected light. The tomb itself is near at hand, yet to one side, an important element in its railed-in space, aligned with the church east and west, but seemingly only incidental to the scene as a whole. Nowhere, in this conscientiously executed study, is there to be found a hint of elegiac sentiment, only evidence of Constable's customary, total absorption in the visual experience and its realisation on the paper. Only, one feels, in his noting of the solitary pair of birds passing overhead might there have been an intended reference to the loved parents beside whose last resting place he was quietly at work.

153

154

10 The British Institution, 1819

PLATE 20 After W. van de Velde, *A States Yacht under Sail Off-shore*
Pencil on blue-tinged trimmed wove paper 9.3 × 11.6 cm.
Inscribed in pencil on the back, 'W:V.Velde – British Gallery.
July the 13– / 1 foot 4½ by 1 d° 7¼ <Hozn> / Hor: 3 Inches/ hight'.

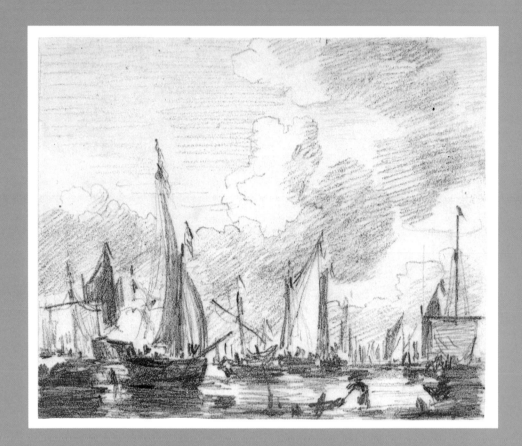

PLATE 21 (?) After W. van de Velde, *A States yacht with Sail set close to the Shore*

Pencil on trimmed wove paper 9.9 × 11.7 cm. Inscribed in pencil on the back:
'W.V.Welde 1.11 by 24 –
Hight of Hor – 3.$\frac{3}{4}$ Hor
2 feet 10 – Inches by
3 feet – 6 – d° –
‾‾‾‾‾‾‾‾‾‾‾‾‾‾‾‾‾‾
Hight of Hor-n
 9$\frac{1}{2}$ Inches', also a rapid outline sketch of masts and sails.

In 1813, the British Institution held the first of its summer exhibitions. Hitherto, the shows had been early in the year and were of works by living artists.[1] The innovatory exhibition of 1813 that opened on 12 April in the Institute's Pall Mall galleries, was devoted to the work of one artist, the late Sir Joshua Reynolds. Constable was given a ticket by an uncle for the grand banquet held on 8 May to celebrate the opening, and he wrote Maria a long, glowing account of that evening and of the people present.[2] This initiated a series of such exhibitions: in 1814, of works by deceased members of the British School, Hogarth, Gainsborough, Wilson and Zoffany; in 1815, Rubens, Rembrandt and Van Dyck; in 1816, works by Italian and Spanish Masters; and in 1818 and 1819, paintings by a variety of Continental Masters – Italian, Spanish, Flemish, Dutch and French.

For ticket-holders, Governors and Directors of the Institution and for Subscribers and their friends, that is for a select public, the galleries were opened on six Monday evenings while the exhibition was on. As a Senior Academician, Joseph Farington was also entitled to tickets for these evening gatherings, and it was with one of his tickets that, on 28 June 1819, Constable attended the last of that season's socials. Normally, neither he nor Maria were much given to such occasions. She had been to one some years before, had been disappointed in the effect by candlelight and found it crowded to excess, merely a place to see and be seen.[3] This time, as she was in the last stages of pregnancy, she would certainly not have wished to be seen, so presumably Constable went on his own. A couple of weeks later he visited the exhibition again, this time with his sketchbook.

It had been the policy of the Institution from the start to encourage copying. In 1806, after the close of the first of the exhibitions – of contemporary art – the galleries had been re-hung with twenty-three paintings by Old Masters loaned by some of the Governors and their friends and re-opened exclusively for students

155

1 Constable first appears as an exhibitor at the B.I. in 1808, when he showed two works: 'A Mountainous scene in Westmoreland' and 'Moonlight: a study'.
2 Besides the Prince Regent, Constable lists Mrs Siddons, Byron ('I was anxious for this sight of him'), and his two friends, Sir George Beaumont and the Bishop of Salisbury, as having been among the guests. JCC II, pp.105–06.
3 22 June; ibid., p.126.
4 *Repository of Arts*, 1 May 1819, Vol.VII, no.XLI, p.294.
5 The private view of the exhibition had been on Saturday, 17 April and the galleries were opened to the public the following Monday. The closing day was announced, rather abruptly, for that day, in the *Morning Chronicle* of 12 July.
6 Constable made his copies from the following, here listed as numbered and described in the B.I. catalogue, with the present title and owner, when known, in brackets.
7 A Herdsman with Cattle, in a landscape Cuyp Marquis of Bute (A Herdsman with Cows and a Horse in Hilly Country. 59.7 × 72.4 cm., Private Collection)
10 Sea Calm W. Vandevelde H.R.H. Prince Regent (*A Calm: a States Yacht under Sail close to the Shore*. 59.6 × 71.2 cm., H.M. The Queen)
36 Sea Calm W. Vandevelde Alex. Baring Esq. M.P. (So far, untraced. Possibly by Van de Capelle or Dubbels)
37 Mountainous Landscape with Cattle and Figures. Cuyp Marquis of Bute (*A Landscape with a Herdsman and Bull*. 45.7 × 45.7 cm., National Trust, Polesdon Lacey)
51 Landscape with Figures Ruisdael and A. Vandevelde Earl of Mulgrave (*A Landscape with a Cornfield*. 45.7 × 54.6 cm., Private Collection; exh., Thos Agnew & Sons, 4 June–5 July 1974)
61 A Sea Port Claude His Majesty (*Harbour Scene*. 74 × 99 cm., H.M. The Queen) Nos 7, 37, 51 and 61 as drawn by Constable are repr. Reynolds 1984: 18.32; 18.33; 19.18; and 19.19.
7 Very possibly Johnny Dunthorne, son of Constable's old friend, John Dunthorne.
8 There is a third *Sea Calm* listed in the B.I. cat., no.129, as being by Van de Velde, the property of Admiral Sir E. Harvey; a work also untraced.
9 Dimensions of two further paintings noted on the back of the sketch of the boy tally with those works that have been traced: a Ruysdael Waterfall (B.I. cat., no.133) and a Hobbema, *Hamlet in a woody clearing* (B.I. cat., no.114), both now in a private collection.

FIG 155 Thomas Rowlandson and
Augustus Pugin
*Copying Pictures at the British
Institution*
from the *Microcosm of London*, 1808.

FIG 156 After Jacob van Ruisdael *A
Landscape with a Cornfield*
Pencil on wove paper, 8.9 × 11 cm.
Inscribed on the back, 'V. W. – 1 foot
4½/ 1 d° 7½/ hight of Hor 3 inches/
Ruysdael'; the following bracketted,
'1 foot 6/ 1 d.° 9½/ British Gallery
July 13.1819'. Private Collection.

FIG 157 *A Boy Reading*
Pencil on wove paper, 9.8 × 12.2 cm.
Inscribed on the back, 'Ruysdael
Water fall/ 4 feet by 6 feet/ Hobemma/
4 feet 3 by 3 – ft – 2–/ [Ru]ysd[ael] sea
Peice/ 3 – 6 by 2 10 – 3 – 8 – 2 10½
for H[orizon]'. Musée du Louvre.

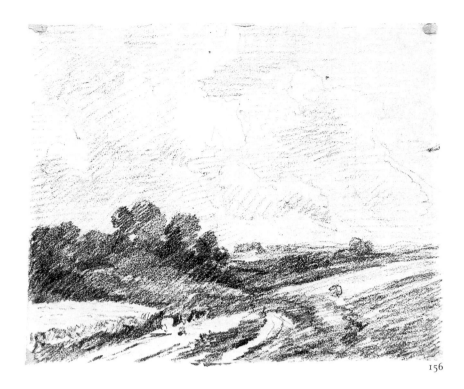

156

157

and artists who wished to copy in surroundings conducive to study. A print of 1808, from the *Microcosm of London* (from a drawing by Rowlandson and Pugin), presents the scene to us, with students of both sexes working at their easels, undistracted by the attentions of a curious public (FIG 155). In May of that year, 1819, there had appeared in the Press a reminder to students that after the exhibition closed they would be able to 'make copies or sketches from the original works.'[4] Constable re-visited the gallery on 13 July, the first of the students' days after the close of the exhibition.[5] The 4 × 5 in. sketchbook he took with him was one in which he had made a number of drawings the previous summer, when Maria was staying with her sister, Louisa, in their father's house on Putney Common, and again, during a short visit he paid to Bergholt in the autumn.

About a third of the paintings in the exhibition were either landscapes or marine subjects, and it was from these that Constable chose to make his copies. So far, six have come to light, but it is possible that there were others. We have copies after a harbour scene by Claude; after a Ruisdael (FIG 156); two after Cuyp cattle subjects; and our two (PLATES 20 and 21), after marines by Van de Velde and an artist at present unidentified.[6] On the backs of two of the copies, of the Ruisdael, *Landscape with a Cornfield*, and one of the marine paintings, *A States Yacht under sail Off-shore* (PLATE 20), Constable noted the date – 13 July 1819. These two and the copy of the other sea-piece, *A States Yacht under sail close to the Shore* (PLATE 21), with an additional drawing from the sketchbook, a study of a boy with a book of engravings (FIG 157),[7] also carry somewhat unusual inscriptions: the dimensions in feet and inches of these and of some of the other exhibits. Singly, or two or three to a page, the sizes of at least eight paintings are noted, with the authorship of seven – three by both Van de Velde[8] and Ruisdael and one by Hobbema.[9] Moreover, under four of the sets of measurements (the three Van de Veldes and an unnamed work), he has added the height of the horizon. The inscription on the back of the copy of the painting listed in the British Institution

158

159

catalogue as 'Sea Calm' (FIG 158), the picture of the States Yacht in-shore (PLATE 21), may be read as: 'W.Vd Welde 1.11. by 24 – / – Hight of Hor[izon] 3.³/₄ Hor', and then, at right-angles, avoiding what appears to be a rapidly sketched drape of sail, '2 feet 10 – Inches by/ 3 feet – 6 – d° – / Hight of Hor.ⁿ / 9¹/₂ Inches –'. None of these measurements seem to agree with the dimensions of the original from which the copy on the recto was taken, a painting now in the Royal Collection (FIG 159). In only one of the eight groups of numerals, the second of the two written on the verso of the Ruisdael *Cornfield* copy (FIG 156), is there agreement with the size of a picture we can be certain he copied. But here, with the *Cornfield*, the written dimensions match those of the original precisely – so precisely, indeed, that one wonders how, if he was taking his measurements of the canvas from the front – where the frame overlaps it – he obtained the dimensions so accurately.

What could Constable's reasons have been for measuring the height of the horizons so carefully in addition to the sizes of these four paintings? One can only guess, of course, but there appears to be a possible connection with a work he is known to have been currently engaged upon.

In the sketchbook he used in 1817, Constable had made two drawings of the recently opened Waterloo Bridge from a viewpoint upstream, near Whitehall Stairs. One was drawn at head-height above the river (FIG 160), the other from a higher position, looking down on the scene (FIG 161). These two sketches mark the start of a long haul, a struggle with a composition that was only brought to a conclusion in 1832, when he sent his painting, titled 'Whitehall Stairs, June 18th'[10], to that year's Academy. There is still much uncertainty about the development of this picture and about the chronological placing of the several studies for it. The first mention of the subject comes in the final paragraph of a letter he wrote to Fisher on 17 July 1819, four days, that is, after his visit to the exhibition in Pall Mall. 'I have made a sketch', he says, 'of my scene on the Thames – which is very promising.'[11] An issue that exercised his mind greatly during the early stages of the composition was the question of what viewpoint to

FIG 158 Back of *A States Yacht under Sail close to the Shore* (PLATE 21).

FIG 159 W. van de Velde *A Calm; a States Yacht under sail close to the shore*
Oil on wood panel, 59.6 × 71.2 cm. H.M. The Queen.

FIG 160 *The Thames Waterfront and Waterloo Bridge*
Pencil on wove paper, 11.4 × 18.4 cm. 1817. Private Collection.

FIG 161 *Waterloo Bridge from the Left Bank of the Thames*
Pencil on wove paper, 11.2 × 17.8 cm. 1817. Museum of Art, Rhode Island School of Design, Providence.

10 Tate Gallery; Reynolds 1984, 32.1, pl.819.
11 This is the first of Constable's surviving letters to Fisher; JCC VI, p.45.

160

161

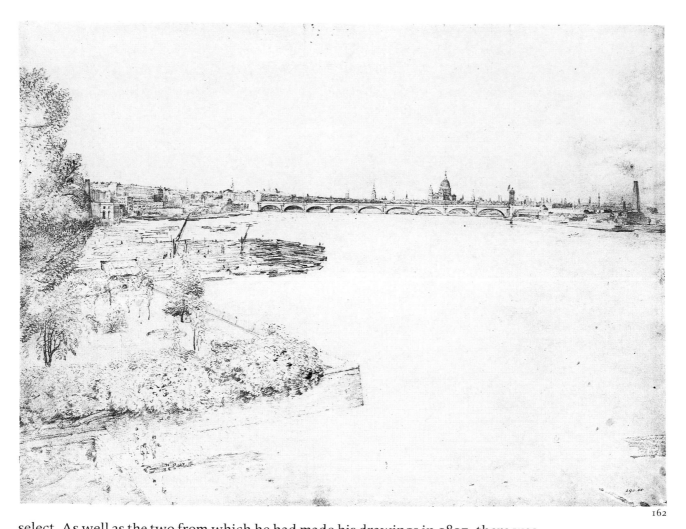

162

select. As well as the two from which he had made his drawings in 1817, there was
the choice of a third, from a still higher position. It is possible that the sketch he
told Fisher about was a drawing now in the Victoria and Albert Museum, a large,
carefully executed, topographically precise pencil study from the height of about
a second floor (FIG 162). Of the scene from this viewpoint as it was on the day (18
June 1817), he painted a trial sketch in oils[12] and on 11 August showed it to Joseph
Farington, his much-respected mentor and critic. Farington objected to his having
made it a birds' eye view, thereby lessening the magnificence of the bridge and
buildings. Constable appears to have accepted the Academician's criticisms and to
have abandoned the view, the highest of the three. But this still left a choice, the
view from midway, or the lowest, from a position standing at the water's edge. In
the end, Constable painted a picture of both: on a 7 ft canvas, the work he
exhibited in 1832, picturing the scene from embankment level, with the Prince
Regent about to embark on the Royal Barge (Tate Gallery); and on a smaller,
20 × 30 in. canvas, a work of particular interest in the present context, now in the
Cincinnati Art Museum, *The Thames and Waterloo Bridge* (FIG 163), a painting of
the same landing-stage, but as seen at the lower level on an ordinary day, with
Londoners and boatmen going about their normal business. It took many years to
complete the former, a *tour-de-force* of freely handled paint work – the pigment
applied with brush and knife, layer upon layer. The more carefully painted
Cincinnati picture belongs to an earlier period, and it seems quite possible that
this version, with its low horizon, smooth finish, and delicate handling, was

12 Possibly, *Sketch for 'The Opening of
 Waterloo Bridge'*. Oil on canvas. Private
 Collection. Reynolds 1984, 19.22, pl.86.
13 The following spring, in a letter of 19
 April 1820 (published only in part, by
 Leslie in his *Life*, ed. 1951, p.75), Fisher
 wrote 'do not part with your London and
 Westminster view without appraising me,
 as I rather think I shall like to have it, in
 case I am strong enough in purse'. This
 may well have been the finished
 Cincinnati picture that Fisher could have
 seen on his visit to London the previous
 month.
14 See JC to Maria (?21) May 1819, JCC II,
 p.248, '...Yesterday I was setting off –
 (after having the fishers all day)...'.

FIG 162 *Waterloo Bridge*
Pencil on wove paper, 30.6 × 41 cm.;
watermark 'J WHATMAN 1811'; faint
evidence of squaring up; numerous
pin-holes t., r. of centre. Victoria and
Albert Museum.

FIG 163 *The Thames and Waterloo
Bridge*
Oil on canvas, 55.2 × 78.1 cm. 1820 or
1824. Cincinnati Art Museum, Ohio.

painted not long after Constable's visit to the British Institution in July 1819, a direct result of his study of the Van de Veldes there.[13]

In Constable's announcement to Fisher of 17 July that he had made a sketch of the river ('my scene on the Thames') it is implicit that they had already discussed the ceremonial opening of Waterloo Bridge as a possible subject for a painting, probably in May, when it is known they spent a day together.[14] We may therefore safely assume that the idea of a rather more expansive river scene than he had ever attempted had been in the forefront of Constable's mind when he saw the Old Masters exhibition on the evening of 18 June, and that it was his prime purpose on the second visit (13 July) to sketch and measure some of the exhibits – it is unlikely to have been a coincidence that on this occasion he had with him a sketchbook and a measure or ruler of some sort. With a Thames-side view in mind and his current concern with the problem of eye-levels, it is hardly surprising that Constable paid special attention to the Van de Veldes (as they were catalogued) in the exhibition – two of which, as we can see (PLATES 20 and 21), were of scenes so like the ones he was currently working on – even that he should take careful measurements of the height of the horizons. In all three of the Dutch Master's (or Masters') marines on show, these were a quarter or less of the height of the canvas. Taking a lead, seemingly, from these proportions, in the Cincinnati picture (a 'Calm', like the three marines he measured, which were each titled 'Sea Calm' in the catalogue), Constable placed his eye-level at a point rather less than a quarter of the height of the painting, lower than in any of his other comparably finished pictures.

These copies of paintings by Claude, Cuyp, Ruisdael and Van de Velde in the British Institution exhibition of Old Masters are unique in Constable's oeuvre. Over the years, he had drawn a number of individual works by other artists in his sketchbooks. But at no other time is he known to have studied a group of paintings in one exhibition so closely and purposefully; and nowhere else is there a record of his having taken the measurements of the canvases and the placing of the horizons in this way. The quality of the copies themselves – especially of the two marines (PLATES 20 and 21) – is a measure of the intensity of the interest he took in those six paintings.

163

11 Salisbury, 1820

PLATE 22 *Salisbury Cathedral from beside the River Nadder*
Pencil on wove paper, left edge slightly trimmed, 11.4 × 18.4 cm.
Inscribed in pencil bottom left '18 July 1820'.

In all, Constable visited Salisbury seven times. On the first and second visit – in 1811 and 1816 – he stayed with the Bishop and his wife at the Palace; the third, in 1820, was by far the longest, lasting some six weeks. On this occasion his host and hostess were John Fisher (now Archdeacon of Berkshire) and his wife, Mary, and for the first (and only) time, Maria and the two children came too – John, aged two-and-a-half years and Minna, eleven months.

Fisher had been pressing Constable to come to Salisbury again for some time. The year before, his uncle, the Bishop, had granted him for life the use of the prebendal[1] residence, *Leadenhall*, an attractive house with its own grounds leading down to the river in the quiet, south-westen corner of the Close. The question of a visit had already been discussed when Fisher wrote on 2 July 1819. 'I reckon to be settling in my house by the first of August. If you do not come & pay me a flying visit this Autumn I will never forgive you' adding, at the end, 'Mem. I have painting apparatus complete Brushes clean & pallet set. Colours fresh ground every morning &c &c'.[2] Constable replied that of all things he would like to join him. 'Such a visit', he wrote, 'would have many charms for me – your society – the cathedral – the walks. . .'[3] Fisher again urged his friend to come for a day or two in a letter of 11 August:

> . . .I like your conversation better than any mans – And it is few people I love to talk to. Life is short let us live together while we can. before our faculties get benumbed. – When we have got settled, you must come on a regular visit with Mrs Constable, till then pay me a short batchelors visit.[4]

But it was not to be. Pressure of work prevented Constable from leaving London that year. So the invitation was renewed the following April, this time extended to include Maria and young John, and by June the trip had been agreed to. Fisher said he could not be there to receive them as he would be in Berkshire on one of his Visitations,[5] but he could be expected on 10 July.

> . . .I do not wish to lose an hour of your society, so beg that you will set off on the 7th or 8th. that I may find you here on my return. My people will receive you. Mrs Fisher is delighted with the thoughts of seeing Mrs Constable and her little boy. We have a capital nursery for him. Bring some good drying oil with you.
>
> You are to stay as long as you find it convenient.[6]

In a final, scribbled note of 30 June, addressed to 'John Constable Esqr A.R.A.&c &c &c' Fisher told Constable to bring the 'babe' (Minna) with him if he did not mind the expense, as they had plenty of room. The note was endorsed by Constable: '– Wednesday morng leave town – &c &c arrive Thursday'.[7] This suggests a planned, overnight stay to break the ten-hour journey for Maria and the two childrens' sake – conceivably, at Binfield, with Mary's parents the Cooksons, where they had spent a few nights on their return journey from Osmington in 1816.[8]

Every circumstance favoured this visit of 1820, and the holiday was a great success. Professionally, Constable was beginning to make his mark. His sole exhibit at Somerset House the previous year, *The White Horse*[9] (his first 6 foot canvas), had earned him his election to the Academy as Associate, and he could now feel that he had established himself as a painter of landscape. This he had followed up with another large-scale painting, *Stratford Mill*,[10] which had received even more favourable notices when it was shown at the Academy this year (1820). In friendship, but also because he admired and believed in the work, Fisher had

1 So called by Constable in a letter to Fisher of 26 August 1827: 'John Dunthorne has compleated a very pretty picture of Your Lawn & prebendal House with the great Alder & cathedral' (JCC VI, p.232). Fisher's house in the Close was in fact a canonical dwelling, but the Bishop was able to collate his nephew as prebendary to Leadenhall, and then to arrange for him to be admitted as canon residentiary. Leadenhall is first recorded in a lease of 1305:' . . .the house of residence call Aula Plumbia', i.e., Lead Hall, from its lead roof, an expensive item in the thirteenth Century, when it was built, and which may have served to distinguish it from neighbouring houses (Salisbury Chapter Muniments, Press IV, Box M). It is first named as such, i.e., 'Leadenhall', in a document of 20 April 1313: 'Grant and Sale . . .of a tenement . . .situated in the south corner of the west part of the Close . . .and all that . . .lies between the said corner tenement and the court of Gilbert Lovel called Leadenhall' (Sal. Cath. Mun.Pr.IV, Box M4). Fisher, in two letters to his wife of 15 July 1819 (Private Collection), written when he was just moving in, spells it 'Ledyn Hall'. Next month, in a letter to Constable of the 11th, he writes it as, 'Leydon Hall' (JCC VI, p.46). Thereafter, when writing from Salisbury, he gives his address as, just 'the close'. Later in the nineteenth century it was sometimes spelled 'Leydenhall'. R. B. Beckett adopted this spelling having misread 'Leydn' for 'Leydon' in the letter of 11 August, and others have followed suit. Now a school, the place is known by both the occupants and the Chapter as 'Leadenhall', and, it is felt, should be spelled so in the Constable literature.

2 JCC VI, p.44.

3 Ibid., p.45.

4 Ibid., p.47.

5 See p.182.

6 Letter dated 22 June; JCC VI, pp.53–4.

7 Ibid., p.54.

8 For the Salisbury coaches, see p.138.

9 Frick Collection, New York. Reynolds 1984, 19.1, pl.68.

10 National Gallery, London. Ibid., 20.1, pl.129.

11 ' < The White > Constables white Horse has arrived safe. It is hung on a level with the eye, the lower frame resting on the ogee: in a western side light, right for the light of the picture, opposite the fire place. It looks magnificently. My wife says that she carries her eye from the picture to the Garden & back & observes the same sort of look in both.' Letter dated 27 April 1820; JCC VI, p.53.

12 Maria may or may just not have known that she too was pregnant by the end of their stay. Charles Golding, their third chid, was born on 29 March 1821.

13 Most of his drawings on this trip are dated. The majority were done during the first half of their six weeks' visit. Between 4 August and the end of their stay there are only four dated drawings; presumably he was working mainly in oils during this period. The dated oils are inscribed, 'End of July 1820', '2d of Augt 1820' and 'Augst 1820'.

14 Thos Agnew & Sons Ltd; Reynolds 1984, 20.16, pl.143.

15 Ibid., 20.15, pl.142, mis-titled *Milford Bridge and Farm Buildings*. Milford Bridge

164

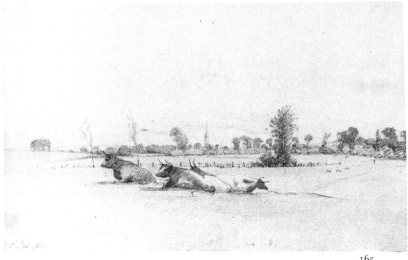

165

FIG 164 John Fisher *Salisbury Cathedral from the North West* Pencil and watercolour on trimmed, wove paper, 14 × 22.8 cm. Inscribed, b.l., 'J F 1820'. In an album of drawings by Fisher, some of which are copies of Constable's 1816 pencil sketches. Private Collection.

FIG 165 John Fisher *Salisbury: the Watermeadows* Pencil and watercolour on trimmed, wove paper 13. 4 × 21.7 cm. Inscribed b.l., 'J. Fisher 1820' and on the back, 'Near Salisbury/ John Fisher'. In the same album as FIG 164. Private Collection.

has two pairs of arches separated by a causeway; the bridge in this drawing is three-arched.

In his letter of 22 June, Fisher had asked Constable to set off on the 7th or 8th of July, although he would not be back from Berkshire until the 10th. Constable's endorsement of Fisher's last note (30 June) indicated that he and Maria were planning to leave London on a Wednesday and arrive the following day. If they reached Salisbury on Thursday 6 July, then Constable spent a whole week without dating a single drawing. If, on the other hand, they arrived on the 13th, he must have set about it with his pencil pretty soon after his arrival. We do not know the full story. They may have changed their minds and travelled down on another day – Tuesday 11 July, perhaps.
16 Royal Holloway College, Reynolds 1984, 22.2, p.335.
17 See FIG 10.
18 See Leslie Parris, *Landscape in Britain, c.1750–1850*, Tate Gallery 1973, no.61, p.42, for a discussion of this print, *re* Gray's *Elegy* and Grignion's etching of Robert Bentley's design for the poem (1753); repr. p.76.

bought *The White Horse*, paying the full asking price of one hundred guineas, despite protestations from the artist. This was now hanging to greet Constable on his arrival at Leadenhall, placed in a western, side light, where, as Mary Fisher said, she could carry her eye from the picture to the garden and back and observe the same sort of look in both.[11] The two families in the Fishers' spacious house, were well pleased with each other. Mary being six months pregnant and their four children hardly out of the nursery, she and Maria appear to have been content to remain at home when the two men wished to go off on one of their jaunts.[12] According to the records, the weather was not ideal – July being thundery and cool and August showery – but Constable was out-of-doors with one or other of his sketchbooks on twenty-one of the days he spent at Salisbury, and in addition painted a number of oil-studies out in the open, so conditions could not have been too bad.

The earliest works of the trip are two drawings dated 13 July.[13] One is of the great alder and the poplar in the *Leadenhall* garden as seen from the house.[14] the other is of a familiar subject (FIG 2), an old willow bent down over a river, with a farm and bridge in the distance.[15] The willow, transferred to the riverbank at Flatford, he used later in the full-size sketch for his Academy picture of 1822 – *View on the Stour*.[16] Two days later, Fisher took him to Stonehenge. There he made an historic drawing (FIG 10), of the ancient pile from the southwest, with a figure seated so as to cast his shadow down on to a leaning, upright stone,[17] a quote perhaps from the soft-ground etching by Gainsborough of a countryman casting *his* shadow, this time on a tombstone as he bends to read the inscription.[18] Constable's large watercolour based on this drawing of 15 July was to be one of the last works he showed at the Academy. There were other expeditions: to Gillingham, in west Dorset, for a few days (where Fisher was now licensed vicar, as well as at Osmington), and to the New Forest. Fisher's duties at the palace would often have prevented him from accompanying Constable when he went out with his sketchbook, but they would undoubtedly have spent some time drawing and painting together, and two of the Archdeacon's surviving drawings of the cathedral from across the meadows (FIGS 164 and 165), both dated 1820, suggest that he certainly had Constable in mind at the time, even if they were not actually in company.

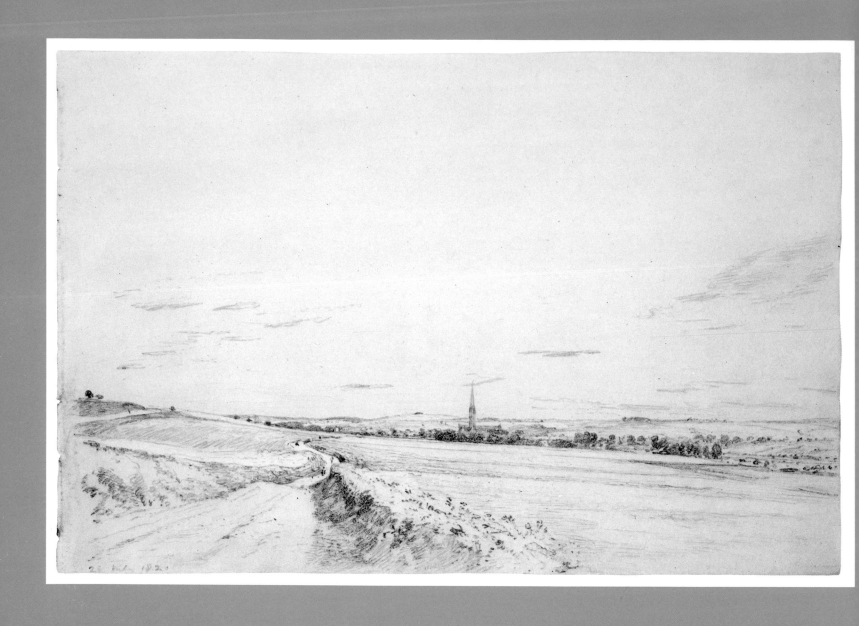

PLATE 23 *The Road from Old Sarum*
Pencil on untrimmed wove paper with stitch marks down left edge 15.6 × 23.6 cm.
Inscribed in pencil bottom left '26 July 1820'.

PLATE 24 *The Mound of Old Sarum*
Pencil on trimmed wove paper 15.4 × 23 cm.
Inscribed in pencil top left 'Old Sarum S.E'.

166

After Stonehenge, the next dated drawing is our *Salisbury Cathedral from beside the River Nadder*, (PLATE 22) drawn on 18 July. This is a view of the cathedral from a north-westerly viewpoint, taken on the north bank of the river that further downstream becomes the Avon.[19] In 1829, the year after Maria's tragic death, he was to return to this same stretch of the river, this time in search of a subject for a major painting. A drawing he then made (FIG 217), with other studies, eventually developed into his main exhibit at the Academy of 1831, *Salisbury Cathedral from the Meadows*. The present drawing is rather different from our other two done on this trip of 1820 (PLATES 23 and 24). They were seen under a high sun, casting hard, sharp-edged shadows. This is in a low key, rather softly drawn, with the broken line of trees on the horizon, the tower and spire, and the nearer trees on the right silhouetted against a hazy sky. It appears to be twilight, but at dawn rather than at the end of the day. Constable was often an early riser. Leslie discovered this when they were both staying at Petworth in 1834. Before breakfast one morning, unaware that Constable had already been out, Leslie found him in his room setting some drawings with fixative, his dressing-table covered with flowers, feathers, and lichen-covered pieces of bark that he had brought back 'for their beautiful tints'.[20] The view of the cathedral (PLATE 22), looking back across the watermeadows, may well have been made on one of these early-morning rambles.

During his weeks in Wiltshire, Constable used two sketchbooks, one

FIG 166 *A View of Salisbury from the South*
Pencil on untrimmed, wove paper, 11.5 × 18.5 cm. Left edge irregular. Inscribed, b.r., '23 July 1820'. Victoria and Albert Museum. On the inside of the bend of the river may be seen the giant alder and the poplar in the Leadenhall garden that Constable often drew and painted. The leaning willow on the opposite bank features in a well-known painting in the Victoria and Albert Museum, *Watermeadows near Salisbury*.

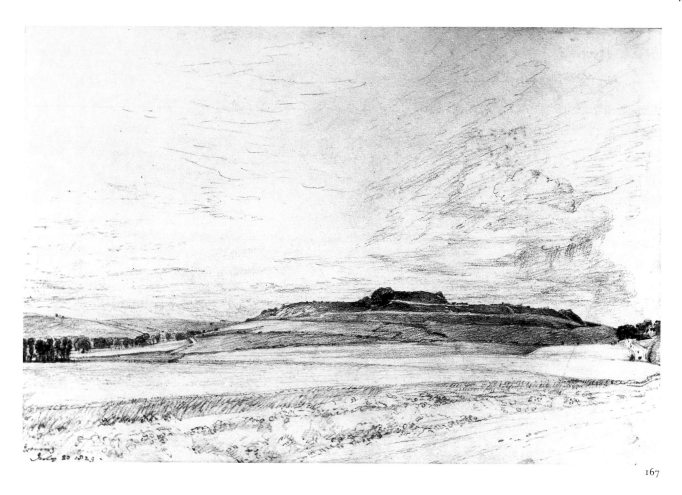

167

FIG 167 *Old Sarum*
Pencil on wove paper, 23 × 33.2 cm.
Inscribed, 'Evening July 20 1829'.
Victoria Art Gallery, City of Bath.

9 See p.234, n.3 and FIG 216 for the somewhat confusing water-courses around Salisbury.
0 See p.318.
1 In the letterpress to the mezzotint of Old Sarum in the *English Landscape*.
2 See FIG 1 and *Salisbury from Old Sarum*, black-and-white chalk on grey paper. Oldham Galleries and Museum. Fleming-Williams, 1976, FIG 26, p.38.
3 Reynolds 1984, 29.17, pl.717; 29.18, pl.718; 29.45, pl.745; 29.65, pl.763.
4 Ibid., 34.1, pl.913.

approximately $4\frac{1}{2} \times 7\frac{1}{2}$ in., the other, nearly $6\frac{1}{2} \times 9\frac{1}{2}$ in. The drawing from the river-bank was done in the small book; for *The Road from Old Sarum* (PLATE 23) and *The Mound of Old Sarum* (PLATE 24), he used the larger one.

Old Sarum seems to have attracted Constable from the very beginning. Rich in historic association – for him, always an attraction – it was peopled in his imagination by a vivid past: by the 'wlly Conqueror' and other succeeding monarchs who were reputed to have held their courts there; by the 'ecclesiastics and warriors'; the 'throngs of knights and barons bold'. This once proud city, he wrote, 'can now be traced but by vast embankments and ditches, tracked only by sheepwalks: "though plough has passed over it"'.[21] On his first visit, in 1811 he had explored the huge earthworks (presumably with Fisher, whom he had just met for the first time) and had made two large chalk sketches on its slopes (FIG 1).[22] In 1829, on his last visit to Salisbury, he made three further pencil studies and one oil sketch of the place,[23] from which there derived two of the Lucas mezzotints and a big watercolour for the Academy.[24] The position of Old Sarum on the sky-line – the site of the old cathedral – may be seen in relation to the present, thirteenth-century cathedral and its encircling Avon in one of Constable's drawings of 1820 (FIG 166), a drawing made from Harnham Ridge, south of the city. One of the 1829 drawings is of the inner Norman bailey ringed by its outer, iron-age terraced ramparts, viewed from the Salisbury approach-road (FIG 167). The road itself passes across the bottom right-hand corner of the drawing and then reappears as

it mounts the hill towards the monument's eastern gateway. It was beside that last bit of the road – where there are figures to be seen in the drawing, minutely noted – looking back towards the distant cathedral, that Constable made one of his most memorable pencil studies, *The Road from Old Sarum* (PLATE 23), a drawing that for its simple grandeur and masterly handling of spatial recession merits comparison with a work by Rembrandt (FIG 168). Here is the same acuity of vision, the same delight in intensely foreshortened planes and a discreet selection and placing of accents for the flickering eye. Rembrandt's windmills alongside the canal diminish in perspective towards a scarcely perceptible horizon; in Constable's view, it is the hollow road between its banks that takes the eye across the fields and beyond into space. In the hands of a previous owner, the mount of Constable's drawing had been cut to overlap three of the edges of the sheet and to mask nearly half of the sky. By this, Constable's conscious choice of a low horizon and the full meaning of the drawing was quite lost. In a letter to Maria of 1823, describing the view obtainable from the top of Beckford's tower at Fonthill, he talks of the magnificence of the woods, the wild region of the downs, the distant Dorset hills, and of Salisbury, 'at fifteen miles off', darting 'up into the sky like a needle.'[25] For him, this view from the roadside just below Old Sarum looking south towards the cathedral provided no less vivid an image, with the tower and tapering spire pointing upwards into the sky.

Although work on the land and on the river was a recurrent theme in his paintings, because Constable seldom drew or painted country-folk from close to, at an intrusive distance, as they laboured in the fields or managed the river-traffic, the importance of the figures in his landscapes seems to have been greatly

FIG 168 Rembrandt Harmenz van Rijn, *View on the Amstel at the Omval* Pen and brown ink, grey wash on grey-prepared paper, 10.8 × 19.7 cm. Christie's 6 July 1987 (lot 16).

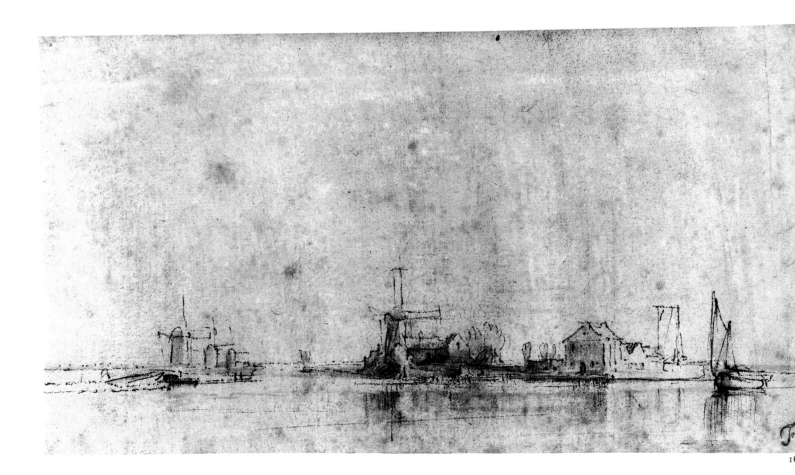

underestimated and their presence often misunderstood. In neither *The Road from Old Sarum* nor his pencil study of the *Mound of Old Sarum* (PLATE 24) does anyone seem to be at work on the land, but, nevertheless, in both, figures play a significant part. In the former they are to be seen, mere specks on the road to Salisbury, in a role of which we ourselves do not always wish to be reminded, as very small elements in a vast natural world. From the figures in the latter – the lone figure walking towards us along the track, the couple across the fields on the extreme left, and then the human mites on the path leading up to the entrance of the fort – we gain a sense of scale, of the awesome size of the concentric, 40 ft high ramparts raised by the hand of man on this promontory above the Avon.

Though a monument from a past age, and an obvious target for sentiments of a nostalgic nature, Constable here views Old Sarum entirely in the light of the present, just as it stood there before him on that day under the brilliant afternoon sun. Precisely which day was it, one wonders? The other drawing, the view of Salisbury from the Old Sarum road (PLATE 23), is inscribed, '26 July 1820'. A pencil drawing of Old Sarum from the fields to the south, at present untraced,[26] judging by the shadows, was apparently done in the morning of the same day. Stylistically, our two are a matching pair. It is quite possible that Constable made all three on that day; the missing, forenoon drawing, *The Road from Old Sarum*, and *The Mound of Old Sarum*, in that order.

25 JCC II, p.284.
26 See *The Art Collection of the Late Viscount Leverhulme, Parts Six and Seven, Original Drawings, Prints and Water Colours*, the Anderson Galleries, New York, 1926, no.85, *Old Sarum from Durnford Downs*. Reynolds 1984, 20.27, pl.149.

12 Greenham Lock, near Newbury

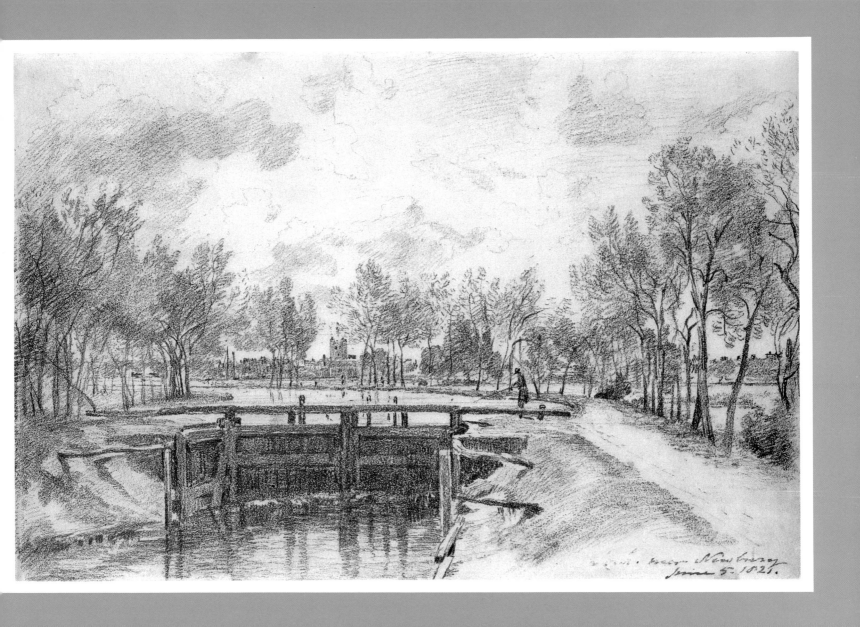

PLATE 25 *Greenham Lock*
Pencil on trimmed wove paper 17.5 × 24.8 cm.
Inscribed in ink bottom right 'Lock near Newbury June 5 1821'.

In a letter from Osmington of 15 December, 1817, John Fisher told Constable of a recent preferment: 'I have just returned from Salisbury', he said, 'whither I have been, to be installed Archdeacon of Berks. The emoluments are nothing: the honour something.'[1] Four Berkshire rural deaneries – Newbury, Reading, Wallingford and Abingdon – thus became Fisher's responsibility, and in the execution of his duties he was expected to visit them annually. It was in the hope of finding Constable and his family already at Salisbury for a summer holiday and awaiting him that Fisher had aimed to return from his Visitation of 1820.[2] The following March he asked Constable to join him on the next one: 'The first week in June I go on my Visitation. Will you accompany me free of expence. I shall take Oxford in my way'.[3]

It is not known exactly when Constable and Fisher started their tour in 1821, but they were together in London on Saturday 2 June,[4] and on 4 June Constable made his first drawings of the tour (three sketches on the banks of the Kennet and Avon Canal at Newbury), and it is probable that they had booked in for their visit the day before. The *George and Pelican Inn*, where they stayed, looks down the main street towards St Nicholas's church just beyond the bridge spanning the canal. The tower of the church is to be seen in two of the drawings Constable made on 5 June, the second – and last – of his sketching days at Newbury. One of these, a pencil and wash study in the Victoria and Albert Museum, is taken from the towpath only a short distance upstream from the bridge and the church;[5] for the other, Constable chose a view-point beside Greenham Lock, about three-quarters of a mile below the town (PLATE 25).

For the tour with Fisher, Constable appears to have provided himself with two sketchbooks: a small one, on the initial page of which he made a drawing of a bridge when they were at Oxford,[6] and a new larger one, 6 × 10 in. His decision to take this fairly large, unused book suggests informed intent, that he knew in advance that he would be on his own quite a lot while Fisher was engaged on his professional duties, and that he would have plenty of time for sketching. The larger book, which is watermarked J WHATMAN/ TURKEY MILLS/ 1819, may

FIG 169 *A Watermill at Newbury* Pencil and grey wash on untrimmed wove paper, 17.3 × 26 cm.; watermark, 'TURKE/ J. WHA/ 18/'. Inscribed, t.l., 'Newbury Berks/June 4. 1821'. Victoria and Albert Museum.

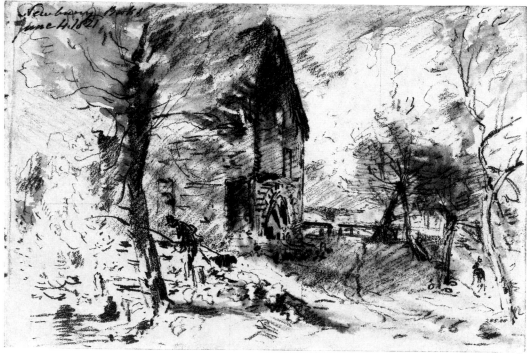

169

FIG 170 *Blenheim Palace and Park*
Pencil on wove paper, 17.3 × 26.1 cm.;
watermark '/Y MILLS /TMAN /19'.
Inscribed, t.l., 'Blenheim. June 1821'.
Victoria and Albert Museum.

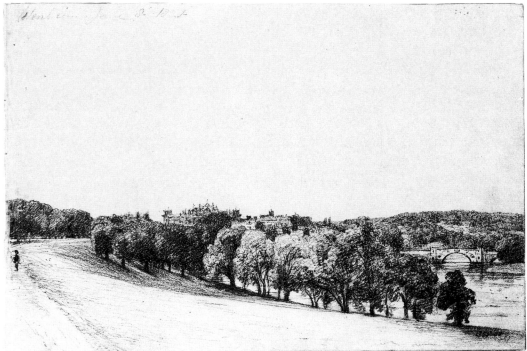

170

have originally consisted of thirty-two sheets. Thirty have now been identified
and located[7] – five with a half watermark. At least seventeen of the thirty
drawings were done on the tour: seven at Newbury, four each at Reading and
Abingdon, one at Oxford and one in the park at Blenheim. Constable used the
sketchbook again on his November visit to Salisbury that year; in Suffolk in April
1823 (on three successive days, see p.182); at Hampstead the following June; and
finally, it seems, for a single study of Coleorton Hall during his stay there with the
Beaumonts that autumn, 1823. Pencil, or a fairly soft grade of graphite, was used
for all seventeen studies done on the tour with Fisher. There is quite a range,
however, in the way it was used: in a fluent, rapid manner, with a comparatively
blunt point in some cases – for example *A Watermill at Newbury* (FIG 169) – in
others with steadier, more deliberate movements of a sharper point as in
Greenham Lock (PLATE 25), and *Blenheim Palace and Park* (FIG 170). Seven of the
drawings have been worked over with neutral grey washes. One, of a cottage near
Reading,[8] has been completed in watercolour, as has another, of a pond and
cottages which may or may not have been done on the Visitation tour.[9] Apart from
this last, all the other drawings are carefully inscribed in ink. *Greenham Lock* is
one of the more unhurried, deliberate pencil studies.

Constable was not by nature an itinerant sketcher. He does not appear to have
been a willing traveller; fresh fields and new horizons were not really for him. On
his arrival in a new area, if there were nothing else to guide him in a choice of
subject-matter, it was generally to the familiar or to whatever he could readily
relate that he most often responded: fishing-boats, colliers, windmills, etc., at
Brighton; bridges, willows, carts, agricultural equipment, etc., wherever else he
found himself with time to sketch. It is not surprising, therefore, that he spent a
great part of his time on the towpath of the Kennet and Avon canal during his two
days at Newbury, drawing what he already knew and understood so well – water-
mills, barges, thatching, overhanging willows and alders, and a lock, the first he
would have come upon when exploring downstream from the town. It was beside

1 JCC VI, p.34. In a footnote, Beckett states
that the archdeaconry was rated 'for first
fruits' (i.e., a half-year's salary, in addition
to the normal stipend), at £54.18s.6½d' at
the time of the "Survey"'. I can find no
date for a survey.
2 Fisher to Constable, 22 June 1820, ibid.,
p.53.
3 6 March 1821, ibid., p.64.
4 Farington records a visit from the two men
on 2 June 1821.
5 *A View of Newbury, with the Tower of St
Nicholas's Church*. Pencil and grey wash.
V.& A. Reynolds 1984, 21.23, pl.232.
6 Constable to Fisher, 5 January 1825: 'I
miss the books you have – one a good size
– & the other smal a View of Oxford
Bridge first page – is it not so?'. JCC VI,
p.189.
7 Reynolds (1984, Text, p.76) lists a further
drawing, 21.28, *Reading from the River*.
coll. Mrs A. M. Constable, Christie's 11
July 1887 (lot 40), present whereabouts
unknown, but suggests this could be his
21.27.
8 Pencil and watercolour. B.M. Reynolds
1984, 21.24, pl.233.
9 Watercolour. B.M. Reynolds 1984, 21.36,
p.243.

FIG 171 *Map of Newbury and Thatcham* c.1800.

171

this lock, Greenham, at around noon on the second of his sketching days at Newbury that Constable settled down to make one of his more careful studies.

The scene was a familiar one – a foreground of timber-work, a stretch of inland water, a distant church tower. The view-point he chose, looking west past the upper lock-gates and through the screen of young trees to the town beyond, was angled to place the distant tower of the church as an eye-catcher, much as he had often positioned Dedham church tower in his Flatford compostions.[10] But though the type of scene was familiar, much of it was entirely novel. This stretch of the Navigation (FIG 171) was engineered to by-pass Greenham Mill upstream (which was just out of sight to the left of the view taken by Constable), and was banked up to quite a height above the level of the fields and the several branches of the Kennet on either hand – a feat of engineering not immediately appreciable in the drawing. Greenham Lock was quite different from those on Constable's native Stour. There they were box-framed with vertical sides and overhead lintels; here, the sides were sloped and turfed down to the lower water-level. At Flatford, the height of the water in the lock was controlled by paddles (as they were called), lowered or raised by a windlass set into the upper frame-work of each gate. Here, in Berkshire, the paddles were attached to a vertical timber, a sort of handle, with holes at suitable intervals, that was either just lifted up by hand and then held in position by pegs, or levered up with a bar thrust into one of the holes, the balance-beam acting as a fulcrum. On the Stour, when the water in the lock was at the required level, the lock-gates were opened by pulling on chains.[11] On the Kennet and Avon, they were operated by pulling or pushing on the massive balance-beam (FIG 172). All these differences – the elevated level, the young trees planted to consolidate the embankment, the grassy slopes, the heavy beams, even the

10 It is quite possible that for Constable the church was more than just a topographical feature in the landscape, that while he was at work beside the canal, Fisher was in fact in conference in the body of the church with the churchwardens of the surrounding parishes. Such a gathering for a Visitation was generally held in an appropriate church, and Newbury then appears to have had only the one, St Nicholas's.

11 These chains are visible in the *Flatford Mill* of 1812 (Christie's, 21 November 1986, lot 105) and in several studies of Flatford Lock, including the drawing of 1827 in the B.M. Reynolds 1984, 27.30, pl.650.

12 On the right-hand side of the back of *Greenham Lock* there is a continuation of the landscape to be seen on the left-hand side of the Huntington drawing. Part of this, a vertical strip separated from the rest by a ruled line, has been more heavily worked over.

13 One of these West Country barges, pulled by a team of horses, is a central feature of an engraving after Havell of a view of the Thames in Oxfordshire; repr. C. White, *English Landscape, 1630–1850,* 1977, pl.cii.

FIG 172 Marianne Mansell (fl.1887–1900), *A Lock-keeper and his daughter opening a Lock for a Hay-barge*
Oil on canvas, 43.5 × 49.5 cm. Phillips (Bath) 17 February 1986 (lot 50). This may not be a scene on the Kennet and Avon canal, but it shows the same method of swinging open a lock-gate, by pushing on the balance-beam.

FIG 173 *Near Newbury*
Pencil on wove paper, 17.3 × 25.9 cm. Inscribed, b.l., 'Near Newbury June 5. 1821. Afternoon'. Henry E. Huntington Library and Art Gallery.

holes in the vertical paddle-handles – Constable noted with precision. He also noted the distant masts of the barges that were alongside the town wharves. Later that same day, on the next page of his sketchbook, he made a detailed study of one of the West Country barges moored against the bank of the Kennet further downstream (FIG 173).[12] These comparatively broad-beamed vessels, with their high sterns, canvas shelters and squat masts, raked back to counter the pull of the tow-rope, were of a type quite unlike the barges of the Stour that he had so often drawn and painted.[13] Two days later (7 June), at Abingdon, he sketched another, this time paying less attention to detail, as he was more concerned with the scene

172

173

174

FIG 174 *A View of Abingdon from the River*
Pencil on wove paper, 17.3 × 26.1 cm.
Inscribed, t.l., 'Abingdon June 7.
1821'. Victoria and Albert Museum.

as a whole, with a stormy sky and dramatic effects of light and dark, but was able nevertheless to note the exposed, arched framework of the shelter on the stern (FIG 174). Between Newbury and Abingdon, Constable and Fisher spent a day (6 June) at Reading. Here, Constable found another type of craft, a narrow-boat, low in the water and with a perilous-looking list to port. This he drew in another of his more finished studies (FIG 175).[14]

A particular feature of the 'Visitation' sketchbook – and of other sketchbooks of these middle years – is the high proportion it contained of drawings like the view of Reading, the Abingdon study, and *Greenham Lock*, landscapes of a strongly pictorial character brought to a comparatively finished state; drawings, that is, in which it appears to have been the intention that they should be viewed and judged as works of art in their own right. As pencil drawings of this kind represent a high point of achievement in Constable's oeuvre, and as they occupy an unique position in the history of European landscape, one would naturally like to know what prompted him to make such studies. Drawings played an important part in the preparatory work for many of the paintings Constable planned to exhibit, but only in a very few cases does he seem to have used the kind of drawing we are discussing as a starting-point for an exhibition-piece, or for reference when at work on a painting. Possibly the very completeness of statement, the finality of a work such as *Greenham Lock*, inhibited further development. If they were not part of the picture-making process, why did he make such drawings?

To some extent they would undoubtedly have been done for their own sake, to gratify the wish for a closer union with the living world about him, or, more plainly, just to satisfy the habitual itch to be drawing. But somehow they don't look as if they were drawn solely for self-gratification. For what other reason then – to be shown? Possibly, but to whom? Not, apparently, to the general public. Constable exhibited both watercolours and drawings at the Academy, but although some we know were worked up from sketchbook drawings, none of the

14 The Kennet had been made navigable from Newbury to Reading early on, in 1723, and the Avon from Bristol to Bath by 1727. The link between the two, and the route from London to Bristol, was completed in 1810. Constable saw the canal in its most prosperous years. By 1818, over two hundred vessels were using the canal; seventy or so were of sixty-tons capacity. In the period 1812 to 1821, the tonnage of coal and stone transported rose from 60,000 to 103,000. Cargoes included coal and iron from Wales; Bath building stone; gravel, chalk and flint; timber from the Baltic; cheese, grain and flour; Mediterranean fruits, West Indian sugar and tea from the East Indies.

FIG 175 *A View of Reading from the River*
Pencil on wove paper, 17.2 × 25.7 cm.
Inscribed, 'Reading June 6. 1821'.
Private Collection.

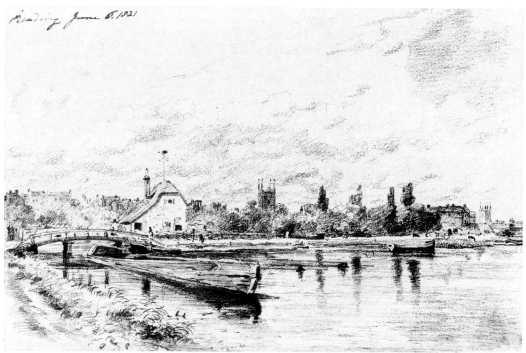

175

exhibited works so far identified appear to have been taken directly from a sketchbook. It is possible that a few were subsequently mounted and put in frames to be hung in Constable's little gallery, the passage-way through to the studio in Charlotte Street where he had both paintings and drawings on view for a limited public, for visitors admitted by card.[15] But this would have been later on. In 1820 and 1821, when he was doing so many of these composed landscape pencil studies, he was still living at Keppel Street, and there is no evidence that he put his work on display there. It was a very small house. If such drawings were not for the public, but were to remain, as drawn, between the covers of the sketchbook, and if we are right in assuming that they were not just for himself, for whom were they intended? The answer is probably to be found on the final page of Leslie's *Life*:

> An extremely interesting portion of Constable's works is known only to his intimate friends – I mean the contents of his numerous sketch books. In these are many complete landscapes in miniature, often coloured, and when not tinted the chiaroscuro is generally given in lead pencil, sometimes with great depth of effect, and always with exquisite taste. – The name of nearly every spot sketched is added, and in looking through these books one thing is striking, which may be equally noticed of his pictures, that the subjects of his works form a history of his affections. – Bergholt and its neighbourhood – Salisbury – Osmington – Hampstead – Gillingham – Brighton – Folkstone, (where his boys were at school,) – and scenes in Berkshire visited by him with Mr. Fisher.[16]

The 'complete landscapes in miniature' are plainly the sort of drawings we are considering. Constable's subjects, Leslie observes, form a history of his affections. He might have added that the drawings themselves were part of that history. From his youth onwards, Constable worked within a close circle, his immediate family and a few intimate friends, and it seems that for the greater part of his professional life, when not at his easel engaged upon a commission or a picture he intended to exhibit, it was mostly for that small circle that he worked.

13 Flatford, April 1823

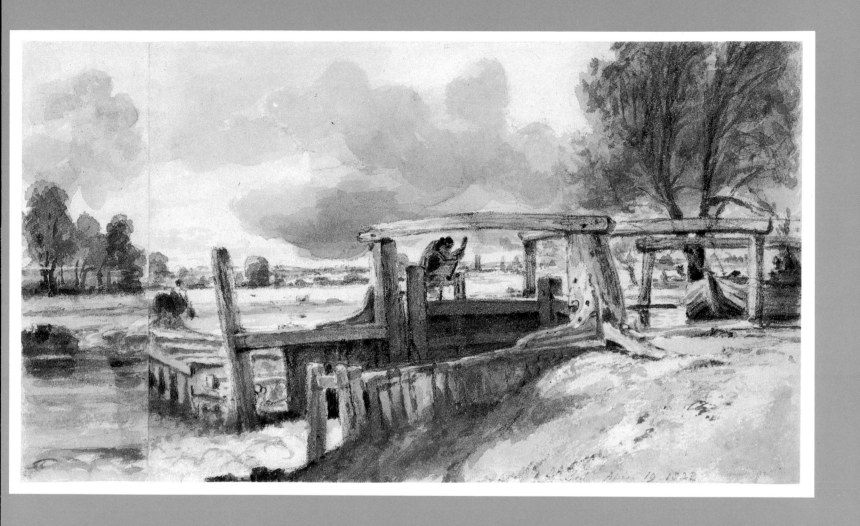

PLATE 26 *Flatford Lock*
Pencil and grey wash on two trimmed sheets of paper from adjoining pages in a sketchbook 17.2 × 5 and 26.7 cm.
Inscribed in pencil bottom right 'Flatford 19 April 1823' and in another hand (?) in faded ink 'April 19 1823'.

176

177

In the summer of 1840, with a biography in mind, C. R. Leslie paid a visit, his first, to Suffolk.[1] He was accompanied by an amateur painter, William Purton, whose friendship Constable had greatly valued in the last few years of his life. The visitors met with a friendly reception; from Constable's younger brother, Abram, still living at Flatford with the youngest of the family, Mary, and from the other sisters, Ann and Martha (Whalley) the last now a widow with a house in Dedham. As guides for a tour over what they considered to be 'classic ground', Leslie and Purton were fortunate in having Constable's eldest boy, John Charles, and a nephew, Martha's son, the Revd Daniel Whalley. They visited the birthplace, East Bergholt House, and were shown the image of the windmill and the name, 'John Constable', with the date, '1792',[2] all neatly carved on one of the timbers of the family mill out on the now cultivated Bergholt Heath. They saw two early altarpieces, at Brantham and Nayland; visited Stoke-by-Nayland; and crossed the river into Essex, where, at Langham, they were disappointed to find the scene of one of Leslie's own Constables, *The Glebe Farm*, scarcely recognisable. At Stratford St Mary the picturesque little mill had already been replaced by a large brick building. Dedham also proved disappointing, because the waterwheel they knew from the painting was hidden from view. At Flatford, however, so startling was the resemblance of some of the scenes to the pictures they knew so well, that they could hardly believe they were for the first time standing on the ground from which they were painted. Leslie and Purton then realised that eight or ten of their late friend's most important subjects could be enclosed by a circle of a few hundred yards around Flatford. Constable, they knew, was fond of introducing the tower of Dedham Church into his compositions; at Flatford they were able to appreciate how readily, from several points, the tower could be seen in the distance across the meadows. In the drawing dated 19 April 1823, (PLATE 26), a view of the lower gates of the lock from the left bank – i.e., the north side – Dedham Church is just visible, immediately to the right of the bar or lever that the lock-keeper is inserting into the windlass. For Leslie and Purton, their visit to Flatford was revelatory. Nowadays, the importance of that short stretch of the river as a provider of subjects for Constable's major paintings is widely recognised; so much so, that it has become the only place in the country visited annually by large crowds, solely because of its associations with the work of an artist.

1 *Life*, 1951, pp.284–6.
2 See FIG 24.

FIG 176 *Flatford Mill*
Oil on canvas, 66 × 92.7 cm. Exhibited
1812. Private Collection.

FIG 177 *Landscape: Boys Fishing*
Oil on canvas, 101.6 × 125.8 cm.
Exhibited 1813. National Trust,
Fairhaven Collection, Anglesey
Abbey.

FIG 178 *Study of Trees at Flatford*
Pencil on wove paper, 47 × 29.1 cm.
c.1812. Fondazione Horne, Florence.

178

Constable exhibited his first paintings of the lock at Flatford in 1812 and 1813.
The former was of the lock and mill-house looking downstream from the opposite
side to our drawing (FIG 176). This, he seems to have painted entirely from five
preparatory sketches in oils, all but one of which appear to have been painted on
the spot. For his next Flatford subject, *Landscape: Boys Fishing* (FIG 177), his
viewpoint was on the same, south bank, but looking upstream, this time with the
upper gates in the foreground. For this picture there appear to be three
preliminary oils, but these are compositional sketches, none was painted direct
from the motif. In this case, Constable apparently worked from pencil studies
made on the spot, two of which have survived, a fine, but badly stained drawing
of the trees on the left (FIG 178), and an equally detailed drawing of the lock-gates
and part of the nearer bank, with the very closest attention paid to the structure of

the timber-work, to the jointing and pegging, and to the working parts, the two windlasses and their chains (FIG 179). For the next few years, Constable worked increasingly out-of-doors, directly from the subject, on canvases he intended for the Academy. This, however, he was only able to do while he had a home in Suffolk. After 1817, for paintings of his native scenes, he had to work again from studies, and as the years advanced and the length of his return visits decreased, he came to rely more and more on oil-sketches painted in years gone by, on drawings already in his sketchbooks, and on his memory.

It is improbable that our knowledge of the studies from which Constable painted his run of great canal pictures, scenes of life on the Stour, is anything like complete. There have undoubtedly been losses. Some survived the rough and tumble of studio usage, the tree and lock studies for example (FIGS 178 and 179), the former tellingly bespoiled by stains, probably linseed oil. But others almost certainly did not. Our drawing (PLATE 26), is related to the fourth of his big canal paintings, *The Lock*, of 1824 (FIG 180), but, surprisingly enough, as the basis for the trees in this picture he used the tree study of *c*.1812 (FIG 178). For the lock itself he must have had an image to work from as full of detailed information as the study of the upper lock-gates he had used in the painting of the boys fishing (FIG 177) – information our drawing (PLATE 26) was not capable of providing. A run through of some of the events of 1823 and the development of two of his exhibited works, *The Lock* of 1824 and *A Boat passing a Lock* of 1826 (FIG 181), may enable us to see how our study fits into the story.

FIG 179 *Flatford Lock, the Upper Gates*
Pencil on wove paper, 27.3 × 45 cm.
Private Collection.

FIG 180 *The Lock*
Oil on canvas, 142.2 × 120.7 cm.
Exhibited 1824. Trustees of the
Walter Morrison Settlement.

FIG 181 *A Boat passing a Lock*
Oil on canvas, 101.6 × 127 cm. Signed
and dated on the beam below the lock
gate on the left, 'John Constable, f.
1826'. Royal Academy of Arts.

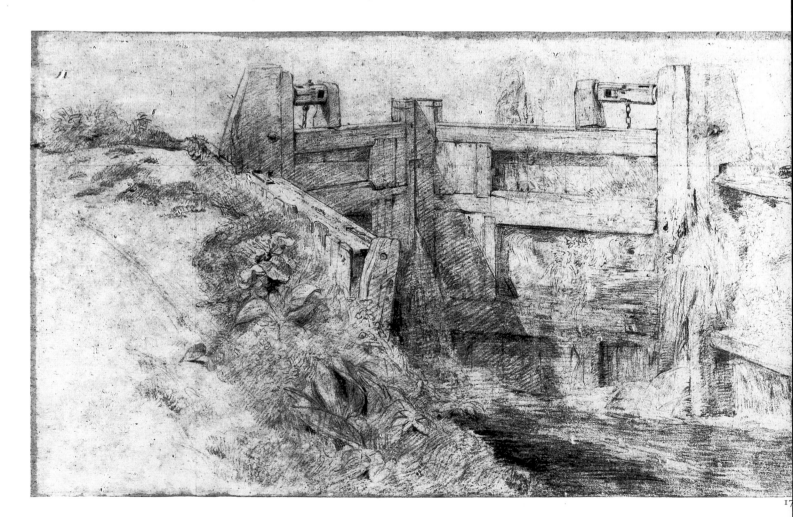

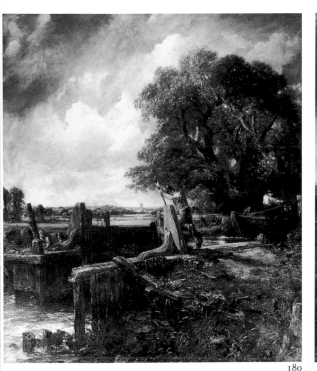

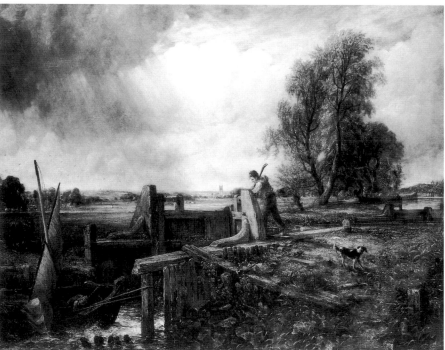

180

181

The early 'twenties are some of the least well documented years in Constable's working life. For 1822, from the family, we only have one short letter his sister Ann sent him and half an undated one from Mary, his other sister in Suffolk.[3] There are none at all for 1823. Were it not for his correspondence with Fisher, we should know little of this, one of the peak periods of his career. 1823 began badly. He and several in his household, children and servants, were quite seriously ill. As he told Fisher in a letter of 1 February: '. . . With anxiety – watching & nursing – & my own present indisposition I have not seen the face of my Easil since Xmas – it is not the least of my anxiety that the Good Bishop's picture [of Salisbury Cathedral] is not fit to be seen.'[4] When he wrote three weeks later on the 21st he was still in a gloom. Some of the children were better, but he remained weak and, he said, 'much emaciated – they took a good deal of blood away from me which I could ill spare.'[5] Although he does not mention this, an additional disappointment must have been his signal failure at the elections for Academician on February 10th. The year before he had failed, but nevertheless had done quite well, winning eleven votes against his successful opponent, William Daniell's seventeen. This year, he experienced the humiliation of obtaining only three votes in the initial round of voting, which ruled him out of the final round when Reinagle, his old but now much despised friend, had triumphed with fourteen votes. His stock appeared to be going down. However, in his letter of the 21st, he was at least able to report that he was back at work again and that he had 'put a large upright landscape in hand', which, if he was well enough, he hoped to have ready for the exhibition. Likewise, he said, he hoped to have the picture finished for the Bishop of Salisbury.

3 JCC I, p.203–4.
4 JCC VI, p.109.
5 Ibid., p.112.

It was May before he wrote again to Fisher. There is no mention in this letter of his having been away, and it is only from three dated drawings, ours of 19 April and two in the British Museum, that we know he had spent a few days in Suffolk between sending-in day at the Academy and the opening of the exhibition. The British Museum pair (FIGS 182 and 183) are dated 20 and 21 April. The former is of a boat-house at Flatford, a picturesque, thatched shelter of cruck design (i.e., with arching timbers forming both wall and roof), that had featured in the first of his six-foot paintings, *The White Horse*.[6] This was drawn not far from the lock, from the little eyot downstream, at the tail-end of which the millstream joined up with the main river. It is the subject of the other British Museum drawing that provides us with a possible explanation for Constable's visit to Suffolk that month. He inscribed it, 'Bentley 21 April 1823'. The village of Bentley (some four miles from Bergholt in the Ipswich direction) is nowhere referred to in the family correspondence, but there is an early mention of Constable's elder brother, Golding, and a family friend shooting in the woods there.[7] These woods were the property of a patron of Constable's, Wilbraham, sixth Earl of Dysart. After the Earl's death in 1821, his sister, Lady Louisa Manners, another patron, succeeded to the title and the family estates. As they were one of the family's earliest properties, Lady Dysart took a great interest in the woods and the game they contained at Bentley, and perhaps because she needed a servant she could trust, appointed Golding, the artist's brother, who was known to be an excellent shot, as their warden. It is not known precisely when the appointment was made, but

FIG 182 *A Thatched Boat-house at Flatford*
Pencil on wove paper, 16.9 × 25.4 cm. Inscribed, b.r., 'E.B. April 20. 1823'. British Museum.

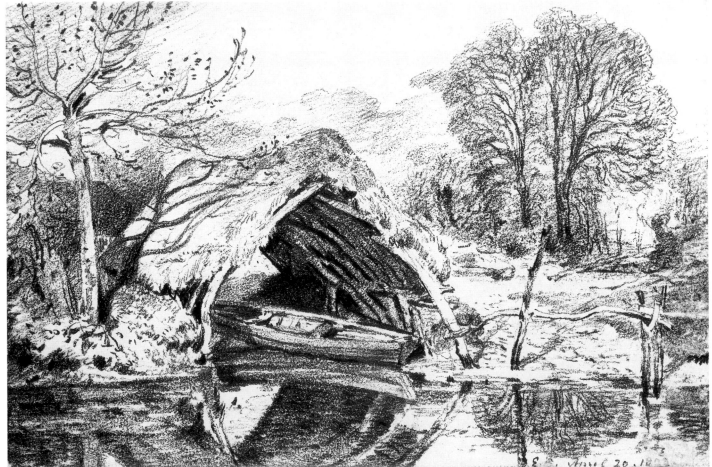

182

FIG 183 *A Farmhouse at Bentley*
Pencil on wove paper, 16.8 × 25.2 cm.
Inscribed, b.l., 'Bentley 21 April
1823'. British Museum.

6 The Frick Collection, New York. Reynolds
1984, 19.1, pl.68.
7 Mrs Constable to J.C., 22 November 1812:
...To Mr Farington by last Nights
Telegraph Co[ach] – a brace of Pheasants –
were forwarded for *your* sake the Produce
of GCs and Mr Torins day's sport on
Friday – in Bentley Woods'. JCC I, p.85.
8 JCC VI, pp.155–6.
9 Ibid., p.146.
10 Ibid., p.150.
11 Ibid., p.155.

from the tone of a letter Golding wrote in February 1824, telling Constable about the woods and their management, one gathers that they had not been in his charge for very long. Constable became very fond of Lady Dysart over the years and performed many services for her. In April, 1824, he told Fisher that he was about to go to Suffolk for a few days; Lady Dysart wanted him to see the woods in Golding's care 'that I may bring a report to her. as he cannot leave them.'[8] Because he understood his sometimes difficult elder brother he was often called upon to act thus, as an intermediary, and maybe it was while he was on one of his errands for Lady Dysart as a go-between, surveying the woods with their new warden, that he found time to pause and make the drawing of Bentley (FIG 183), the third done on that short trip to Flatford.

After telling Fisher in February (1823) that he had a large upright landscape in hand, Constable said nothing further on the subject until December, when, in a letter of the 16th, he told the Archdeacon that he had settled on a plan of work and had almost decided on 'my Lock' as one of his exhibits at the next Academy.[9] This, he put into effect, and on 17 January 1824 reported that he had just finished a little picture of Waterloo Bridge and was working on his 'upright lock'.[10] The painting (FIG 180) was ready, and, he said, 'going to its audit' – i.e., to face the public – by 15 April, 'it is a good subject and an admirable instance of the picturesque'.[11] The work was well received, and was bought on the opening day, by a wealthy business man, James Morrison, for 150 guineas, an unique experience for Constable.

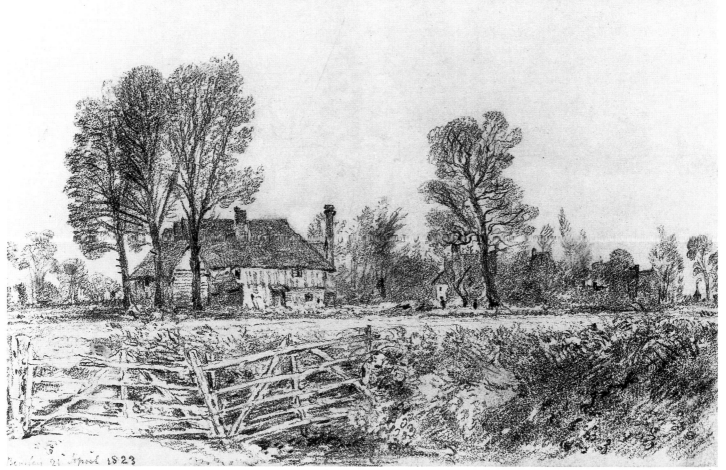

183

It is at present the generally accepted view that the subject of the large upright landscape on which Constable said he had made a start in February 1823 was Flatford Lock; and it is also reckoned that the full-size sketch for the final work of 1824 at Philadelphia (FIG 184) is the work in question. This painting raises a number of interesting problems, as it was originally an horizontal composition, the canvas having been extended top and bottom into an upright. Here, however, we need only consider what part, if any, our drawing played in the planning and execution of this sketch and the final work (FIG 180).

Apart from their proportions, the most striking difference between the drawings and the two paintings is the total absence in the latter of the lintels, the timbers that spanned the lock itself. The entrance to the lock, with the lintels sketched in with rapid strokes of the brush, is to be seen in Constable's often-reproduced little oil, *Barges on the Stour* (FIG 185), *c*.1810, a scene viewed from the river-bank beside the mill-house. The lines of over-reaching lintels may also be seen on page 54 of Constable's sketchbook of 1813, where the lower of two little sketches is of a pair, or 'gang' of barges at the lower entrance to the lock (FIG 180). But the best record we have of the appearance of the lock at this time is provided by his painting crony, John Dunthorne, senior, in an on-the-spot oil-painting taken from almost the same view-point (FIG 187). Here may be seen the full run of the posts and lintels, from the first, across the entrance, to the next, spanning the lower gates, and then on to the upper end of the lock. This was painted in 1814. The study (PLATE 26), drawn nine years later, appears to be an equally objective account, and it is therefore noticeable that the first lintel is missing and that only one of its supporting members remains. When composing his picture of the lock, the exclusion of the over-reaching timbers and their supports was a question that exercised Constable not a little. As we can see from the study (PLATE 26), they impose a repetitive, grid-pattern difficult to manage and to contain in the composing of a picture, besides obscuring the view. In the upright Philadelphia sketch (FIG 184), pentimenti and X-ray photographs clearly reveal the existence of posts and lintels at an earlier stage in the development of the composition, probably when it was of an horizontal format. It is possible that when making our drawing, the nearer post and lintel were rather in the way and that here too Constable left them out. It is more probable, however, that he has faithfully recording exactly what he saw: that the lintel over the entrance and one of its supports had been removed, as unsafe. The whole lock, we know, had fallen into a state of disrepair, and brother Abram had quite recently been complaining about its condition.

Canalized originally between 1708 and 1713, over the years the river Stour, with its locks, staunches, shoals and towpaths, had needed constant attention. In 1781, Constable's father and one William Strutt, were asked by the Commissioners of the Stour Navigation (spelt 'Stower' in the minutes) to make a comprehensive survey of the river. The two men had much to say in their report; mostly their adverse comments concerned depths of water, but some lock-gates, they said, were in need of repair – Flatford Lock, for example, as well as the footbridge immediately above it,[12] referred to in a later complaint as Mott's Bridge (meaning Lott's Bridge, after Willy Lott?). As we have seen, (p.112), Constable himself appeared before the Commissioners in 1808 to report on the poor state of the shoals and locks at Flatford and Dedham and the 'Float' over the county river.[13] In 1815 it was Abram's turn to complain that 'Flatford Locks are in a very ruinous

FIG 184 *The Lock: full-scale Sketch*
Oil on canvas, 141.7 × 122 cm.
1823–24. Philadelphia Museum of Art.

FIG 185 *Barges on the Stour*
Oil on paper laid on canvas,
26 × 31.1 cm., *c*.1811. Seemingly, the
scene at high water on a spring tide.
Victoria and Albert Museum.

FIG 186 *Scenes on the Stour*
Pencil on wove paper, 12 × 8.9 cm.
Inscribed, t.l. in the lower drawing,
Augst 11 1813', and in the water,
'Augt 12 1813'; below, 'Lock'. Page 54
in the 1813 sketchbook. Victoria and
Albert Museum.

FIG 187 John Dunthorne, Snr.
Flatford Lock
Oil on panel, 23.5 × 35.9 cm. Inscribed
on the back, 'Oct 1814 John
Dunthorn'. The only known painting
by Constable's neighbour and
painting companion. Colchester and
Essex Museum.

184

12 E.S.R.O. EI 394/1.
13 Ibid.

185

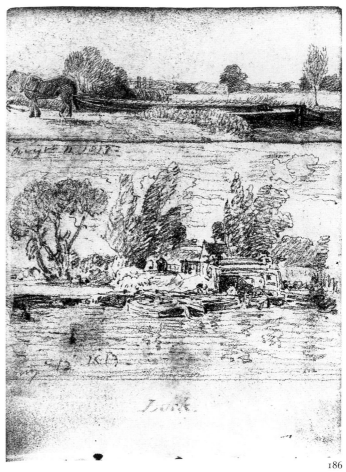

186

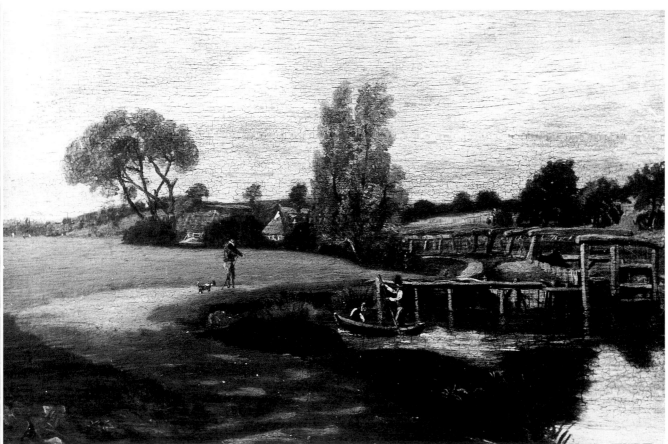

187

State, that the Upper gates thereof cannot be opened without the Assistance of an Horse – also the Float Jump in Float Meadow over the County River is very ruinous, and in Decay'.[14] Repair work was ordered to be completed within nine months, but five years later (1820), Abram was again protesting about the condition of the lock at Flatford, it being ruinous and the bank dangerous. This time it was noted in the minutes that repairs were to be completed in one month.[15] Something was done, certainly around the entrance to the lock, and it was at this stage that Constable returned to the spot and made his drawing. But the area continued to give rise to anxiety. In 1827, when he was shortly expecting a visit from his brother and, for the first time, the two eldest children, Abram was again agitating for work to be done, the gates being 'in a very bad state causing the loss of much water' and the banks upstream 'worn away and in a dangerous state'.[16] Abram's final complaints to appear in the minutes were made in May and September, 1829. He then stated that the 'haling paths ['towpaths] opposite the Floodgates at Flatford Mill are now in so ruinous a State, that they will very soon be impassable', and that 'the lock at Flatford Mill remains in a bad State and Condition, the Leakages amounting to at least 100 Locks of water in 24 Hours, – that the Banks between the Lock and Bridge are so low, and so much worn away, that they are in immediate Danger of being carried away by the water, and a serious Breach made therein'.[17]

The upkeep of the Stour meant much to Constable, for quite a proportion of his income derived from his share of the profits from the family business, and the success of the business – i.e., Abram's management of the mills, etc. – was largely dependant upon the river, a sufficient head of water to drive the mill-stones and the ready passage of the traffic it carried. Yet, somewhat perversely, when it came to a choice of subject-matter, Constable seems to have been drawn most readily towards dilapidation and decay – the old rotten banks and slimy posts of his much quoted letter to Fisher of 23 October 1821.[18] It is surely indicative that for the subject of his main Academy exhibit of 1825, *The Leaping Horse* (FIG 188), he chose the Float Jump over the county river, the ruinous state of which had been a recurrent theme in the list of complaints he and Abram made to the Commissioners of the Stour Navigation over the years.

The upright *Lock* that he exhibited in 1824 (FIG 180) is one of four paintings of the subject. The others consist of a copy of the 1824 picture, painted the following year, and the two horizontal, considerably modified versions, an unfinished work in the National Gallery of Victoria, Melbourne (FIG 189) and the similar painting, *Boat passing a Lock* (London, Royal Academy) that he exhibited in 1829 (FIG 181). With only very slight differences, the lock itself is identical in all four paintings, identical down to the varying heights of the vertical boards lining the near side of the lock entrance, the rusty nut and bolt on the massive post just in front of the lock-keeper, and the waterside plants growing on the bank. For repeats such as these to be so alike, there must have been in existence a detailed study, from which all four were painted. This, as we have suggested, may have been a much earlier drawing, matching the one of the upper lock-gates (FIG 179) and the study of the trees (FIG 178). If this is so, and if he had already started on an upright *Lock* (perhaps the Philadelphia sketch, FIG 184) from material already to hand, why, on this trip to Flatford in 1823, was there a need to make another drawing? If the large upright he said he had in hand in February was indeed the Philadelphia *Lock*, it would after all be very natural that he should want to refresh his memory

FIG 188 *The Leaping Horse*
Oil on canvas, 142.2 × 187.3 cm.
Exhibited 1825. Royal Academy of Arts.

FIG 189 *Study of a Boat passing a Lock*
Oil on canvas, 103.5 × 129.9 cm.
c.1824. National Gallery of Victoria, Melbourne.

14 It is interesting to note that when Golding's uncle, Abram Constable, the then owner of Flatford Mill, was given permission to 'Navigate from Flatford to Manningtree' in 1744, the onus was on him, 'at his own expense' to 'take away the shoal at the foot of the Lock at Flatford Mill and [that he] shall be obliged to draw down the Water for Repairing the Lock upon a Weeks Notice without being allowed any thing for the same'. E.S.R.O. WI: 1324/1.
15 E.S.R.O. EI 394/1.
16 Ibid.
17 Ibid.
18 JCC VI, p.77. Fisher had written (26 September, Leslie, *Life*, p.84); 'I had nearly forgotten to tell you that I was the other day fishing in the New Forest in a fine deep broad river, with mills, roaring backwaters, withy beds, etc. I thought often of you during the day. I caught two pike, was up to the middle in watery meadows, ate my dinner under a willow, and was as happy as when I was 'a careless boy'. Constable replied; 'How much I can Imagine myself with you on your fishing excursion in the new forest, what River can it be. But the sound of water escaping from Mill dams, so do willows, Old rotten Banks, slimy posts, & brickwork. I love such things'.

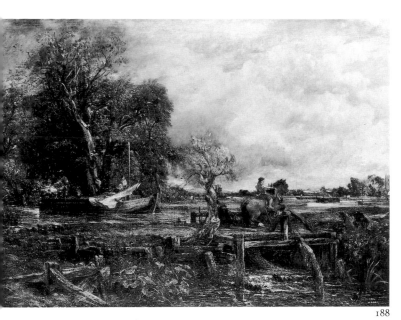

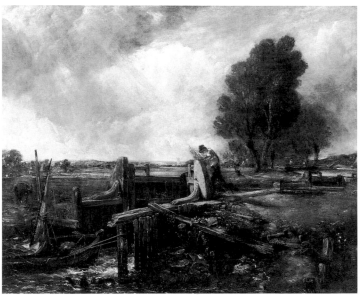

188

189

of a scene he had begun to re-live. The fact that this is the first of the three drawings he made on successive days suggests a certain eagerness to see it again. He would probably have known about the repairs, but it may have come as something of a surprise to find the place so changed. The boards and posts lining the near side of the lock entrance were new. The massive post supporting the nearest lintel had been given a second 'foot', a brace, at a right-angle to the other. The rusty nut and bolt in the same post had been replaced by another, lower down. (Constable noted the hole where the previous one had been.) The near bank had been entirely rebuilt and now there was none of that rich plant-growth he liked to have in his foregrounds.

All these changes were duly noted (PLATE 26). While at work he extended his drawing to the left, over on to the back of the previous sheet in his sketchbook, possibly with an idea for another, horizontal composition, with the lock and the over-reaching timber-work more off-centre to the right. (It is a shame that so much of the inner edges of both sheets were trimmed away when the drawing was removed from the sketchbook for mounting.) In the background, to the right of the drawing, he included the willow, in place of which, in the *Lock* of 1824 (FIG 180) he substituted an adaptation of his early study of trees further along the bank. This willow subsequently became a prominent feature in both of the later *Locks*. The actual siting of it in relation to the other trees beside the towpath is most clearly shown in Dunthorne's pedestrian but informative painting of the scene from the south bank (FIG 187), but the clearest account of this twin-

branched willow is to be found in a magnificent drawing of the river above the upper lock-gates in the British Museum (FIG 190), a page from the sketchbook of 1827. It is in our drawing, however, that the willow in question first makes its appearance in this context. In both this drawing (PLATE 26) and the British Museum study, the great branches plainly spring from low down on a common trunk. This, for some reason, Constable changes in the two horizontal canvases, representing the willow as a pair – in the Melbourne painting (FIG 189) with the trunks almost joined at the base, in the exhibited work, *Boat passing a Lock* (FIG 181), with the nearer crossing over in front of the other. Possibly our drawing was all he had to go on when these two pictures were on his easel, and he made the British Museum drawing in 1827 to see what the tree was really like.

It may also have been our study that subsequently led to a re-thinking of the skies for the two later paintings of the lock. The other drawings he did on this trip into Suffolk were crisp, pencil studies, as we have seen (FIGS 182 and 183). In our study, only some of the basic outlines were drawn in pencil – lightly touched in. Essentially, it is a monochromatic painting in which the brush and the flowing washes to a considerable extent had conditioned what he 'saw', i.e., his responses. For Constable, the sky was always an integral part of landscape. The previous year he had made 'about 50 carefull studies of *skies* tolerably large' in oils, sketches

FIG 190 *Flatford Lock*
Pencil on wove paper, 22.2 × 32.7 cm.; watermark, 'J WHATMAN TURKEY MILL/182/'. British Museum.

FIG 191 *Thunder Clouds*
Oil on paper, 25.5 × 30.5 cm. Inscribed on the back, 'Sept 10 1821. Noon. Gentle wind at West/ very sultry. After a heavy shower with thunder./ Accumulated thunder clouds passing slowly away/ To the south east. Very bright & hot. All the foliage/ sparkling and wet'.

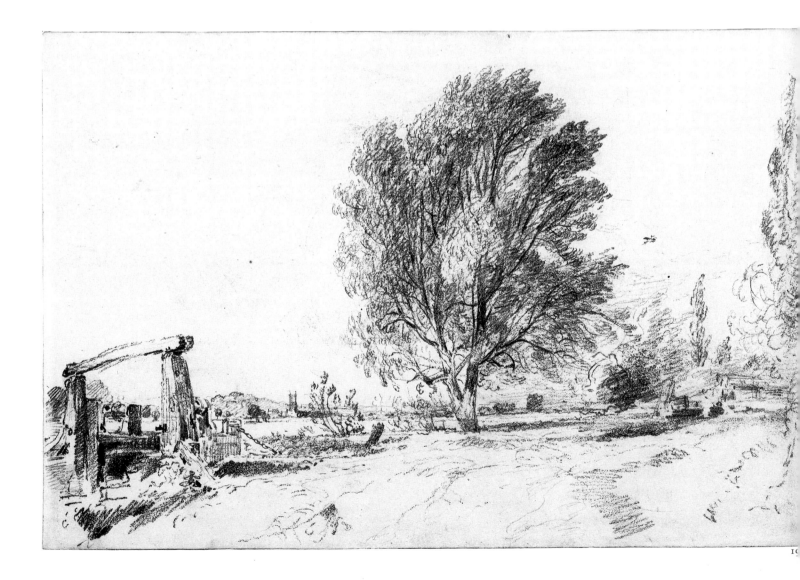

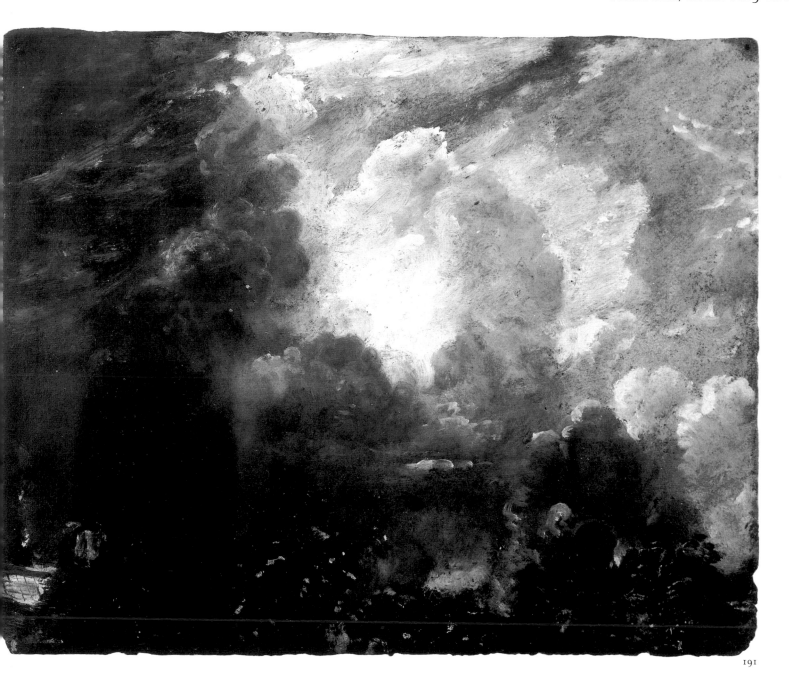

191

such as the study of an assembly of cumulous clouds that he had observed on 10 September 1821 (FIG 191), in which he had endeavoured to capture the bulk and weight of the clouds passing before him. Brush in hand, while sketching the familiar lock, he was again able to observe the character of the sky, in this case overcast with an almost oppressively low cloud-base. For his *Lock* of 1824 he chose to paint a bright sunny day with plenty of clouds, but of which none was unduly moisture-laden. This type of sky he had already established in the upright canvas he had begun some weeks before his visit to Flatford. For the two later paintings of the scene Constable chose to depict quite a different day: a day with darker clouds, low-based, like those in his drawing, through which occasional shafts of sunlight were intermingling with veils of rain.

14 Worthing

FIG 193 *Brighton Beach at Sunset*
Pencil, black chalk and pink and grey
wash on wove paper, 17.4 × 25.8 cm.
Inscribed, b.l., '&Sep^r 1. 1824'. Leger
Galleries, 1981.

have brought with me several works to complete What a blessing it is thus to be able to carry ones profession with me. A medical man cannot take his patients with him or you your flock.' 'My wife is much stronger & better – for this change', he added in a postscript.[6]

The weeks passed, profitably. Somehow he managed to find space in their lodgings to work away on the commissions he had been given by Arrowsmith and another French dealer, Claude Schroth. These kept him indoors, but he also found time for painting out of doors. The 18th, when he wrote to Fisher, was a Sunday. On the following two days he made four oil studies: two looking along the beach[7] (one, the often reproduced sketch of colliers ashore in the distance under an almost cloudless sky, FIG 192); one looking straight out to sea at a menacing squall; the fourth of the coast towards Shoreham from inland.[8] After this initial, joyful outburst, there is a spread over the next four weeks of a dated oil every few days. A number, probably done during the same period, are undated. Five are of windmills among the fields beyond the town (e.g., FIG 6).

Then, quite suddenly, Constable appears to have abandoned sketching in oil (or to have ceased dating his sketches) and we have a succession of drawings, mostly of a new type – carefully executed pen and wash studies – nine of which (including *Worthing*, PLATE 27) are dated. These run on right through to the end of his stay, which was finally extended into mid-October.[9]

The earliest of these drawings of Brighton is a pencil-sketch, a beach scene with the houses and gun battery on West Cliff. This is indistinctly inscribed 'Aug 20', but the date may refer to an oil-sketch of a windmill painted on the other side of the sheet of paper.[10] The next, probably drawn on 24 August, is a large pencil-sketch of the Devil's Dyke, a deep combe on the north side of the Downs behind Brighton, a popular beauty-spot from which there may be obtained a fine panorama of the country inland.[11] After the first of the fully dated sketches, *Brighton Beach at Sunset* (FIG 193), a view looking westwards along the shore, drawn in pencil and grey and pink wash and inscribed 'Sepr 1. 1824', nearly all

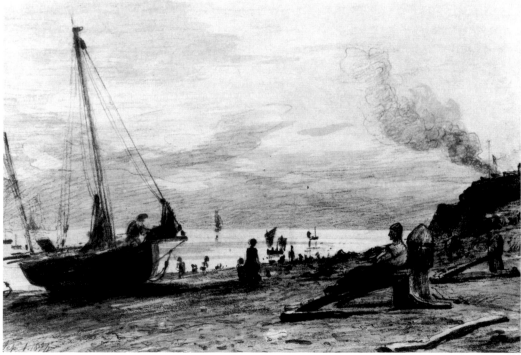

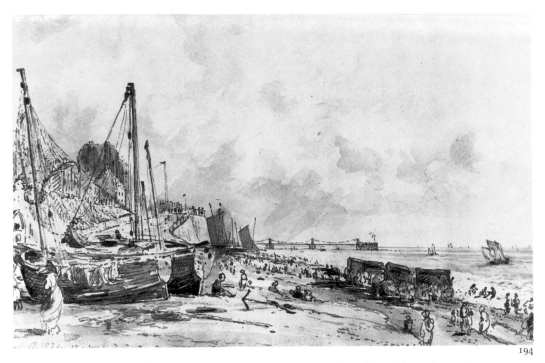

194

FIG 194 *Brighton Beach, looking East*
Pencil, pen and grey wash on wove
paper, 17.5 × 25.5 cm. Inscribed, b.l.,
'Sep.ʳ 13. 1824. 10 oclock'. Private
Collection.

FIG 195 *Fishing Boats on Brighton
Beach*
Pencil, pen and brown ink and grey
wash on trimmed, wove paper,
17.8 × 26.1 cm. Inscribed, b.l., '25 Sep.ʳ
1824'. Christie's 19 March 1985 (lot
106).

FIG 196 *Fishing Boats on the Beach: a
stormy Sea*
Pen and wash on wove paper,
17.8 × 26 cm. Leger Galleries, 1981.

the remaining Brighton drawings are in pen (or fine brush) and wash over an
initial pencilling (FIGS 194, 195, 196 and PLATE 27). Neither the change from
painting to drawing (if the switch was as complete as it appears to have been), nor
the particular character of the pen and wash drawings can be fully accounted for.

Brighton Beach, looking east, (FIG 194), is a general view and depicts a pleasant
mix-up of holiday-makers with some of the longshore fishing-fleet. In all the
other twenty or so drawings, it is the fishing boats and their crews and
occupations that take centre-stage. Constable became fascinated by the wealth of
material – the anchors, capstans, blocks and rigging, the nets, sails, hulls and all
the gear peculiar to the trade. He was also quick to note the occasional felicity, like
the glimpse of square-rigged vessels out at sea seen through a veil of netting
(FIG 195). Most of the drawings are of the boats high up on the beach with their
crews taking it easy. But Constable was also ready with his sketchbook when the
men were struggling desperately to haul their craft to safety from threatening seas
(FIG 196). Clearly, he was attempting to present as comprehensive a picture as
possible of this Sussex fleet and the longshoremen who worked it. To what
purpose, one wonders? A partial answer is to be found in his correspondence with
John Fisher during the next few months.

In a letter postmarked 29 August, that is just before he appears to have begun
on his studies of the boats and their crews, Constable writes in tones of disgust
about Brighton, describing it as 'the receptacle and offscouring of London', where
the magnificence of the sea is drowned in the din and tumult of vehicles and the
beach is only Piccadilly by the sea-side;

> Ladies dressed & *undressed* – Gentlemen in morning gowns & slippers on or
> without them altogether about *knee deep* in the breakers – footmen – children –
> nursery maids. dogs. boys. fishermen – *preventative service men* (with hangers
> & pistols). rotten fish & those hideous amphibious animals the old bathing
> women – whose language both in oaths & voice resembles men – all are mixed
> up together in endless & indecent confusion

In short, he felt there was nothing there for a painter but the breakers and the sky.

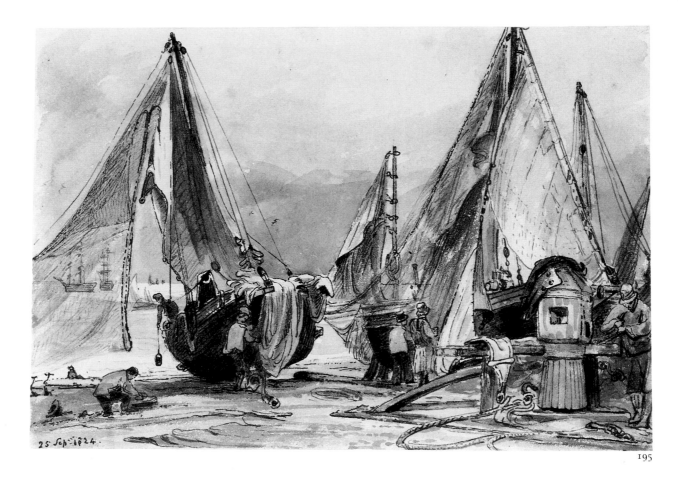

195

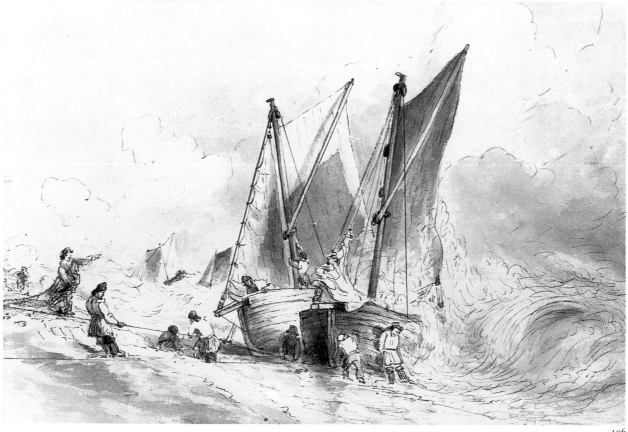

196

the fishing boats are picturesque but not so much as the Hastings boats, which are luggers. The difference is this [sketch of two boats with different rigs] but these subjects are so hackneyed in the Exhibition and one in fact so little capable of that beautifull sentiment that Landscape is capable of or which rather belongs to Landscape that they have done a great deal of harm to the art – they form a class of art much easier than Landscape & have in consequence almost surplanted it. & have drawn off many who would have encouraged the gro[w]th of a pastoral feel in their own minds – paid others for pursuing it. But I am not complaining – I only meant to call to your recollection that we have a Calcott & Collins – but not Wilson or Gainsborough.[12]

While showing a fine contempt for the popularity of paintings of coastal subjects, Constable was nevertheless finding a store of unhackneyed material for himself down on the shore among the fishermen and their boats. What use had he in mind for the studies he was making and why the novel character of his studies – pale wash drawings, carefully outlined with a fine brush or reed pen?

Sometime after his return to London, Constable talks about the sketchbook in which he had made the Brighton shore studies in a letter to Fisher, 'they are all boats – and coast scenes – *subjects* of this kind seem to me more fit for *execution* than sentiment'.[13] Fisher answered from Bath, where he was staying with his wife (who had recently been seriously ill), with a request for the loan of one of the new sketchbooks. 'Should you be afraid to send me by the Bath coach one of your new sketchbooks? We are sadly at a loss for employment; and copying <your> the leaves of your mind is a great source of amusement to my wife.'[14] It is Constable's response to this request that provides us with a clue as to the purpose of the Brighton drawings. The letter is dated 17 December, from Charlotte Street.

> Every thing which belongs to me – belongs to you and I should not have hesitated a moment about sending you my Brighton book – but I will tell you – just at the time you wrote me my frenchman [Arrowsmith] was in London. We were settling about work. and he has engaged me to make twelve drawings (to be engraved here. and published in paris). all from this book size of the plates the same as the drawings. about 10 or 12 inches. I work at these in the Evening. This book is larger than my others – and does not contain odds. and ends – (I wish it did) but all complete compositions – all of boats. or beach scenes – and there may be about 30 of them. if you wish to see them for a few days. tell me how I am to send them to you.[15]

The engraver of the twelve drawings, he told Fisher in the same letter, was to be S. W. Reynolds, who was going over to Paris the following June also to engrave *The Hay Wain* and *A View on the Stour* which had 'made a decided stir'[16] there.

So, in December, we have Constable executing a commission for Arrowsmith, twelve drawings to be taken from the thirty or so fully composed sketches (not just odds and ends) that he had made in a large sketchbook during his sojourn that summer in Brighton. Of the subsequent fate of the twelve drawings and of the plan to have then engraved we have no knowledge. Altogether twenty-five drawings of Brighton subjects from the same 10½ inch sketchbook have so far been identified. It is not known whether any of the dozen intended for the engraver are amongst them.

Almost all of the twenty-five are 'complete compositions' outlined with carefully controlled movements of the pen in diluted ink and with a well-judged tonal scale of washes. As Constable's handling is usually so much more spontaneous, this calm, deliberate type of execution has caused some puzzlement, even some doubt as to the drawings' authorship.[17] The outstanding question for

which one would like to find an answer concerns their facture. How, exactly, were they done? They do not seem to have been inked and washed in on the spot, their execution is so deliberate, yet most of them record momentary happenings – a woman with her back to the wind (FIG 194), the lowering of a bucket (FIG 195), a patch of sunlight on the shore (PLATE 27) – incidents that look as if they had been noted at the time. Two of the studies from the sketchbook are in pencil only (one, a fully worked-up drawing, the other, slightly and more sketchily drawn[18]), but there are traces of pencilling to be seen in nearly all of them. This suggests a possible mode of procedure: that they were sketched in on the spot in pencil, but in a manner that would enable them to be worked over, veritably re-drawn subsequently in ink and wash. If this was his method – a rather different approach from his customary, much less calculated way of setting about things – it implies a degree of pre-determination, that he was in fact working in accordance with some sort of plan. We can only guess what this was, but it is possible that he had it in mind to publish a set of beach subjects and that the original suggestion that he should do the twelve drawings for Reynolds to engrave was his and not Arrowsmith's.

In his letter to Fisher posted on 19 August, he had told the Archdeacon about a new friend:

> While in the feilds. (for I am at the west of this city – and quite out of it). I met with a most intelligent and elegant man Mr Phillips – we are become intimate & he contributes much to our pleasure here. he is a botanist – & all his works on natural history are instructive and entertaining – calculated for children of all ages – his history of trees is delightfull – I shall buy them[19]

Phillips had published a number of books on botanical and horticultural subjects and later suggested that Constable should contribute a paper on Landscape to his Brighton literary journal.[20] It may have been during his talks with Phillips, an active writer, that an idea came to Constable that he, too, should venture into publishing. Before making a name for himself as author, Phillips had been in business as a banker in Worthing, then another new and prospering sea-side resort, some twelve miles west of Brighton. It may also have been in the company of his new friend that Constable visited Worthing and made our drawing of the signal station (PLATE 27) – there is no other reason for his being there that we know of.

With four children under seven, Constable and Maria seldom appear to have ventured far from their lodgings in Western Place, but in the letter to Fisher quoted above he tells the Archdeacon of their excursion to Devil's Dyke and the impression he formed of the view.

> Last Tuesday [24 August] the finest day that ever was we went to the Dyke – which is in fact a Roman remains of an embankment[21] over looking – perhaps the most < natural > grand and affecting natural Landscape in the world – and consequently a scene the most unfit for a picture. it is the business of a painter not to contend with nature & put this scene (a Valley filled with imagery 50 miles long) on a canvas of a few inches. But to make something out of nothing, in attempting which he must almost of necessity become poetical. but you understand this better than me.

Three weeks later, on the shingle at Worthing, he practised what he had preached – made something out of nothing (PLATE 27) – in attempting which, 'almost out of necessity', he created an image that approaches uncommonly close to poetry.

12 Constable to Fisher; JCC VI, p.171. There is a helpful note on the popularity of beach scenes in Malcolm Cormack's *Constable*, 1986, p.247, n.11.

13 17 November 1824; JCC VI, p.182.

14 9 December 1824; ibid., p.184.

15 Ibid.

16 Constable to Fisher 17 December 1824; ibid., p.186. Reynolds, a great admirer of Constable's work, was engraving *The Lock* at this time, the painting bought by Morrison at the Academy. For some reason the print reached the proof stage, but was never published.

17 Cormack, 1986, p.157.

18 *Boats on the Beach at Brighton*. Private Collection; Reynolds 1984, 24.39, pl.510. *Fishing Boats on Brighton Beach*. Private Collection; ibid., 24.50, pl.521.

19 JCC VI, p.172.

20 Constable to Fisher, 9 September 1826, JCC VI, p.224.

21 Apparently a popular misconception at that time.

15 Brighton Beach, 1828

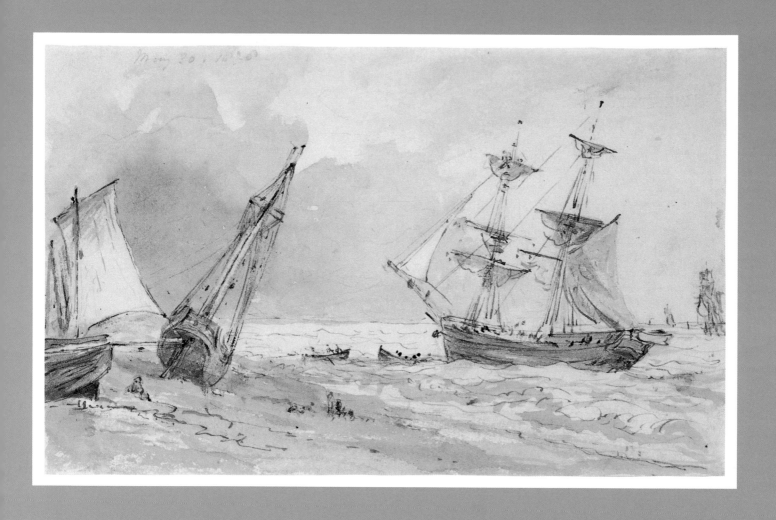

PLATE 28 *The Schooner Malta on Brighton Beach*
Pen and ink and grey wash on slightly trimmed wove paper 11.2 × 18 cm.
Inscribed on the back by Constable's son, Charles Golding 'Brighton, Wreck of a
schooner lying on the beach, May 30 1828. J.C. made 4 other sketches of this wreck on
the same day. And on the 29th (the day previous), he made four of her in different views.'

The Schooner Malta on Brighton Beach (PLATE 28), is one of a series of drawings by Constable – a group unique in his oeuvre – depicting scenes he witnessed in May 1828, when a collier was stranded on the shore at Brighton after a most unseasonable south-westerly gale. There was nothing unusual about the sight of a vessel of this size ashore on that beach. For its very survival as a fashionable resort, Brighton depended to a considerable extent on a steady delivery of supplies by sea, and two or three brigs of a hundred tons or so close inshore or high and dry at low-tide were so regular a feature of life on the beaches that normally they roused no more interest than the fishing-boats that thronged the shore. These ships were frequently colliers, the extended portion of an immense fleet many thousands in number that was at sea in all but the most inclement of winter months bringing coal down from Newcastle and Sunderland to the east-coast ports and the London docks. Shoreham, the nearest harbour, being some distance along the coast, and there being a suitable hard at Brighton, the master of these colliers found it convenient to bring their vessels straight in at high-water and beach them there; a line ashore and an anchor out astern (later, for kedging her off), held the ship squarely in position. Unloading would begin as soon as the receding tide made it possible for horses and carts to come alongside.[1]

Although Constable initially recoiled in disgust from the humanity on Brighton beach, as we have seen he eventually became fascinated by the sea itself 'and its everlasting voice',[2] and by the longshore working life: the fishermen, their craft and gear, the drying of their sails and nets, and the hauling of the boats high up the beach, beyond the reach of the sea. In all, he made not far short of a hundred sketches down on the shore – oil-sketches, pencil and pen and ink drawings, and watercolours. Colliers are to be seen in several of these. One of his better-known oil-sketches of Brighton in the Victoria and Albert Museum shows three colliers in the middle distance, beached, on a receding tide (FIG 192).[3] In a fine wash drawing, *Brighton Beach with a Rainbow* (Oldham Art Gallery), we see three collier brigs similarly high and dry at low-water, with the nearest discharging her cargo into the carts below.[4] Another study, this time from fairly close to, gives an authoritative account of colliers and their rigging, with lines out fore and aft.[5]

Constable's interest in sailing vessels, and colliers in particular, was only natural. His father, it may be remembered, had been a coal- as well as a corn-merchant, and had owned sailing vessels, as well as a fleet of barges that brought his coals up the Stour to Flatford.[6] It is unlikely that Constable, with the rest of his family, had not been present at an event of some importance for the family business that took place in August 1797, the launching of one of Golding's vessels from the yard where she had been built, downstream from Flatford at the mouth of the Stour; an occasion recorded thus in the local paper;

> On Thursday se'night was launched at Cattawade, near Manningtree, a new corn brig, called the Telegraph, belonging to Mr Golding Constable; the day proved fine, an immense concourse of people were assembled, who testified their approbation by repeated acclamations, with good wishes for her success, and the long life and prosperity of her owner...[etc.][7]

The Constables had many links with the sea and with shipping and of course particularly with colliers. In the present context it is interesting to note that as a midshipman Constable's uncle, John Watts, his mother's brother (a Commander, R.N., when he died at sea in 1801), had sailed with Captain Cook on the latter's last

1 Henry Edridge (1769–1821) and Copley Fielding (1787–1855) both made studies of colliers unloading at Brighton. That of the former, engraved by George Cook and published 1 June 1814, depicts a collier aground, with the unloading and transport of the cargo up the beach shown in great detail. Fielding's view, engraved by Charles G. Lewis and published in 1829, though more consciously pictorial, is nevertheless equally informative. This time, two colliers are discharging their cargo, one well up on the beach, the other further out, not yet high and dry, suggesting that the masters of these vessels did not always bring their ships in together. Two-horse teams are alongside both colliers; a third horse is helping a team up the ramp from the beach.

2 Constable to Fisher, post-marked 29 August 1824, JCC VI, p.171.

3 *Brighton Beach, with colliers*. Oil on paper. V.& A., Reynolds 1984, 24.11, pl.487.

4 *Brighton Beach, with a rainbow: colliers unloading*. Pencil and grey wash. Oldham Art Gallery, Reynolds 1984, 24.34, pl.506.

5 *Coal brigs at Brighton Beach*. Pencil, pen and wash. Cecil Higgins Art Gallery, Bedford, Reynolds 1984, 24.47, pl.518.

6 There are many references to Golding Constable as coal-merchant in the East Suffolk and Essex Record Office archives. He had coal-yards at Brantham and East Bergholt (beside the windmill on the Heath), quays at Mistley and Flatford, and is listed as the supplier of coals to Dedham almshouses and Tattingstone poorhouse. (East Bergholt, i.e., Flatford, is listed as one of thirteen ports represented at a meeting of coal-merchants in 1789 during a dispute with the coal fitters and shipowners of Sunderland over prices: *Ipswich Journal*, 11 July 1789). It is perhaps worth noting that Golding became a Director of the Tattingstone poorhouse shortly after obtaining a contract for the supply of coals there and a year before he became the regular supplier of 'bread flour'. An indirect reference to his son, the painter, is to be found in an entry in the Tattingstone papers: 'Ordered that M. G. Constable be paid Twenty Pounds, for his Clerks & Sons for their care and attention in Arranging the Accounts to Michaelmas last.' (ESRO ADA A7/AB1/1). Penmanship, according to Leslie (*Life*, 1951, p.3), was the only thing Constable excelled at in school.

It is possible that a drawing in the V.& A. that Constable made beside the dry-dock at Flatford (i.e., the 'port', East Bergholt) in 1827, in fact depicts men at work shovelling a barge-load of coal into a cart, Reynolds 1984, 27.28, pl.657.

7 *Ipswich Journal*, 19 August 1796. The date of the launching was 10 August.

8 News of John Watts, that he had sailed for the West Indies, is contained in the earliest of John Constable's surviving letters, written to his father from Edmonton, 11 August 1796 (JCC I, p.12). An unusually fine portrait drawing by Constable (dated 18 November 1818), believed to be of a Capt. Allen, was sold at Christie's, 16 November 1982 (lot 84). This was probably Cmdr Watts's nephew, John, Constable's cousin, who sailed with his uncle as midshipman in *H.M.S. Osprey* on Watt's last voyage.

9 Constable to Fisher, 11 June 1829, JCC VI, p.236.

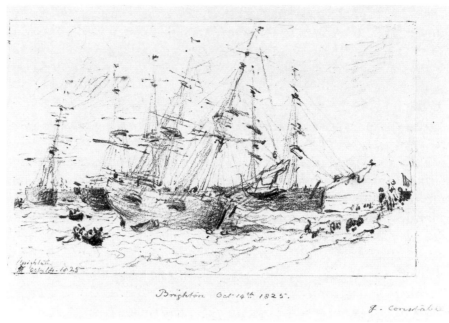

197

voyage, and that Cook always chose to sail in stout, Whitby-built colliers on his
voyages round the world, in preference to larger and faster vessels already in the
Service.[8]

Constable's earlier visits to Brighton had been relatively happy ones.
Circumstances had changed radically, however, and for the worse when he was
there with his family in the summer of 1828. The year had started promisingly
enough with the birth of a seventh child, Lionel, on 2 January. But in February
there was a major disappointment. After an humiliating round of visits,
canvassing for votes, he had come a poor second to William Etty (the painter of
'Satyrs and lady bums')[9] in the election for Academician. The news that his wife
had inherited a relatively large sum of money – £20,000 – from her father had
come as something of a relief, but this had been offset by the decline in Maria's
health, the rapidity of which had become alarming. Only sea-air, it was thought,
would provide relief. Her affliction, pulmonary consumption, had sadly reduced
her strength and for a time she was too ill to make the journey. But when the
spring came, some of the children were sent on ahead to Brighton, and eventually,
in the warmer weather, probably soon after Lionel's christening at Hampstead on
23 May, Constable was able to take his wife down to Sussex. There she remained,
'sadly ill', until August. She was thin and weak when Constable brought her back
to Well Walk and survived only until November. He never really recovered from
her loss.

Oil-sketches and drawings record his visits to Brighton in May and July. All the
drawings come from a smallish, $4\frac{1}{2} \times 7$ in sketchbook that he had used before in
Brighton, in 1825. Three are of the colliers that regularly brought their cargoes in
to be unloaded on the shore. Two of these are dated 14 October 1825. One shows
the flotilla at half-tide in a choppy sea, with the nearest hard aground and already
tilting over on her side (FIG 197).[10] The first two drawings Constable made in May,
1828, rapid pencil sketches of Hove Church and a fishing boat on the shore, were
done on the 16th, possibly when he was down with the children before Maria's
arrival.[11] Next, we have five drawings dated 30 May, all of the same scene, a
schooner driven ashore, lying high up on the beach.

10 In the other (*Brighton Beach, with colliers.*
Pencil. Courtauld Institute Galleries,
Reynolds 1984, 25.20, pl.591), a view from
the west, the vessels are seen as from a
distance.
11 *The Old Parish church, Hove*. Pencil.
V.& A., Reynolds 1984, 28.5, pl.682. *Scene
on Brighton Beach*. Pencil. Private
Collection. Ibid., 28.6, pl.683.

From the two local papers, *The Brighton Herald* and *The Brighton Gazette*, we can glean some information about this event. From the *Herald* and *Gazette* we learn that a strong south-west gale, bringing unseasonably cold, misty weather, had been hampering the mackerel boats sadly, one of which had lost twenty of its nets, and most of which had had to run into Shoreham harbour to shelter for the night. On 5 June , the *Gazette* reported that.

> . . . a very fine vessel, the Malta from Sunderland, with coals, lies on the beach at the bottom of West Street, but, it is expected she will be got off. The cargo is discharged. Another vessel, the Shepherd, coal laden, was also stranded at Hove, but got off to sea on Tuesday [the 3rd], after sustaining considerable damage.

The *Malta* was still stranded when the *Herald* went to press on the 7th: 'owing to the roughness of the weather. . . she now lies too high on the beach to float'. The *Gazette* of 12 June reported the *Malta* still on the beach:

> . . . the attempts made to get her off having hitherto proved unsuccessful. A large concourse of spectators assembled on Sunday evening [the 8th] to witness the efforts then made; but owing to a rope breaking, the task was abandoned until the return of the spring tides. It was fortunate the rope broke in the sea; had it been on the beach, many persons would in all probability [have] been seriously injured.

A week later the *Gazette* had better news of the *Malta*; on the 12th, after further unsuccessful endeavours, she was 'got off to sea'.

Several ships named *Malta* were registered with Lloyds in 1828. However, an inscription on the back of one of Constable's drawings and his knowledgeable rendering of the vessels enable us to identify the ship that was so badly stranded at Brighton that summer. The drawing in question (PLATE 28) shows the shore with two ships, one a brig already afloat, or nearly so, with one sail set and the rest ready – i.e., 'hanging on the bunt' – to take her out into deeper water, and another, a vessel of a very different rig, lying awkwardly on her side high up on the beach. The inscription, written many years later by Constable's second son, Charles, reads,

> Brighton, Wreck of a schooner lying on the beach, May 30 1828. J. C. made 4 other sketches of this wreck on the same day. And on the 29th. (the day previous), he made 4 of her in different views.

Charles Golding spent half his life at sea and had seen many fine ships driven ashore. It is therefore perhaps something of a tribute to those who finally managed to get the *Malta* off, that in his judgement (in ignorance of course of her subsequent successful launching) she was doomed, a wreck. Having served in several himself, he knew a schooner when he saw one, and with nine of his father's drawings of the scene before him, would have had little difficulty in identifying the class of ship to which the stranded vessel belonged: the *Malta* was a schooner, without doubt. This fact rules out all but two of the ships of that name in the Lloyds' register. Of the remaining pair, both launched in 1806 – one at Brixham, the other in Denmark – from the rather un-English lines of her stern and hull, it seems almost certain that our *Malta*, the schooner in Constable's drawings, was the foreigner: tonnage, 108: partly built of fir (an inferior wood, and therefore given only a seven-year rating by Lloyds); master, one, Wood; owner, Morley, after several years' registration in the name of Barnett.

FIG 198 *Coast Scene with Colliers on the Beach at Brighton*
Pencil and grey wash on untrimmed, wove paper, left edge irregular, 11.5 × 18.1 cm.; watermark, 'J WH/ TURK/ 18/'. Inscribed, t.l., 'May 30 1828'. Victoria and Albert Museum.

12 Charles refers to the sketchbooks in the two letters he wrote to his elder brother from Bombay in January 1838: 'I hope those books I mentioned in my last letter were taken care of for me I would sooner have them than £100. . . in case that letter did not reach you I will repeat them I mean the Book of Sketches in the Coutes Indiamen and the two Brighton sketch books'. And again later, when sailing up the channel, homeward bound, the following August: 'I saw in a paper for March 1838 an account of some of my Fathers Pictures advertised for Sale . . . I most sincerely hope you were able to reserve for me the 2 Brighton sketch books and the Portfolio of Sketches made by him in the 'Coutes' Indiaman the latter he had really given to me.' MSS, family collection.
13 Reynolds 1984, text, 28.8, p.192.

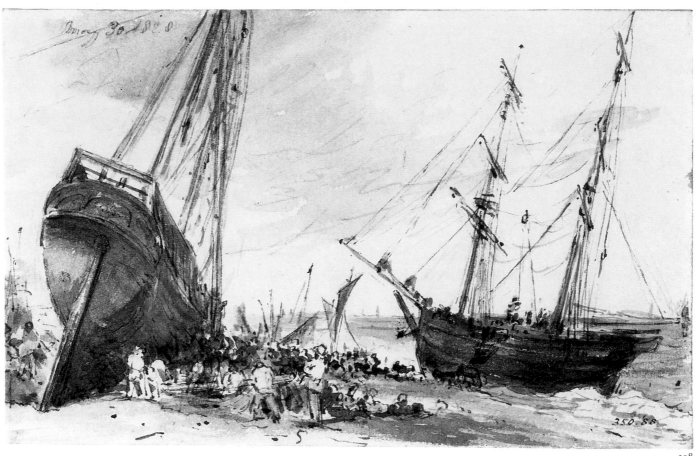

198

Constable appears to have told his son, Charles, some years later, that he could have two of his Brighton books, as well as a portfolio of drawings that he made in 1803, when he spent nearly a month at sea in an Indiaman, the *Coutts*.[12] It is likely that one of these sketchbooks was the one he used in 1825–28. Charles refers to four views of the stranded schooner done on 29 May and five on the 30th. So far none of the first four have come to light. The five we have may be listed as follows – titles as they have hitherto been given.

1 *A Coast Scene with Colliers on the Beach at Brighton* (FIG 198)

A view of the *Malta* and another collier, a brig, close to, from the west. Here, the brig is not yet high and dry, the sea still washes around her keel, but already a cart and team of horses is at her side and unloading has begun. Most of the crowd has gathered round the *Malta*, where some appear to be attempting to 'fill in' under the bilges to stop the vessel heeling over any further, while others (as Graham Reynolds has pointed out)[13] seem to be engaged in lowering something – perhaps a spar to reduce top-weight.

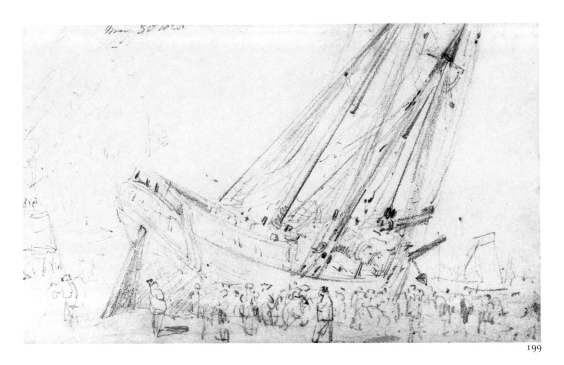

199

FIG 199 *A Beached Vessel at Brighton*
Pencil on wove paper trimmed l.,
11.5 × 17.8 cm. Inscribed, t.l., 'May 30
1828'. Coll. John Day.

FIG 200 *A Coast Scene with Vessels at Brighton*
Pencil, pen and ink and grey wash on
untrimmed, wove paper, left edge
irregular, 11.5 × 18.6 cm. Inscribed,
faintly, t.l., 'May 30 1828'. Victoria
and Albert Museum.

FIG 201 *Boats unloading*
Pencil on wove paper, left edge
untrimmed, 11.4 × 17.9 cm. Inscribed,
t.l., 'May 30 1828'. Fine Art Society,
1964.

II *A Beached Vessel at Brighton* (FIG 199)

The *Malta* from close to, looking north-east, drawn just before or soon after I, if a portly figure with arms folded to be seen in both drawings is one and the same. Constable may have taken paper and pencil only down to the beach. As the level of heads in this drawing indicates, he seems to have stood while making the sketch. The monochrome washes and pen-work in the other drawing could have been added subsequently; the inked-over date in I suggests two stages in the work.

III *A Coast Scene with Vessels at Brighton* (FIG 200).

A general view of the beach from the north-west; in the distance the *Malta*, the brig and a fishing-boat. Four of the wooden capstans used for hauling the fishing-boats up beyond the reach of high-water are to be seen in the foreground; nearby, a rope-house, the forward half of a boat up-ended to serve as a store for nets and other gear.[14]

IV *Boats unloading* (FIG 201).

The *Malta* and the brig with the other collier, the *Shepherd*, from the east. It must have been quite a storm, that sou'wester in May 1828, for three colliers to have been driven ashore on this stretch of the coast, broadside on. Normally, as we can see in FIG 197, the masters of the colliers ran their ships aground squarely, at 90 degrees to the shore. Here, in FIG 201, we have all three vessels that were in trouble: the *Malta*, perilously high up on the beach, the brig nearby, and in the distance the badly damaged *Shepherd* at Hove, all aground as the sea and the force of the wind rather than the ships' masters had willed it. In I and III, Constable had deftly indicated the *Malta's* improvised shore-lines. These are more clearly indicated in the present drawing – one from the main-mast to a point at the cliff-top, the other from the fore-mast to the base of the cliff, possibly to a capstan. The securing of these lines as soon as possible would have been essential to prevent the collier

14 'Rope-house'; this is so named in one of the etchings E. W. Cooke made of the boats and fishing equipment on Brighton beach in 1829–30.

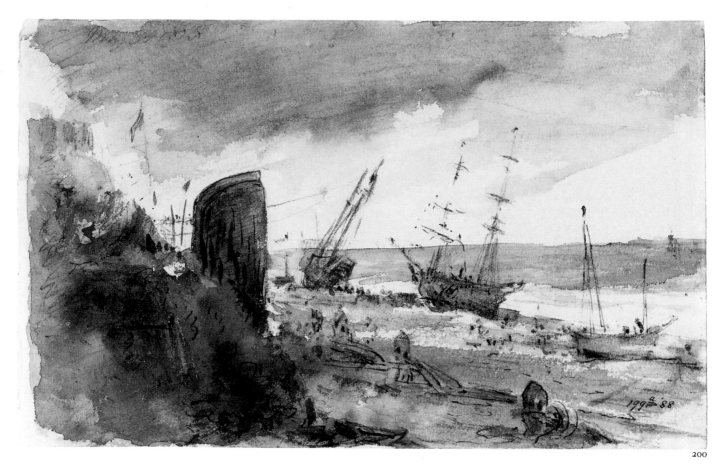

200

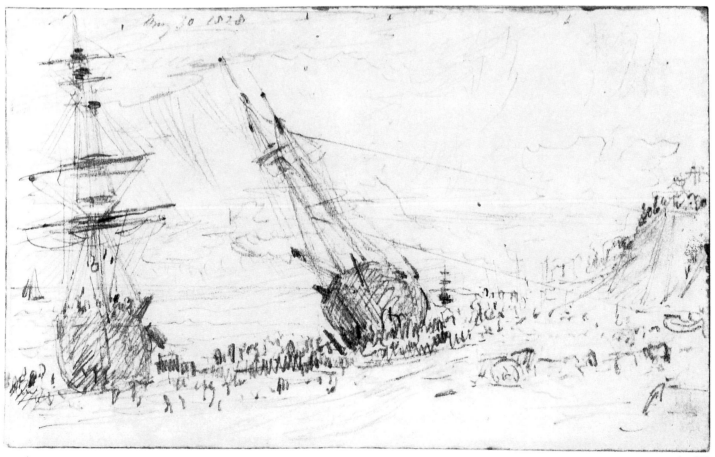

201

listing still further over to starboard. In the foreground, with great simplicity of line, Constable has noted one of the carts with its team of horses proceeding up the beach with a load from one of the vessels.

V *The Schooner Malta on Brighton beach* (PLATE 28)

There was a spring-tide on 30 May, when the rise and fall on this part of the coast was at a maximum – some twenty-one feet. High-water that day was just before noon (11.41, a.m.).[15] In PLATE 28 we see the tide either about an hour before or an hour or so after high-water. Constable has drawn the brig with one of her sails, a jib, set, presumably prior to floating off after discharging her cargo and making her way out to sea. If this was the case, the hour must be *before* mid-day, for no master of a grounded vessel would be attempting to get away on an ebb-tide. The deserted appearance of the beach favours a time before high-tide, too. It is more likely that the crowds round the *Malta* in the other drawings would have gathered when the tide was further out (i.e., during the early part of the morning), than in the face of an advancing, angry sea. If the ship in full sail on the right-hand side is heading for the shore, as she appears to be, this too would indicate a flood-tide.[16] The time for beaching vessels of this size would have been just before high-water, not on an ebb-tide.

To us, it may not seem to matter greatly whether Constable made his drawing after or before noon, when the tide was coming in or going out. But iconographically it does matter, as it did for the artist, bent on rendering every aspect of this small sea-shore drama.

It is possible that two further drawings from the 1825–28 sketchbook should be added to the five already listed:

VI *Coast scene at Brighton* (FIG 202)

The vessel aground on the extreme left, with some of the sails on her yards partly furled, looks very like the brig we know from the other drawings, and

FIG 202 *Coast Scene at Brighton with Vessels on the Beach*
Pencil, pen and grey wash on untrimmed, wove paper, 11.5 × 18.7 cm. 1828. Victoria and Albert Museum.

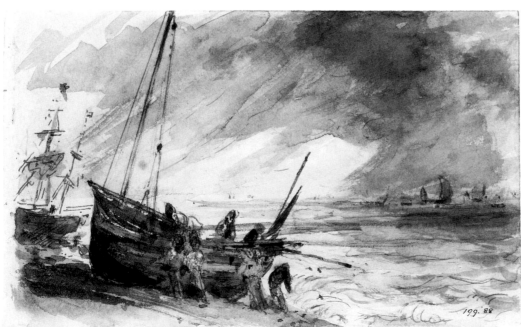

202

the boat in the foreground, with her crew struggling to secure her, has been drawn up on the beach in a position similar to that of the fishing-boat in III (FIG 200). Constable's noting of the boats sailing away into the squall on the right also agrees with the report in the *Brighton Gazette* (of 5 June) that part of the fleet had put out to sea in defiance of the storm and had returned safely the next morning with a gratifyingly large catch of mackerel. Though forceful and vividly descriptive, this is not the same type of drawing as the others. They have all the hall-marks of having been done on the spot. The present drawing lacks their sense of immediacy, and despite the vigorous handling looks more like a work executed in recollection.

VII *Shipping off-shore* (FIG 203)

 This second drawing, a hitherto unrecorded page from the 1825–28 sketchbook, may be the concluding work in the series. On the right, we have a small fleet of square-rigged ships, the nearest of which is a brig, unusually high out of the water. The weather looks fair; only far out to sea is there a suggestion of a rain-squall. It is the inscription 'J.C. 30' and the appearance of a brig showing a lot of the freeboard (as a recently unloaded vessel would, before taking in ballast) that links this drawing with the series of 30 May. Slightly against accepting it as a drawing from the *Malta* series is the fact that the wind is now easterly; in V (PLATE 28) the wind still seems to be coming from the west or south-west.[17]

FIG 203 *Shipping Off-shore*
Pencil and grey wash on wove paper, left edge slightly trimmed,
11.5 × 18.5 cm. Private Collection.

A vessel of a hundred tons stranded on Brighton beach was an unusual sight, and the apparently doomed *Malta* and the preparations for an attempt to float her off attracted a lot of attention. Constable was not enamoured of crowds, and as a spectator, therefore, stood well back, but he too must have spent several hours down there on the shore observing the scene from different viewpoints. What were the reasons for the keen interest he took in the two vessels? Was it anything more than just natural curiosity about the fate of a seemingly wrecked collier, a vessel engaged in a trade he knew so well? The full sequence of drawings suggests that Constable was more than just curious. The undated drawing of the brig at the height of the storm (FIG 202), with the rain fiercely angled in the wind, is surely the recollection of a scene witnessed. He must therefore have been down on the shore at the time, experiencing the full force of the gale. Whatever it was that drove him out of his lodgings – agony of spirit, a desperate need for fresh air, or just news that there was a ship in trouble – it is likely that, having seen the two vessels driven ashore, he found himself caught up in their fate and impelled to record the event, to play the part of narrator – for him an unaccustomed role. It is also more than possible that the story unfolding on the beach proved strangely relevant, that for him, with his wife coughing her life away back in their lodgings, the distressed ship and the efforts to save her had a special meaning, and that drawing the *Malta* in her predicament provided a certain degree of cathartic relief.

 Whatever his feelings at the time, the quickness of eye and hand seems to have been quite unaffected. Not since the noisy East Bergholt fairs (see pp.98–105) had he observed and so successfully captured the movement and bustle of crowds. Never before this series of the stranded *Malta* on Brighton shore, however, had he attempted such a narrative. If Charles Constable was right, and there *were* four drawings done on the previous day, then perhaps we only know half of the story.

15 Low-water was at 5.31, a.m. and 17.53 on 30 May 1828.

16 A relatively unfamiliar oil-painting of square-rigged vessels making for the shore, *Sailing Ships off the Coast at Brighton*, very probably colliers, was shown in the exhibition, *Constable's England*, at the Metropolitan Museum, New York, in 1983; repr. in colour in the catalogue, no.49. Reynolds 1984, 24.76, pl.547.

17 One would like to include a third drawing from the same sketchbook, *Coast Scene at Brighton*. (Pencil and grey wash) depicting a windy shore with three square-rigged ships, one a brig. In character, it is very like III, FIG 200. V.& A., Reynolds 1984, 28.12, pl.688.

16 Hadleigh Castle

PLATE 29 *Hadleigh Castle*
Pen and iron-gall ink on wove paper of a brownish hue due to action of iron-gall,
trimmed bottom and left, 10.1 × 16.6 cm.
Watermark '/TMAN /MILLS /8'.

Although there are still many gaps in our knowledge of Constable's working methods due to loss or perhaps even to plain ignorance, a considerable number of his preliminary studies have survived and in a few cases it is possible to follow the development of a major painting right through from start to finish. Before beginning on one of his large canvases it was his now well-known practice (a practice unique among artists) to realise the subject fully in a compositional sketch on a full-size canvas. Almost all of these big sketches have now been located. Often, this large-scale work was preceded by smaller ones – dry runs, as it were. Usually, these were also in oils, on quite small boards. Further back still, there were the source-works, the original drawings or oil-sketches from which the picture evolved. A number of seminal works have also been identified. Their character varies, but almost all have one thing in common, they record direct experience. For the subject of none of his major paintings was Constable entirely dependent upon recollection or invention.

While he was still based on East Bergholt, that is while the scenes he wished to perpetuate were relatively close by, it was possible for Constable to find a subject in the field and to collect the necessary material for the painting on the spot, even to make further sketches while the painting was still in progress. For a while he was able to dispense with preliminaries almost entirely and to paint intended exhibits direct from the motif. But after his last long sojourn on home ground in 1817, for ideas for pictures of his most favoured, native scenes, he became dependent on material previously collected – on early oil-sketches or uncompleted paintings, or on the contents of his sketchbooks.

Subsequently, his most fruitful seasons for the gathering of such material proved to have been the summers of 1813 and 1814, when many of his working hours were spent, pencil in hand, with his small pocket sketchbooks in the countryside around his home. It was within the covers of just two of the still-intact sketchbooks of those summers that he found the source material for some of his greatest paintings, for *The White Horse, Stratford Mill* ('The Young Waltonians'), *View on the Stour, The Leaping Horse* and *Valley Farm*. From the other sketchbook of 1814, now dismembered, only about a dozen pages have so far come to light. But years later he turned to the sketches in this book also: in 1832, to a drawing of a farmhouse (see PLATE 8) for the subject of a watercolour;[1] and in the winter of 1828/9, at a time of blackest despair, to one of the slighter sketches it contained, a brief note of Hadleigh Castle, a ruin much as he may then have felt his own life to be.

Somewhat confusingly, there were two Hadleighs in Constable's working life: one, the Suffolk market town (on the River Brett, a tributary of the Stour) that he knew well, as it lay no more than five miles from his home; the other, the fourteenth-century castle in Essex overlooking the Thames that he saw on only one occasion during a brief visit to that part of the country in 1814. Constable's earliest 'Hadley' (as he spelt it) was done on the spot, on the banks of the Brett, in 1798. *Hadleigh Castle* (PLATE 29) is a work of a very different sort, a compositional study done in the studio thirty years or so later at some remove from the original sketch of the subject. But, unlike the other, this pen-and-ink drawing played a part, a significant part, in the development of one of Constable's major paintings.[2]

His tour of Essex in June 1814 has been mentioned already (see p.8). The trip was undertaken while he was staying with an old family friend, the Revd W.W.Driffield, vicar of Feering, a parish near Colchester. Constable told Maria

FIG 204 *Southend*
Pencil and watercolour on untrimmed, wove paper, 8.1 × 10.7 cm. Inscribed t., 'Southend – even⁸ – 23ᵈ June 1814' and below, 'South End Jun 23. 1814'; on the back, 'prittlewell Church/ near Southend', presumably referring to a missing drawing. Victoria and Albert Museum.

FIG 205 *Two sketches: Sheerness and Coast Scene near Southend*
Pencil on untrimmed wove paper, 8.1 × 10.9 cm. Inscribed on the back, 'Sheerness' and below, 'Southend Hadleigh Castle'. 1814. Victoria and Albert Museum.

1 *A Farmhouse.* Pen and ink and watercolour. Inscr. 'Water Street, Hampstead. To Mr John Allen, East Bergholt, Suffolk/ with the sincere regards of his friend/ John Constable, R.A./ Nov.22. 1832'. (Constable was then at East Bergholt for the funeral of his one-time assistant, Johnny Dunthorne.) High Museum of Art, Atlanta, Georgia. Reynolds 1984, 32.18, pl.829.
2 'Hadleigh Castle. The mouth of the Thames – morning, after a stormy night.' Royal Academy, no.263. A pioneer article 'John Constable's "Hadleigh Castle"', was published by R. B. Beckett, *Art Quarterly*, Vol.xxx, no.4, in 1963. The most comprehensive study of the subject to date is Louis Hawes', 'Constable's Hadleigh Castle and British Romantic Ruin Painting', *The Art Bulletin*, vol.lxv, no.3, pp.455–70, illustrated with twenty-one plates.
3 Constable to Maria Bicknell, 3 July 1814, JCC II, p.127.
4 A full account of the voyage is to be found in Constable's letter to the elder Dunthorne of 23 May, 1802; JCC II, pp.3–4.

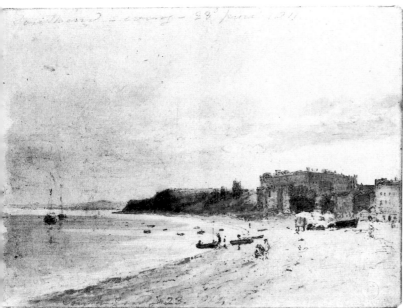

204

205

about their excursion in a letter written after his return. His host, he said, 'had occasion to visit his living of Southchurch – and I was happy to embrace his offer of accompanying him – by which I saw more of the country of Essex than I had before.'

> while Mr.D [he continued] was engaged at his parish I < strolled > walked upon the beach at South End. I was delighted with the melancholy grandeur of a sea shore – at Hadleigh there is a < Cast > ruin of a castle which from its situation is a really fine place – it commands a view of the Kent Hills the nore and the north foreland & looking many miles to sea... [later] I have filled as usual a little book of hasty memorandums of the places I saw – which You will see.[3]

Most of the known drawings from this sketchbook were done at Feering or on the Essex tour. Two record his stroll along the beach – a watercolour of Southend (FIG 204), and a neat pencil-sketch of the cliffs and shore from the water's edge (FIG 205). Above this second drawing, along the top of the page, he made a delicate little panoramic study from higher up, of the view looking diagonally across the mouth of the Thames towards Sheerness and the Nore, the stretch of sea across the mouth of the Thames, water through which he had sailed on a short but memorable voyage in an Indiaman, the *Coutts*, in 1803.[4] Seemingly with little time left, Constable made two further comparatively hurried sketches, both of the

206

castle he had seen in the distance when making his drawing of Southend: the first, from among the ruins looking back the way he had come, with Leigh Church a mere pencil pressure-point on the horizon (FIG 206); the second, from inland, with the castle in the middle-distance standing out against the full sweep of the estuary and the far-off Kentish hills (FIG 207). When making the first, his rapidly drawn sketch of the ruined towers from closer to, he could have had little idea of its ultimate importance.

In August 1828, when Constable brought his sick wife back home from Brighton, there were still hopes of a recovery. Though sadly thin and weak, she was coughing less, her appetite had improved and the nightly perspirations had 'in a great measure, ceased.'[5] But in fact she had little strength left, and it was not long before fears for her life were being openly expressed. A few days before she died, C. R. Leslie paid his friends in Well Walk a visit. He found Maria on a sofa in their 'cheerful parlour', and in her presence Constable put on a brave face, but before he left Leslie was taken aside into another room, where Constable wrung his hand and burst into tears without speaking. The end came on 23 November. Constable was shattered. Four days later he wrote to a friend.

> ...my loss, though long looked for, now it has come, has overwhelmed me, a void is made in my heart that can never be filled again in this world.
>
> I seem now for the first time to kow the value of the being I once possessed, and I know not where to look for consolation. I turn to my seven lovely infants, but children are a doubtfull good and that which the sight of them even now affords is of a mournful kind.
>
> My dear departed angel died in my arms on Sunday morning.[6]

With her departure, he told his brother Golding, the face of the world was totally changed.[7]

For a short while Constable stayed on at Hampstead. Then, with his seven children – all under eleven years of age – he moved down to Charlotte Street, and, it seems, followed the advice of his friends and began to think about his work. In a letter of 29 November, written on hearing of Maria's death, Fisher had strongly urged him during his trial to apply himself rigidly to his profession. Some of the

5 *Life*, 1951, p.167.
6 JC to H.W.Pickersgill, R.A.; JCC IV, p.282.
7 'hourly do I feel the loss of my departed Angel – God only know how my children will be brought up – nothing can supply the loss of such a devoted – sensible – industrious – religious mother – who was all affection – but I cannot trust myself on the subject – I shall <I> never feel again as I have felt – the face of the World is totally changed to me – though with god help I shal endeavour to do my next duties'. JC:FDC, p.81.
8 JCC VI, p.240.
9 Ibid., p.241.
10 Unpublished, except in Reynolds 1984, Text, 28.23, p.195.
11 Listed by Bartsch as no.45.
12 Reynolds 1984. Text, p.195.

finest works of art, he had said, had been the result of periods of distress: Richard Wilson, whom they both admired, had painted all his 'pathetic landscapes' under the pressure of sorrow. 'Set about something to shew the world what a man you are, & how little your powers can be depressed by outer circumstances.'[8] These adjurations Fisher had followed up a week later in a second letter. Constable's docter, Herbert Evans, a new friend, had reported that he was in a 'state of complete self-possession'. This state, Fisher entreated him to retain,

> ...for [he said] you have need only to look within yourself, and find satisfaction. I wish if "Brighton" [*Chain Pier, Brighton*] is not out of your possession that you put it on an easil by your side, Claude fashion [?], & so mellow its ferocious beauties. Calm your mind and your sea at the same time, & let in sunshine and serenity. It will be then the best sea-painting of the day.[9]

Brighton was probably still too fresh and painful a memory for him to be able to take up the painting and start re-working it. But the notion of a coastal scene as the subject for a picture appears to have caught on. Only a few days after receiving Fisher's letter, on 13 December, Constable is to be found writing from Charlotte Street to William Tiffin, a dealer in the Strand, about an engraving he wanted, one of a series of views of the ancient ruins in Rome by the Italianate landscapist, Herman van Swanevelt.[10] The print Constable mentions specifically has, he says, 'a road [and] Round Tower on the Right'. The seventh in the series best answers this description, *Ruins on the Palatine Hill* (FIG 208)[11] which, as Graham Reynolds pointed out,[12] is almost a mirror-image of the composition in FIG 206, the original pencil-sketch of Hadleigh Castle in a similar ruined state, with its massive walls cleft and open to the elements. Further evidence of Constable's interest in ruins and of a link between the two compositions is provided by the enclosure with his letter to Tiffin, a pair of pen-and-ink drawings on one sheet of two more Swanevelt prints from the Roman series that he wanted the dealer to find for him (FIG 209). Stylistically, the sketches on this sheet closely resemble our pen-and-ink Hadleigh composition (PLATE 29). There may have been no great distance in time separating the two.

208

209

FIG 210 Herman van Swanevelt *Ruins on the Palatine Hill*
Etching, 8.6 × 14 cm. Christopher Mendez, 1988.

FIG 211 Herman van Swanevelt *Ruins on the Palatine Hill*
Etching 8.1 × 13.7 cm. Christopher Mendez, 1988.

210

211

It would be helpful for an understanding of Constable's studio works to have some idea of the strength and scale of his powers of visual recall; to know how dependent he was on the sketches he had made from nature; how much he was prepared, or able, to invent (or even to fudge), and how much he could rely on his memory. In short, after a lapse of time, just how well he was able to visualise the scenes he wished to paint. In this context there is something to be gained from a brief comparison of the pen-and-ink drawings he sent to Tiffin (FIG 209) with the original Swanevelt prints that he wanted the dealer to find for him (FIGS 210 and 211; prints listed by Bartsch as Nos 37 and 38). From some of the minor inaccuracies in the two pen drawings – for example the misplacement of the break in the top of the arcaded wall in FIG 210 – and from the omissions – the two figures

FIG 212 *Sketch for Hadleigh Castle*
Oil on millboard, 20 × 24 cm.
1828–29? Collection Paul Mellon,
Upperville, Virginia.

walking away on the right and the wooded slopes beyond — it is clear that Constable's *aides-mémoire* for Tiffin were not direct copies, that they were drawn from memory. Where and when he had seen the originals is not known. Perhaps it was quite recently, in a friend's collection; possibly that of the collector John Sheepshanks, from whom he had borrowed a rare Swanevelt etching to copy.[13] But whenever it was, comparison shows that although there are minor discrepancies, on the whole, Constable's recollection of the two Swanevelt prints was remarkably complete, that, in fact, his visual memory was exceptionally good — approaching the so-called 'photographic'. From this we may proceed with the reasonable working assumption that when he was at his easel in his London studio engaged on one of his Suffolk subjects, he could visualise the scene pretty clearly and could paint effectively from that mentally held image. If Constable and his children ever played what is sometimes called Kim's Game — a game where the players write down as many objects as they can remember of a random collection arranged on a tray that they had only been allowed to see for a minute or two — we can be certain that he would have excelled.

It is not known when Constable made his first compositional sketch of Hadleigh Castle viewed from close to (FIG 212). It has been suggested that this preliminary study in the Mellon Collection may have been started before the death of his wife. This is quite possible. It is painted with unusually heavy, almost brutal strokes of the brush, in a manner not unlike the handling to be seen in the last of his Brighton oil-sketches of that summer that he painted on 20 July. A view looking out to sea

213 *Landscape with nymphs listening to a piping satyr, after Herman van Swanevelt.* Pen and ink; 8.9 × 11.1 cm. Inscr. 'Copy from the scarce Swanevelt lent me by Mr. Sheepshanks Hampstead 1828. 1829 May 27 John Constable R.A.'. B.M. Reynolds 1984, 29.11, PLATE 709.

214 *Stormy sea, Brighton.* Oil on paper laid on canvas. Yale Center. Reynolds 1984, 28.13. Pl.690.

212

with menacing black clouds racing in from the right.[14] The Mellon sketch could well have been done in the same agony of mind, at Hampstead, during Maria's final weeks. It is also a possibility that it was Fisher's talk of Constable's *Chain Pier, Brighton* that led to a reconsideration of the Hadleigh subject, a re-think, as a result of which there took place quite an important change of emphasis.

Reproducing almost exactly the same original drawing, the subject of the Mellon sketch is essentially a ruin, with the sea only a distant strip of light. Our pen-and-ink drawing (PLATE 29) represents an entirely new approach. With the castle more to one side and with the introductioin of a wide stretch of water and low-lying shore, this has become a proper coastal scene, like the Brighton picture. The change of emphasis – this opening up of the composition – brought into play new thematic material: the 'Nore',[15] with all its shipping; and the landscape on the far side, the North Foreland, the Kentish Hills and Sheerness, with its harbour (the entrance to the Medway), a landscape for part of which he could turn to the little panorama he had drawn so carefully in 1814, above the sketch of the cliffs (FIG 205). Before, the composition had consisted chiefly of a massing of forms, with the monstrous cleft in the round tower a positively threatening feature. Now, Constable was attempting to achieve an equilibrium, a finer balance of solid and void, as well as an evocation of two earlier lives – of his during that difficult period before his marriage, and then, earlier still, when he was in his twenties, and had spent nearly a month on board the Indiaman as a guest of his father's friend the commander, on the first leg of the *Coutts'* voyage to the Far East.

When first trying out the extension of the composition to the right in the pen-and-ink drawing, Constable exaggerated the height of the hills and somewhat over-stressed the importance of the whole Kentish coastline. On the scale of the final painting (FIG 213), there was no need for this; he could render the thin strip of landscape relatively accurately and achieve the balance he wanted by other means, by spotlighting Sheerness with a shaft of sunlight and by detailing with great intensity the Medway anchorage and the passing ships. There were other changes to the composition first introduced in the pen drawing. In the Mellon sketch some of the original drawing's scribbled shapes at the foot of the further tower became crude, lumpish forms, parts of the crumbling ruin, but among the original pencil scribbles Constable had noted rather more precisely an ovoid, bush-like shape. One cannot be certain what he meant this to represent, but if it was a bush or young tree as it seems to be, this could have provided him with the idea for a mature tree, taller than the tower beside it, that he drew rising up from among the fallen masonry in the pen-and-ink study, a feature he retained and elaborated in the two final canvases – perhaps as an expression of his belief in 'the resurrection and the life'.[16]

The figure with the dog was also freshly considered. When he came to make his first oil-sketch of Hadleigh (the Mellon painting), he had evidently felt that to animate the scene he required more than the few birds wheeling around the main tower that he had originally noted (FIG 206), and so had introduced a figure on the extreme left of the composition, a shepherd standing watch while his flock grazed about him. In the pen-and-ink re-shaping of the composition he brought the shepherd rather more into the picture with the dog at his heels, but dismissed the sheep. At the next stage, the full-size, penultimate canvas in the Tate Gallery,[17] there are sheep-like forms to be seen, but many are indistinguishable from lumps of masonry. In the final work that he exhibited in 1829, in which a number of

15 In his correspondence with David Lucas, Constable quite often refers to his painting of Hadleigh Castle and the mezzotint of it as 'the Nore'. Often used somewhat loosely as a synonym for the mouth of the Thames, the Nore is more accurately described (in translation) by J. van Keulen in his *Atlas* of 1727 (2nd part, p.17) as 'a sand near the Island of Grain, running a half mile eastwards, and at the east there is a buoy with 12 foot at low water. . .The church at Minster on the Isle of Sheppey lies South by East and the point of Sheerness lies S W from the buoy of the Nore.'

16 Quoted by Constable in a letter to Maria Bicknell of 9 May 1819:
'Every tree seems full of blossom of some kind & the surface of the ground seem quite living – every step I take & on whatever object I turn my Eye that sublime expression in the Scripture < seems verified before> 'I am the resurrection & the life ' &c seems verified < before> about me.'
Fleming-Williams and Parris, 1981, p.33.

17 Oil on canvas. Parris 1981, pp.128–33, repr. p.129.

FIG 213 *Hadleigh Castle*
Oil on canvas, 122 × 164.5 cm. Yale
Center for British Art.

other figures and beasts are to be seen, the flock has vanished, and the shepherd, a solitary figure with his crook and his dog, plods somewhat wearily through the ruins.

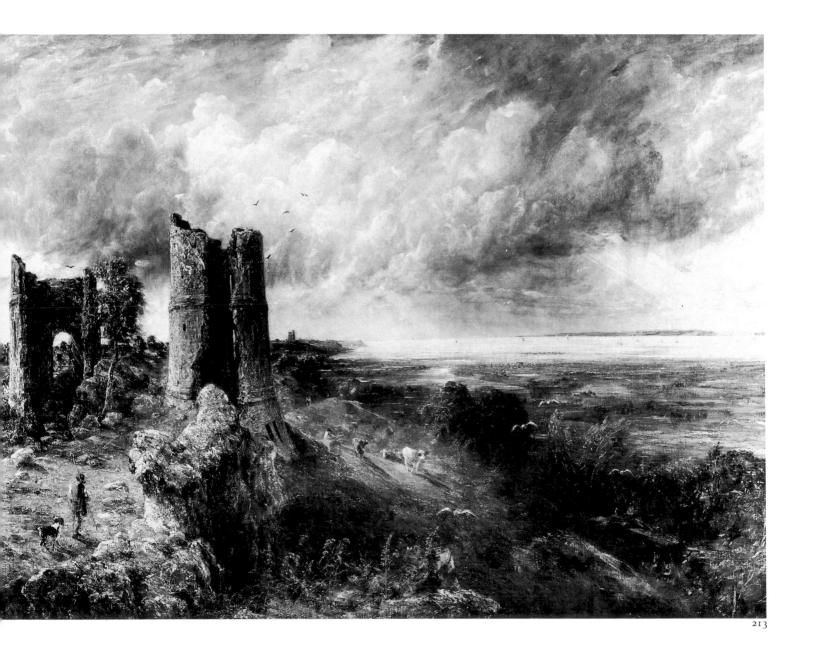

17 The Small Salisbury – retouched

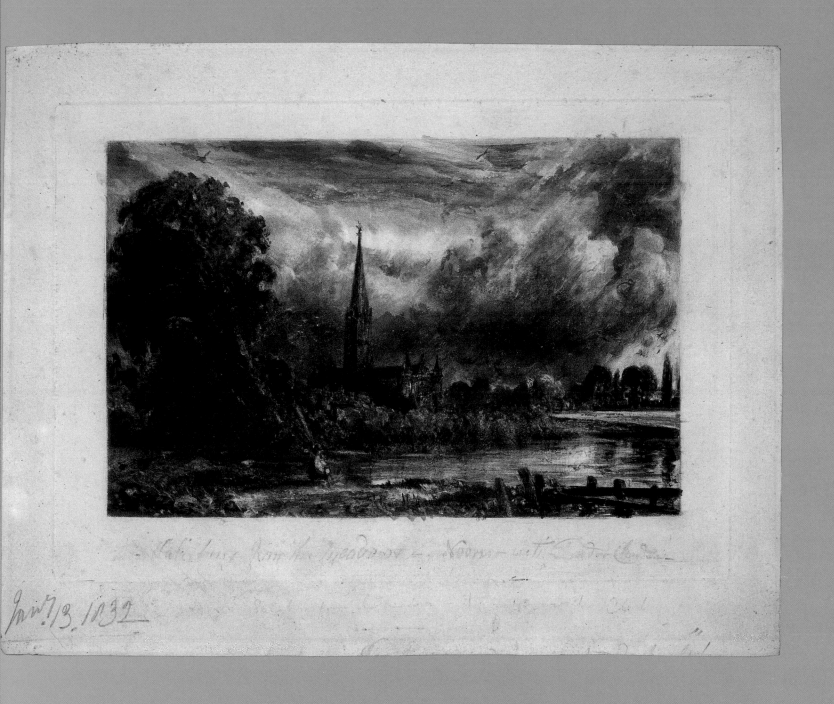

PLATE 30 *The Small Salisbury*
Mezzotint on wove paper touched with grey wash and white 22.5 × 28.9 cm.; plate
17.1 × 25 cm; image 17.6 × 23.4 cm.
Inscribed in pencil below image 'Salisbury from the Meadows – Noon – with thunder
clouds'; and in pencil bottom left 'Jan.ᵞ 13. 1832'.

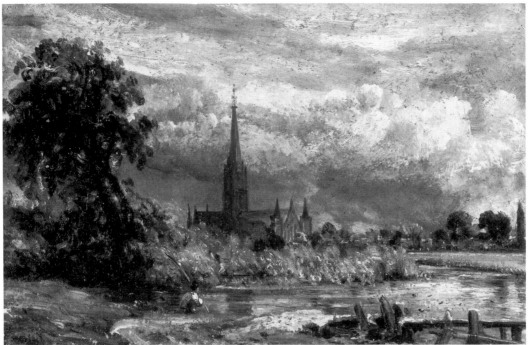

214

FIG 214 *Salisbury Cathedral from Long Bridge*
Oil on paper mounted on card, 18.4 × 27.9 cm. 1829? Private Collection. An oil sketch that only came to light in 1982.

PLATE 30 reproduces a progress proof of a mezzotint after one of Constable's oil-sketches, a print over which the artist has worked with wash and white heightening. Only a few small areas have been left untouched; the work is otherwise entirely autograph. The original sketch from which the mezzotint *Salisbury Cathedral from Long Bridge* (FIG 214) was made, is one of a pair of small compositional studies in oil for the six-footer, *Salisbury Cathedral from the Meadows* (FIG 215), that came to light in 1982. Both derive from pencil drawings Constable made on the spot in the larger of the sketchbooks used during his two visits to Salisbury in 1829.

That year, Constable clearly had his eye on the cathedral in the middle distance as the subject for a new easel-painting. In all, the larger sketchbook contained seven drawings of the cathedral, all but one of which were of the great church from across the meadows or from similar view-points. On previous visits he had drawn the cathedral many times (this visit of July 1829 was his sixth): from nearby in the Close; from afar – Harnham Ridge to the south and Old Sarum to the north; and from the surrounding fields and river-banks. But in none of his earlier sketchbooks is there to be found such a concentration on one type of view – the church with its spire as seen above the tree-tops from the water-meadows. He had obviously decided on the kind of view he needed and had prowled along the river-banks for an aspect that would compose well. While doing so he also appears to have been on the look-out for an incident that might provide human interest.

On the banks of the northern branch of the River Nadder (see FIG 216), he found two view-points he liked, one of the cathedral from some distance upstream, the other from a spot rather nearer, beside a footbridge (Long Bridge) that crossed the confluence of the two millstreams below Fisherton Mill. It was from here that West Harnham could be reached from Salisbury by a footpath – the Town Path – that had been incorporated into the complex system of floated water-meadows to the west of the city. Of each of these views he made a drawing.

FIG 215 *Salisbury Cathedral from the Meadows*
Oil on canvas, 151.8 × 189.9 cm.
Exhibited 1831. Private Collection, on loan to the National Gallery.

FIG 216 *Map of the River-system and the watermeadows west of Salisbury.*

215

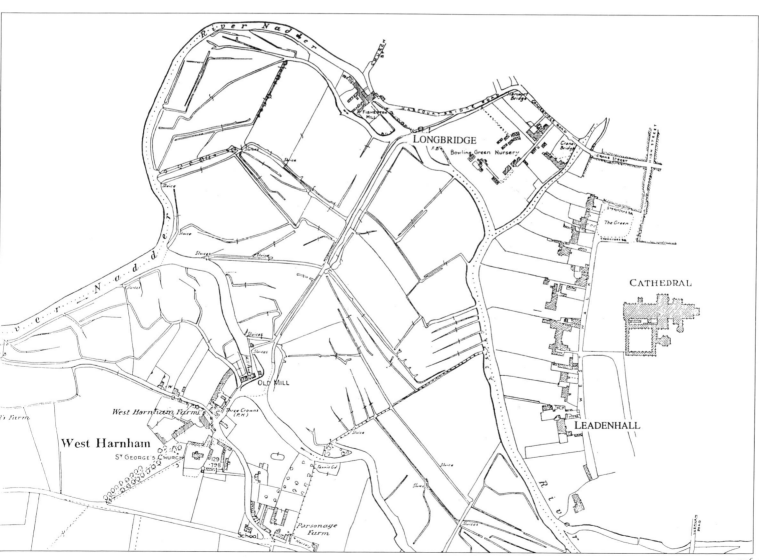

216

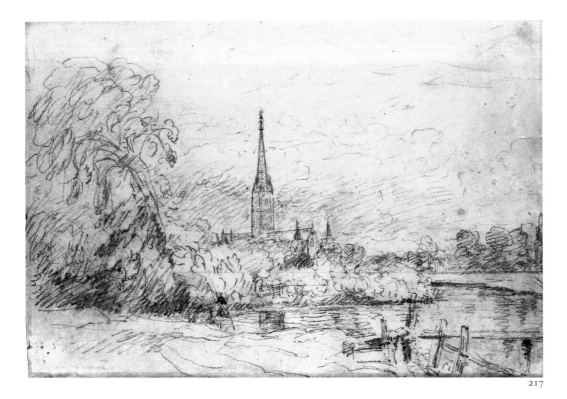

217

1 Shirley (1930, p.193), in his description of the mezzotints, talks of progress proof 'a' having scaffolding at the top of the spire, and progress proof 'c' lacking scaffolding.
2 Possible reasons for the ruled horizons or horizontals that appear in a number of Constable's drawings are dicussed on p.273ff.
3 The water-course along which the driver is taking his horse and cart to the ford, is a channelled branch of the River Avon (now diverted to the south), the main stream of which joins forces with the River Nadder a little further downstream (see FIG 216). The rivers around Salisbury, and the naming of the several systems can easily confuse the visitor (as well as the art historian), especially as the names on the older maps differ from those in present use. FIG 216 shows the systems to the south and west of the cathedral and its Close. It will be noted that to the west the Nadder splits into two branches, and it is the northern branch that passes through Fisherton Mill, is forded at Long Bridge, and first joins the Avon – at which point it defers, and surrenders its name, so that the water flowing past the Leadenhall lawns, so often painted by Constable, is that of the Avon. The Nadder finally loses its identity when the southern branch joins the Avon just above East Harnham. Here, incidentally, there is room for further confusion. A short distance before this, a branch of the Avon leaves the main stream to rejoin the parent river a little further down. This creates an island, St John's Island. It is here, where the river divides, that the southern route out of Salisbury crosses the Avon by two bridges. Constable drew and painted both bridges. The well-known drawing in the B.M. of 1820 (Reynolds 1984. 20.55 pl.176) and the Luton Hoo painting (ibid. 20.54 pl.175) are of the three-span southern bridge that crosses the main stream. The watercolour, *Old Houses at Harnham Bridge* in the V.& A. (ibid. 21.72 pl.275), is of the subsidiary branch of the Avon and the bridge that crosses it to the north of St John's Island.

From Long Bridge, a pencil-sketch (FIG 217), with a ruled horizon, a certain amount of detailing in the cathedral (including what appears to have been some scaffolding high up near the top of the spire[1]), part of the footbridge sketched in, and with the figure of a fisherman on the near bank to left of centre. Of the view of the cathedral from farther off he made a rapid, less careful drawing (FIG 218), with the elements more spaciously disposed and with the germ of an idea noted that ultimately became an important feature of the final painting – men and horses with wagons or carts making their way through waist-high reeds or rushes towards the river-bank. Quite an elaborate series of ruled horizontals informs this drawing – three on or near the horizon and a fourth across the breadth of the river lower down on the right.[2]

Neither of these two drawings is dated. However, there is another of the subject from the same sketchbook, in the Lady Lever Gallery, Port Sunlight, that has been inscribed with a date, a drawing of the Long Bridge scene but composed afresh on a more open scale, with a horse pulling a cart, axle-deep, towards the ford, and a dog following a figure on the footbridge (FIG 219).[3] Unfortunately, part of the date has been lost through trimming, and the inscription now reads '. . . 11. 1829', only. The loss in this case is particularly regrettable as the drawing appears to represent a second stage in the development of the composition of *Salisbury Cathedral from the Meadows*, and it would have been helpful to know by which date he had reached that stage, by 11 July, that is within four days of his arrival on the first of his visits, or, working at a more leisurely pace, by 11 November, during his second visit of the year. Some of the evidence seems to favour the second date.

From a letter Fisher wrote on 9 August we learn that he and Constable had already discussed the subject of the artist's next picture, of the cathedral, and that Constable planned to make a start on the work, which was to be on a sizeable scale, on his next visit. 'The great easil has arrived & waits his office', Fisher wrote,

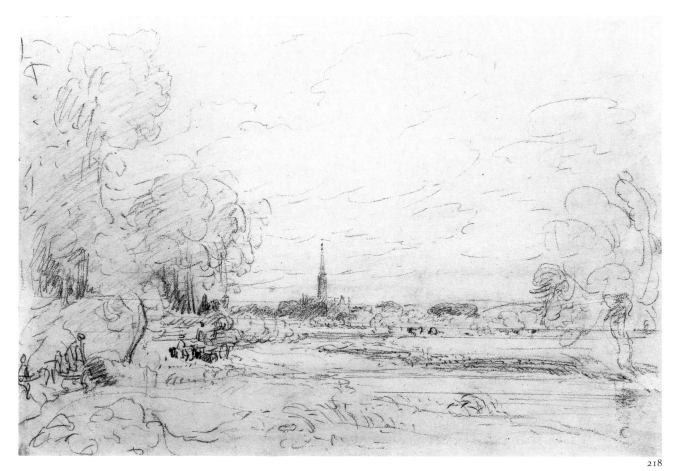

218

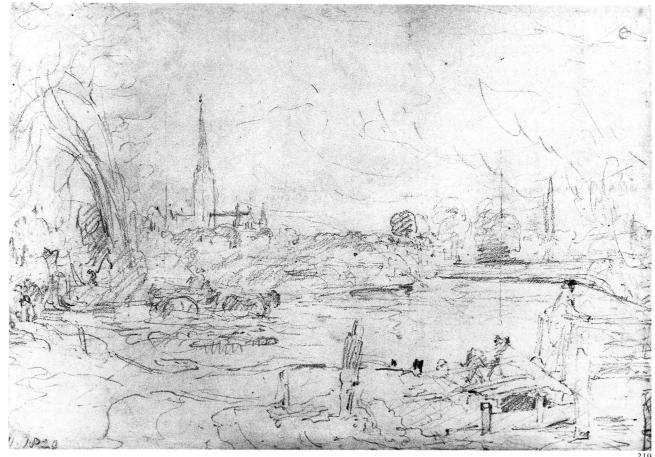

219

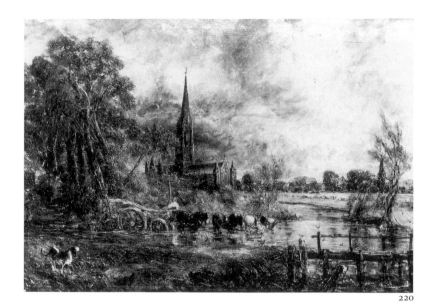

220

'Pray do not let it be long before you come and begin your work. I am quite sure the "Church under a cloud" is the best subject you can take. It will be an amazing advantage to go every day & look afresh at your material drawn from nature herself.'[4]

Knowing full well Constable's procrastinating habits, Fisher was anxious that his friend should join him at Leadenhall, his house in the Close, to start on the new work before the inclement weather set in. On 3 September he wrote to say that he was shortly coming to town and proposed bringing Constable back with him by the night coach on the 11th. The remarkable passage from his letter that follows has much to tell us about the men and their friendship, but also about Constable's scheme for work. He was evidently intending to start on his next big canvas not, as had been his practice ever since his marriage, in his London studio, but down in Wiltshire, in the Archdeacon's house.

> I yearn to see you tranquilly & collectedly at work on your next great picture; undisturbed by gossips good & ill natured; at a season of the year, when the glands of the body are unobstructed by cold, & the nerves in a state of quiescence. You choose February & March for composition; when the strongest men get irritable & uncomfortable; during the prevalence of the NE: winds, the great distruction of the frame, & the gradual cause in England of old-age. How at such a season, can your poetical sensitiveness have its free and open play? Sep: Oct & Nov: are our healthiest months in England, Recollect, Milton had his favourite seasons for composition. The season you select for composition is the chief reason of the unfinished, *abandoned* state of your surface on the first of May [when the exhibition at the R.A. was opened to the public]. Your pictures look then like < ... > fine handsome women given up to recklessness and all abominations.
>
> I long to see you do, what you are fully capable of, < .. > "touch the top of English Art." To put forth your *power* in a *finished polished* picture; which shall be the wonder & the imititation – struggle of this & future ages. – But any freak of imagination or anxiety distracts you. Now come and work, & don't *talk* about it.[5]

Between this last letter and the next of 21 October, Fisher appears to have received one from Constable about his forthcoming visit, possibly to assure him that he would be coming down before long. It was matters of some importance

221

222

that were keeping him in London. He had begun work on a most ambitious project, the employment of a young engraver, David Lucas, to produce for him a series of mezzotints from his oil-sketches and paintings for publication. Fisher may have been unaware of this. 'You have said for the last three months,' he wrote, 'that you were coming here, & and I have been patiently expecting you. But I am sorry to say that the trees are already naked . . . I know nothing that will give me more relief & pleasure than your company. So come soon.'[6]

It is not known exactly when Constable was able to tear himself away from his work with Lucas. Sir Thomas Lawrence wrote on 27 October to acknowledge the receipt of one of the freshly printed mezzotints, a view of Old Sarum, which Constable had sent him,[7] so Constable may still have been in town then. But in a letter postmarked 23 October[8] his brother Abram had said he thought there was a chance for the weather to be fine for his Salisbury journey, and it is unlikely that Abram, a miller, would have attempted a forecast for many days ahead, so Constable may have joined Fisher before the end of the month. This makes sense. Hitherto, it was thought that the main purpose of Constable's second trip was to fetch his daughter, Minna, who had been spending the summer with the Fishers.[9] But Constable's dispatch of a large easel in August is surely evidence of an intention to work on a big canvas on his next visit to Salisbury, and when Fisher wrote in September he was clearly expecting Constable to begin his next great picture down there. Three weeks would have been time enough for a reasonable start on a large canvas, perhaps on the full-scale sketch now belonging to the City of London (FIG 220). Which brings us back to the work that preceded it – the oil-studies and the drawings on which they were based – and the questions, when they were done and in what order.

In all, there are three small oil-studies for the big *Salisbury Cathedral from the Meadows* (FIG 215), the newly discovered pair, originally given to Alice Fenwick by Isabel Constable (FIGS 214 and 221), and a larger one in the Tate Gallery (FIG 222). The first two have much in common. They are of a similar size and both are painted on paper prepared with a brown ground. Though there are some touches of red in the Long Bridge sketch that are not in the other, Constable has otherwise used the same limited palette in both – Prussian blue, umber and yellow

4 JCC VI, pp.250–1. Much, possibly too much, has been made of Fisher's remark about the 'Church under a cloud'. An article in *Turner Studies*, Vol.5, no.1, 1985, 'Constable's ''Church under a cloud'' some further observations', by Edward S. Harwood, presents refreshingly new ideas on the subject.

5 JCC VI, p.252.

6 Ibid., p.253–4.

7 JC:FDC, p.234.

8 JCC I, p.257.

9 'Constable's last visit of all to Salisbury was made in November. It was probably a short one, undertaken for the purpose of bringing Minna home,' Beckett commented in JCC VI, p.254.

ochre.[10] Despite certain differences in handling, the Fenwick pair have a definite 'family' likeness, a resemblance they do not share with the Tate painting. This (FIG 222), just about twice the size of the other two, is painted on canvas, and in a style Constable adopted for some of the preparatory sketches in his later years – loosely connected dabs and touches of paint applied with the brush or palette-knife, with little or no attention paid to detail, producing overall a flickering, fluffy sort of texture. The two Fenwick sketches are much less arbitrary in character. These, as we have said, were both taken from drawings made on the spot (FIGS 217 and 218). The Tate Gallery painting was based on the dated, Port Sunlight pencil-sketch (FIG 219), a drawing that we should perhaps look at again for a moment.[11]

This pencil study, lacking entirely the spontaneity of the other two, appears to be a reconstruction of the scene from memory. Its purpose is clear: to take the Long Bridge view a stage further. For a large work on the scale Constable had in mind, neither of the other drawings, nor the more fully realised oil-sketches would do. In the Mellon drawing and its companion oil, the cathedral was evidently too remote. The two Long Bridge oil- and pencil-sketches appear satisfactory as they are, on a small scale, but enlarged on to a six-foot canvas the cathedral might loom too large with only a solitary fisherman to balance its dominating bulk. The Port Sunlight sketch (FIG 219) envisages possible modifica-tions – the horizon raised, the cathedral reduced in scale, the fisherman moved aside to the left-hand edge – and introduces two new incidents, a driver taking his horse and cart towards the ford and a dog and its master about to cross the footbridge.

These, with further innovations, were tried out in the Tate painting. Instead of one horse, a team led by a grey now pulled the cart (which as yet showed no signs of becoming a wagon). Buildings now replaced a pollarded willow trunk on the extreme left-hand side.[12] The fisherman was given only a passing thought, a couple of flicks of the brush, near the water's edge under the main tree. In the drawing, just beneath the cathedral, there is a suggestion of roof-tops. A small red-roofed building, probably the 'gardner's shitten house' Constable refers to in a letter,[13] is to be seen in the Fenwick sketch among the bushes below the spire. This survives as a spot of red in the Tate Gallery painting and, with a cluster of red roofs and smoking chimneys becomes an integral part of the final work. It is interesting to note that the fisherman in the Fenwick sketch, with his red jacket and rod at the slope, is transposed in the final version into the carter with his whip over his shoulder.[14]

With an apparently complete set of preliminary sketches such as this before us, the pattern of work that preceded the move to the first large canvas seems to be fairly clear. First a sketchbook reconnaissance of the meadows and river-banks with the subject, a view of the cathedral at a distance, already in mind. Then, a short-listing to the two drawings made beside the Nadder to the north-west – the Fitzwilliam and Mellon pencil sketches (FIGS 217 and 218). Next, a try-out in oils of these two subjects – the two Fenwick paintings (FIGS 214 and 221). Then a compositional reframing, the Port Sunlight pencil drawing (FIG 219), a version of the Long Bridge view with the scene extended to the right and peopled with figures, horses and a dog. Finally, before starting on a full-size canvas, the new scheme is in turn tried out in oils, this time on a larger scale – i.e. the Tate Gallery painting (FIG 222).

It is not equally clear when and over what period of time Constable carried out this preliminary work; whether he made a start in July on his first visit, or during his second one in November. Fisher's remarks in his letter of 9 August about the church under a cloud help us neither one way nor the other. Our only guide appears to be the cropped date in the bottom left-hand corner of the Port Sunlight drawing, '...11 1829'. This slightly favours a choice of the second, the November visit for the later stages. On 4 July Constable told Fisher that he and his two children would be travelling down to Salisbury on the 7th.[15] Would he have reached the third stage of the work, the recomposing of the subject, within four days of his arrival? Is it not more probable that there was a longer period of gestation for a work of such importance, and that he reached that fairly advanced state much later, well on into his second visit — that is, by 11 November?

After this dated drawing — whether July or November — we know nothing more until just before the final painting was sent in for the Academy of 1831. As usual, Constable appears to have been working on it only days before sending-in day on April 5th. On 23 March he wrote to David Lucas,

> ...I have made a great impression to my large Canvas — Beechey was here yesterday — and said 'Why *damn* it Constable what a *damned* fine picture you are making but you look *damned* ill — and you have got a *damned* bad cold' so that you have evidence on Oath of my being about a fine picture & that I am looking ill.[16]

He was still at work on the painting on the 28th when his ten-year-old son, Charles, wrote to tell his sister Minna that: 'Papa is painting a beautiful Picture of Salisbury Cathedral'.[17]

Hung in the exhibition in Somerset House, by Constable's own choice, next to Turner's even larger and veritably molten *Caligula's Palace*,[18] the *Salisbury* had a mixed reception. 'Fire and water', said the *Literary Gazette*, comparing the two, 'the one all heat the other all humidity.' The *Times* critic considered Constable's work to be vigorous and masterly, despite clouds such 'as no human being ever saw' and a foreground spotted all over with 'whitewash'. The reviewer for the *Observer* and *Morning Chronicle*, who was conducting a one-man vendetta against Constable, likened the *Salisbury* to a song 'roared out by a coal-heaver...for coarseness and vulgarity are the marked characteristics of Mr C.' In a letter of 2 June (1831), Constable told Leslie that the *Library of Fine Arts* had spoken highly of his, Leslie's exhibits (which included the well-known *Uncle Toby and the Widow Wadman*), '& perhaps fairly of my "Chaos" as they term the Salisbury. They say (after much abuse & faults) "it is still a picture from *which it is impossible to turn without admiration*"'.[19] In his *Life* Leslie tells us that the *Salisbury* was a picture that Constable felt would in the future be considered his greatest — 'as conveying the fullest impression of the compass of his art.'[20] Needless to say, the painting failed to attract a buyer.

There was something of a Pygmalion in Constable. For him, a painting such as the *Salisbury* seems to have become a thing with a life of its own, requiring maintenance, continual care and replenishment. He was at work again on the picture in January 1833, prior to sending it in for the British Institution exhibition of that year and Leslie was asked to come and see the result. 'I have got the great Salisbury into the state I always wanted to see it — and yet have done little or nothing — "it is a rich and most impressive canvas" if I see it free from self-love. I long for you to see it'.[21] One wonders what he meant by 'little or nothing'; in a

10 Visual estimate only of pigments used.

11 Both are squared-up with ruled, diagonal lines for enlargement.

12 In the final work, these became the tower of St John's Church — which, from Long Bridge, would not have appeared so close to the cathedral — and some red brick houses. It was evidently Constable's intention to include St John's in the Tate version of the composition, for the pencil outline of the tower can be seen as a pentimento a little above the painted image of the buildings. Constable had a liking for 'eye-escapes', as they might be called, right on the edges of his big compositions. In *Dedham Vale: Morning* of 1811 (Tate 1976, no.100, repr. p.76) there are two — Dedham Church on the left hand and a little landscape vignette with cattle (based on a drawing in the Louvre) on the extreme right-hand side. In *View on the Stour* (Reynolds 1984 22.1 pl.334) the eye picks up the line of the distant meadows through the branches of a willow on the left; and Dedham Church is placed in a topographically impossible position to the right in *The Leaping Horse* (ibid. 25.1 PLATE 572). In *The Cornfield* (ibid. 26.1 PLATE 611) the eye 'escapes' through to the sky past the headland of ripe wheat half-way up the left-hand side of the picture.

13 In a list of instructions to David Lucas for alterations to the mezzotint, the large *Salisbury*, enclosed with a letter of 11 November 1836 (JCC IV, p.457); in a letter of 19 January 1837 (ibid., p.433), also referred to as 'the necessary'.

14 In the final painting, an old woman in a red shawl makes her appearance on the nearer bank close to the left-hand edge.

15 JCC VI, p.248.

16 JCC VI, p.346.

17 JCC V, p.130.

18 *Caligula's Palace and Bridge*, Tate Gallery. Thornbury (*Life of J. M. W. Turner*, 1862, Vol.II, p.45) was given an account by David Roberts of an incident at General Phipp's house which Finberg (*Life of Turner*, 1961, p.327) dated 1831. Constable had been on the R.A. Hanging Committee that year, and, according to Roberts (no admirer of Constable, it seems) '...was as usual, lavish of the pains he had taken and the sacrifices he had made in arranging the exhibition. But, most unfortunately, he had, after placing an important work of Turner's, removed it, and replaced it by one of his own. Turner was down upon him like a sledgehammer; it was no use his endeavour to persuade Turner that the change was for his advantage, and not his own. Turner kept at it all evening, to the great amusement of the party, and I must add, he [Constable] richly deserved it, by bringing it on himself.'

19 JCC III, p.40.

20 *Life*, 1951, p.237.

21 JCC III, p.89.

previous letter, written a day or two before, he had told Leslie that he had 'much to do with the great Salisbury' and was 'hard run for it'[22] (i.e., pressed for time). There was further repainting in August of the following year, 1834, before the picture was sent for exhibition in Birmingham.

> My dear Leslie
> I have never left my large Salisbury since I saw you. It would much – very much – delight me, if, in the course of today (as it goes tomorrow), you could see it for a moment. I cannot help trying to make myself believe that there may be something in it, that, in some measure at least, warrants your (too high) opinion of my landscape in general.
> Prithee if possible come.[23]

There is no record of further work on the *Salisbury*, but Constable's commitment to the picture was entire, and presently a new opening renewed his interest in the work.

Ten years before, in 1824, when Constable had suddenly become a name famous in Paris, with a promising new market in prospect, the engraver S. W. Reynolds had borrowed Constable's Academy exhibit of that year. 'A boat passing a lock', an upright canvas of Flatford, commonly known as *The Lock* and had started on a large, 15 × 13 in. engraving of it. For some reason this was not a success. Progress proofs from the plate are mentioned in the Correspondence[24] but the print was never published. At this time David Lucas (1802–81) was serving his apprenticeship with Reynolds (he may even have worked on the mezzotint of *The Lock*) and it is possible that he and Constable first met in the Reynolds workshop. Five years later, in 1829, he began to work for Constable, and for the next three years was engaged almost exclusively on the plates for his employer's ambitious but ill-starred *Various Subjects of Landscape, Characteristic of English Scenery* (known, for short as the *English Landscape*), the publication in five parts of mezzotints after twenty-two of the artist's oil-sketches and paintings. When his work for Constable began to slacken off, in the autumn of 1832 Lucas decided to undertake an enterprise of his own, the engraving of a large, 22 × 14 in. plate version of the subject that Reynolds had attempted, Constable's *Lock*. With an equally large mezzotint of *The Cornfield*, this was finally published in 1834 by F. G. Moon, Publisher to the King. Lucas next attempted *Stratford Mill* ('The Young Waltonians'), but there were ructions over this and he laid the plate aside. When the air had cleared a little he set to work preparing an even larger plate (21 × 27 in.) for his penultimate Constable, *Salisbury Cathedral from the Meadows*. This huge canvas, Constable's second largest, was sent round to Lucas on 27 December 1834, 'with every good wish for its success.'[25] Over many of the earlier mezzotints – the small *Salisbury*, for example, as we shall shortly see – there had been agonized storms of despair and rage, passionate remonstrances and rebutments, mostly on Constable's side. This time, things were rather less fraught. Constable had played no part in the work on the two prints that Moon had published, but he encouraged Lucas to undertake the large *Salisbury* and even offered to share the cost. 'If you were afraid of the whole risk', he wrote on 20 December 1834, 'I would releive you – I would at least advance money all the time – and do my share if required in any other way – most satisfactory to your own peace of mind.'[26]

Lucas was now no longer working exclusively for Constable and progress on the plate was slow. However, proofs began to circulate the following June and a

date was finally fixed for publication on 20 March 1837. It is doubtful, though, whether the final version was ready for the publishers, Hodgson and Graves, by then. Constable was still writing to Lucas with instructions on the 29th. That letter proved to be his last. On the night of the 31st, he suffered an entirely unheralded heart attack, and died within the hour.

The renewal of his working partnership with Lucas had given Constable a lot of pleasure. As before, Lucas would copy the original (squared up with threads to facilitate the work)[27] on to the steel plate, scraping and burnishing the prepared ground to obtain his lights. Then, at some stage, he would take a few trial impressions, progress proofs, and send or himself take some of these to Constable. If Lucas was doing as he wished, Constable would only comment and the work would proceed. But just as he found it difficult to bring a major painting to a finish, feeling as he seems to have done, that a picture had to be kept alive by constant attention, so it had been with many of the earlier plates, and so it was with the *Salisbury*. Successive proofs, worked over with wash and white heightening (as with our small *Salisbury*) and even with bits of white paper stuck to the surface, would be sent back to Lucas with written instructions, or Lucas would be sent for to be told what fresh improvements Constable had thought up. He was delighted with the first impressions: '. . . it never can or will be grander than it is now. It is awfully so', he wrote on 30 June 1835.[28] On September 6th he had something to say about rainbows, probably because he had been at work on a large watercolour or the studies for it – a view of Stonehenge with parts of a double rainbow seen against a stormy sky.

> It is long since I have seen you – many week – I am most anxious to see you on all accounts – but I wish to talk to you about our Rainbow in the large
> < picture > print – if it is not exquisitely done – if it is not tender – and elegant – evanescent and lovely – in the highest degree – we are both ruined – I am led by this having been very busy with rainbows – and very happy [?] in doing them – by the above rules. Would it not be better to leave it wholly to be done when the print is finished – but of this you know best whether it is practicable or not . . . I hope the "Rainbow" is not begun yet, till I see you.[29]

We can sample Constable's attention to detail and the demands he made of Lucas by following his observations on the rainbow in the remaining letters to his engraver. The general result he was aiming to achieve is well set out in a letter to Lucas of 15 February 1836.

> we must bear in recollection that the sentiment of the picture is that of solemnity, not gaiety – nothing garish, but the contrary – yet it must be bright, clear, alive, fresh, and all the front seen[30]

19 January, 1837, from notes sent to Lucas with a touched proof:

> . . . As to the sky – let it all alone present except <?. . .> clearing the rough light away from the lightning.
> Never mind the birds – except the one between the spire and the bow [i.e. rainbow] – I have cleared the Whole of the bow & interior light it is quite right and had better be done – & as it forms the *subject* of the picture must be clear clean – & tender – though conspicuous –
> . . . We must keep this proof as a *criterion* and get as much of it as we can – the *Bow* is grand whole – provided it is *clean* & <? . . .> tender
> The water under the dark horses must come to this – and look as it does after the waggon – and hind wheel –
> How I wish I could scratch and tear away at it with your tools on the steel[31]

22 Ibid., p.88.

23 Ibid., pp.112–3.

24 Constable to Maria C., January 1825, JCC II, p.374; Constable to Fisher, 23 January 1825, JCC VI, p.191.

25 JCC IV, p.419.

26 Ibid., p.418.

27 In 1836, Lucas was working on a large plate from Constable's *Dedham Vale* of 1828 (National Gallery, Edinburgh). On November 11 Constable wrote to Lucas asking to have the picture back for a few days, as his sailor son, Charles, was home on leave and wished to see it (JCC IV, p.429).

If the *Dedham Vale* is so that Joseph [a handyman] *could return with it till after Sunday as Charles wants to see it, if the threads are off. If not never mind* – only he may never see it again!!!!

This talk of the 'threads' must surely indicate that the painting was squared up for copying with thread. For enlarging, ruled pencil lines were drawn on the sketch and the big canvas (traces of these can be seen on the Tate sketch and the 6ft Guildhall sketch for *Salisbury Cathedral from the Meadows* Reynolds 1984, 31.2, pl.793). But for reducing from a large painting to a steel plate, this would not have been possible. It would have been practicable, however, to criss-cross the big canvas with threads that could readily be removed after use.

28 Ibid., p.420.

29 Ibid., p.421.

30 Ibid., p.427.

31 Ibid., pp.433–4.

It will have been noticed that by this time the rainbow had become the main theme of the picture. On 17 February he wrote to a friend at Arundel: 'My "great Salisbury" print is done. I shall call it "the Rainbow"'.[32]

Next, in a letter written on 18 March, two days before the date of publication:

I send you the proof, fearing you are ill.
...the cloud near the bow on the right – about midway – is too sharp, for about two or three inches – see grey chalk, & compare these changes with those you have ...

I have much anxiety about the bow – it has never been quite satisfactory in its *drawing* to my Eye – John [his eldest son] and I have now clearly and directly set it out – and in the most accurate manner possible – which must obviate all cavillings – & carping – from the learned *Ignorant*.

pray do it. and if you are frightened see me – but it can most easily be done ... Joe [a messenger] shall bring the bow proof back if you like to see it with me first ...I have put a pin in the centre of the rainbow. It is in the elder bush.[33]

Finally, from his very last letter, dated 29 March 1837 (a Wednesday – he died on the Friday night), written after a visit from Lucas.

I am quite pleased to see how you are preparing for the New bow – the proof is about what I want – I mean that you took hence
I took the Centre from the Elder bush – a blossom to the left – you will do possibly the same.
Go on as you think proper[34]

The references to the centre of the arc of the rainbow in Lucas's proof being an elder bush are of particular interest. Much has been written about underlying meanings in *Salisbury Cathedral from the Meadows*, the final painting. A popular 'clue' has been Fisher's remark about the church under a cloud being the best subject for the picture. Paul Schweizer has pointed out that the rainbow, a symbol of hope and divine blessing, significantly, ends just above Fisher's *Leadenhall,* the house in the Close of the friend to whom above all Constable felt he was indebted.[35] More recently, Edward Harwood has drawn attention to the fact that the quotation from Thomson's *Seasons* Constable chose for the catalogue entry when the painting was exhibited at the Academy (a passage describing the passing of a storm) was probably an indirect allusion to the artist's own mournful circumstances, as it is in fact the conclusion of a tragic tale of young lovers, *Amelia*, the 'beauteous maid', having just been reduced to a 'blackened corse' by a lightning bolt, leaving her lover, *Celedon*, speechless and 'fixed in all the death of woe'.[36]

Now, only in the large *Salisbury*, the mezzotint, is the rainbow centred on the elder tree. In the great painting, from which Lucas worked, the centre of the arc appears to be sited somewhat lower, nearer the water's edge. It can hardly be a coincidence, however, that Constable should have chosen to centre the rainbow on the elder blossom when setting it out on the proof for Lucas. He had painted the elder frequently, for it was a favourite, but since mediaeval times the tree had been associated with death, and Constable was fully aware of this. He refers to the elder as a melancholy tree[37] and in a lecture drew the attention of his audience to the 'elder bush, with its pale funereal flowers' that Titian had painted above the head of the dying saint in his *St Peter Martyr*.[38] If the rainbow, the 'glittering robe of joy' in the Thomson quotation,[39] is there in the painting as an emblem of hope,

of redemption, then are we not justified in assuming that the recentering of the rainbow in the mezzotint on the elder, a symbol of death, was also part of a private, submerged iconography? A return to the story of the small *Salisbury*, the real subject of this chapter, may bring us a little closer to answering the question.

The enjoyment of prints can be something of an acquired taste, and to some, for whom Constable's works are a prime source of pleasure, David Lucas's mezzotints may seem little more than black-and-white reproductions of rather poor quality – mere imitations of the original oil-sketches and paintings. Prints, however, are often capable of responding to sympathetic viewing, and few English mezzotints are more rewarding than those in the *English Landscape*, especially if one follows the story of their making. Constable's reasons for attempting such an enterprise were complex – like the history of the undertaking itself – but fundamentally one must suppose that he was motivated by the simple desire to have his landscapes better known, to reach a wider public, and to present himself to the world as he wished to be seen.

The work, as we have said, was originally a series published in five parts: four views in each of the first four parts, with a frontispiece and tailpiece in the final one. But besides the twenty-two published mezzotints, there were a number that Constable rejected for one reason or another. Some were intended for a sixth part that never materialized. Later, there was talk of publishing some of these and one or two others as an appendix, a sort of coda. A few were abandoned as 'ruined', generally because Constable simply could not refrain from making endless attempts to improve them. The small *Salisbury*, first mentioned somewhat airily in December 1830 as a possible subject for the third number – 'Salisbury, or Fisher's Garden, or Framlingham Castle'[40] – was one of those only finally published after Constable's death, in 1855, by Bohn, in a debased form.[41]

It may be remembered that Constable had started on his *English Landscape* with Lucas between his visits to Salisbury in 1829. The original sketch, *Salisbury Cathedral from Long Bridge* (FIG 214) appears to have been chosen as a subject for engraving quite late in the history of the project. The second part, which included a view of *Old Sarum*, had appeared in December 1830. Constable enclosed a plan for the remainder in a letter written to Lucas on 17 May 1831. The fifth part was to consist of:

> White Horse
> Salisbury
> Head of a Lock
> Vessels aground[42]

In his letter, Constable promised to let Lucas have 'the Salisbury [presumably the oil-sketch] for I know of nothing better = & Old & New Sarum — will suit each other.'[43] The first mention of a proof of the Long Bridge view comes in a letter to Lucas of 5 July 1831.

> I returned from Suffolk yesterday. I shall be at home *this Evening* at 7 – if you can come – with a proof the anything in particular the <'Morning'> 'summer morning' —— how get you on with the '*Mill Stream*' & how is the first proof of the '*Salisbury*'. from the meadows[44]

At present we do not know exactly how many different stages of Lucas's work on the plate were recorded by the taking of proofs, but the number – twenty or so – is considerable, matched apparently by very few of the other plates; evidence of the

2 JCC V, p.37.

3 JCC IV, pp.435–6.

4 Ibid., p.438.

5 Paul D. Schweizer, 'John Constable, Rainbow Science, and English Color Theory', *The Art Bulletin*, September 1982, Vol. LXIV, no.3, p.426.

6 Edward S. Harwood, 'Constable's "Church under a cloud": some further observations', *Turner Studies*, Vol.5, no.1, pp.27–9.

7 Constable to Leslie, 21 June 1835, JCC III, p.126.

8 Leslie, *Life*, 1951, p.294.

9 *Summer*, lines 1223–32;
 As from the face of Heavens the shattered clouds
 Tumultuous rove, the interminable sky
 Sublimer swells, and o'er the world expands
 A purer azure. Nature from the storm
 Shines out afresh; and through the lightened air
 a higher lustre and a clearer calm
 Diffusive tremble; while as if in sign
 of danger past, a glittering robe of joy,
 Set off abundant by the yellow ray,
 Invests the fields, yet dropping from distress.
 In Constable's rendering of this passage for the Academy catalogue, 'shattered' (line 1223) is replaced by 'scatter'd', and 'yet dropping from distress' (line 1232) significantly, by 'and nature smiles reviv'd'.

10 In a plan for nos 1–6, dated 9 December 1830, JCC IV, App. A, p.445.

11 Titled, *English Landscape Scenery: a series of forty mezzotinto engravings on Steel, by David Lucas*, etc.

12 JCC IV, App. A, p.447 'The White Horse', from the painting, so-called, exhibited in 1819 at the R.A., (Frick Museum, New York); Reynolds 1984. 19.1, pl.68.
 'Salisbury',
 'Head of a Lock', *A Lock on the Stour*, from *Landscape, Boys Fishing* (Anglesea Abbey), published in Part 5 of *English Landscape*, 1831.
 'Vessels aground', *View on the Orwell*, from *Shipping on the Orwell* (Reynolds 1973, V.& A. no.96).

13 Unpublished letter, Christchurch Mansion, Ipswich.

14 JCC IV, p.349.

importance Constable attached to the subject.[45] To follow and describe the work at each stage would be a task beyond the scope of the present chapter. Here it is the intention to present the story in brief and to discuss just three of the more interesting stages.

On the scale he was working for the *English Landscape* (where the image averaged about $5\frac{3}{4} \times 7\frac{1}{2}$ in), Lucas seems to have been happiest when he was engraving from one of the smaller originals such as the Long Bridge oil-sketch (FIG 214), when he could most readily provide an equivalent to the artist's brushwork with his burnishers and scrapers. He also tended to be at his best at the earlier stages when he was working on his own, unhindered by the often bewildering and contradictory instructions and suggestions with which he was frequently bombarded by Constable. In FIG 223, the first proof with the edges cleaned,[46] we see Lucas working freely and responding quite spontaneously to the original oil-sketch. By this time he had a deep understanding of Constable's art – no man, after all, had worked more closely with the artist and experienced to the same extent the full range of heights and depths to which Constable could soar and plunge – and this early proof ('B') is a splendid example of Lucas's ability to capture the dash and spirit of one of Constable's sketches in oils. Much, of course, evaded him. He never managed the birds (swallows or martins) low over the water to the artist's satisfaction – the 'v' formula then widely adopted just would not do – and colour, naturally, posed problems. In places, such as the sun-lit tree above the river-bend which Constable had painted dull green against a dull, blue-grey sky, Lucas had to substitute tonal for colour differentiation. But all in all, when seen on their own, these early proofs are remarkable achievements.

The whole series of progress proofs of the small *Salisbury* falls roughly into

FIG 223 David Lucas after Constable
Salisbury Cathedral
Mezzotint, progress proof 'B',
17.5 × 25 cm. Fitzwilliam Museum, Cambridge.

FIG 224 David Lucas after Constable
Salisbury Cathedral
Mezzotint, progress proof 'I',
17.5 × 25 cm. Fitzwilliam Museum, Cambridge.

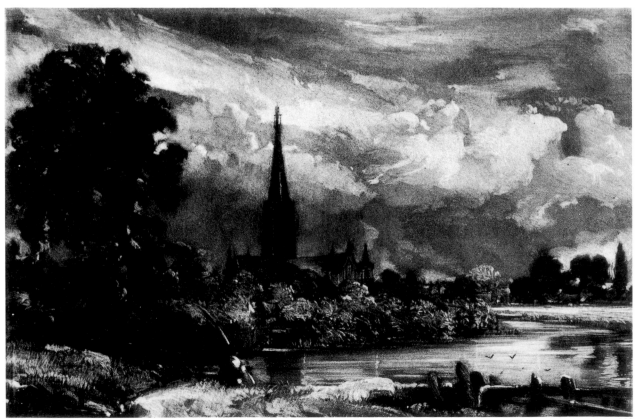

223

5 In the standard work on the subject, *The Published Mezzotints of David Lucas after John Constable, R.A.*, 1930, the author, Andrew Shirley, lists thirteen different progress proofs of the 'Small Salisbury', labelling them 'a' to 'm'. Individual proofs differ. One, taken in haste perhaps, may be more slightly inked than another. Photographic comparisons can be misleading, too, as some museum departments use more contrasting paper than others. On present reckoning, however, out of forty progress proofs seen of the small *Salisbury* (the actual objects when possible, otherwise, photographs) there appear to have been at least twenty-one different impressions; in my reckoning to be labelled 'A' to 'U'. In Shirley's listing, only four other progress proofs reach double figures: *Jaques and the wounded stag* (twelve); *A Heath*, a Hampstead view (thirteen); and the frontispiece, the artist's family home at East Bergholt (twelve).

6 In this proof, Lucas reproduced the scaffolding at the very top of the spire to be seen in the original oil-sketch as well as in the drawing in the Fitzwilliam Museum. It does not appear in subsequent proofs. The same feature may be discerned in a drawing of the cathedral from due west in a private collection (see Reynolds 1984, 29.20, pl.719). There is no record of work on the spire being done at this time, but the cathedral archives for the period are incomplete.

7 JCC IV, p.360 and 362.

8 Ibid., p.364.

three groups; divided thus by radical changes after the ninth proof, 'I' (FIG 224), when Constable began to worry seriously about the way the mezzotint had developed, and by startling changes after the fourteenth proof, 'N', when he appears to have been inspired by the sight of a painting by a friend recently dead.

The first of these changes occurred early in the New Year, 1832, after Constable had been prostrated by a paralytic attack of rheumatism. By then, work on the plate had already moved the image on some way beyond the original: there were radiating shafts of light in the sky, flashes of lightning near the cathedral tower, and the birds over the water had been dismissed and recalled. Much had been done on the river and to the bushes along the bank. Constable, in some pain, had been greatly agitated by the disastrous failure of a plate of his beloved *Glebe Farm*.

> . . .I frankly tell you [Lucas] I could burst into tears — never was there such a wreck . . .it is *all — all* — that I have wished to avoid in the whole nature of the work. The book is made by me to avoid all that is to be found there — a total absence of breadth, richness, tone, chiaroscuro — & substituting soot, black fog, smoke, prickly rubble, scratches, edginess, want of keeping, & an intolerable and restless irritation.[47]

It was in this state of mind, with his right-hand crippled, that he began to re-work a proof (the ninth) of the Salisbury — our PLATE 30. This is dated 13 January, 1832. On the 15th, still unable to write, he dictated the following to his eldest son for Lucas.

> Dear Sir
> Papa desires me to say that he is anxious to sea you as soon as possible for — he has cut you out a week's work in Sallisbury
> I am yours truly
> John Constable[48]

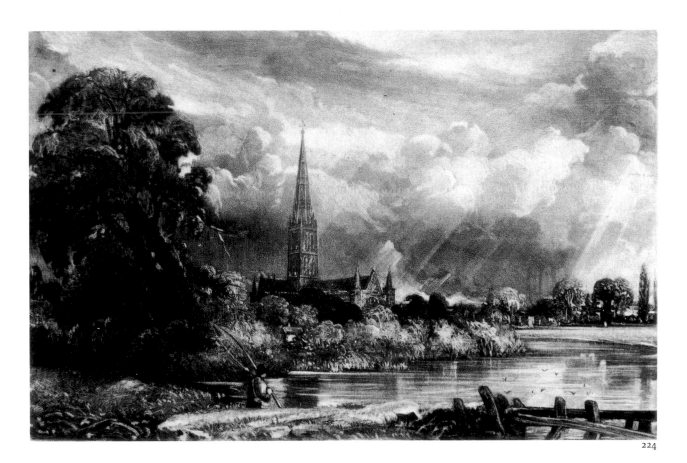

224

The next day the artist was well enough to write to Lucas himself: '...I am playing the devil with the Salisbury for on looking at an early proof – I find we have "lost every thing" – '.[49] A week later (the 23rd), he was asking for two or three more 'Salisburies in its present state.'

Six touched proofs have so far been located of the small *Salisbury*: four in the Fitzwilliam Museum, Cambridge, one (very heavily over-worked) in the family collection, and our dated, ninth proof, of 13 January (PLATE 30). This last is the only one we can place with any degree of confidence at a precise stage in the chronology of the series. We are able to do this because parts of it were incorporated into the next, the tenth proof. None of the changes envisaged in the other five seem to have had any effect on the development of the design. Constable appears to have used quite a range of media for his work on the six proofs: grey, blue and black crayon, soft graphite pencil, as well as the black watercolour and white body-colour that is to be seen in PLATE 30. The black watercolour (or Indian ink, it is difficult to tell which) that he used had a warm, brownish tinge which when diluted to a paler tone matched perfectly the lighter areas of the mezzotint. His white is of a bluer, colder tint; this is fortunate as it makes it easier to read his additions to the print and to gain some idea of how his thoughts were running at the time.

FIG 225 David Lucas after Constable
Salisbury Cathedral
Mezzotint, progress proof 'J',
17.5 × 25 cm. British Museum.

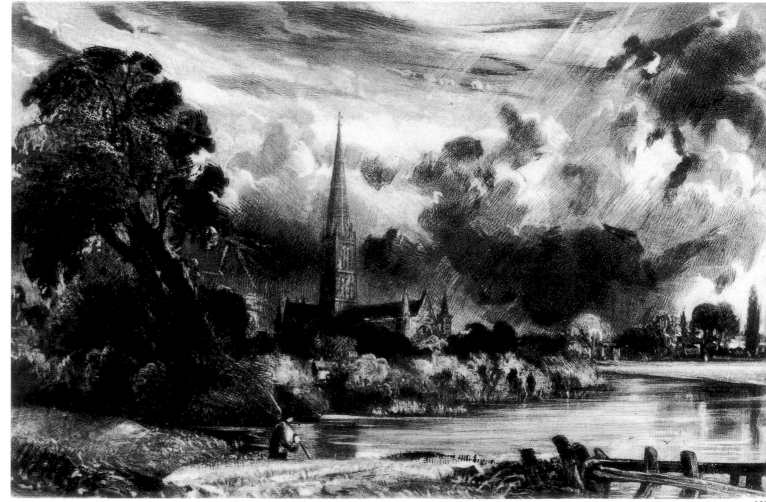

Basically, there appears to have been a desire for greater unity, and for an intensity of feeling to be seen in the original oil-sketch (FIG 214), something of which Lucas had successfully captured in the first few proofs, but which the ninth (FIG 224) now lacked. To remedy this Constable changed the mood of the sky, breaking up the complacent-seeming line of low, billowy clouds and introducing a stormier element high up on the right, as well as harsher streaks of dark in the main upper layers of cloud. He eliminated the birds over the water again, replacing them with three larger ones carried away by the wind high up. He remodelled the tower and spire, rendering them more three-dimensional. With black, he darkened the line of trees on the further bank; with white, he gave them a simpler, rounder character. Some of his thoughts while white was in his brush were inexpressible on a steel plate — the aerial, floating touches around and in front of the tower, for instance — but Lucas took note of the shafts of light angled down from above, as we can see from the tenth proof, 'J' (FIG 225). There were also refinements of drawing to be seen. Working from the touched proof of 13 January (or another like it), Lucas straightened and strengthened the rather feeble curving line of the meadow-bank. To make all these alterations he had to re-ground a lot of the plate. This he appears to have done in a positive frenzy, moving the rounded edge of the rocker in a wild confusion of directions to create shapes and patches of dark cross-hatching, in places over and over again to obtain his deepest marks.[50] In this tenth proof the lightning still shows through the fine zig-zags made by the rocker over the steel; by the thirteenth, it has disappeared behind further downward shafts of soft light.[51]

Lucas's agitated work on the plate may be a reflection of Constable's increasing pessimism about the results, as proof succeeded proof. On 28 February he told the engraver that he considered the state of the plate 'so *utterly* hopeless' that he was determined to abandon it,

> . . . for I now see that the rotten muck which it is necessary to you to *reground* a plate can neither be wrought upon — nor will it *stand* if it is = this I argue from seeing that You have scarcely touched the plate only for < the > some few trifles since You first brought it to me with the regrounding — now this is a fortnight ago.[52]

The abandonment may have been made a shade easier by the fact that Constable was now at work with renewed enthusiasm on the concluding stages of his marathon task, *The Opening of Waterloo Bridge*, that was to be his main exhibit at the forthcoming Academy. In the letter in which he told Leslie of the picture 'very beautifully strained' on a new stretcher, he talked of how he and Lucas between them 'had contrived to spoil the little Salisbury'.[53] The mezzotint is not among the titles proposed for the final issue of the *English Landscape* that Constable sent to Lucas on the same day — 3 March.[54]

Constable's interest in the *Salisbury* revived some months later, however, when plans began to develop for an appendix to the *English Landscape*. 'I have just looked at the New Sarum', he told Lucas on 22 September (1832), 'What a pity I did not let well alone — it is beautiful'.[55] On 7 October he refers to the appendix and to having touched proofs of the *New Sarum* and *Glebe Farm*: 'P.S. [he continues] You will be surprised & pleased at the touched proofs — they tempt one, to proceed — so clever and artfull is the Devil.'[56] The idea was discussed of enlarging the plate of the Salisbury and those of five other subjects Lucas had engraved.

49 Ibid.
50 Lucas's rocker and scraper are preserved in the Department of Prints, Fitzwilliam Museum.
51 By the twelfth progress proof, the proliferating shafts of downward streaming light present an image reminiscent of the astonishing fourth state of Rembrandt's 'Three Crosses'.
52 JCC IV, pp.368.
53 JCC III, pp.62–3.
54 JCC IV, p.369.
55 Ibid., p.381.
56 Ibid., p.383.

There then occurred an event that appears to have brought about a dramatic change.

On 2 November, in a house only a short distance from Constable's Charlotte Street home, there died Johnny Dunthorne at the age of thirty-four. The son of old Dunthorne, Constable's one-time sketching companion at East Bergholt. Johnny had ground colours for Constable in Suffolk as a thirteen-year-old, and for several years in the 'twenties had worked for him in his studio as a full-time assistant. A talented landscape painter in his own right, more recently he had set up on his own as a picture-restorer. Johnny, totally guileless, was much loved, and though he had been ill for some months, his death came as a great shock. For Constable, it was a cruelly ill-timed blow; he was still suffering from the loss of his greatest friend, Archdeacon Fisher, news of whose unexpected death had reached him only a couple of months before.

The younger Dunthorne painted a number of landscapes, including some of Constable's favourite scenes in Suffolk. Prominent among the landscapes by him that have so far been identified is a 10 × 14 in oil, *The Rainbow* (FIG 226), a river

FIG 226 John Dunthorne, Jnr *The Rainbow*
Oil on canvas, 25.2 × 36.2 cm. Yale Center for British Art, Paul Mellon Collection.

226

FIG 227 David Lucas after Constable
Salisbury Cathedral
Mezzotint, progress proof 'P',
17.5 × 25 cm. Fitzwilliam Museum,
Cambridge.

scene with a rainbow arching upwards from the right, and outside it the glimmerings of a second one. It must surely be to this work that Constable was referring at the end of the following passage, taken from a letter written to Lucas three days after Johnny's death.

> I shall be here tomorrow at 8. or about. to sleep & go to Suffolk on thursday — to attend the last scene of poor John Dunthorne — but he 'fought a good fight' and must have left the World with as few regrets as any man of his age I ever mett with. — his poor father has been here today — is gone back — he is entirely broken-hearted — he was so proud of him — and well he might be so.
> Do not *cutt* the plate of the New Sarum — yet — I have touch[ed] another proof to day and it looks so well I think you may like it — & perhaps we may adopt it. I did it in seeing poor J Dunthorne's rainbow this morning.[57]

The second of the two major changes in the small *Salisbury* series is of course the advent of the two rainbows (FIG 227). There is no further reference to the 'little Salisbury' or the 'New Sarum' in the Correspondence, but three proofs in the Fitzwilliam worked over in pencil, crayon, grey wash and white record the flurry

57 Ibid., pp.385–6.

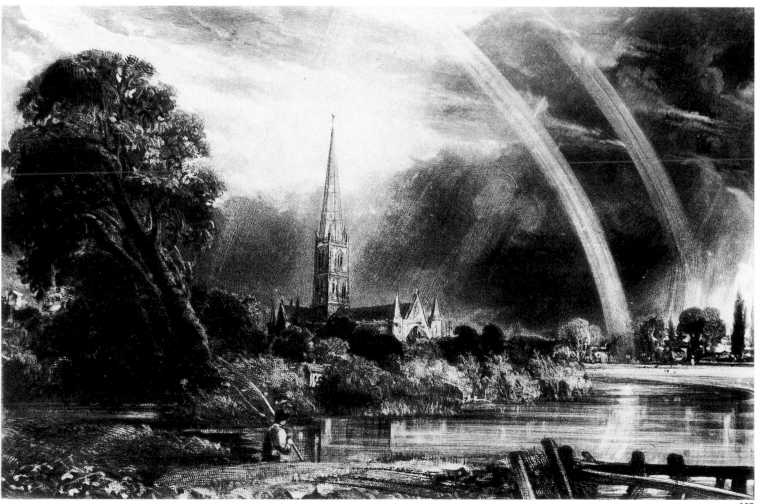

227

of activity that seems to have followed Constable's emotional response to the sight of Johnny's painting, his *Rainbow*. Constable, we know, was sceptical of the powers of the landscape painter to convey lofty ideas. In a lecture (as recorded by Leslie) he spoke of Ruisdael's picture known as 'An Allegory of the Life of Man' which in his opinion failed because the artist 'attempted to tell that which is outside the reach of art . . . there are ruins to indicate old age, a stream to signify the course of life, and rocks and precipices to shadow forth its dangers. But how are we to discover all this?'[58] He nevertheless believed firmly in the powers of association. His *Cenotaph*, a painting of a monument to Sir Joshua Reynolds, was itself a tribute to his old friend Sir George Beaumont, in whose grounds there stood the memorial. How many times he drew and painted the view of the fields behind his parents' house where he and Maria had strolled in the early, happy days of their courtship! The very frontispiece of his *English Landscape*, a view of the family home at Bergholt is of a scene steeped in early associations. It is therefore not unreasonable to suppose that the double rainbow he introduced into his little *Salisbury* had a special meaning for him, that the two 'bows' were burnished by Lucas into this final stage of the work on the plate in memory of Constable's two, much-loved friends.

In the last three proofs ('S', 'T' & 'U'), only the faintest traces are visible of the various birds that Constable at one time or another had thought of including in the design. But, startlingly white against the darkest part of the sky, low down, just above the sunlit tree at the foot of the rainbow (FIG 228), there is to be seen a pair of birds, one a little smaller than the other. Were these, too, emblematic? It is difficult otherwise to explain their sudden appearance at this late juncture – that is, if they require an explanation.

AUTHOR'S NOTE
Since writing the above, it has come to my notice that there is an ancient legend that associates the appearance of two white birds at Salisbury with the death of a Bishop of that diocese. Though the story seems to be widely known in the city, so far I have not been able to find a reliable documentary account of the strange manifestation.

FIG 228 David Lucas after Constable
Salisbury Cathedral
Mezzotint, progress proof 'T',
17.5 × 25 cm. British Museum.

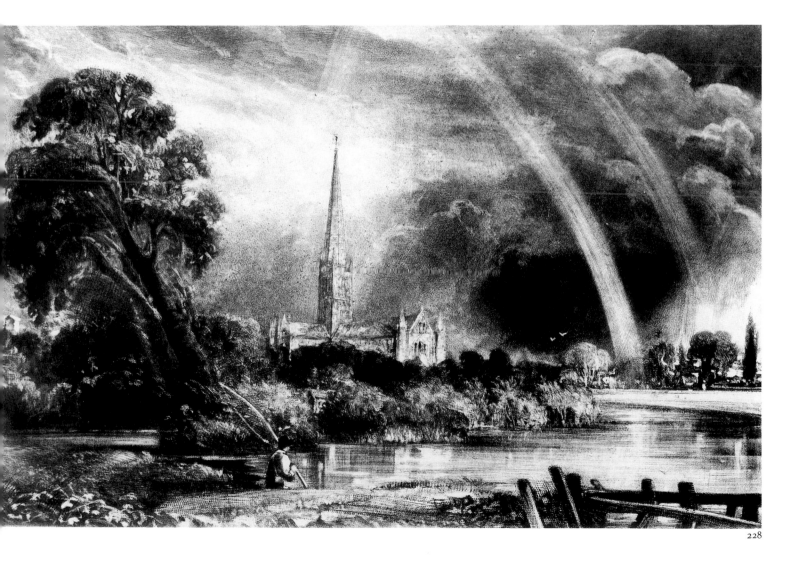

228

18 Greenstead Mill

PLATE 31 *Greenstead Mill*
Pencil, pen and watercolour on trimmed wove paper 14.6 × 19.8 cm.

When staying with the Fishers at Salisbury in 1829, Constable made several sketches of views from Leadenhall, looking across the watermeadows towards West Harnham, at least three of which were not true *plein air* studies as they were taken from inside the house. These appear to be the very last oil-sketches he was to make from nature. From 1830 onwards, watercolour was the medium he chose for outdoor painting, and after 1831, as an exhibitor, Constable turned increasingly to this medium.

In that year he had shown two works only, both oils, a *Yarmouth Jetty* and the big *Salisbury Cathedral from the Meadows* (FIG 215). In 1832 he exhibited a contrasting, full quota of eight works, four oils and four watercolours. Three of the watercolours were singled out for special mention by the reviewer of the *Literary Gazette*:

> Nos. 632, 643, 644. J. Constable, R.A. – Under these numbers we have a church, a mill, and a farmhouse, making a trio of rural associations at once picturesque and pleasing. Need we add, that they sparkle and glitter with the *dew* of Mr. Constable's pencil? Indeed, as water-colours, so they ought.[1]

FIG 229 *Stonehenge*
Watercolour on wove paper, 38.7 × 59.2 cm. Exhibited 1836. The original sheet extended t. and l. The hare on the left is on an additional piece of paper stuck down. Victoria and Albert Museum.

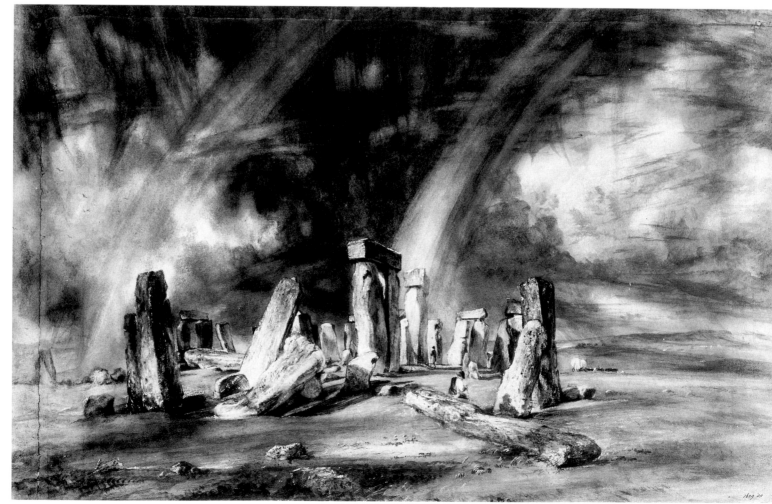

229

FIG 230 *Greenstead Mill*
Pencil on trimmed, wove paper,
8.7 × 11.7 cm. Inscribed, b.l., '26 July
1816'. Ex Hornby Album. Lawrence
Fine Art, Crewkerne. Compare the
setting of the sails here, on a fine day,
with those in *Greenstead Mill*
(PLATE 31) – on, according to
Constable, 'a squally day'.

230

16 June 1833, p.378.
Watercolour. V.& A. Reynolds 1984, 34.1,
pl.913.
'Study of trees made in the grounds of
Charles Holford, Esq., at Hampstead'.
Pencil. Cecil Higgins Art Gallery, Bedford.
Reynolds 1984, 34.3, PLATE 914. This has
been accepted provisionally as the
Academy exhibit, no.481. The
whereabouts of neither *Stoke Poges Church*
nor the illustrations to stanza 11 of the
Elegy are at present known. Both were at
one time owned by Samuel Rogers: the
former being lot 1242 in the Rogers sale at
Christie's 28 April–10 May 1856.
Oil on canvas. Tate Gallery. Ibid., 35.1,
pl.987.
Oil on canvas. National Gallery, London.
Ibid., 36.1, pl.1052.
There are three other versions of the
subject:
a. Pen and watercolour. E. P. Pool
Foundation Collection, Edmonton.
b. 'Stanway Mill'. Watercolour. Private
Collection. Ibid., 33.35 PLATE 891.
c. Pen and watercolour. Private Collection
(seen 17 January 1980). a and b, with the
familiar 'fish-fry' knife-work appear to be
versions by the artist, possibly *after* the
subject of this chapter (PLATE 31), which
is the stronger of the three. C, is a rather
less well understood copy by another
hand.

As these were the first drawings he had shown for many years and the first watercolours since his notable failure of 1806 with his *Trafalgar* (FIG 70), Constable possibly found this an encouraging notice. Next year, he sent in four oils and three more drawings, and in 1834 chose to be represented by drawings only: a view of Old Sarum;[2] an unusually large study of trees (29 × 23 in.)[3]; Stoke Poges Church, 'the scene of Gray's *Elegy* – also where he was buried'; and from Gray's *Elegy*, stanza 11 (the stanza beginning, 'Can storied urn or animated bust...'). In 1835 Constable was represented by just one oil, *The Valley Farm*,[4] and in his final year, 1836, he exhibited two works only, *The Cenotaph*,[5] an oil, and *Stonehenge* (FIG 229), the largest of his exhibited watercolours. *Greenstead Mill* (PLATE 31) – or one of the other known versions of the subject[6] – is without doubt No.647 in the Academy catalogue for 1833, a work titled 'A windmill – squally day'. Of the seven drawings shown in the Academies of 1832 and 1833, this is the only one we can identify with a reasonable degree of certainty.

It was based on a drawing (FIG 230), one of six made in 1816 during a brief visit to see an old friend at Feering (near Colchester) and to call on a local patron of some importance, General Slater Rebow, a call that would shortly lead to a commission and the execution of one of Constable's most successful outdoor landscapes,

Wivenhoe Park (FIG 231)[7]. On 28 July, the day after his return he wrote to Maria from Bergholt:

> ...I have been at Mr. Driffield's and one day at General Rebow's – and nothing could have been more friendly than my reception at all places – Good old Driffield congratulates me on the conclusion I have come to respecting your self – If John Fisher should not be able to marry me in September Mr Driffield will – so that we have two strings to our bow –[8]

Three of the six sketches done on this trip are dated 26 July. Two are of windmills. One of these is inscribed 'Stanway Mill' (FIG 232); the other is the original of our watercolour, *Greenstead Mill* (FIG 230). The third drawing is of a cottage at Feering.[9] The other three drawings are all dated 27 July: an unidentified windmill (FIG 233); a sketch of a bridge in Colchester;[10] and a drawing of the lake at Wivenhoe.[11] For some time it was thought that the windmills in these sketches of 26 and 27 July were one and the same – all three being Stanway Mill, so named in Constable's drawing of the 26th. However, contemporary maps and a recently published magesterial work on the Essex windmills[12] suggest otherwise; that the three drawings were of different mills; that the original of our drawing was a mill at Greenstead; and that Constable was technically incorrect in naming the windmill in his drawing of the 26th (FIG 232) 'Stanway Mill'.

FIG 231 *Wivenhoe Park, Essex*
Oil on canvas, 56.1 × 101.2 cm. 1816.
National Gallery, Washington.

7 Oil on canvas. National Gallery, Washington. Ibid., 17.4, pl.6.
8 JCC II, pp.188–9.
9 Pencil. Fitzwilliam Museum, Cambridge. Repr. Reg Gadney, *John Constable, A Catalogue of Drawings and Watercolours,* etc., 1976, no.17, PLATE 75.
10 *East Bridge, Colchester.* Pencil. Whereabouts unknown; stolen from the Municipal Art Gallery, Colchester, 1928. Ian Fleming-Williams, 'The Honeymoon Sketchbook', *The Old Water-colour Society's Club; Sixty-First Annual volume,* 1988, p.10. FIG 5.
11 *Fishing with a Net on the Lake in Wivenhoe Park.* Pencil and grey wash. Reynolds 1973, no.146, pl.118.
12 Kenneth G. Farries, *Essex Windmill, Millers and Millwrights,* 5 vols, 1981–88.

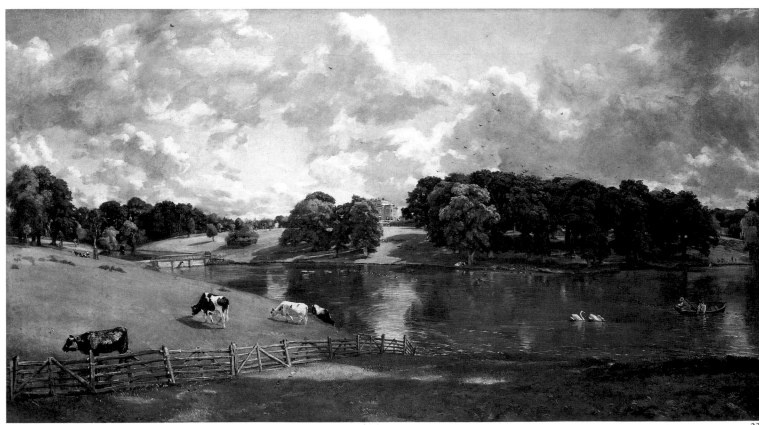

FIG 232 *'Stanway Mill'*
Pencil on trimmed, wove paper,
8.8 × 11.7 cm. Inscribed, b.l.'
'Stanway Mill/ 26 July 1816'.
Christchurch Mansion, Ipswich
Borough Council.

FIG 233 *A Mill near Colchester*
Pencil on wove paper, 8.8 × 11.7 cm.
Inscribed, b.l., '27 July 1816'.
Hornby Library, Liverpool City
Library.

232

233

Stanway was a small village on the London road about half-way between Colchester and Feering. As a parish, to the west it was bordered by the Roman River, a stream making its way south-eastwards, to join the Colne below Colchester. A map of 1777 (FIG 234) shows the windmill standing on the far side of the river and therefore in Copford, the neighbouring parish. In 1801, it was as 'a capital post wind-mill in the parish of Copford . . . by the side of the high road' that the mill was described in a notice in the *Chelmsford Chronicle*.[13] As Constable viewed it from the main road, the mill was partly hidden by the house occupied by the miller, one John Ely.

Greenstead is a village the other side of Colchester, to the east, quite near Wivenhoe Park. It is the church tower to be seen in the distance in the watercolour and the original sketch of 26 July (PLATE 31 and FIG 230) that enables us to identify the windmill. More clearly visible in the watercolour, this is plainly the tower of St Mary-at-the-walls, the church built against the remains of Colchester's Roman fortifications,[14] a tower recognizable by the stair-turret on the north-east corner (FIG 235). The tower viewed from this angle places our mill to the east of Colchester. On that side, in 1816, there stood two windmills, but only one of these, Greenstead Mill, was of the correct type, a post mill. The other was a tower mill.[15] Greenstead Mill first appears in the local press when it was advertized to let in 1784. It appears again, this time for sale, in the *Ipswich Journal* for 28 July 1798:

WINDMILL COMPLETE
Situated in the Parish of Greenstead, Colchester,
now in the Occupation of Mr. John Riches, on lease,
which expires Michaelmas 1807
To be SOLD by AUCTION,
BY Wm. BUNNELL,
On Monday, next the 30th inst. between the hours
of 4 and 6 o'clock in the afternoon, at Mr. Ling's,
the sign of the Rose and Crown, East Street.

The above Mill is well situated for an extensive
retail trade, as well as for the London Markets,
being within half a mile of a quay, where corn &c.
is shipped. Particulars and conditions at the time
and place of sale.

From the thirteenth century onwards, until fossil fuel succeeded wind as a main source of static power, windmills played an important part in rural economy, and were as much a feature of the landscape as the parish churches, even, in parts of the country, rivalling the church towers as eye-catchers on the sky-line. As we have seen, they fascinated Constable from an early age and his youthful training as an apprentice miller enabled him to draw them with authority. His brother Abram is reported as having said that he had seen mills painted by very good artists, 'but they won't go round; John's mills always will.'[16] Constable's knowledge of the working of these 'picturesque machines' (as Leslie called them) enabled him to appreciate and subsequently to lecture on a fellow artist's understanding of their management: on how Ruisdael, in a painting of a winter scene, had represented an approaching thaw by the positioning of a pair of windmills, one with its sails furled turned in the direction from which the wind blew when the mill left off work, the other with 'canvas on the poles', turned the other way, which indicated a change in the wind, towards the warmer south.[17]

FIG 234 *A Map of the County of Essex* (Chapman and Andre) 1777. Detail.

FIG 235 *The Tower of St Mary at the Walls* Photographed by John Bull 1989.

13 23 January 1801.
14 St Mary's had a long-standing association with the Rebows of Wivenhoe. In 1714 it was partly re-built at the instigation of 'one of the wealthiest of its parishioners, the cloth merchant and M.P., Sir Isaac Rebow.' Geoffrey H. Martin, *A Guide to Colchester*, 1959, p.45. A family monument, standing under the tower, bears the names of later Rebows.
15 In a post mill the main body, including sails and machinery, turns round a fixed centre post, the lower part of which is sometimes (as in Greenstead Mill) contained within a round house. A tower mill is built of brick or stone, surmounted by a rotating arm.
16 C. R. Leslie, *Selections from the Letters and Other Papers of John Constable, Esq. R.A., Arranged in Connection with a Sketch of his Life*, etc., 1842, p.6 n. Bound in with a set of the *English Landscape* mezzotints, this trial run for the opening pages of Leslie's biography consists of title-page, preface and four pages of the *Life* corrected and amended by the author. In the first edition of the *Life*, Abram's comment on the windmills was changed to: '"When I look at a mill painted by John, I see that it will *go round*, which is not the case with the mills of other artists"'.
17 JCD, p.64.
18 The setting of sail-cloths is well illustrated by four photographs in Rex Wails *The English Windmill*, 1954, PLATES VIII a–d.

234

235

We find further evidence of Constable's specialized knowledge of mills when we compare the sails of the windmill in the pencil sketch of 26 July (FIG 230) with those in the watercolour (PLATE 31). A sail of this type consisted of a wood framework over which there could be spread a sail cloth, a narrow length of woven material, the breadth and length of the sail, held fast at the inner end and along one edge, the full length of which could be spread to catch a light wind, but which by means of cords (pointing lines) could be folded – i.e., reefed – in varying degrees to meet stronger winds. The pointing lines enabled the miller to choose one of four settings for his sails, settings known as first reef, sword point, dagger point and full sail.[18] July 26th was evidently a fine summer's day and the sail cloths were then fully spread to catch a light wind. Constable gave the title 'A windmill – squally day' to the watercolour when it was exhibited at the Royal Academy in 1833. On a day of gusty winds it would be necessary for a miller to reef his sail cloths, and as he has depicted just such a day in his painting, Constable has here altered the sails accordingly – setting them at sword or dagger point.

236

FIG 236 *A Windmill at Stoke, near Ipswich*
Pen and watercolour on wove paper, 12.1 × 17 cm., 1814. Subsequently engraved by John Landseer for *The Social Day*, a poem in four cantos by Constable's friend Peter Coxe.

As we have seen, Constable's earliest drawings were in pen and ink or pen and wash. After 1800, for some years, he only used the pen occasionally, when drawing for an engraver or when making a presentation drawing. *A Windmill at Stoke, near Ipswich* (FIG 236) – possibly the 'little picture' Constable told Maria in February 1814 that he had lately made for his friend Coxe 'to help illustrate his poem (The Social Day)'[19] – shows an early re-use of the pen in combination with watercolour. *Harnham Bridge* of 1827 (FIG 237), done for an 'album of water colour drawings by the best water colour painters of the day',[20] is a sample of the formal style he adopted for ladies' albums. In essence the latter is a tinted pen drawing. *Greenstead Mill* (PLATE 31) is a work of greater complexity. Here, among washes of colour, in places a dense mass of colour layers, the pen-work is less conspicuous, much more closely integrated with the watercolour, giving the impression that pen and brush (and later, the knife) were used in an alternating sequence, each building on the work of the other, the watercolour unifying and softening some of the ink outlines, the pen pointing up, sharpening and clarifying the brushwork. Where, in an oil-painting of this time, he would drag and flick a palette-knife loaded with white paint over the canvas to obtain the sparkle and glisten he so prized, here Constable employed a sharp point, presumably a knife of some sort, to scratch the pigment away and reveal the white paper. Along the sweeping, upward thrust of the hedgerow from the left of the picture there is a positive shoal of little flicks, each with a head and tail, like microscopic fry. Elsewhere, the knife was employed as a scraper: quite strongly for the plumes of smoke streaming in the wind and in the windows; tenderly and delicately, to pick out the lights on the figure, bent under its load, and on the bushes and trees in the distant landscape to the left – this last a miniature of great charm.

19 JCC II, p.116. Peter Coxe, The Social Day, a Poem in Four Cantoes, 1823.
20 See catalogue of the *Haldimand Collection*, Christie's, 18 March, 1980, Introduction.

FIG 237 *Harnham Bridge*
Pen, brown ink and watercolour on
trimmed, wove paper, 18.3 × 26.5 cm.;
watermark, 'J.WHAT/'. Inscribed on
the back, 'Old Houses on Harnam
Bridge Salisbury/ with the Antient of
S! Nicholas/ John Constable. 1827.'
Private Collection.

In a sense, of course, the entire work is a miniature. In the eighteenth and early nineteenth centuries there was quite a market for copies of paintings by the Old Masters done on a considerably reduced scale and there were artists, both men and women, who made a speciality of working in this genre. Their products are now not highly prized, but at one time they were much favoured by Royalty and commonly to be met with on display among silhouettes and other such bibelots. *Greenstead Mill*, and other watercolours believed to have been exhibited in 1832 and 1833, are all less than 6 × 8 in., the size a miniaturist would choose for a rendering of Titian's *Diana and Actaeon* or Correggio's *Nativity*. In the design and execution of *Greenstead Mill* (and likewise of the other watercolours he is thought to have exhibited), it was clearly Constable's wish that it should be judged as a picture, a considered work of art on a par with a full-scale painting in oils, not just as a study or sketch, and, for a public accustomed to the miniaturization of masterpieces, this was not expecting too much. Nor, after a period earlier this century, when only the simplest and most limpid of watercolours satisfied contemporary taste, is it expecting too much to find an appreciative audience now for a complex little painting like *Greenstead Mill*. From comparable work of our century such as the much acclaimed, Henry Moore *Shelter* drawings (in ink, resist crayon and watercolour), we have learned that small can be great as well as beautiful.

237

19 East Hill, Hastings

PLATE 32 *East Hill, Hastings*
Pencil, pen and watercolour on trimmed wove paper 12.9 × 20.9 cm.

It was only recently, in 1987, that the subject of this watercolour (PLATE 32) was correctly identified, as being a view of the coastline that ran eastward from the shingle bank at Hastings. Hitherto, it had been titled *Cliffs at Folkstone*. Constable's presence has not otherwise been recorded at Hastings (so the mistake is understandable), but his accurate rendering of the stratification of the cliff-faces renders this identification indisputable. From the drawing, the eye of the professional palaeontologist[1] can recognise with little difficulty the three main geological formations that are to be seen exposed on that stretch of the coast: *Wadhurst Clay*, from the top of the nearest cliff-face, down as far as the first, scratched-out light band; *Ashdown Sands*, down to the lowest band of stratification (the line that runs on into the furthest cliff); and, lowest of all, *Fairlight Clay*. The drawing can also be dated with reasonable safety.[2] But there remain two questions outstanding: why Hastings and why a drawing that stresses so strongly the geological character of that coastline?

In February, 1833, somewhat reluctantly, Constable had sent his second son, the eleven-year-old Charles, away to a school at Folkestone run by a Revd Thomas Pearce.[3] Charles's education, with that of his elder brother John, for the past two years had been in the hands of a young living-in tutor, Charles Boner. The experiment at Dr Pearce's had proved successful, and it was therefore decided that the eldest boy John, aged fifteen, should join his brother at the school in Folkestone. So, on 10 August, after a short holiday with his two boys in Suffolk, Constable took John and Charles down to the school himself. By this time the companionship of his eldest boy had become almost a necessity, and Constable

FIG 238 *Folkestone: the Harbour* Pencil and watercolour on wove, trimmed paper, 12.9 × 21 cm. 1833. Fitzwilliam Museum, Cambridge.

FIG 239 *Folkestone: from the Sea*
Pencil and watercolour on wove,
trimmed paper, 12.4 × 20.5 cm. British
Museum.

239

found his absence exceedingly hard to bear. 'To part with John is breaking my heart', he confessed to Leslie, soon after his return, 'but I am told it is for his good'.[4]

For some weeks all was well; letters from John arrived regularly, and his father replied to them contentedly. Then, an expected Monday letter failed to arrive and by Wednesday the ever-anxious Constable and the whole household were frantic. Their concern proved well-founded. John, much given to restless nights, had walked in his sleep and injured his leg. This had brought on a severe attack of erysipelas which necessited bed, the application of leeches (one hundred and fourteen, John proudly informed Boner) and an incision 'to let the matter out'. The boy was quite ill. On hearing of his misadventure, Constable rearranged his work and on 10 October set off for Folkestone. There, at John's bedside and with Charles and his friends, he remained for almost two weeks. During that time he made a number of drawings, one of which was *East Hill, Hastings*.

The Folkestone drawings are mostly of the harbour area, with boats or vessels figuring prominently (FIG 238). Two, of the harbour-mouth, with the town behind, appear to have been viewed from some distance out at sea (FIG 239). All are watercolours. This is unusual; it was not Constable's normal practice in an unfamiliar locality to work so exclusively in colour. Pencilled colour-notes in one of the harbour drawings – also something of a departure for Constable – suggest that in this case at any rate the colour was applied later. A few are outlined in pen rather more carefully than was customary at this stage of his career. In some, for example the view from the harbour (FIG 238) and the Hastings study (PLATE 32), the degree of attention paid to detail, to plain factual narrative, is quite at odds with his current, freer, more expressive manner.[5]

If his heart was in it, Constable was able and sometimes quite pleased to comply with the wishes of others and, if needs be, to submit himself and his art to the dictates of the company he was with. There are many stories of his obduracy, but there are as many of his willing, if occasionally wry acceptance of duties or tasks that other more professionally motivated artists would have scorned to perform.

Namely, H. G. Owen, of the Department of Palaeontology, B.M. (Natural History), to whom I am extremely grateful for the identification. There are no doubts at all about the coastline, but there is an element of uncertainty as to the precise location of the spot from which Constable made the drawing. There have been regular and massive land-slips along this stretch of the coast. *Rock-a-nore* is the most likely viewpoint, but Mr Fred White, a member of the crew of the Hastings life-boat, suggested *Hook's Ledge* to the east of the town, looking towards *Cliff End*, as a possibility. This is now (and probably was in Constable's time too) only approachable by sea.

It comes from the sketchbook used in 1833 at Folkestone and again in 1834, when Constable was staying at Arundel. Stylistically, it is consistent only with the other drawings of 1833.

The greater part of the story of the schooling of Charles and John at Dr Pearce's will be found in JCC v, pp.141–72 and JC:FDC, pp.83–94.

JCC III, p.106.

To be seen in the other drawings from the sketchbook, those of 1834.

For his children, for whom he felt deeply responsible, there seem to have been no limits, and a likely explanation for the uncharacteristic handling of some of the Folkestone views is that they were done to amuse and instruct his sons and their schoolfellows.[6] It is possible that *East Hill, Hastings* was done for a similar purpose, that the detailed account of the several beds of stratification in the cliff-faces was intended for the edification of his son, John, then still confined to his bed at Dr Pearce's.

Both Constable's elder boys were magpie collectors, and a residue of their collections has survived in a cabinet purchased at the time to house their treasures.[7] Charles's main love was for ships and the sea, John was chiefly interested in the sciences, and they collected accordingly: Charles hunted for shells; John, for mineral specimens and fossils. In this pursuit they received every encouragement from their father. The pleasure he took in their company is reflected in the short account he sent Leslie of their ten-day holiday in August of that year.

> ...I had a delightful visit into Suffolk. We ranged the woods and feilds, and searched the clay pits of Suffolk for the bones, and skulls, & teeth of fossil animals, for John – & Charles made drawings and I did nothing at all – but I felt happy to [see] them enjoy themselves. All my family were kind to the boys.[8]

In John and Charles's correspondence there are many references to their collections. John tells his sister, Minna, of unpacking, arranging and writing out the names of his minerals. He asks Charles (then at Folkestone) to send him 'stratum super stratum if there is any chalk, you will find the best fossils there';[9] then corrects himself in his next letter, '...there are very valuable fossils at Folkestone but you would not know them if you saw them. I made a great misttack about the chalk'.[10] The source of John's freshly superior knowledge of the Folkestone fossil-beds was probably a friend of his father's, Robert Bakewell, a prolific writer on scientific matters, best known for his *Introduction to Geology* (1813), who lived nearby, in Downshire Hill. Constable had been acquainted with Bakewell for some years (see p.144), but he had lately come to know him rather better – presumably because of John's interest in geology. In a letter of 28 October, that is after his return from Folkestone, Constable wrote to John about a meeting with Bakewell: '...I told him how You liked his book ...I have spoken to Mr Bakewell about a Map – of gological <?strands> stratum & uper stratum – they are dear things – but You shall have one'.[11] The book he mentions would of course have been Bakewell's *Introduction to Geology*, a copy of the third (1829) edition of which had been presented to John, inscribed by the author.[12]

By 1833, there was a growing body of literature on the geology of Kent and Sussex. Gideon Mantell, a Lewes doctor (the discoverer of the first fossil remains of the giant iguanadon), had already published three works on the subject. And in this year, 1833, none other than the President of the Geological Society, W. H. Fitton, published his *Geological Sketches of the Vicinity of Hastings*. Constable and his son may have had access to any of these, but the only work we can be sure they would have read is John's copy of Bakewell's *Introduction*. There, however, they would have found plenty to interest them about the Sussex and Kent coasts. Bakewell specifically names a particular formation in the area 'Hastings sands', and refers to the numerous fossil remains Mantell had discovered further inland in this bed. In the edition he gave John, Bakewell lists

6 Like most of Constable's children, Charles was an enthusiastic draughtsman and in the letters written to him at school there is much talk of sketching and painting: e.g., Constable (in this case, to Leslie), 13 April, 'we have good news of dear Charley ...He has sold his first picture – a drawing (God knows what it is) is bought by the Curate of Folkestone for one shilling – ready money I dare say' (JCC III, p.102). One of Charles's school fellows, a boy named Colville, also became a keen artist – and Constable obligingly supplied him with a new paint-box and some art books, and presented him with an inscribed drawing; *Stoke Poges Church*. Sepia (iron-gall ink?) wash. Reynolds 1984, 33.14, pl.871.
7 Family Collection. The minerals, shells and fossils collected by Constable's children were added to by later members of the family and the only certain item of John's it still contains is a piece of lapis lazuli given to him by the artist's colourman George Field.
8 JCC III, p.105.
9 JCC V, p.160.
10 Ibid., p.161.
11 JC:FDC, p.91.
12 Family Collection. This is the American edition, with a preface and an Appendix, a course of lectures given at Yale, by B. Silliman.
13 From notes taken by Leslie of the fourth lecture given by Constable to the Royal Institution in 1836; JCD, p.69.

FIG 240 Robert Bakewell *The Wealden Beds* from his *Introduction to Geology*, 1833.

the types of fossils to be found there: petrified trunks of large plants; arborescent ferns and gigantic reeds; the shells of fresh-water genera; the remains of fish and three species of turtles; the bones, teeth and scales of at least four giant species of the lizard family – a mouth-watering list for the keen fossil-hunter! This edition was illustrated with only a frontispiece – of a trilobite – and seven fold-in plates of maps and diagrams. The fourth and enlarged edition of the *Introduction* was published in 1833. This, which Constable and his son could also have seen, has the same plates (plus one), but in the text, additional wood-cuts. These show reconstructions of whole skeletons of two monsters, the ichthyosaurus and plesiosaurus, as well as some teeth and skulls of other creatures. One of them compares a tooth of a living iguana with fossil teeth of Mantell's Iguanadon. More significantly, on page 282, there is a geological map showing the Wealden beds (parts of Surrey, Sussex and Kent), with Hastings itself central in the coastal stretch of the Hastings sands (FIG 240). Bakewell, or some other knowledgeable friend, may have suggested that Constable ought to take his sons to Hastings, where, on the shore below those cliffs, fossils were to be found. But from their reading alone it would not have been difficult for them to conclude that the cliffs at Hastings warranted investigation.

In 1816, when staying with the Fishers at Osmington, Constable's interest had been aroused by the headlands and cliffs along that coast, and in the little *Redcliff Point* (PLATE 16), while still concerned with the scene pictorially, he had shown some appreciation of that cliff-face as a stratographic record. This pencil-sketch, in the earlier essay (p.144) was likened to a field-note by a scientific observer. In *East Hill, Hastings*, a starker, far less pictorially conscious image, with the attention held by the backward-leaning cliffs (the very antithesis of the picturesque) and the repeated, strongly emphasized striations, the motivation appears to have been primarily scientific: the aim, to present as objectively as possible a raw slice of the earth's history. If this drawing was not done specifically for his son John – unable to make the trip to Hastings – its true purpose must nevertheless be closely related in some way to his son's and his own current interest in geology and the natural sciences. 'Painting', he once said in a lecture, 'is a science, and should be pursued as an inquiry into the laws of nature. Why, then, may not landscape be considered as a branch of natural philosophy, of which pictures are but the experiments?'[13] Was he not, in this painting, pursuing just such as enquiry?

240

20 View on the Arun

PLATE 33 *View on the Arun*
Pencil on trimmed wove paper 13.6 × 23 cm.
Inscribed in pencil bottom left 'July 19 1834'.

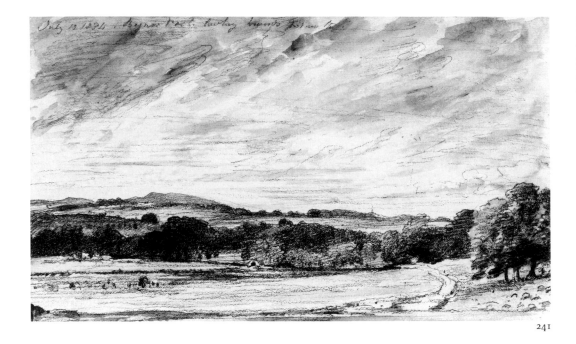

241

FIG 241 *Bignor Park*
Pencil and watercolour on trimmed, wove paper, 13.6 × 23 cm. Inscribed from t.l., 'July 13 1834. Bignor Park, looking towards Petworth'. British Museum.

Constable did not at first take a favourable view of Sussex. He wrote a fairly trenchant comment on the scenery around Brighton on the back of one of his oil sketches, a painting of a windmill in the fields near his lodgings there:

> Augst. 3ᵈ [1824] Smock or Tower Mill west end of Brighton the neighbourhood of Brighton – consists of London cow fields – and Hideous masses of unfledged earth called the country.[1]

It was not long after, that Fisher received the letter from him (see p.206), likening Brighton to Piccadilly by the sea-side. It may also be recalled that as a painter he had been unimpressed by the splendid views from the Downs inland. Characteristically, it was through a new friendship that, ten years later, Constable 'discovered' West Sussex and that the landscape of that part of the county became for him a revivifying source of material.

Constable's new friend, an unrelated namesake, George Constable (1792–1878), a prosperous brewer and maltster who lived at Arundel, was also a keen amateur painter and in a small way a collector of contemporary watercolours. In December 1832 he was shown a set of the *English Landscape* mezzotints when staying with a friend in Charlotte Street, quite near Constable's House, No.63. Immediately, he wrote to Well Walk to ask the price of a set, 'the most perfect and interesting work on landscape I have ever seen.'[2] The two met and were mutually charmed. They corresponded and within a year George Constable had become the artist's 'dear friend', a rare promotion. He won the heart of Constable's eldest son, John Charles (and the father's too), with the gift of a collection of fossils. Invitations followed, and in July 1834 Constable and his son arranged to travel down to Arundel for a holiday with the brewer and his family. John Charles went on ahead; Constable joined him there on the 9th.

Drawings record several expeditions: on the 10th to Bignor Park, some miles inland (FIG 241), owned by a well-known collector, John Hawkins; on the 14th to Petworth, where Constable and his friends were greeted most handsomely by the owner, the Earl of Egremont;[3] and on another day a visit to Chichester.[4] For most of the time, however, Constable seems to have been content to explore the Arun

1 *A Windmill near Brighton*. Oil on paper. V.& A.; Reynolds 1984, 24.17, PLATE 491.
2 JCC V, p.10.
3 Constable to Leslie, 16 July. 'He wanted me to stay all day – nay more he wished me to pass a few days in the house. This I was much pleased at, but I excused myself for the present, saying I would so much like to make that visit while you was there – which he took very agreeably, saying let it be so then, if you cannot leave your friends now. He came out to us 3 times, & once to the riding house from which I was sketching the [view], all of which pleased him.' JCC III, p.112. Somewhat apprehensively, Constable accepted the Earl's invitation and spent two very successful weeks with the Leslies at Petworth that September.
4 When he made a watercolour of the cathedral now in the V.& A. Reynolds 1984, 34.27, PLATE 936.
5 JCC III, 111–12.
6 *North Stoke, Sussex*. Reynolds 1984, 34.16, pl.925.
7 At the sale of the contents of the Hornby Album; Lawrence Fine Art of Crewkerne, 19 April 1979 (15).

FIG 242 *Arundel Docks*
*c.*1870. Arundel Museum and
Heritage Centre.

valley itself, with the river winding its way between beech-clad hills, and to soak-in this new landscape. Some extracts from a letter he wrote Leslie on the 16th will best convey the impact the scenery was making upon him.

> In all my walks about this most beautiful spot I am continually thinking of you. How much your company would enhance the beautiful things which are continually crossing my path. John is enjoying himself exceedingly. The chalk cliffs afford him many fragments of oyster shells and other matter that fell from the table of Adam in all probability . . . The Castle is the cheif ornament of this place – but all here sinks to insignificance in comparison with the woods, and hills. The woods hang from excessive steeps, and precipices, and the trees are beyond everything beautifull: I never saw such beauty in *natural landscape* before. I wish it may influence what I may do in the future, for I have too much preferred the picturesque to the beautifull – which will I hope account for the *ruggedness of my style* . . . The meadows are lovely, so is the delightful river, and the old houses are rich beyond all things of the sort – but the trees above all, but anything is beautifull.[5]

Overwhelmed, as he seems to have been by the beauty of the West Sussex countryside, it is notable that in only two of the fourteen drawings Constable made on this trip – *Bignor Park* (FIG 241) and a magnificent pencil study in the British Museum of the view looking up the valley towards North Stoke[6] – did he attempt to capture the verdant richness of the scenery around Arundel. Perhaps, for the time being, he felt that the beauty of this new 'natural landscape' was rather beyond him. Most of his sketches were of familiar subjects: cottages, the castle, windmills, and in the case of our drawing, *View on the Arun* (PLATE 33), three in one, as it were – a water-mill, a barge and a windmill. Titled 'On the Arun' when it made its first appearance with seventeen other unrecorded Constable drawings,[7] strictly speaking this is not a scene on the River Arun, but a view of a creek or tidal mill-pool off the river at low water.

Arundel, on the right-bank of the Arun, was at this time a flourishing inland port with a shipyard, quays and docks below the town bridge on both sides of the river (FIG 242). Upstream, the Arun was canalized to link up with a waterway

242

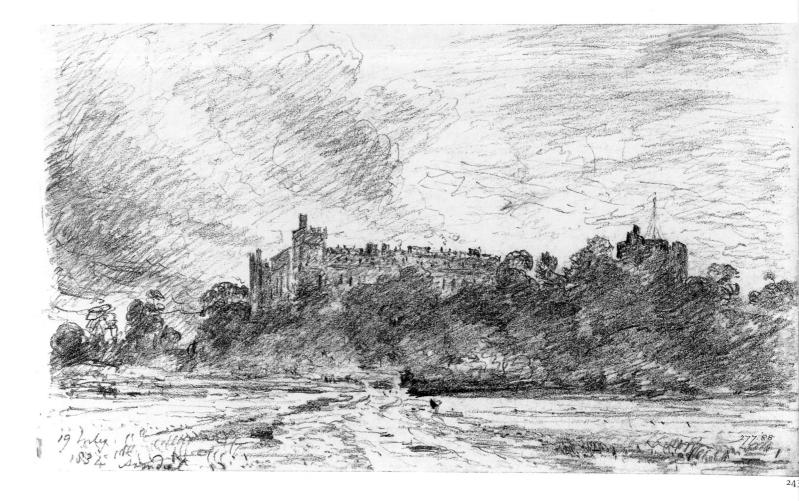

system that ran northwards to join up with the River Wey and thence to the Thames. In the 1830s, a local firm, the Arundel Barge Co., ran its own fleet of barges carrying a variety of goods, ranging from coal, flour and bark, to hoops (for barrels) and soldiers' baggage (as there was a canal route through Arundel from London to Portmouth). When Constable was staying there the waterways were in their hey-day. In the year 1830, the Arundel barges alone shifted 4,600 tons of cargo. In two of the iillustrations in an informative book on the Wey and Arun Junction canal,[8] we see barges similar to the one Constable drew; in one, a painting of *c.*1850, the barge is bow-on to the river bank close to the windmill at what was known as Portreeves Acre, the mill visible on the extreme right in *View on the Arun*.[9] In both cases the illustrations show the barges navigating by sail; here, in Sussex, the practice of horse-haulage, as on Constable's Stour, appears to have been uncommon.

Local historians have been puzzled by the topography of *View on the Arun*, one of Constable's wide-angled scenes. It appears to have been drawn at the edge of a mill-pond at a point below the town bridge, as a vessel the size of the one to be seen beyond the mill to the left, with men at her yard furling a sail, could not have passed under the single span of the bridge. Maps of the area have not so far revealed the presence of a tide-mill or creek in this position.

8 P.A.L. Vine, *London's Lost Route to the Sea*, 1965.
9 In 1829 this mill became the property of the Duke of Norfolk. Information kindly supplied by Mrs Sarah Rodger, Castle Librarian.
10 Pencil. Henry E. Huntington Art Gallery San Marino. Reynolds 1984, 34.26, pl.935.
11 Oil on canvas. The Toledo Museum of Art, Toledo. Ohio. Reynolds 1984, 37.1, pl.1086.

Constable. It is not clear when he adopted the practice, but he was certainly establishing his eye-level with a ruled line by 1814 (FIG 245) and there are isolated examples to be found among his drawings throughout the rest of his working life, most often when he is sketching unfamiliar ground. Such ruled horizons are notably absent in the Lake District drawings of 1806, but instead, as we saw, a number were squared-up with a grid of horizontals and verticals irregularly spaced. We can only hazard a guess as to the purpose of this system, if system it was, but there has to be a beginning made on each fresh sheet of paper, and around a ruled grid or upon a single horizontal Constable may have found that he could most readily construct that invisible web of directions and related distances, the mental establishment of which permitted him to draw with such freedom and confidence.

As a coda to this short chapter we should perhaps take the opportunity to point out a rare conjunction: two comparable views of the same subject – Constable's second drawing of 19 July, his pencil study of Arundel Castle (FIG 243) and Turner's watercolour, *Arundel Castle and Town* (based on drawings he had made in 1824), that he had exhibited in a London gallery the previous year (1833).[12] Turner has taken his view from the eastern approach to the town (FIG 246). In the centre we see the Portreeves Acre windmill that Constable drew in his *View on the Arun*. In Turner's drawing we can also see the masts and yards of the shipping in the port. Two contemporary interpretations of the same subject could hardly be less alike than Constable's pencil-sketch of the castle seen darkly against the sky and Turner's colourful, dreamy evocation. Two years later, in May 1836, Constable gave his friend at Arundel a brief account of the Exhibition at Somerset House. 'Turner', he said, 'has outdone himself – he seems to paint with tinted steam, so evanescent, and so airy – The publick thinks he is laughing at them, and so they laugh at him in return.'[12]

12 Messrs Moon, Boys and Graves Gallery, 6 Pall Mall.
13 12 May, JCC v, pp. 32–3.

21 Four Blots and Jaques

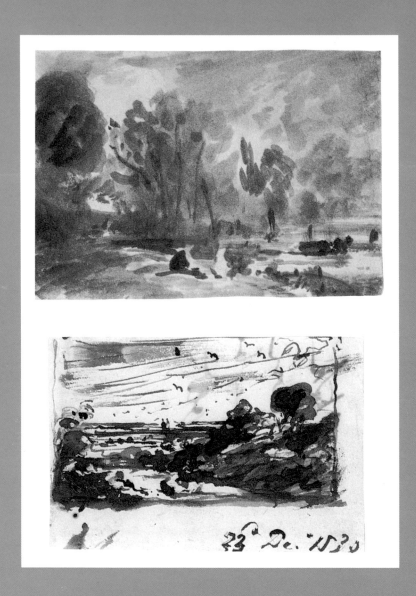

PLATE 34 *Compositional Study for 'Stratford Mill'*
Grey wash on semi-absorbent trimmed paper 6.5 × 9.2 cm.

PLATE 35 *View of Dedham from Langham*
Pen and iron-gall ink wash on wove writing-paper trimmed to 5.7 × 8.5 cm.
Watermark '/ATMA /URKEY /3'.
Inscribed with pen '23ᵈ Deʳ 1833'; on the back with pen a draft list of titles for *English Landscape*: 'Stok/ Noon/ Sea be[ach]/ Old S[arum]'.

PLATE 36 *Landscape Composition with Horse and Rider*
Pencil and brown bodycolour on writing paper, irregular on three sides 9.3 × 13.3 cm.

PLATE 37 *Stoke-by-Nayland*
Pencil and iron-gall ink wash with white heightening on irregularly trimmed wove paper 12.2 × 16.5 cm.

247

FIG 247 *A Barge on the Stour*
Pencil and iron-gall ink on laid paper
torn along left side, 20.5 × 16.2 cm.;
watermark, '/ALLFORD 1829'. Victoria
and Albert Museum.

Constable's striking pair of 'sepia' landscapes in the Victoria and Albert Museum (FIGS 247 and 248)[1] has often been reproduced, singly or together, but apart from some perceptive comments by Graham Reynolds and Kim Sloan,[2] not a great deal has been written about them. This is understandable, for though they are vivid, expressive images, it is difficult to know what they are expressing and what can usefully be said about them. To this day, they remain enigmatic, but because other similar drawings have been coming to light and more is known about an important source, the theoretical works of Alexander Cozens, they now seem less like isolated incidents in Constable's oeuvre and a little easier to account for. In this chapter we shall be considering some of the recent arrivals (PLATES 34, 35, 36 and 37) with four studies for a book illustration two published and two unpublished (PLATES 38, 39, 40 and 41), as 'blots' or examples of the 'blottesque'.

1 The use of the term 'Sepia' for brown-coloured pen and/or wash drawings has been widespread. As in the present case, these descriptions have often been misleading. For most of his 'blots', Constable appears to have used an ink popular with artists since the seventeenth century – iron-gall ink. This was an ink made from an extract of crushed and boiled galls (oak-apples), to which ferrous sulphate and gum arabic had been added, with a few further ingredients, varying according to the receipt. A dark, purplish brown, almost a black, when used, this ink becomes lighter and browner in time and also has the habit of 'moving through' the paper and appearing on the back. Sometimes its acidity will eat the paper away. Sepia, made from the liquid discharged by squid and cuttlefish, was used comparatively seldom. See James Watrous, *The Craft of Old-Master drawings*, Wisconsin, 1957, pp.69–74 & 78–9.
2 Reynolds 1984, Text, no.36.28, pp.294–5; Sloan, 1986, pp.85–6.
3 Known as such, after Knight's *Discourse on the worship of Priapus*...etc., contained in *An Account of the Remains of the Worship of Priapus, lately existing at Isernia*...etc. 1787. See Clarke and Penny, *The Arrogant Connoisseur: Richard Payne Knight, 1751–1824*, 1982, pp.50–64.

FIG 248 *View on the Stour*
Pencil and iron-gall ink on laid paper
torn along left side, 20.5 × 16.9 cm.;
watermark, 'GILLING &/'. These two
sheets are from one, torn in half.
Victoria and Albert Museum.

248

Where the two Victoria and Albert Museum landscapes appear in the general literature, references are usually made to Claude, Leonardo and Alexander Cozens. Constable's admiration for the paintings of Claude was lifelong and unbounded, but only once is he known to have mentioned the Frenchman's drawings. This was in a letter to Fisher written in January 1824, when he was railing against the Directors of the British Institution (none of whom, he said, 'have any affection for the *new* art'), and in particular against the wealthy collector, Richard Payne Knight, 'Priapus' Knight,[3] who had called two days before, admired his pictures, seen him hard at work, had gone away after buying nothing, and that same day had given sixteen hundred pounds 'for some drawings or slight sketches by Claude < which look very much as if he had > I saw them – drawings – they looked just like papers used and otherwise mauled –

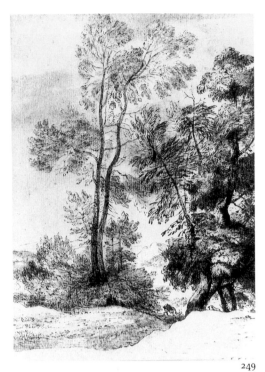

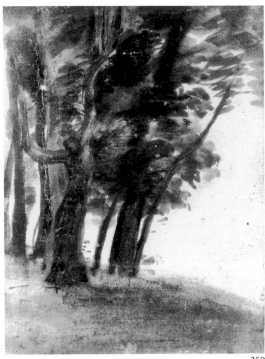

249

250

FIG 249 After Claude Lorraine *Trees and Deer*
Pen and ink and brown and grey wash on laid, early paper,
28.8 × 20 cm. Inscribed on the back, 'Copied from a drawing by Claude Lorraine/ left to Sir Thos Lawrence/ Hampstead July/ 1825', etc. Yale Center for British Art.

FIG 250 Claude Lorraine *Landscape*
Brown wash on trimmed, laid paper, 12.3 × 9.1 cm. British Museum.

& purloined from a Water Closet'.[4] This, however, is Constable in a querulous mood. A painstaking copy of a Claude study of trees that he made the following year (FIG 249), belies such wholesale condemnation,[5] and we only have to glance at examples of Claude's work with a liquid-laden brush (FIGS 250 and 251) to appreciate their relevance to Constable's own wash drawings. Leonardo, here, falls into context with Alexander Cozens.

One of the 'fathers' of the English Watercolour School, Cozens (1717–86), is now best remembered for his invention of the blot technique for the stimulation of the imagination. Like many of his fellows, Cozens was largely dependent for a living upon teaching, but he was perhaps more fortunate than some in counting royal princes, members of the nobility and boys at Christ's Hospital and Eton College among his many pupils. As he himself tells us, it was during one of his lessons that he first realised the value of the blot.

> Reflecting one day in company with a pupil of great natural capacity, on original composition of landscape, in contradistinction to copying, I lamented the want of a mechanical method sufficiently expeditious and extensive to draw forth the ideas of an ingenious mind disposed to the art of designing. At this instant happening to have a piece of soiled paper under my hand, and casting my eyes on it slightly, I sketched something like a landscape on it, with a pencil, in order to catch some hint which might be improved into a rule. The stains, though extremely faint, appeared upon revisal to have influenced me, insensibly, in expressing the general appearance of a landscape.
>
> This circumstance was sufficiently striking: I mixed a tint with ink and water, just strong enough to mark the paper; and having hastily made some rude forms with it, (which, when dry, seemed as if they would answer the same purpose to which I had applied the accidental stains of the 'forementioned piece of paper) I laid it, together with a few short hints of my intention, before the pupil, who instantly improved the blot, as it may be called, into an intelligible sketch, and from that time made such progress in composition, as fully answered my most sanguine expectations from the experiment.

4 17 January 1824, JCC VI, p.149–50.
5 The identification of the Claude was first published by R. Rosenberg in *La Revue de l'Art*, XIV, 1971, pp.115–16. FIG 17. The two drawings (Constable's in colour) are pl.53 and FIG 54 in Haverkamp-Begemann and Logan, *Creative Copies*, 1988, pp.182–3.
6 See pp.4–5.
7 Known only from a single two-page text in the Hermitage; see Sloan, 'A new chronology for Alexander Cozens. Part II: 1759–86', *Burlington Magazine*, June 1985, no.987, Vol.CXXVII, pp.355–63, FIGS 6–17.
8 Ibid., p.354, FIG 7.
9 *New Method*, p.6.
10 Ibid., p.8.

FIG 251 Claude Lorraine *Landscape* Pencil and brown wash on laid, trimmed paper, 20.5 × 27.2 cm. British Museum.

This comes from Cozens's *A New Method of Assisting the Invention in Drawing Original Compositions of Landscape*, 1785,[6] the last of his several published theoretical works. In the earliest of them, *An Essay to Facilitate the Inventing of Landskips* (1759)[7] he begins with a well-known passage from Leonardo's *Treatise on Painting*, which, he later stated, he had been told about 'in the course of prosecuting this scheme' – i.e., when developing the blot method.

> Among other Things I shall not scruple to deliver a new Method of Assisting the Invention, which, tho' trifling in Appearance, may yet be of considerable Service in opening the Mind, and putting it upon the scent of new Thoughts; and it is this: If you look at some old Wall cover'd with Dirt, or the odd Appearance of some streak'd Stones, you may discover several Things like Landskips, Battles, Clouds, uncommon Attitudes, humerous Faces, Draperies Ec. out of this confused Mass of Objects, the Mind will be furnished with abundance of Designs and Subjects perfectly new.[8]

Cozens considered his method superior to Leonardo's, as his own blot could be made at will, without recourse to 'rude forms ...in walls, &c. which seldom occur';[9] and in the *New Method* defines the true blot as an assemblage of dark shapes or masses made with ink and likewise of light ones produced by the paper being left blank – not a drawing, that is, but an assemblage of accidental shapes from which a drawing may be made. 'To sketch in the common way', he says,

> ...is to transfer ideas from the mind to the paper, or canvas, in outlines, in the slightest manner. To blot, is to make varied spots and shapes with ink on paper, producing accidental forms without lines, from which ideas are presented to the mind.[10]

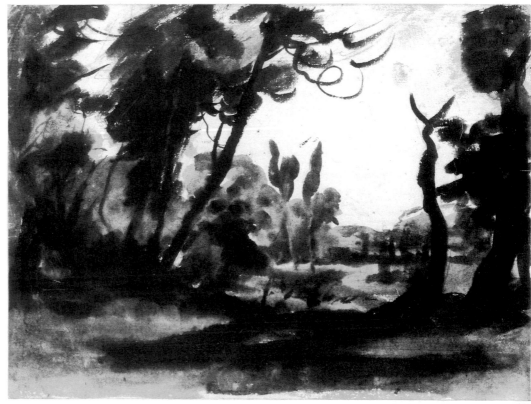

251

In the *Essay* of 1759 Cozens provides instructions for making blots, but these are more clearly given in the *New Method*. Before starting, the pupil is instructed to possess the mind with a subject – i.e., a landscape of some kind – then to take a brush 'as large as can conveniently be used' and with a mixture of ink and water 'with the swiftest hand make all possible variety of shapes and strokes' on the paper, 'confining the disposition of the whole to the general subject in your mind'.[11] The blots, he says, may be of two kinds: light or dark ones. 'The First done with a faint degree of colour; the drawings to be made out on the blots themselves, without the intervention of any other paper'. The second to be made with the 'darkest degree of ink', from which a tracing can be made and a landscape completed. To produce a variety of the smaller accidental shapes, Cozens suggests that the paper may be crumpled and then flattened out for the making of the blots.[12]

Advertisements for Cozens's *New Method* appeared in 1784, but the title-page bears no date and it is only possible to say that it was probably published before his death in April 1786.[13] After a text of thirty-three pages and a short index, there follows a list of the examples and then twenty-eight engraved plates illustrating the 'Method'. The first sixteen of these are aquatints of blots executed in black ink on crumpled paper. The next five are line engravings, four to a page, illustrating different kinds of sky (to these we shall shortly return). The last group, a mixture of aquatint and mezzotint, shows how two blots may be developed into finished landscapes, using the second method, that is, by working on a tracing of the original blot. FIGS 252, 253 and 254 are numbers 40, 41 and 43 from this group, described by Cozens as follows:

40 A blot
41 A print representing a drawing done with a brush, from the
 preceding blot
43 A third drawing done from the blot.

FIG 252 Alexander Cozens *'A Blot'* PLATE 40 in *A New Method of Assisting the Invention in Drawing Original Compositions of Landscape.* c.1785.

FIG 253 Alexander Cozens *'A drawing done with a brush, from the preceding blot'* pl. 41 in *A New Method.*

11 Ibid., p.23.
12 Ibid., pp.24–5.
13 See Oppé, 1952, pp.40–1, and Wilton, 1980, p.31.

254

255

256

FIG 254 Alexander Cozens *'A drawing done from the blot'*
pl. 42 in *A New Method*.

FIG 255 Alexander Cozens *A Coastline with a Ruined Tower*
Brown and grey wash on wove paper, 16.5 × 20.2 cm. Private Collection.

FIG 256 Alexander Cozens *Landscape with Trees*
Brown wash on wove paper, 14.1 × 16.3 cm. Collection E. H. Coles, 1923. Present whereabouts unknown.

In this instance, the engraved blot looks as though it was an off-print, an impression taken from a blot made on another piece of paper. The two finished landscapes (FIGS 253 and 254), while based on the same blot, are quite different. It was Cozens's aim to show that a variety of scenes could be imagined from a single blot. In neither the *Essay* nor the *New Method* does Cozens illustrate the other kind of use for a blot, where it is initially done in 'a faint degree of colour' and then worked over with darker washes of diluted ink. *A Coastline with a Ruined Tower* (FIG 255) and *Landscape with Trees* (FIG 256) show him working over initial light washes, but neither, of course, has been taken very far. When working on a finished composition of his own, we have no idea how often he used this method of stimulating the imagination that he taught his pupils.

Although Constable wrote enthusiastically about the work of Cozens's son, John Robert, only once, in a letter does he mention the father, Alexander.[14] However, there is no lack of evidence of his interest in the elder Cozens. In a private collection there is a set of fifteen of Constable's copies after the illustrations to another of Alexander Cozens's theoretical works, the *Various Species of Landscape, &c. in Nature*,[15] and in the Courtauld Collection there is a set after the engraved plates of the skies in the *New Method*.[16] In addition, there are autograph manuscript copies of some of Cozens's texts and Constable's pages of notes and some brief references to 'Cousins' (in this case, almost certainly the elder), all of which appear to have been made when he was staying at Coleorton in 1823 with his friends, Sir George and Lady Beaumont.[17]

It is unlikely, however, that it was on this visit that Constable first became acquainted with Cozens's work and the fruits of his teaching. Among Constable's earliest contacts in the art world there were several who had known Cozens and at least two who had been taught by him. Beaumont, an early mentor, had been a pupil of his at Eton, and Sir George's penchant for the ideal rather than the landscape of fact probably stems from the tuition he received as a boy. One of his drawings, a view from the mouth of a cave, is inscribed 'from an Accidental blot of Indian Ink on a Palate Coleorton Octʳ 6 1806'.[18] Dr John Fisher, later Bishop of Salisbury, another early friend (himself a keen watercolourist), had been a tutor to Prince Edward during the last two years (1780–82) of Cozens's appointment as drawing master to the young Prince (later Duke of Kent),[19] and Fisher would have known Cozens and been familiar with his works and methods of teaching. In 1802, it was Fisher, by then a Canon of Windsor, who arranged for Constable to be interviewed at Windsor by General Harcourt for a teaching post at the new Military College in Marlow, of which Harcourt had been appointed Governor. Mary Harcourt, the General's wife, is one of Cozens's best recorded women pupils.[20] Farington noted Constable's trip to Windsor thus in his Diary:

Wednesday May 12th
...Constable called is going to Windsor with Dr Fisher who is to introduce him to Genl. Harcourt who wants a person to teach drawing at a Military School.
Thursday May 20th
...Constable called. He had seen Genl. & Mrs Harcourt while with Dr Fisher at Windsor. I gave him my opinion that as He stood in no need of it, He shd. not accept a situation which would interfere with his professional pursuits.

It may have been noticed that Constable was interviewed by Mrs Harcourt as well as the General. As a Cozens pupil and a capable amateur, she would have been a better judge than her husband of the five drawings Constable made at Windsor while staying in the Canons' residence, drawings presumably designed to demonstrate his competence as a draughtsman and his suitability as an instructor for the young gentlemen at the College.[21]

Two drawings, one, the early blottesque *River in a Rocky Landscape* (FIG 257), unquestionably by Constable, and the other, *A Landscape with Distant Mountains* (FIG 258), very probably an early work by him, provide reasonably convincing evidence that already, at around the turn of the century, Constable knew something of Cozens's blot techniques and had had access to at least one of his fully finished works. The first comes from the Whalley portfolio, the contents of which were discussed in the first chapter (p.38). With another brush drawing of a rocky landscape, this imagined scene of beetling cliffs and precipitous rock-faces

FIG 257 *River in a Rocky Landscape* Grey wash on laid paper, 12.6 × 20 cm. *c.*1798. Private Collection.

FIG 258 After Alexander Cozens *Landscape with Distant Mountains* Pen and ink and grey wash on laid paper, trimmed with scissors, dimensions between ruled lines, 20.2 × 26 cm.; pin-holes t. centre, b.l., & b. r. From a Cobbold family album. Private Collection.

14 'Cousins was all poetry', in a letter to Fisher 4 August 1821, JCC VI, p.72; '...he was the greatest genius that ever touched landscape', in a letter to W. Carpenter, 15 June 1835, JCC IV, p.147. Alexander is just mentioned as the father in this letter.
15 See Tate Gallery 1976, no.224, pp.135–6, repr. p.136.
16 Ibid., no.210, repr. 128–9.
17 In an extra-illustrated copy of Leslie's *Life*, 1843, at the Yale Center; published in full in Wilton, 1980, p.26.
18 V.& A., repr. Sloan, 1986, p.49, pl.61.
19 Oppé, 1952, pp.39–40.
20 Ibid., pp.34–5. As the Hon. Mrs Harcourt, 'Honorary Exhibitor', she exhibited landscapes at the R.A.; two in 1785 and two the following year.
21 Reynolds 1973, nos 33 (pl.16), 34 (pl.16) & 35 (pl.17); Rhode Island School of Design, Tate Gallery 1976, no.30, repr. p.47. A fifth, *Windsor Castle from the River*, pen and ink and watercolour, 9.4 × 16.2 cm. was shown to the author by Andrew Wyld in 1983. See Wilton, 1980, pp.56–7, PLATES 26–7.

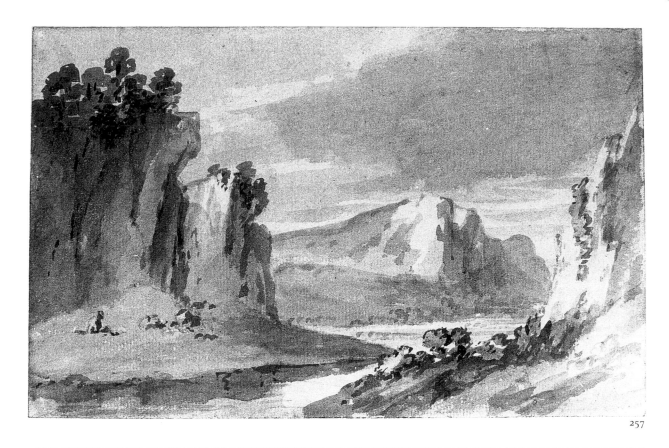

257

258

is one of the very few drawings from the portfolio Mary Constable left to her nephew entirely lacking in any signs of J. T. Smith's influence. We would be unable even to guess as to what had inspired Constable in this instance to venture so far outside his own experience of landscape, were it not for his known contacts at this time with one-time pupils and associates of Cozens, and the likelihood that he had therefore seen examples of Cozens's inventions in the 'sublime' mode, such as the prosaically titled *Landscape with Riverbed and Mountains* in the Metropolitan Museum (FIG 259) and had already been introduced to the pleasures of 'blotting'. The other drawing, *Landscape with Distant Mountains* (FIG 258) is unquestionably a copy of one of Cozens's more elaborately worked-up, classical compositions, a work at present untraced, but similar in feeling and treatment, if not in design, to a drawing in the Courtauld Collection (FIG 260). As in so many of his copies, it is impossible to detect Constable's hand in this drawing, but it comes from an album that until quite recently belonged to an Ipswich family, the Cobbolds, of whom in his early years he used to see a great deal, and 'by John Constable' (in this instance, contributory evidence) was written on the page on which it had been pasted. So its authenticity is reasonably well founded; well

FIG 259 Alexander Cozens *Landscape with Riverbed and Mountains* Wash on laid paper, Metropolitan Museum of Art, New York.

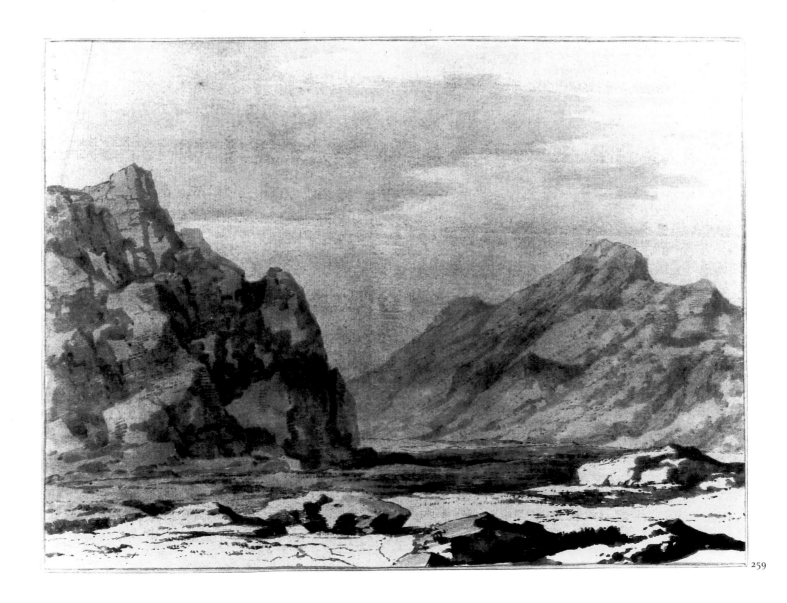

259

FIG 260 Alexander Cozens *Landscape with a Blasted Tree*
Brown wash on wove paper, 31.1 × 40 cm. Courtauld Galleries.

260

enough, one feels, for it to be included as further evidence of his awareness of Cozens at quite an early stage in his career. However, it is the copies and notes from the *Various Species* and *The New Method* that Constable made at Coleorton in the autumn of 1823 that demonstrate most clearly the extent of his interest in the work of the elder Cozens.

The visit to Leicestershire in 1823 lasted nearly six weeks, from 20 October to 28 or 29 November, a period much longer than he had planned for, and of a length away from home that eventually brought his gentle wife almost to despair. 'I begin to be heartily sick of your long absence', she wrote on 17 November,[22] and on the 21st, on hearing that the Beaumonts were pressing him to stay on over Christmas, said she thought it complimentary, but that Sir George had 'forgot at the time you had a wife.'[23] It was the kindness of his host and hostess and the opportunity to study at close hand such a magnificent collection of Old Masters – particularly the Claudes – that kept him there so long. There were occasional expeditions in the afternoons, but Constable spent most of the daytime copying two of the Claudes: first *The Death of Procris*, a landscape with a setting sun (now no longer accepted as autograph)[24] and the *Landscape with a Goatherd and Goats*,[25] considered by Constable and others as well to have been painted from nature, a painting, he said, that contained 'almost all that I wish to do in Landscape'.[26] In the evenings, while he looked through portfolios and made drawings, Sir George would read aloud from Shakespeare – '''As You Like It'' and the seven ages I never heard so before'[27] – or from Wordsworth's *Excursion*.

22 JCC II, p.299.
23 Ibid., p.302.
24 National Gallery, London, no.55; see 'Noble and Patriotic': the Beaumont Gift, 1988, no.7, p.44, repr. p.45.
25 do. no.58; ibid., no.5, p.41, repr. p.40. For Constable's copy, see Tate 1976, no.223. repr. p.134.
26 JCC II, p.295.
27 Ibid., p.292.

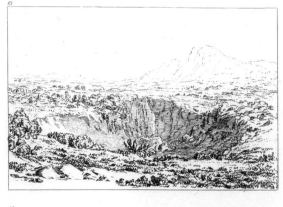

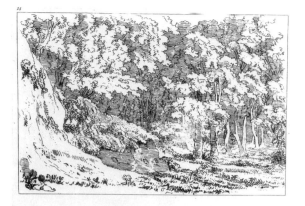

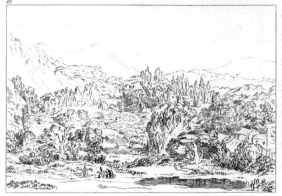

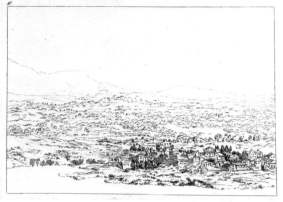

261

262

FIG 261 Alexander Cozens *Various Species of Landscape* Etching, sheet four (13–16), approx. 9.6 × 14.4 cm. British Museum.

FIG 262 After Alexander Cozens *'A Recess near the Eye'* Pen and ink on wove paper, 11.4 × 18.4 cm. Inscribed along the bottom, 'A Recess near the Eye, where little or no part of the Sky is seen'. 1823? Private Collection. One of a set of sixteen.

FIG 263 After Alexander Cozens *Cloud Study* Pencil on wove paper, approx. 9.3 × 11.4 cm. Inscribed, '8. Half Cloud half plain. the lights of the Clouds/lighter – and the shades darker than the plain/part and darker at the top than the bottom/ The tint once over in the plain part, and/ twice in the Clouds.' Courtauld Institute of Art. One of a series of twenty, two of which show the watermark 'W THOMAS 1822'.

263

Presumably it was during these peaceful evenings that Constable made his copies from Cozens. Of the etchings for *Various Species of Landscape*, printed on just four pages, four to a page (FIG 261), he made sixteen pen and wash copies. He included Cozens's numbering, 1–16, but does not appear to have copied the captions from the printed list designed to go with the etchings, as the wording is not the same. In the printed text, No.14 is titled 'A recess near the eye'. Along the bottom of his copy (FIG 262) Constable has written 'A Recess near the Eye where little or no part of the Sky is seen'. Less time was spent copying the twenty engravings of types of skies that formed the middle section of Cozens's *New Method*: the clouds were drawn summarily in pencil, the captions written out in pen and ink (FIG 263). In addition, Constable transcribed two of Cozens's lists relating to the *Various Species*: a metrical version of the titles for the sixteen etchings; a list of emotions suited to each type of landscape (for example, for No.14, FIG 262, the spectator is expected to experience 'Study. coolness. repose melancholy. religious fear – concealment peace security danger Tranquility solitude stillness'!); and he also made notes of some of Cozens's sayings – possibly learnt from his host. One of these is of particular interest as it complements J. T. Smith's advice against inventing figures to go in landscape (p.41) and accords so closely with Constable's own practice.

> Cousins said the figures in Landscape should so far from Intruding – that they should hardly be seen – to be ''as if rising out of the < Effect > ground – '' and passing by[28]

Besides the Cozens landscapes, skies and texts, Constable made copies of several of his hosts's own drawings. He told Maria about this in a postscript to a letter of 18 November: 'I amuse myself Evgs making sketches fr Sir Gs drawings about dedham – &c – I could not carry all his sketch book[s] – he filled so many'.[29] He copied a pencil drawing that Beaumont had made at East Bergholt in 1790 of a path through a wood with a donkey and rider;[30] inscribed a pencil and wash drawing of a windmill, 'From a drawing by Sir George Beaumont Bart done at Coleorton

28 See Wilton, 1986, p.26.
29 JCC II, p.302.

Hall';[31] and made another copy of a sketch Beaumont had done at Dedham in 1791.[32] FIG 264, another pencil and wash drawing, is inscribed in the top right-hand corner, 'both these are from Sir G.Bt'. Beaumont's original sketch of this tower has not yet been identified so it is not possible to say how closely Constable was keeping to it, but his copy is strongly blottesque in character (even though it was worked over with an initial pencilling). As he was investigating Cozens so thoroughly at the time, this, after all, is not surprising.

Only one of the four blots, *View of Dedham from Langham* (PLATE 35), is dated. Inscribed '23ᵈ Deʳ 1830', this, as we shall shortly see is connected with a mezzotint, *Summer Morning*. The first of the four (PLATE 34), relates to an earlier work, one of Constable's greatest paintings, *Stratford Mill*, his main exhibit at the Academy of 1820.[33]

Remarkably little is known about how *Stratford Mill*, the second of Constable's six-footers, came to be painted. It is first mentioned in Farington's Diary for 1 April, 1820: 'Constable called & spoke of a picture he has prepared for the Exhibition but has not and does not intend to consult opinions upon it.' Hitherto, Constable had almost always sought advice about a work he proposed to send in to the Academy. This indifference towards opinion bespeaks a new degree of confidence in his own powers. The reception of *Stratford Mill* (then catalogued simply as 'Landscape') by a section of the press, fully justified this freshly independent attitude. Farington, for 9 June, wrote: 'Constable called & shewed a very flattering Criticism published & a newspaper highly paneygerising his Landscape in the Exhibition.'

Work on *Stratford Mill* had been preceded by three oil-sketches: (i) an on-the-spot sketch of the lock at Stratford with children fishing that he had painted some years before, in 1811;[34] (ii) a composition roughed out on a 12 × 18 in. canvas, in which the scene is extended to the right to include the lower reaches of the river and a barge against the right bank;[35] and (iii), a full-scale sketch on a 6-ft canvas (FIG 265), parts of which are worked out in considerable detail. Between this third sketch and the final painting there were to be no major changes, but Constable did alter some of the figures and also make some minor but important adjustments. He reduced the number of figures in the foreground to three, removing the standing youth and giving his rod to the crouching boy and also making more of the little child in the middle. The men in the barge remained the same – one in the stern, one in the bows and the third on the bank – but here he replaced a tow-horse with an anchor, indicating thus a different stage in the progress of the barge up-river. The sense of over-all repose he further enhanced by the removal of the startled moor-hen in the bottom right-hand corner.

It has been suggested that the 'blot' of the *Stratford Mill* composition (PLATE 34) was done at a later date, perhaps from memory.[36] This seems unlikely. More probably, it would appear to have been part of the composing process. On such a small scale, one cannot be positive about a true reading of every brushstroke, but there are some meaningful blobs and light shapes left between them in the centre, for example, where the suggested grouping is nearer to sketches ii and iii than to the final version. Of greater significance, however, are the differences on the right bank. In PLATE 34, hard against the right-hand margin we see a firmly placed dark blob. This, clearly, was intended to represent the tow-horse that in sketch ii is placed right beside the barge and that in iii (FIG 265) is to be seen grazing contentedly at some distance in the meadow. If the

30 Sotheby's 10 March 1988 (lot 42). Private Collection.
31 Reynolds 1984, 23.27, PLATE 415.
32 Ibid., 23.79, PLATE 463.
33 National Gallery, London, ibid. Reynolds 1984, 20.1, pl.129.
34 Christie's 19 November 1982 (lot 100). Private Collection; repr. Cormack, *Constable*, 1986, p.116, pl.112.
35 Reynolds 1984, 20.3, pl.131.
36 Reynolds 1984, Text, 20.4, p.45.

FIG 264 After Sir George Beaumont *A Ruined Tower amidst trees*
Pencil and grey wash on grey paper, 22.3 × 18.6 cm. Inscribed, t.r., 'both these are from Sir G B¹'. 1823. Royal Albert Memorial Museum, Exeter.

FIG 265 *Study for Stratford Mill*
Oil on canvas, 131 × 184 cm. 1820. Yale Center for British Art.

264

265

Stratford 'blot' was Constable's recollection of the final painting, that blob would not have been there. Furthermore, in both sketches ii and iii (and in the final version) the standing figure in the barge is placed in the bow; yet in the 'blot', the only sign of a figure thereabouts is a vertical stroke, that must surely represent a figure, in the *stern* of the vessel. Such alternative thinking can only indicate some early stage in the development of the composition, but precisely, which? In the blot, the placing of the horse well away from the barge suggests that the composition was a modification of ii, in which the tow-horse is placed beside the barge. On the other hand, the lone figure at the back of the barge could well mean that the 'blot' was made between i and ii, that it was in fact the inceptive work, the very first attempt at a realization of the whole composition. Viewed on its own, the drawing represents a nice example of Constable following Cozens's instructions for the production of the kind of blot that, after possessing the mind 'strongly with a subject', should be done 'with a faint degree of colour: the drawings to be made out on the blots themselves, without the intervention of any other paper.[37]

From *Stratford Mill* of 1820, the next 'blot' or blottesque drawing, *Dedham Vale from Langham* (PLATE 35), carries us forward by some ten years into the midst of Constable's work with Lucas on the mezzotints for his *English Landscape*, a work that echoes Cozens's *Various Species* in its full title, *Various Subjects of Landscape, Characteristic of English Scenery*, and, with its eventual editorial emphasis on chiaroscuro, would undoubtedly have earned the elder Cozens's approval. By 23 December 1830, the date of the little 'blot' of Dedham Vale, the first part of the *English Landscape* had been published and the second part was just about to appear. Each part consisted of four mezzotints in a thick paper wrapper. The planning of the third part, with a further two numbers, appears to have begun that autumn. Several lists of possible subjects were drawn up and after much juggling around, on 9 December a provisional plan was written out for all five parts, the complete work. In this, 'Dedham Vale' features in the list for the fourth part (along with a 'Glebe Farm', a 'Large Canal' and 'Warwick Castle').[38] This was changed, though, and sometime between that date (9 December) and 19 February 1831, Lucas started work on the plate of *Dedham Vale* for a differently planned third part. On this last date, Constable wrote to Lucas, '...Go on with what you like, of the 3rd number – the "Morning" [*Dedham Vale*] or the "Evening" – of which I send you a touched proof'.[39] Titled 'Summer Morning', the Dedham Vale subject (FIG 266) was finally published in September with 'Summer Evening', 'A Heath' and 'Mill Stream'.[40] For us, the questions for which we should like to find answers concern the part, if any, played by the little blottesque *Dedham Vale* (PLATE 35) in the making of 'Summer Morning'.

The scene depicted is an eastward-looking view of the Stour valley from fields near Langham, with Dedham in the middle distance and the widening estuary beyond. This was a favourite subject with Constable. From here, or from further along the hillside towards the London road, he made a great many pencil and oil-sketches. There are four oils of this view, all from viewpoints within a few yards of each other. Two are of particular interest for us here. One is in the Victoria and Albert Museum (FIG 267), the other, dated 17 July 1812, in the Ashmolean Museum (FIG 268). For the mezzotint of the view, 'Summer Morning', Lucas was given the former sketch (FIG 267), to work from with its tranquil sky, single cow and lone figure. How, one wonders, had Constable come to make this choice? It

37 *A New Method*, p.24.
38 JCC IV, Appendix A, p.445.
39 Ibid., p.342.
40 Constable to Leslie, 9 September 1831, 'In a day or two I shall have a third number to offer you, it is at the binders'. JCC III, p.46.

FIG 266 David Lucas after Constable
Summer Morning
Mezzotint, image, 14.1 × 21.7 cm.
British Museum. An early progress
proof. The figure with the bottle
slung over his shoulder on a stick has
been variously seen as a man with a
scythe, as a gamekeeper, a violinist
and as a shepherd playing a flute to
the cow.

FIG 267 *Summer Morning: Dedham
from Langham*
Oil on canvas, 21.6 × 30.5 cm. c.1812.
Victoria and Albert Museum.

FIG 268 *Dedham from Langham*
Oil on canvas, 19 × 22 cm. Inscribed,
b.l., '13 July 1812' Ashmolean
Museum, Oxford.

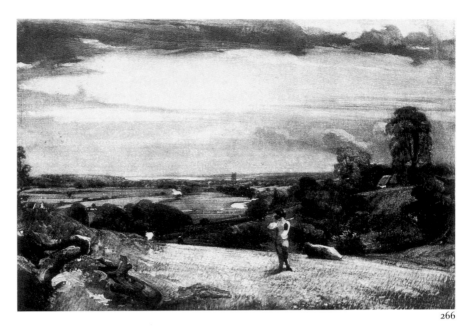

266

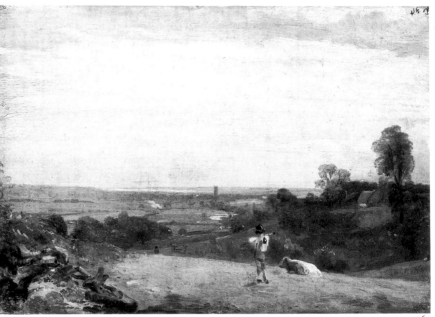

267

268

269

FIG 269 *Summer Evening*
Oil on canvas, 31.7 × 49.5 cm.
Exhibited 1812? Victoria and Albert
Museum.

would seem to have been his intention to pair off 'Summer Morning' with a 'Summer Evening' and at the same time to contrast the one with the other. In the painting from which Lucas engraved the 'Evening' mezzotint (FIG 269, a view looking in the opposite direction, towards Langham from the fields below East Bergholt), the sun is setting, but in a sky where the nearer, upward-sweeping clouds are of a somewhat disturbed character. Of the four paintings from Langham he had to choose from, only the sky in the Victoria and Albert Museum version (FIG 267), with its steady horizontals – the sky of a dewy, early morning – contrasts effectively with the evening, Bergholt view. As an additional attraction, this sketch also had a ready-made focal point, the strolling figure with his water (or cider?) bottle slung over his shoulder on a stick. In the event, as work on the mezzotint progressed, Constable made many changes, as was his wont, and in its final published state there was a plough in the foreground of the mezzotint, in the sky shafts of sunlight and a number of birds, and on the near slope three cows and a milkmaid with her pail.

At which stage did Constable make his blottesque miniature of Dedham Vale? On the available evidence, it seems most likely that it was part of the important earlier, decision-making process, when he was trying to decide which of the oil-sketches would best suit his plans for the third part of the *English Landscape*. To make this choice it would have been helpful to see one, at least, as it might appear divested of colour, in pen and wash, a medium more akin to the printed impression.

Of the four versions, the little *Dedham Vale* (PLATE 35) is closest to the Ashmolean sketch (FIG 268). Both have a sky with a strong upward, linear drive from left to right, a dynamic echoed by the flighting birds more strongly in the drawing than in the oil (in neither of the other sketches is there a bird to be seen). In both, the centre is framed – cradled almost – distinctly, if unevenly, between low repoussoirs of trees to right and left. In each, the viewpoint is on the slope, down off the crest of the hill. Constable may have done more than this one

41 Private Collection. Reynolds 1984, 33.14,
pl.871.
42 Ibid., 25.3 and 25.4, PLATES 574 & 575.

IG 270 *The Leaping Horse; Detail*
Oil on canvas, 142.2 × 187.3 cm. Royal
Academy of Arts.

IG 271 *A Barge on the Stour*
Pen and iron-gall ink and watercolour
on untrimmed, wove paper, left edge
irregular, 11.5 × 19.3 cm.; watermark,
/TMAN /31'. Victoria and Albert
Museum.

blottesque composition to help him to make his choice. Most artists' studios are workshops. The creative process is essentially an untidy and often messy business, and much is spoilt or destroyed in pursuit of the objective. In his case, it is likely that many of his preliminary studies were treated as little better than waste once they had served their purpose. The little *Dedham Vale* survived. Its date places it in the critical period when work was starting on the third part of the *English Landscape*. Perhaps it owes its survival to its dating, to the fact that it was a record that in some way might have to be referred to in the future.

The third 'blot' (PLATE 36) presents problems. Of the four, it probably best illustrates Constable's adoption of Cozens's first method of blot-making, that is, after a little exploratory work with the pencil, a working over pale initial washes with increasingly decipherable, darker brush-work. But the drawing is difficult to date and all too easily invites pigeon-holing. The subject seems to be a river scene with a tow-horse and rider, a barge (?) and a group of overhanging trees. The silhouetted horse and rider on the left immediately suggests a mirror-image of the bare-footed boy in *The Leaping Horse*, urging his steed over the jump (FIG 270). The general composition, however, in particular the shadowy mass of trees on the right, relates more closely to a watercolour in the Victoria and Albert Museum of *c.*1832, *A Barge on the Stour*, a similar subject, again a canal scene, but in this case with a horse standing patiently in the water beside a barge while a boy scrambles up on to its back (FIG 271). The relationship of our blot to this drawing is intriguing because Constable used the central section of the latter – horse, boy, overhanging trees and distant water-meadows – for an upright composition, namely the second of the two Victoria and Albert 'blots', also titled *A Barge on the Stour* (FIG 247), which, with its companion has always been assumed to be a late work, *c.*1836.

In all, apart from our examples, about a dozen brush drawings by Constable have survived that can reasonably be termed 'blots'. Only one of these, a rapid sketch of Stoke Poges church done for one of his sons' schoolfellows, is dated (23 August 1833).[41] All, however, seem to belong to the 1830s. As well as the true blots, there exist a much larger number of blottesque drawings – pen and wash compositions mostly. Some of these are dated or dateable. With the exception of the two magnificent large studies for *The Leaping Horse* in the British Museum,[42] none appears to be earlier than 1830. Where, therefore, are we to place this third

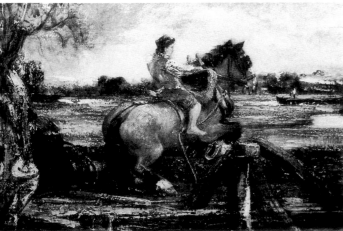

270

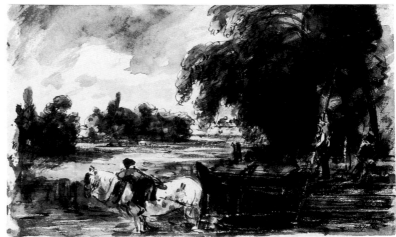

271

FRONTISPIECE.
To Mr. Constable's English Landscape.

EAST BERGHOLT, SUFFOLK.
"Fond recollections round thy memory twine."

*Hic locus ætatis nostræ primordia novit
Annos felices latitiæque dies:
Hic locus ingenuis pueriles imbuit annos
Artibus, et nostræ laudis origo fuit.*

London Published by Mr. Constable 35 Charlotte St Fitzroy Square, 1831.

272

blot of ours? Were it not for the Victoria and Albert Museum watercolour (FIG 271) and the 'sepia' drawing of the same subject (FIG 247), one would be tempted to link it with *The Leaping Horse*, as an exploratory composition at an early stage, for the brushwork to be seen in PLATE 36 closely resembles some of the free handling in the two British Museum studies. But without further evidence to support a dating of 1824/5, somewhat disappointingly perhaps, we must recognise the likelihood of its being later, and at present place it somewhere between the watercolour of *c.*1832 (FIG 271) and the 'sepia' blot of *c.*1836 (FIG 247), drawings with which it has rather more in common.

From the work he had in store or lying about in the studio, Constable made a wide-ranging selection of subjects for the *English Landscape* mezzotints. He also chose from amongst a variety of formats – from small oil-sketches, cabinet pieces and medium-sized exhibition paintings, as well as from the large, unsold six-footers and their full-scale trial runs. All the known originals from which Lucas worked on his plates are oils, and two of the four subjects for which originals are lacking were probably also oil sketches or paintings.[43] Nothing, however, is known as to the character of the originals from which Lucas engraved the remaining pair of plates, the *Frontispiece* (FIG 272) and *Stoke by Neyland* (FIG 273).

43 *Summer Afternoon – After a Shower* and Vignette: *Hampstead Heath, Middlesex.*

These, of course, may also have been oils, but at the same time it is quite possible that they were drawings – wash or pen and wash studies, blots, even, not unlike the last of the present four blots, the *Stoke-by-Nayland* (PLATE 37).

As we saw with the heavily retouched *Small Salisbury* (PLATE 30), when he began to work on a progress proof, Constable would occasionally allow himself to be carried away, and was capable of completely over-working one of Lucas's 'pulls' with ink-wash and Chinese white – metamorphosing a printed into a painted image. This did not happen in the case of a third proof 'C', of *Stoke by Neyland* (FIG 274), in which the retouching is restrained and more explicit. It is possible

273

274

275

that some of the changes here were first roughed out in a form in which he could invent with greater freedom – in a sketch like the *Stoke-by-Nayland* (PLATE 37) or on a companion work. The character of a recently discovered progress proof for the *Frontispiece* (FIG 275) taken at a stage earlier than the other recorded 'first' proof[44] seems to be a pointer in this direction.

This apparently unique impression, looks very like an attempt by Lucas to interpret the liquid washes of a blottesque drawing with his rocker, burin and scraper. The subject is the artist's birthplace from beyond the gardens at the back. Of the house, as we have seen, Constable made a number of drawings (FIG 102; PLATE 11 and FIG 118) and from the fields at the back at least three oil sketches. To none of these does the engraved view bear much resemblance. Plainly, the scene with which Constable introduced the completed run of twenty-two mezzotints, the *English Landscape*, to his public, was an evocation of a rather more fanciful character. The notion that the original may have been a blottesque recollection of the subject gains support from the existence of another equally

44 Shirley, 1930, p.189.

IG 275 David Lucas after Constable
Frontispiece
Mezzotint on wove paper, image,
4 × 18.6 cm. Earliest known progress
proof.

IG 276 *A House, Cottage and Trees by
Moonlight*
Diluted iron-gall ink, grey wash and
white heightening on thin wove
paper, 18.6 × 22.7 cm. Victoria and
Albert Museum.

fanciful view of the house – perhaps a rejected, alternative composition – a brown and grey blot in the Victoria and Albert Museum, this time of the house from the front with its poplar and Dunthorne's workshop and cottage on the left (FIG 276).

Stoke by Nayland church, on the crest of a hill some five miles from East Bergholt, was a subject that greatly attracted Constable. The tower appears on the skyline in many of his westward-looking views of the Stour valley, and from close to it was the subject of twenty or so drawings and paintings: chalk, pencil and oil sketches early on (c.1810–14); an exhibited watercolour (probably no.632, 'A church', in the Academy of 1832); the mezzotint (FIG 273); and finally a late

276

composition in oils (FIG 277). For the mezzotint, Constable chose a viewpoint from the road leading up to the village from the south, an aspect of the church, with its tall tower and surrounding huddle of cottages, that he had sketched a number of times. Lucas's first attempt on the steel plate, revealing an unaccountable ignorance of the tower's orientation (FIG 278), was corrected for the second progress proof (in which a woman with a bundle or sheaf on her head first appeared), and on the aforementioned third proof 'c' (FIG 274) Constable made a number of further changes, introducing a rainbow, a figure leaning on a gate, several birds in the sky, etc. It is to the work in progress at this stage that our *Stoke-by-Nayland* (PLATE 37), with its double rainbow and the figure at the gate appears to. be related. But although the white shape above the road near the middle may be the sheaf on the woman's head, there are blots and patches just to the right that suggest Constable had something else in mind for this part of the composition – cattle, or some such, of which there is not a hint in any of the later proofs of the print. For a development of these barely suggested forms, as well as for a re-use of other features, we have to turn to the work of his last years – the Chicago *Stoke-by-Nayland* (FIG 277).

In his biography, Leslie published a letter Constable wrote in 1835 to a friend who had evidently been encouraging him to paint a 'Stoke'. The scene the artist was visualising is described in some detail: 8.00 or 9.00 a.m. on a summer morning after a slight shower 'to enhance the dews in the shadowed part of the picture'; a plough, cart, horse, gate, cows, donkey, 'all good paintable material for the foreground and the size of the canvas sufficient to try one's strength.'[45] According to Leslie, a large picture of the subject was never painted, but it is now generally agreed that the Chicago painting is a full-size sketch for the work Constable was intending to execute. In our drawing (PLATE 37) – so like the late oils in its tempestuous handling – besides the suggestion of sunlit forms on the road that became the cattle, plough, cart and horses, there are other links with the Chicago *Stoke*. While the composition on the canvas was extended upwards and outwards to the right, the church, reduced in scale and dramatic effect, nevertheless remained close by the left-hand edge as in the drawing. Also, as in the drawing, the prominent, white, end wall of the cottage just below the church, was done away with. In the touched proof 'c' of the mezzotint (FIG 274), a figure at the gate is suggested by a few indeterminate dabs of the brush. In the drawing, this is a large, almost sinister figure, a form seemingly quite out of scale, that in the painting became the man leaning over the gate with the monstrous, pumpkin-sized head.

In these last years, maybe as a sort of protest against sensations of mounting frustration, or to compensate for his own lessening powers of recall and invention, Constable seems to have relied increasingly upon his inner strength and upon an unharnessing of his great stores of energy, for so long contained and controlled, for so long denied full expression. More and more in his oils he worked with his palette-knife; using it to dab and drag thick 'helpings' of paint across a canvas, a surface already roughened with broken layers of pigment; using the knife to apply juicily-shaped passages of impasto; sometimes, in an apparent frenzy of application, lashing and cutting at the surface with the paint-coated edge of the knife, as if it were some kind of whip. To stand close – to within a

45 *Life*, 1951, p.250. Leslie dates this letter 6 February 1836, but as Beckett points out (JCC V, p.44), further on Constable talks of his son 'Charley' reading his studies 'by my side'; by February 1836, the boy was serving as a midshipman at sea in the Indian Ocean. Beckett reckons July 1835 a more likely date.

46 In a letter to Dominic Colnaghi endorsed 1828 (only known from a catalogue entry), Constable asks to know the fate of 'my drawing of Jaques. I wish much to make a picture from it, about a kitt catt [i.e., 28 × 36 in.] Will you request that permission from whomsoever may possess it.' Beckett (JCC IV, p.157) suggests that the drawing failed to sell and was no.492 in the Academy of 1832. This may not necessarily have been the case. The reviewer of the first number of the *English Landscape* in the *Athenaeum* for 26 June 1830, describes three works seen on a visit to Constable's 'Gallery' at his house in Charlotte Street. The only one he names (the other two were *The Cornfield* and *The Lock*) was a watercolour of Jaques looking at the wounded deer in the Forest of Arden. 'It *is* the forest which Jaques haunted. There he lies on the knotted roots of the oak; and you can *hear* the brook. The trees are apart – scattered – giving room for the deer to go fleeting by, and for the foresters with their goodly bows over the far grass dappled with sunlight...' etc. This description does not convincingly match the watercolour (FIG 279) thought to be the exhibit of 1832. Is there yet another Jaques drawing to discover, and an oil too? In 1839 (20 April), in a sale of part of the collection of James Stewart an acquaintance of Constable's, a 'Jaques and the Wounded Stag: *a rare specimen*', lot 23, presumably an oil, was sold for £6.10s.

47 Constable's interest in this scene from *As You Like It* may go back as far as his childhood. When he was at school at Lavenham, the school playground was just across a narrow back-street from the house of the engraver Isaac Taylor, and at that time Taylor was working on a large *Jaques and the Wounded Stag*, which, with the other pictures he had in his workshop, he was happy to allow all to see. See p.33, n.9.

48 Two of the four not discussed here are in private collections: Reynolds 1984, 35.34, pl.1043 and 35.35, pl.1044; one is in the V.& A., ibid., 35.33, pl.1042; the other is in the B.M., ibid., 35.32, pl.1041. This last is drawn on the back of a draft for part of the letterpress for *Summer Morning* in the *English Landscape*.

49 JC:FDC, p.242.

FIG 277 *Stoke by Neyland*
Oil on canvas, 126 × 168.8 cm.; 1835?
The Art Institute of Chicago.

FIG 278 David Lucas after Constable
Stoke by Neyland
Mezzotint on wove paper, plate mark
14.3 × 22 cm. First progress proof with
the church seen cornerwise.
Fitzwilliam Museum, Cambridge.

couple of feet of these canvases – and to take part in the action, as it were, is an exhilarating experience. On a small scale, this tremendous release of power towards the end of his working life can scarcely be better illustrated than by some of the sketches he made (PLATES 38, 39, 40 and 41) for a publication, the *Seven Ages of Shakespeare*, edited by a friend of his, the biographer John Martin (1791–1855).

Encouraged by the success of an edition of Gray's *Elegy*, with thirty-two wood-engravings after designs mostly by well-known artists – De Wint, Copley Fielding, Westall, Collins, etc, – in 1834 Martin planned a second venture, Jaques's famous speech from *As You Like It* (Act II, Scene VII) beginning, 'All the world's a stage...', likewise to be illustrated by reputable artists. For the first edition of the *Elegy*, Constable had contributed three designs – a fourth appeared in later editions. For the *Seven Ages* there were to be fewer illustrations, one each, by twelve artists. It is not known on what basis these were given their assignments – Wilkie, 'The Infant', Collins, 'The Schoolboy', Calcott, 'The Justice,' etc. – but Constable was a fairly obvious choice for a portrayal of Jaques, as he had painted a watercolour and possibly an oil too of the melancholy courtier in the Forest of Arden some years before[46] and had also exhibited a watercolour titled 'Jaques and the wounded stag' in the Academy of 1832.

The play was a favourite of Constable's (one recalls his delight at Coleorton on hearing Sir George Beaumont's rendering of the Seven Ages speech, as 'I had never heard before') and the number of attempts he made to arrive at a satisfactory design – nearly twenty, according to Martin – shows how readily he took to the idea of approaching the subject yet again.[47] At present only nine of the original 'nearly twenty' sketches can be accounted for,[48] but three of these have made their appearance just in the last couple of years, and there seems to be no reason for supposing that there are not others awaiting recognition. It is not known when Constable began to rough out his designs for Martin's edition of the *Seven Ages*. In the Correspondence it is only referred to once, on 10 February 1835, in a somewhat cryptic note from Leslie (who, later, provided a frontispiece for the work): 'Martin was here to day, with his seven ages, he is pleased with my idea of the fates'.[49] This merely tells us that the work was then a current topic. It is only

277

278

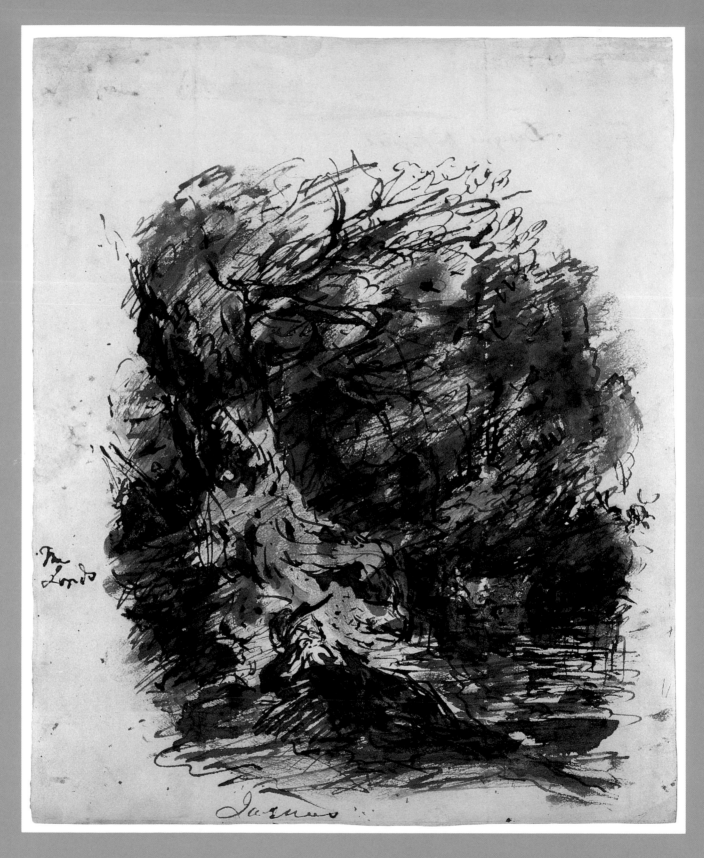

PLATE 38 *Study for Jaques and the wounded Stag (A)*
Pen and iron-gall ink wash and white heightening on writing paper that has been folded
as for a letter 22.8 × 18.5 cm.
Inscribed on the left in ink 'The/ Lords' and below 'Jaques'; on the back 'Designs for
"Jaques"' and vertically, in another hand, 'Mr Constable/Charlotte St', both in ink.

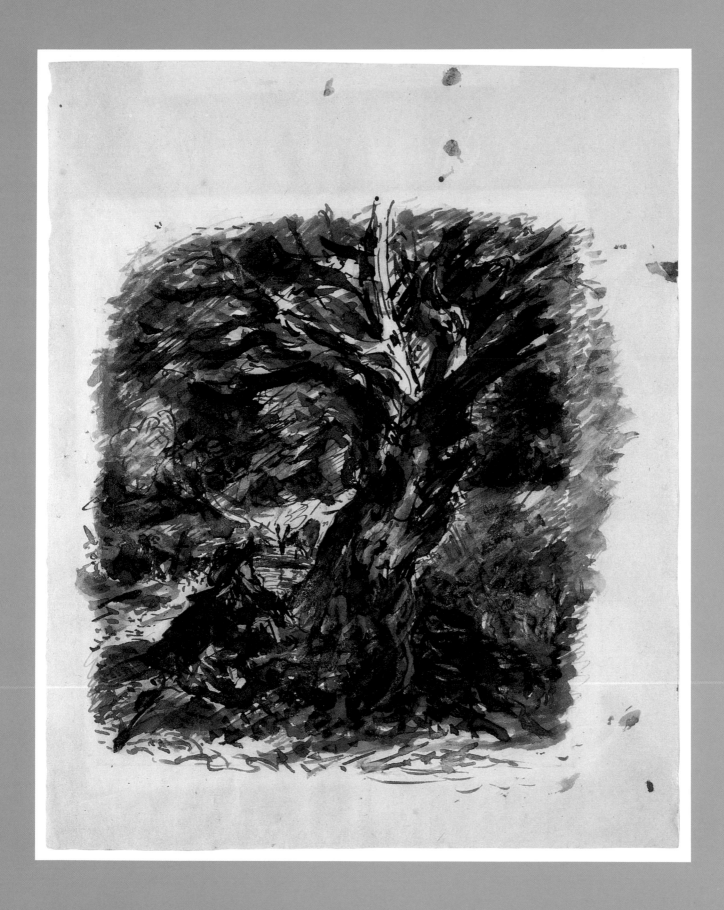

PLATE 39 *Study for Jaques and the wounded Stag (B)*
Pen and brush and iron-gall ink with white heightening on writing paper, left edge
irregular 22.8 × 18.5 cm.

known that Constable was unable to arrive at a design that he felt to be conclusive, and that in the end it was left to Leslie, after the death of his friend, to select one of the designs for the engraver. This is best told by Martin himself in the Introduction he wrote for his *Seven Ages*, which was finally published in 1840.

> During the progress of this work through the engraver's hands, two of its contributors have "made their exit", John Constable, R.A. and William Hilton, R.A. The interest which the first-named took in the trifling affair required of him, is best evinced by the fact that he had made nearly twenty sketches for the "melancholy Jaques", which by the kindness of C. R. Leslie, Esq., R.A., now accompanies this work; that gentleman having selected the design he judged most appropriate, and careful of the reputation of his deceased friend, took the additional trouble upon himself of transferring it to the wood. Without his assistance, this effort, however trifling, of one of our true painters of English scenery would not have appeared – a matter that would have caused deep regret to the Editor, in being prevented exhibiting this tribute to the talent and memory of one in whose society he has enjoyed many pleasant hours.

The scene in the play Constable found such a source of inspiration, is the first in Act II, The Forest of Arden, when the exiled Duke, after his 'tongues in trees, books in the running brooks, sermons in stones, and good in everything' speech, talks of venison, of the 'poor dappled fools' with forked heads it irks him to kill, and is told by a courtier of how he and Lord Amiens espied the melancholy Jaques, and

FIG 279 *Jaques and the Wounded Stag*
Pencil, reed (?) pen and brown ink and watercolour on wove paper, 20.1 × 31.3 cm., extended on all four sides to 23 × 32.8 cm., the whole laid on 3-layer, laminated Whatman paper. Exhibited 1832?

FIG 280 *Study for Jaques and the Wounded Stag*
Pencil on writing paper, 13 × 10.2 cm. Much of the pencil-work has been gone over with a stylus or pointed tool, as if to transfer.

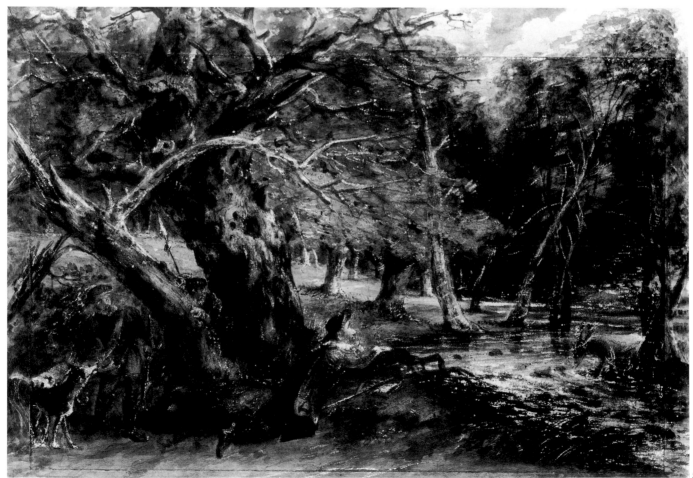

279

Did steal behind him as he lay along
Under an oak whose antique root peeps out
Upon the brook that brawls along this wood;
To the which place a poor sequester'd stag,
That from the hunters's aim had ta'en a hurt,
Did come to languish.....
...on the extremist verge of the swift brook
Augmenting it with tears.

And of how they left Jaques

.......weeping and commenting
upon the sobbing deer.

280

Constable echoed the next speech in the play –'*Duke*Show me the place./ I love to cope with him in these sullen fits,/ For then he's full of matter' – in a letter to Leslie of 2 March, written, still in a rage from a visit the day before of a wealthy collector whose views on art he abhorred:

> ...I long to see you. I love to cope with you (like "Jaques") in my sullen moods: for I am not fit for this world (of art at least).[50]

For the watercolour he exhibited in 1832, which was strongly criticised for its 'scraped effects',[51] Constable chose to depict Jaques, gazing compassionately across the brook at the stag, conveniently unaware of Amiens and his companion (and a couple of hounds) peering at him from behind the oak (FIG 279). To accompany his exhibit, Constable selected lines from Peter Coxe's *The Social Day* for the Academy catalogue: 'The melancholy, feeling Jaques, whose mind griev'd o'er the wounded, weeping hind.'

In two of his designs for Martin's *Seven Ages*, Constable toyed with the idea of including Amiens and his companion again, but as an upright composition was better for a whole-page illustration, he seems to have preferred a more simple approach – just Jaques, alone under the oak, his attention held by the wounded beast. Our first examples, *a* (PLATE 38), *b* (PLATE 39), *c* (PLATE 40) and *d* (PLATE 41), are all variations of this theme; though 'the Lords' Constable wrote in the margin of *a* and some of the adjacent work with pen and chalk may have been an indication that the shadows might yet reveal the two courtiers stealing up on the contemplative Jaques.

One of the 'Jaques' to have appeared recently (FIG 280, in which Constable tried out the idea of having a courtier listening to Jaques from behind the oak), is entirely in pencil – presumably a fair illustration of how some of the others were first sketched in. In *a*, over traces of faint pencil-work, Constable began by

50 JCC III, p.95.
51 'We dislike these *scraped* effects; they are unworthy of an artist who is capable of employing the legitimate resources of the art. '*The Reviewer*, 20 May 1832, vol.1, no.21, p.82.

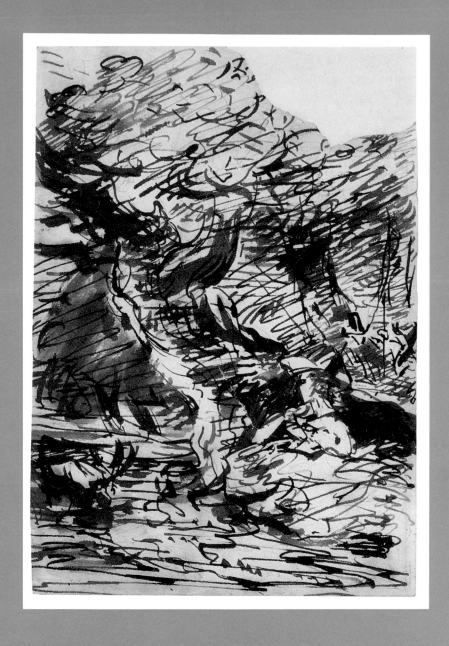

PLATE 40 *Study for Jaques and the wounded Stag (C)*
Pen and iron-gall ink and wash on writing paper (top right corner missing)
14.5 × 10.1 cm.

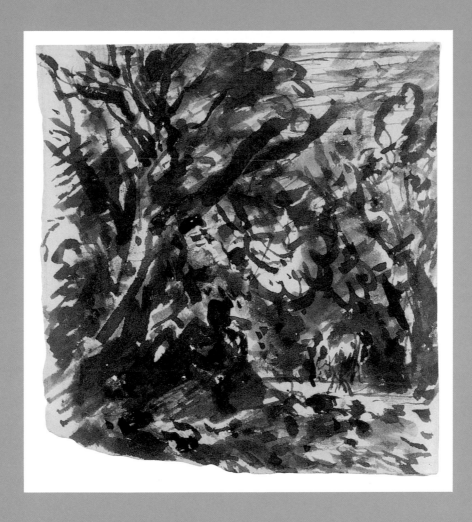

PLATE 41 *Study for Jaques and the wounded Stag (D)*
Brush and iron-gall ink on trimmed writing paper 11.4 × 10.7 cm. On the back,
part of a letter: '?...
 Some papers by Joan
 I hope Your friend will
profit by our lectures – for
Your sake [?lent] him one for
the whole season – so this I hope
he will not [?...] & [?with]
[?...] when he feels [?...]'

rubbing in areas of tone with diluted iron-gall ink, in places using a largish brush, but elsewhere also his fingers. Several small areas of pale, wet washes were brushed in – just above Jaques's hat one can make out a single wet curved stroke with a square-ended brush. In many places, but particularly around the edges, there are to be seen both clear and smudged imprints of fingers (or thumb), dabbed, dragged or rubbed on the surface of the paper. Then, in the darkest of iron-gall inks, still with his fingers, but mainly with what appears to have been an assortment of tools – brushes, thick and fine, and more than one kind of pen – he attacked this initial work, his own type of blotting, with a veritable storm of sweeps, dots, violent zig-zags and scribbles; an assault that bears comparison with the more demonstrative passages of palette-knife painting in his big, late canvases. While some of the ink was still wet, the storm concluded with a few final flourishes in what appears to be white chalk. The effect is astonishing; reminding one of passages in some of Jackson Pollock's drawings.[52] Jaques in this drawing is readily discernible, or, at least, his upper part is. One imagines that the stag is (or was) somewhere in the direction of his gaze, but it is not easy to make out the form of the creature in such a welter of scrawling and scribbling.

To the right of the oak in our second design, b (PLATE 39), again in the direction in which Jaques seems to be looking, we have another area of turmoil, of painting and re-painting, with a final blotting out of the recognisable forms with white. Had he first intended to have the stag here? For this design there does not seem to have been any underdrawing in pencil; instead, Constable launched straight in with a fine pen and diluted ink. Again, there are visible signs of dabbing and smudging with the finger or thumb. On top of this, he worked vigorously with a pen and brush, still with diluted ink, and marked with a blob the spot where he later drew the deer with pen and a darker ink – a rather awkward siting for poor Jaques. For the final stages, the final attack, again a variety of tools were used – brushes and pens. Remarkable, is the strangely disordered rendering of the boughs and branches of the oak, their dark, heavy forms painted in with almost brutally forceful strokes of the brush.

Design c (PLATE 40), is a relatively straightforward work: over some slight graphite pencilling, a little brush- and pen-work in diluted ink; the design completed with brush and pen in the darkest possible, pure iron-gall ink. It contains some fine rhythmical passages, in places vying and clashing with one another, and much of the handling is exciting to follow. As an illustration, however, it is not really a success. Jaques's upper part is clearly delineated, but where is the rest of him? Is he leaning forwards or backwards? Granted it is a scene from a play, but even so, are not Jaques and the stag rather absurdly close together, separated only by the width of the brook?

Most of Constable's nine designs for Martin's Seven Ages are alike in the vigour of their execution, but they differ greatly in mood. This suggests quite a long working period – months, rather than weeks. No attempt has as yet been made to arrange them chronologically. In the last two, c and d (PLATE 41), both on torn scraps of writing-paper (d, on the back of a draft of a letter),[53] we have a pair expressive of very different moods: the former, edgy and rather scratchily drawn; the latter, entirely the work of finger and brush – almost Palmer-like, with its rounded shapes and rich play of light through dark – is one of the most moving of the series, and the nearest of all nine to a true Cozens blot, i.e., a variety of spots and shapes, without lines, from which ideas are presented to the mind.

52 In a statement, Pollock said, 'When I am in my painting, I'm not aware of what I'm doing. It is only after a sort of "get acquainted" period that I see what I have been about. I have no fears about making changes, destroying the image, etc., because the painting has a life of its own. I try to let it come through.' Frank, Jackson Pollock 1983, p.109; from Possibilities (Winter 1947), p.79. One feels that Constable would have understood this.

53 Part of which reads: '...I hope your friend will/ profit by our lectures – for/ Your sake lent him one for/ the whole [?season] this I hope/...' This does not help much with dating the drawing (Constable gave lectures on landscape in 1833, 1835 and 1836), but if 'season' has been correctly read, this might refer to the series of four he gave at the Royal Institution in May and June 1836.

FIG 281 Samuel Williams after Constable *Jaques and the Wounded Stag* from *The Seven Ages of Shakespeare*, 1840.

From these deeply emotional works, it is something of an anti-climax to turn to the final product (FIG 281), the design engraved by Samuel Williams that Leslie had selected as the 'most appropriate', and had taken the trouble himself to transfer to the woodblock, so careful was he, according to Martin, of the reputation of his friend.

281

22 Dowles Brook

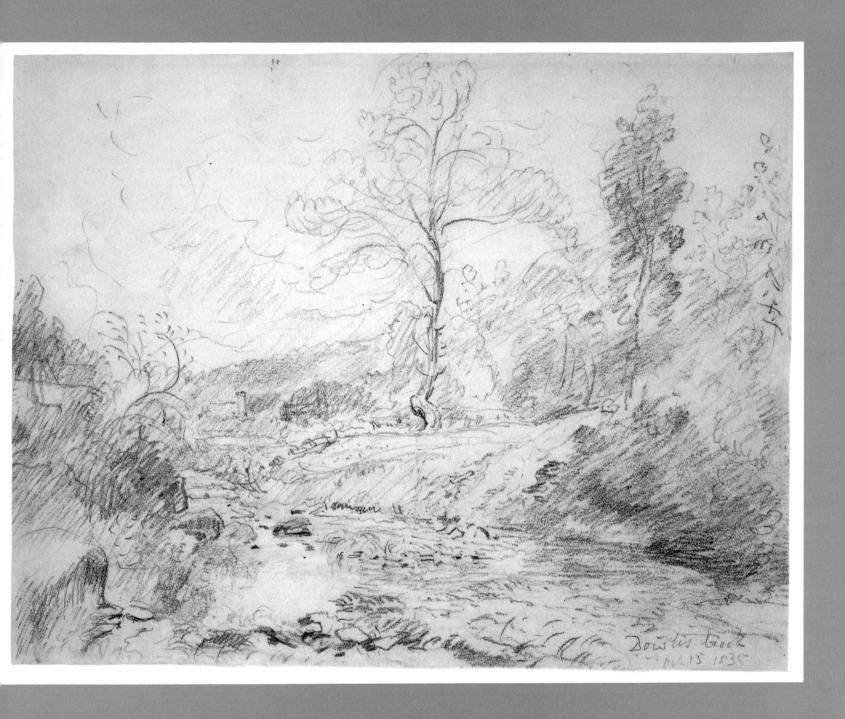

PLATE 42 *Dowles Brook*
Pencil on trimmed paper 21.8 × 27.8 cm.
Inscribed in pencil bottom right 'Dowlis brook/ Oct 1835'.

Constable's Worcestershire drawings of 1835 represent the final statements he was to make when face to face with nature. *Dowles Brook* (PLATE 42) is the last of the five dated studies in the group and therefore may be the very last sketch be made out-of-doors in any medium. After this trip into the country, in the remaining sixteen months of his life, he was to leave London once more, in December of the following year, to spend Christmas at Flatford with Abram, his brother and his sister, Mary; a visit recorded by no known drawing or painting.

Dowles Brook, dated 15 October 1835, was done at the end of a stay with his sister-in-law, Sarah Fletcher and her husband at Spring Grove, their house near Bewdley, a town on the Severn some miles north of Worcester. Constable had been there before once only, in the winter of 1811, at a moment of crisis in his relationship with Maria Bicknell and her parents.

In the opening stages of his courtship of their daughter, there had been a time when the Bicknells welcomed Constable as a regular visitor to their home in Spring Gardens, just off Whitehall. Mr Bicknell, with Maria on his arm, would call on the young artist at his lodgings in Frith Street. Then, Mrs Bicknell's connections with East Bergholt (her father, Dr Rhudde, being the rector), seemed only to strengthen ties between the two families. However, closely following upon two sad deaths – that of Mrs Bicknell's mother, Mrs Rhudde, in March 1811, and the Bicknell's elder son, Durand, the following month – there developed an unaccountable change in the Bicknell parents' attitude towards Maria and her suitor. She was sent away for safe keeping into the country, to Spring Grove, to stay with her half-sister (Charles Bicknell's widowed daughter by a previous marriage) and on calling at the Bicknells' home in Spring Gardens, Constable found he was no longer able to gain admission. In some distress, on 23 October, he wrote Maria a brief letter, the first in a long and very moving correspondence.[1] Was he asking for the impossible, he said, if he requested a few short lines from her? In her reply, Maria entreated him to think of her no more but as one who would ever esteem him as a friend. 'I have too long', she said, 'given way to a delusion that I might have known must sooner or later have an end'.[2] By this time he was ill: 'the most severe indispositiion I have ever experienced'.[3] Charles Bicknell granted him an interview and then wrote a 'fearfully dreaded letter'[4] to his daughter, in which he expressed his main objection to the match, a lack 'of that necessary article Cash'.[5] This, Constable seems to have felt to be the least of their problems, and on 12 December wrote her that he could see no obstacle to an unreserved correspondence between them. He had failed to appreciate how loyal she could remain to her parents. In her answer (of 17 December), she said she could never consent to act in opposition to the wishes of her father, that she could not continue the correspondence and begged and again entreated him to cease to think of her, to forget that he had ever known her.[6] To this, there could be only one answer: he took a seat in the first available coach to Worcester, made his way to Bewdley, and arrived for the weekend at Spring Grove, unannounced. He was well received; apparently, the boldness of his action had made a favourable impression. He left on Sunday (the 22nd), regretting that

> . . . the fine weather on sunday should not have happened a day or two sooner
> – that we might have had a walk to the banks of the severn – for in addition to
> the fineness of the morning the frost had made it dry under foot I was at
> Worcester two or three hours before the Mail set off – which gave me an
> opportunity of seeing the Cathedral and most of the Town – & I had a very

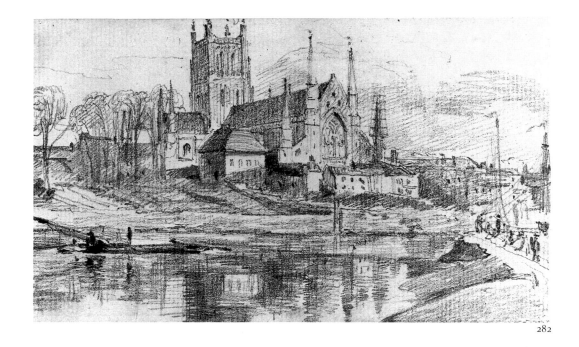

282

beautifull walk down the river [see FIG 282] – I may now say that some of the happiest hours of my life were passed at Spring-Grove – mixed as they were with moments of unutterable sadness nor could it be otherwise when I reflected that you who might – & who deserved to have been entirely happy – I had taken pains to render not so – [7]

For some time Constable's family had been urging him to exert himself manfully. 'Though You are miserable', his uncle, D. P. Watts, had written after his interview with Mr Bicknell, 'yet You are a *Man.* if you weakly sink that heroic character, You would have been but a feeble Prop to a Woman who puts herself in Your protection. Arise! revive! bravely surmount even Shipwreck and Ruin!'[8] He had risen to the occasion and by his dash into the country won both his spurs and Maria. Hitherto, 'Dear Sir' or 'My dear Sir' in her letters, by April he was 'My dear John'.

In 1835, it was an invitation to give a short series of lectures to the local Literary and Scientific Institution on the 6th, 8th and 9th of October that took Constable down to Worcester. But it must have been very largely a desire to see Spring Grove again and to re-live those memorable few days of twenty-four years back that brought him to Bewdley the following week. After her marriage, Maria had kept up with her half-sister through Sarah's step-daughter, Caroline, but since his wife's death Constable appears to have rather lost touch with her relations at Spring Grove. In 1815, Sarah, his sister-in-law (more precisely his half sister-in-law), a widow since 1806, while continuing to reside at Spring Grove, had married again. Her husband, the Revd Joseph Fletcher, twelve years her junior, was now, in 1835, Rector of St Andrews in the nearby parish of Dowles. Spring Grove, in its spacious grounds, lay a mile or so south-east of Bewdley, then, still a prosperous inland port on the Severn. Dowles (as in 'owls' – a parish of some 80 inhabitants in 1845), with its church, was on the western, right bank of the Severn, a mile upstream from Bewdley.

1 JCC II, p.50.
2 26 October; ibid., p.51.
3 29 October; ibid.
4 2 November; ibid., p.52.
5 4 November; ibid., p.53.
6 17 December; ibid., pp.55–6.
7 24 December; pp.56–7.
8 1 November; JCC IV, p.31.

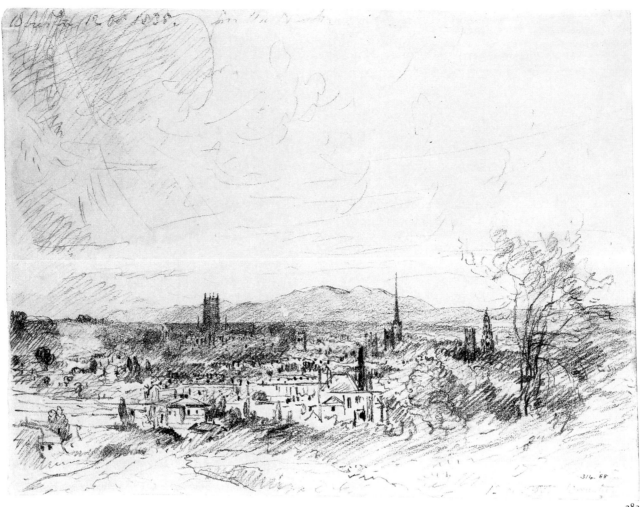

283

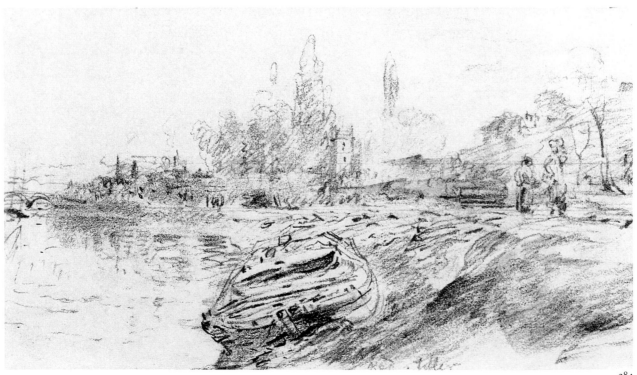

284

On this Worcestershire trip, Constable took with him the 9 × 11 in. sketchbook that he had used earlier in the year in Sussex; and in it he made nearly a dozen drawings: two, on 10 and 12 October, of Worcester itself – from the river[9] and from the north (FIG 283); several of Bewdley and of scenes on the bank of the Severn (FIG 284); and on 14 October, a detailed study of a plough (FIG 285). The following day, the 15th, he drew, *Dowles Brook* (PLATE 42). It seems strange that in neither of his visits, in either 1811 or 1835, does he appear to have made any sort of record of Spring Grove, of the house – a plain but quite imposing, pedimented building – or of the grounds, handsomely laid out around the lake with its picturesque island;[10] that, instead, he chose to sketch the town nearby, to make his study of the plough and to draw one of the Severn trows (FIG 284) – as the local barges were called. However, in *Dowles Brook* we have a drawing that at least related to his hostess, Sarah Fletcher and her family, if not to Spring Grove.

The subject is a watersplash. Constable took his view-point from the left bank of the stream, just where it crossed the Bewdley/Bridgenorth road, then little more than a track, now the B4194, metalled, and carried across the brook by a stone bridge that completely blocks the view down the valley that Constable drew. In the drawing, downstream on the left, half hidden, we see a building, probably a barn belonging to Dowles Farm; beyond, in the distance, on the other side of the brook, Dowles Church, St Andrews (sadly, closed in 1827 and demolished in 1956), of which Joseph Fletcher was rector. Here, in Constable's time, in a family vault in the churchyard, were buried Sarah's first husband, Samuel Skey (1758–1806), and two of their children, Charles Bicknell who died in infancy, and Samuel, who died, aged ten, in 1812.[11]

Constable's drawing of the scene – the shallow brook entering the more open part of the valley, the shadowed banks, enveloping scrub and woods, the lone tree and the barely suggested, rather wild sky – is representative of the work of that final season of sketching and well illustrates the very personal system of notation, a kind of restless shorthand, that he had evolved in these last years for the rendering of landscape. This was a system permitting extremes of handling, from heavily chiselled darks to the lightest of touches of the pencil and, between, every sort of scribble and zig-zag, each mark a recognisable element in the landscape only when seen in context, a system that permitted a wide range of emotional responses.

9 Pencil. Museé du Louvre, RF 29904.
 Reynolds 1984, 35.21, pl.1030.
10 Now (1989), a Safari Park.
11 Subsequently to be read on the tombstone
 (but now vanished and almost illegible),
 were inscriptions commemorating Sarah
 Fletcher (1775–1840) and her surviving
 son, Arthur (1806–60), the latter, as a
 child, was a great favourite with
 Constable.

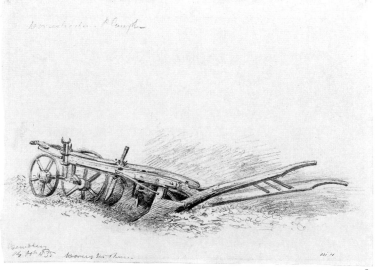

285

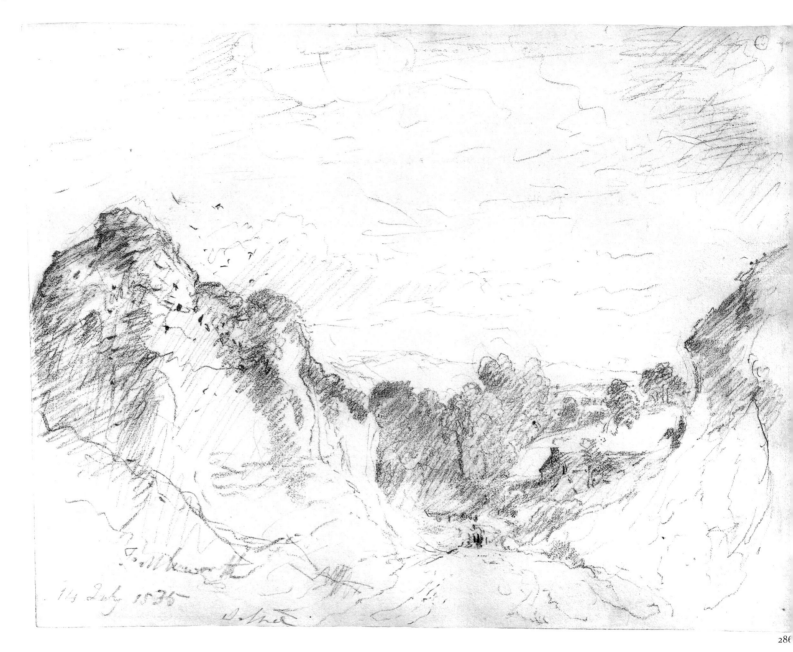

286

This year, 1835, he filled two sketchbooks. *Dowles Brook* is from the larger of the two, the earlier pages of which he had used in July when staying at Arundel with George Constable. The smaller book is one of the few to have remained practically intact.[12] Most of the drawings it contains were done during his Sussex visit. In both books he made a number of drawings in and around Fittleworth, a village a few miles north of Arundel. Some are of the watermill there, but four are of a sunken lane that descended steeply into the valley below. The first (FIG 286), a diving, foreshortened perspective between high banks with a cart or group of figures in the distance at the bottom of the hill, is dated 14 July. The other three in the intact sketchbook, all dated 16 July, seem to be less like views each drawn from a single spot, than the same place at different moments in time – landscape experienced as a sequence of events (FIGS 287, 288 and 289). From the oils of these years we know that Constable's outlook on landscape was radically changing, moving off into directions that at present we do not fully understand. Does the restlessness that informs *Dowles Brook*, the Fittleworth drawings and others in

12 V.& A. Reynolds 1984, 35.19. Consisting of 25 pages of drawings (from which two may have been removed), the book was used between 13 and 27 July while the artist was at Arundel and Kingston-upon-Thames.

FIG 286 *A Sunken Lane at Fittleworth*
Pencil on wove, trimmed paper,
22.2 × 28.5 cm.; watermark,
'J. WHATMAN 1833'. Inscribed, b.l.,
'Fittleworth/ 14 July/ Alfred'.

FIG 287 *A Lane between steep Banks*
Pencil on wove paper, 11.5 × 18.8 cm.;
page 27 in intact sketchbook, paper
watermark, 'J. WHATMAN 1832'.
Inscribed, b.l., 'July/ 16 1835'.
Victoria and Albert Museum.

FIG 288 *A Tree growing in a Hollow*
Pencil on wove paper, 11.5 × 18.8 cm.;
page 29 in intact sketchbook.
Inscribed, b.r., 'Fittleworth/ 16 July'.
Victoria and Albert Museum.

FIG 289 *A Sunken Road*
Pencil on wove paper, 11.5 × 18.8 cm.;
page 31 in intact sketchbook.
Inscribed, b.l., 'Fittleworth/ July 16
1835'. Victoria and Albert Museum.

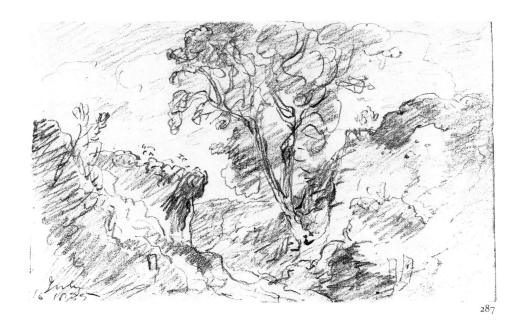

287

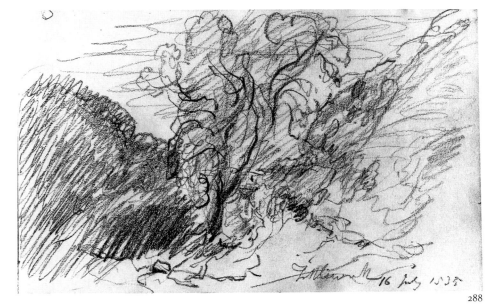

288

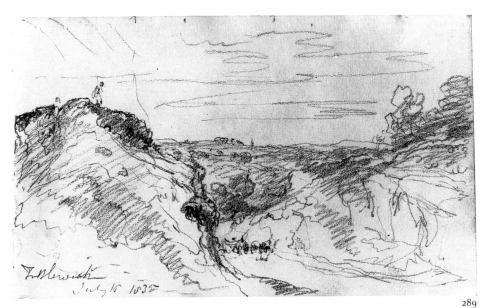

289

this last period of his working life signify a greater realisation of landscape? Charles Rhyne has spoken and written movingly about his belief that Constable was attempting more than just the optical experience the countryside provided; that the chronological development of his technique 'was a response to his desire to convey his full experience' of the localities he knew so intimately, 'that he sought progressively to find equivalents in paint for not only the visual appearance, but also the touch, even the sounds and smells of his native landscape, the full sensory experience of place.'[13] One is here reminded of Constable's reply to a letter of Fisher's telling of a day's fishing in the New Forest, 'with mills, roaring back-waters, withy beds, &c',[14] when he talked of the things he loved, the *sound* of water escaping from mill dams, willows, old rotten banks, *slimy* (author's italics) posts and brickwork. 'As long as I do paint', he said, 'I shall never cease to paint such Places.'[15] Further evidence of the fullness of Constable's appreciation of landscape is to be found in a passage in Leslie's *Life*. At the time they were both staying at Petworth and Leslie says that he there had an opportunity of witnessing his friend's habits.

> He rose early, and had often made some beautiful sketch in the park before breakfast. On going into his room one morning, not aware that he had yet been out of it, I found him setting some of these sketches with isinglass.[16] His dressing-table was covered with flowers, feathers of birds, and pieces of bark with lichens and mosses adhering to them, which he had brought home for the sake of their beautiful tints. Mr. George Constable told me that while on the visit to him, Constable brought from Fittleworth Common at least a dozen different specimens of sand and earth, of colours from pale to deep yellow, and of light reddish hues to tints almost crimson. The richness of these colours contrasted with the deep greens of the furze and other vegetation in this picturesque heath delighted him exceedingly, and he carried these earths home carefully prepared in bottles, and also many fragments of the variously coloured stone. In passing with Mr. G. Constable some slimy posts near an old mill, he said, 'I wish you could cut off and send their tops to me.[17]

With a drawing such as *Dowles Brook* one cannot truthfully say that the sounds of the shallow stream are audible or that we can feel the breeze that seems to be moving through the branches, but Constable's love was for landscape in its entirety and if we wish for a fuller understanding of his intent we should not discount the probability that at Dowles it was the *complete* experience beside that watersplash that he was endeavouring to capture, an experience compounded of his past – and the reasons that had brought him to that place – with the immediacy of the present, the scene before and around him and all of the living world contained therein.

13 Charles S. Rhyne, 'Constable's Last Major Oil Sketch: the Chicago *Stoke by Nayland'*. Article and lecture commissioned by the Art Institute of Chicago; completed August 1987; copy on file in the Department of European Painting, Art Institute of Chicago.

14 26 September 1821; JCC VI, p.76.

15 23 October 1821; ibid., p.77.

16 Constable appears to have used diluted isinglass, a pure form of gelatin from Sturgeon, as a fixative for many of his pencil drawings. Where he missed a part and there is a consequent loss of graphite, this often shows as a slight lighter patch. Some of the pencil-work in *Bewdley from the River Bank* (FIG 284) was unfixed, and there are slight losses here as a result – e.g., among the trees to the right of the church tower.

17 *Life*, 1951, pp.236–7.

Chronology

1776	11 JUNE John Constable born at East Bergholt, the fourth of Golding and Ann (née Watts) Constable's seven children.
1788	15 JANUARY A daughter, Maria Elizabeth, born to Charles and Maria Elizabeth Bicknell (née Rhudde), the first of five children.
c.1792	John Constable leaves Dedham Grammar School and enters the family business.
1795	Is introduced to Sir George Beaumont.
1796	Spends some weeks with maternal relations, the Allens, at Edmonton, where he meets J. T. Smith, John Cranch and a circle of antiquarians and literati.
1799	4 MARCH Admitted a probationer at The Royal Academy Schools.
1801	23 JULY to 17 NOVEMBER Stays with his sister Martha's in-laws, the Whalleys, at Fenton, Staffordshire, during which time he makes a short tour of Derbyshire.
1803	APRIL/MAY Spends four weeks on an Indiaman, the *Coutts*, on the first leg of its voyage to the East.
1806	1 SEPTEMBER to 19 OCTOBER, tours the Lake District.
1809	Declares his love for Maria Bicknell. A visit to Malvern Hall, Warwickshire. His oil sketches from nature of an innovatory cast.
1811	SEPTEMBER A visit to stay at Salisbury with the Bishop, Dr Fisher; meets the Bishop's nephew, John Fisher, later Archdeacon of Berkshire, who becomes his closest friend. DECEMBER Spends a weekend at Spring Grove, Bewdley, Worcestershire, with Maria Bicknell and her half-sister, Sarah Skey.
1814	JUNE Makes a short tour of Essex with Revd W. W. Driffield.
1815	MARCH Death of Ann Constable, the artist's mother.
1816	19 MAY Death of his father, Golding Constable. 2 OCTOBER Marries Maria Bicknell at St Martin's-in-the-Fields; they spend most of their honeymoon at Osmington, Dorset, with John Fisher and his wife.
1817	Takes a house, 1 Keppel Street, Bloomsbury. 4 DECEMBER Maria gives birth to a son, John Charles.
1819	Exhibits *The White Horse*, the first of his six-foot canvases. 1 NOVEMBER Elected an Associate of the Royal Academy.
1820	He and his family spend several weeks in the summer with the Fishers at their house, *Leadenhall*, in Salisbury Close.
1822	Moves to 35 Charlotte Street, previously occupied by Joseph Farington, R.A.
1821	JUNE Accompanies Fisher on his Visitation of Berkshire.
1823	APRIL A short visit to Flatford. AUGUST Joins Fisher at Gillingham, Dorset, for a few days. OCTOBER/DECEMBER A long visit to the Beaumonts' at Coleorton, Leicestershire.
1824	Two of his large paintings exhibited at the Salon in Paris MAY Takes his wife to Brighton for her health; later, spends much of the summer there with his family.
1827	AUGUST Leases a house, 6 Well Walk, Hampstead. OCTOBER Enjoys a holiday at Flatford with his two eldest children, John and Minna.

1828　2 JANUARY Birth of Lionel Bicknell, Maria's seventh child.
JUNE Maria now seriously ill; takes her again to Brighton.
23 NOVEMBER Death of Maria Constable at 6 Well Walk.

1829　10 FEBRUARY Elected Academician by a majority of one vote.
Visits Fisher at Salisbury twice – in JULY and NOVEMBER.
SEPTEMBER Begins work on his *English Landscape* with the engraver, David Lucas.

1830　JUNE The first number of *English Landscape* published.

1832　JANUARY Afflicted by rheumatic fever – unable to use his right hand.
25 AUGUST Death of John Fisher in Boulogne.
2 NOVEMBER Death of his erstwhile assistant, Johnny Dunthorne.

1833　OCTOBER Spends nearly two weeks at Folkestone to be near his son, John, who is ill at his school there.

1834　JULY Visits a new friend, George Constable (no relation), at Arundel, Sussex.
SEPTEMBER Joins his friend C. R. Leslie, at Petworth, Lord Egremont's house.

1835　JULY Takes his two eldest children to stay at Arundel.
OCTOBER Lectures at Worcester and stays for two or three days at Spring Grove.

1836　MAY Delivers four lectures on Landscape at the Royal Institution, Albemarle Street.

1837　31 MARCH Dies at his house in Charlotte Street. Buried at Hampstead.

Picture acknowledgements

The colour plates in this book were photographed by Prudence Cuming Associates, London.

The photographs of contemporary locations are courtesy of the author (FIGS 139, 144) and John Bull (FIG 235).

The figure illustrations referred to below have been reproduced by kind permission of the collectors, galleries, institutions or companies under which they are listed, and have been arranged according to location.

ARUNDEL
Arundel Museum and Heritage Centre FIG 242
BATH
City of Bath, Victoria Art Gallery FIG 167
BOSTON (Massachusetts)
Museum of Fine Arts FIGS 135 (Bequest of Mr and Mrs William Caleb Loring), FIG 245
CAMBRIDGE
Syndics of Fitzwilliam Museum FIGS 217, 223, 224, 227, 238, 278.
National Trust, Fairhaven Collection, Anglesey Abbey, Cambridgeshire FIG 177
CINCINNATI (Ohio)
Cincinnati Art Museum FIG 163 (Gift of Mary Hanna)
CHICAGO (Illinois)
Art Institute of Chicago FIG 277
COLCHESTER
Colchester and Essex Museum FIG 187
The Victor Batte-Lay Trust, The Minories FIGS 24, 25
CREWKERNE
Courtesy of Lawrence Fine Art FIG 230
EXETER
Royal Albert Memorial Museum FIG 264
FLORENCE
Fondazione Horne FIGS 63, 64, 178
GRASMERE
Wordsworth Trust, Dove Cottage FIGS 80, 81, 82, 86, 87, 88, 90
IPSWICH
Ipswich Borough Museum and Galleries, Christchurch Mansions FIGS 61, 145, 146, 232
East Suffolk Record Office FIG 95
KENDAL
Abbott Hall Art Gallery FIG 91
KENNETT
Kennett and Avon Council Trust Limited FIG 171
LEEDS
Leeds City Art Galleries FIG 78
LIVERPOOL
National Museum and Galleries in Merseyside, Lady Lever Art Gallery, Port Sunlight FIG 219
Liverpool City Libraries and Art Galleries, Hornby Library FIG 233
LONDON
Trustees of the British Museum FIGS 15, 66, 149, 150, 151, 152, 182, 183, 190, 225, 228, 239, 241, 250, 251, 261, 266
Courtesy of Christie's Limited FIGS 38, 74, 76, 168, 195, 246
Courtauld Institute Galleries FIGS 207 (Witt Collection no. 2873), 260 (Spooner Collection), 263 (Lee of Fareham Collection)
Fine Art Society FIG 201
Guildhall Art Gallery FIG 220
Courtesy of Leger Galleries FIGS 193, 196
Courtesy of Christopher Mendez FIGS 208, 210, 211

National Gallery FIGS 112, 215 (loan)
Courtesy of Phillips Limited FIG 172
Royal Academy of Arts FIGS 181, 188, 270
Royal Collection, by gracious permission of Her Majesty the Queen FIG 159
Courtesy of Sotheby's Limited FIGS 17, 131
Tate Gallery FIGS 8, 9, 65, 67, 108, 109, 110, 114, 127, 147, 148, 153, 222, 272, 273
Victoria and Albert Museum FIGS 2, 3, 4, 6, 7, 10, 16, 19, 26, 27, 41, 44, 60, 68, 70, 71, 79, 94, 96, 100, 103, 104, 105, 106, 107, 118, 120, 121, 122, 126, 140, 141, 154, 162, 166, 169, 170, 174, 185, 186, 192, 198, 200, 202, 204, 205, 206, 229, 236, 243, 247, 248, 267, 269, 271, 276, 283, 285, 287, 288, 289

MANCHESTER
Manchester Art Galleries FIG 69
University of Manchester, Whitworth Art Gallery FIG 75

MELBOURNE
National Gallery of Victoria FIG 189 (Felton Bequest 1950/51)

MICHIGAN
University of Michigan Art Museum

MUNICH
Staatliche Graphische Sammlung FIG 115

NEW HAVEN
Yale Center for British Art FIGS 36, 43, 52, 72, 77, 213, 218, 226, 249, 265 (Paul Mellon Collection)

NEW YORK
Metropolitan Museum of Fine Art FIGS 259 (Harris Brisbane Dick Fund, 1930. (30.49.7)), 274 (anonymous gift, 1939. (39.68.12))
Courtesy of Salander O'Reilly Galleries Inc. FIGS 48, 93

NORWICH
Norfolk Record Office FIG 45
Norwich Central Library FIGS 55, 56, 57, 58

OLDHAM
Oldham Art Galleries and Museums FIG 1

OXFORD
Ashmolean Museum FIG 268

PARIS
Musée du Louvre FIGS 62, 157 (Department of Graphic Arts)

PHILADELPHIA (Pennsylvania)
Philadelphia Museum of Art FIG 184 (The John H. Mcfadden Collection)

PROVIDENCE (Rhode Island)
Museum of Art, Rhode Island School of Design FIG 161 (anonymous gift)

SAN MARINO
Henry E. Huntington Library and Art Gallery FIGS 92, 98, 101, 117, 125, 173

TOLEDO (Ohio)
Toledo Museum of Art FIG 244 (Gift of Edward Drummond Libbey)

UPPERVILLE (Virginia)
Collection of Paul Mellon FIGS 212, 218

WASHINGTON (DC)
National Gallery FIG 231

WINCHCOMBE
Trustees of the Walter Morrison Settlement, Sudeley Castle FIG 180

WINDSOR
The Provost and Fellows, Eton College FIG 85

The following illustrations are from the collections of:
John Day (FIG 199); Miss Sadie Drummond (FIG 37); Tom Girtin (FIG 73); Leonard Voss Smith (FIG 209).

Index